CW00656258

DANCING IN THE STREETS

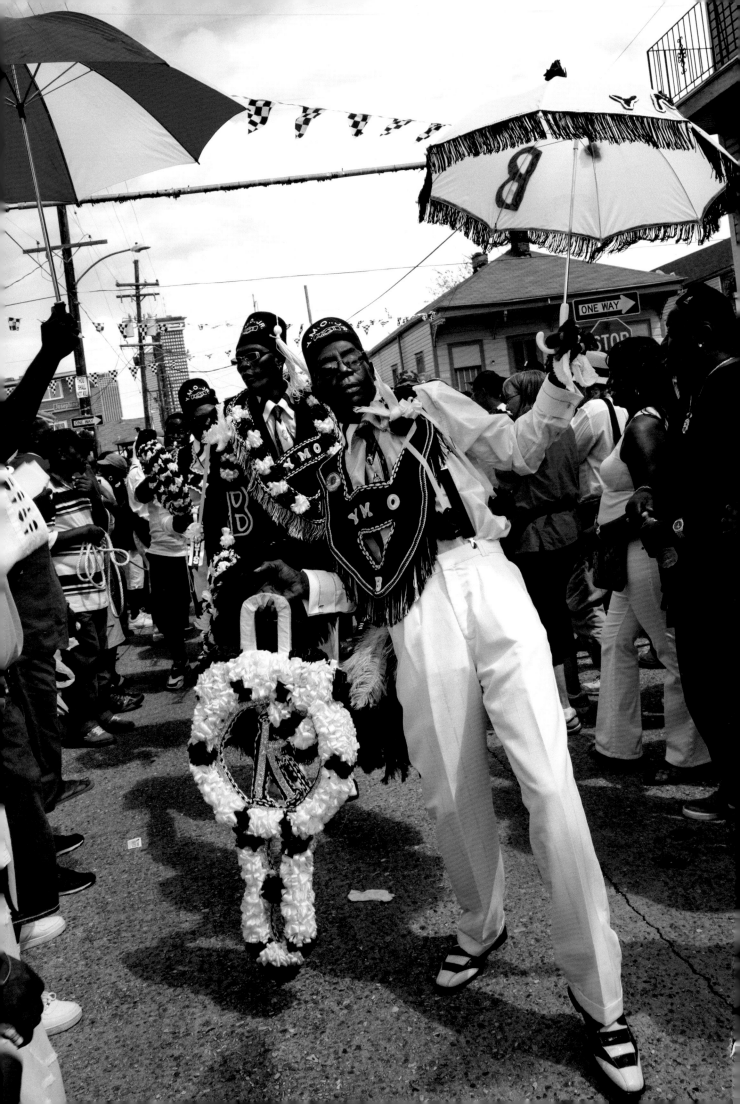

DANCING
IN THE
STREETS

SOCIAL AID AND PLEASURE CLUBS OF NEW ORLEANS

JUDY COOPER

WITH ESSAYS BY RACHEL CARRICO, FREDDI WILLIAMS EVANS, CHARLES "ACTION" JACKSON,
MATT SAKAKEENY, AND MICHAEL G. WHITE

THE HISTORIC NEW ORLEANS COLLECTION
2021

The Historic New Orleans Collection is dedicated to the stewardship of the history and culture of New Orleans and the Gulf South. A museum, research center, and publisher, The Collection is operated by the Kemper and Leila Williams Foundation, a Louisiana nonprofit corporation.

© 2021 The Historic New Orleans Collection

533 Royal Street
New Orleans, Louisiana 70130
www.hnoc.org

Front and back jacket images by Judy Cooper
© Judy Cooper

Project editor: Molly Reid Cleaver
Director of publications: Jessica Dorman
President and CEO: Daniel Hammer

Art direction, jacket, and book design: Georgia Scott
New Orleans, Louisiana

Printed and bound in Canada by Friesens

25 24 23 22 21 1 2 3 4 5

ISBN: 978-0-917860-82-9

Library of Congress Cataloging-in-Publication Data

Names: Cooper, Judy, 1938- author.
Title: Dancing in the streets : social aid and pleasure clubs of New
 Orleans / Judy Cooper ; with essays by Rachel Carrico, Freddi Williams
 Evans, Charles "Action" Jackson, Matt Sakakeeny, and Michael G. White.
Description: New Orleans, Louisiana : The Historic New Orleans Collection,
 2021. | Includes bibliographical references and index.
Identifiers: LCCN 2021010299 | ISBN 9780917860829 (hardcover)
Subjects: LCSH: Parades--Louisiana--New Orleans--History. | African
 American fraternal organizations--Louisiana--New Orleans--History. |
 African Americans--Louisiana--New Orleans--Social life and customs. |
 New Orleans (La.)--Social life and customs.
Classification: LCC GT4011.N6 C66 2021 | DDC 394/.509763--dc23
LC record available at https://lccn.loc.gov/2021010299

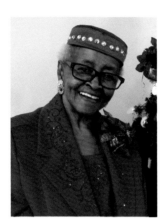

Dedicated to Clara "CJ" Joseph, who was one of the first members of the second line community to befriend me and introduce me to her fellow community members. She opened many doors. Without her guidance and friendship, this book might never have been written.

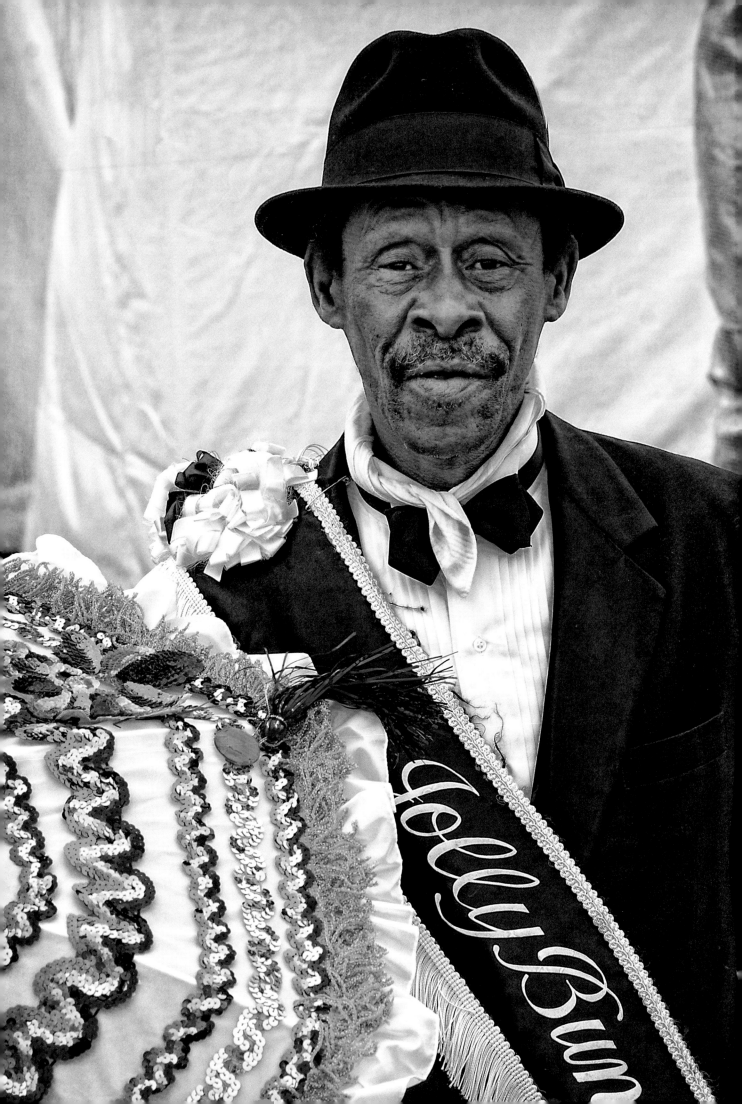

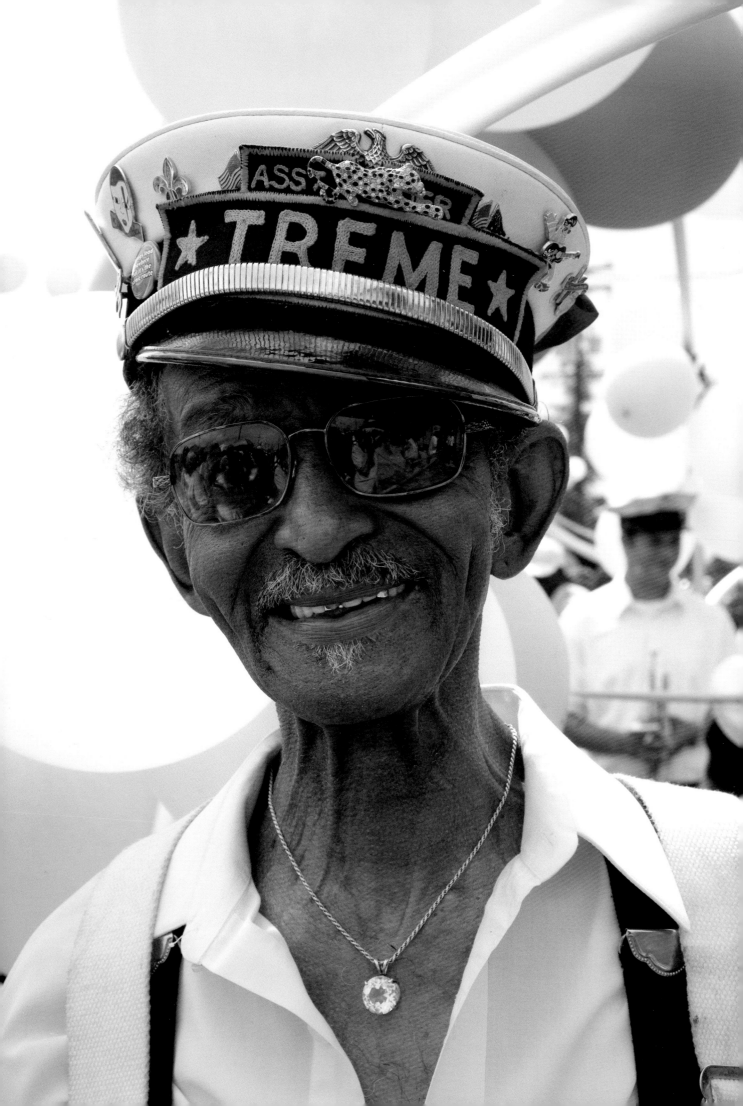

CONTENTS

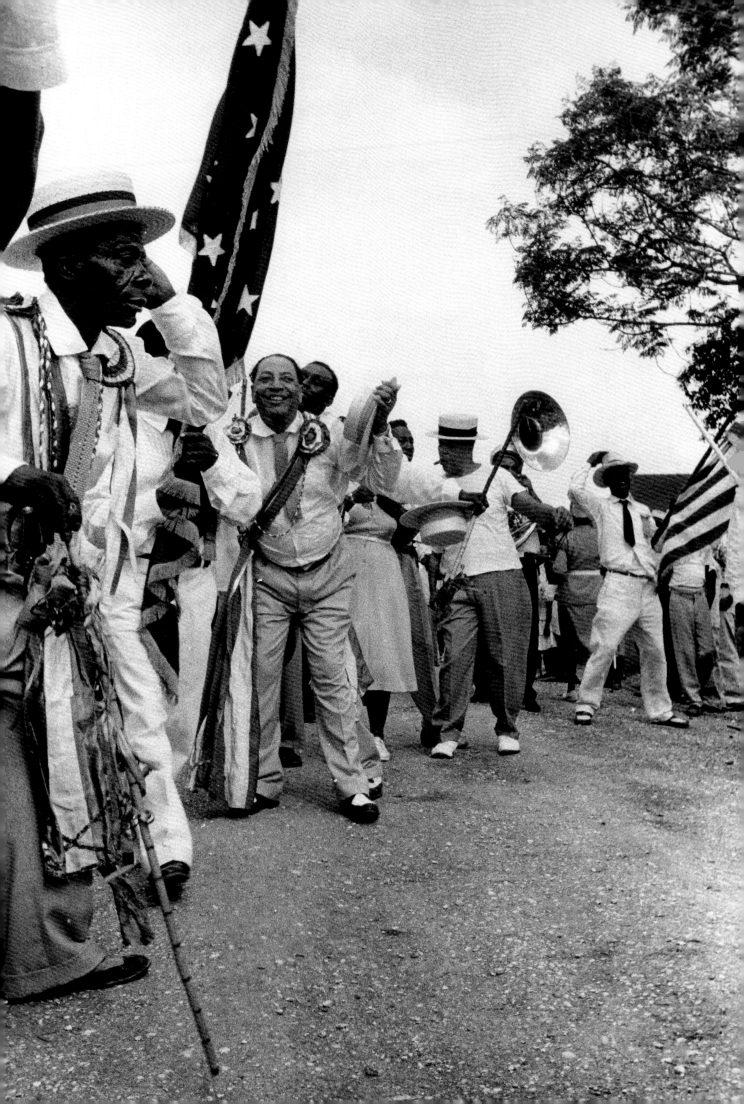

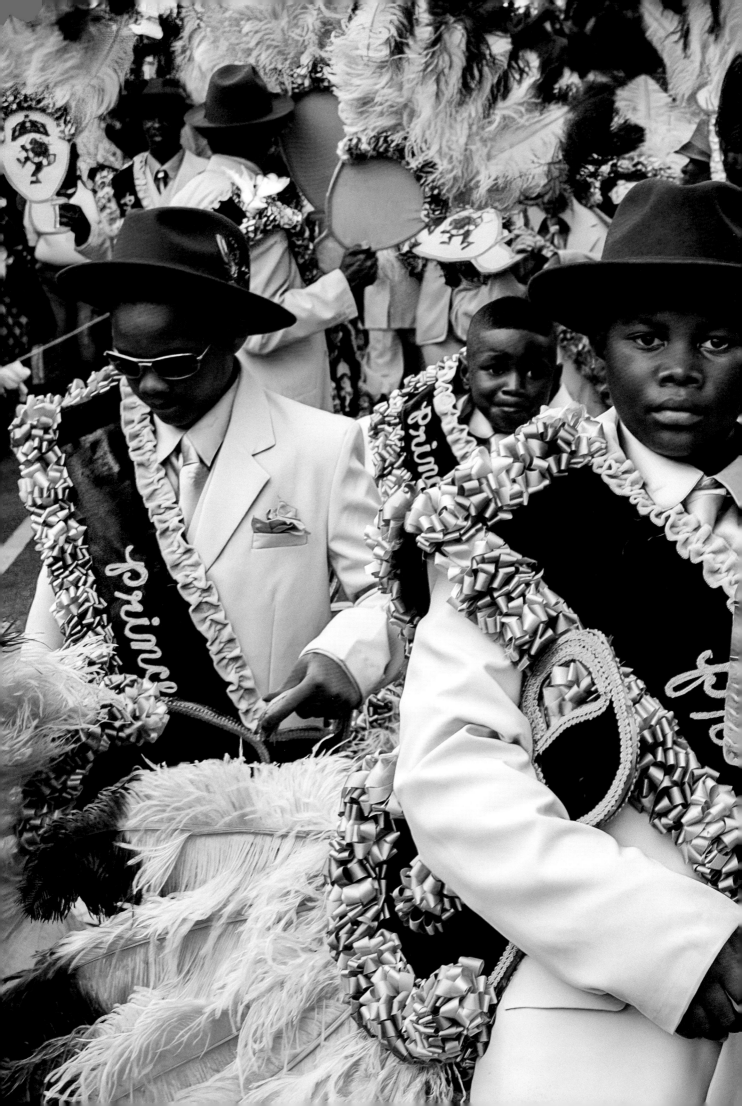

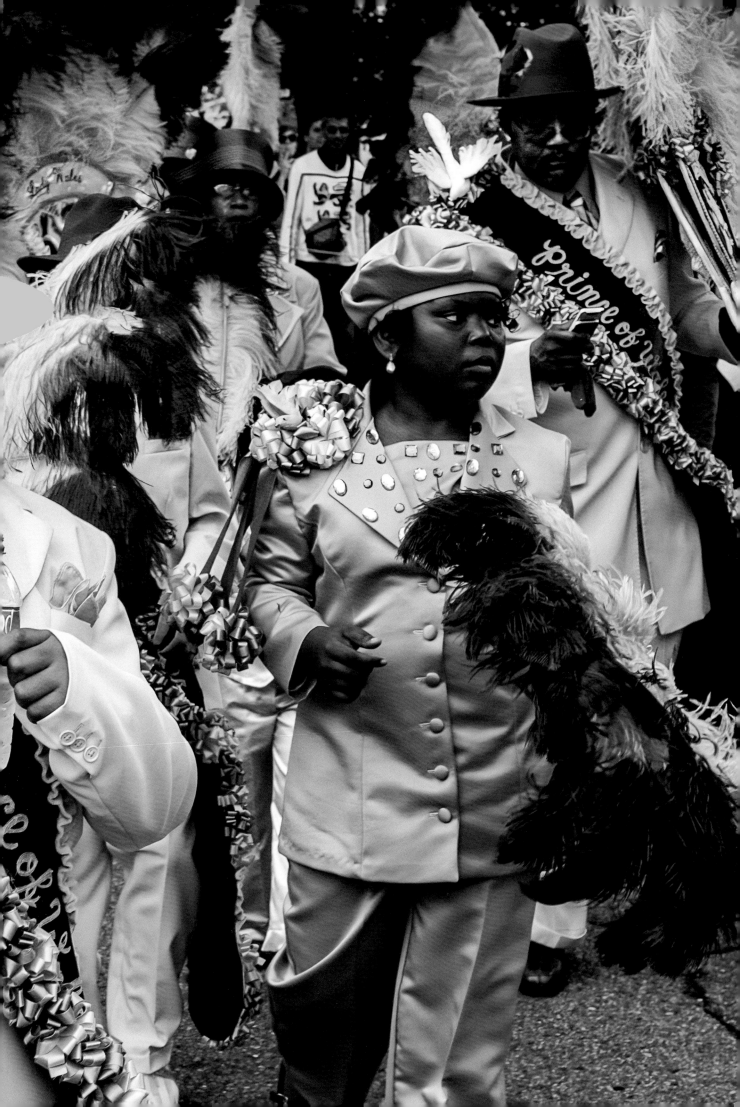

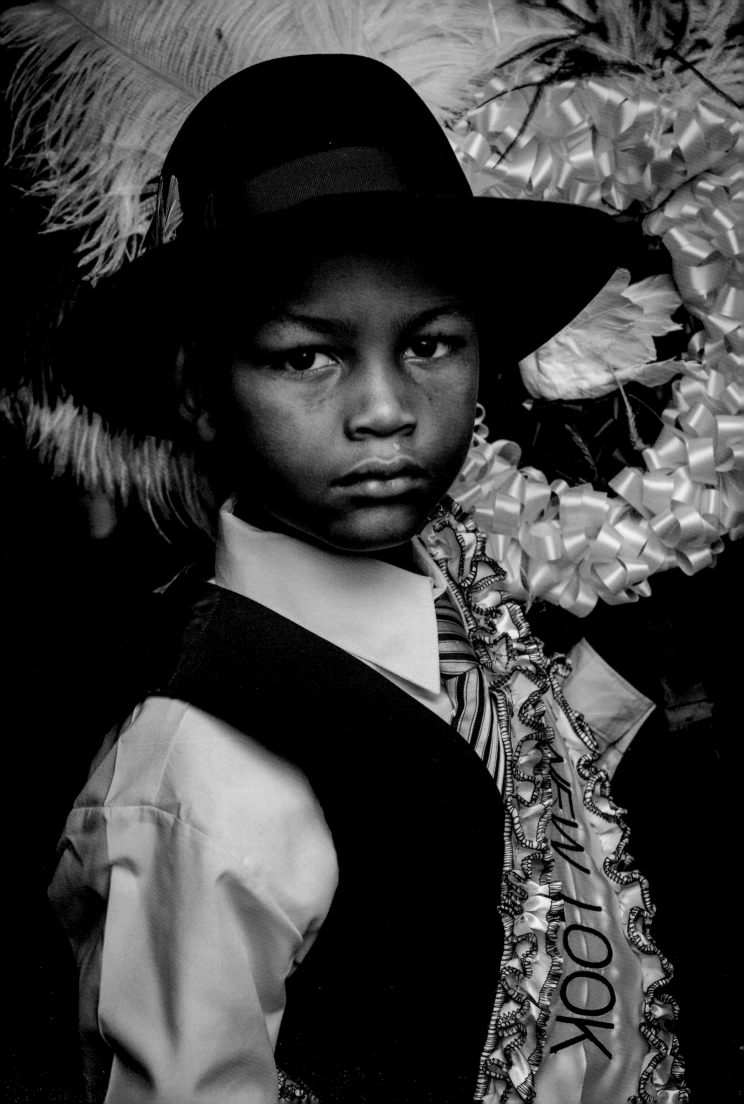

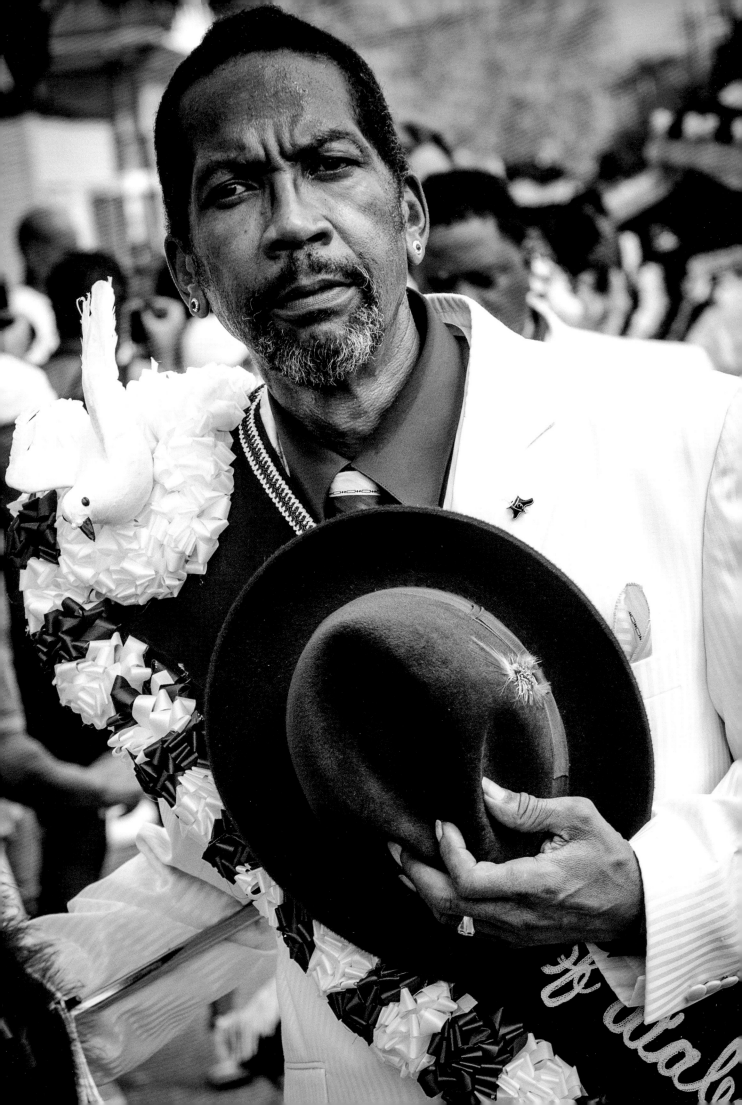

FOREWORD

DANIEL HAMMER

At the time of this book's publication, the streets of New Orleans have been empty of social aid and pleasure club parades for more than a year, marking the longest continuous interruption in a tradition stretching back generations. Full of color and artistry, music and footwork, and friends and neighbors, the parades—commonly called second lines—have become one of the city's defining cultural practices, providing a weekly physical and symbolic gathering place for Black history and expression.

The clubs parade for themselves and their communities, but the whole city benefits. Second lines—the freedom and festivity of dancing in the streets—have become part of the bedrock of New Orleans's identity, instilling pride in residents across race, class, and place of origin. The city's billion-dollar tourism industry uses the distinctive imagery and sounds of second lines to attract visitors, supporting the entire region's economy as a result—but not, it must be said, with equitable compensation for everyone involved. New Orleans is indebted in many ways to its social aid and pleasure clubs, for keeping alive the "circulatory system" of Black music and culture (to borrow a term from one of this book's contributors, Matt Sakakeeny) that helps make the city unlike any other.

The Historic New Orleans Collection (THNOC) has been honored and humbled to mount the 2021 exhibition *Dancing in the Streets: Social Aid and Pleasure Clubs of New Orleans*, our first large-scale show devoted to the second line community and its history. The curatorial team—John H. Lawrence, Eric Seiferth, Jude Solomon, and Jason Wiese—began by drawing from THNOC's extensive photographic holdings, including important collections from the photographers Michael P. Smith, Bill Russell, John Bernard, and Jules Cahn. Guided in the early planning stages by longtime second line photographer Judy Cooper, the group curated more than eighty images from contemporary photographers, nearly all of them weekly attendees of the parades.

OPPOSITE Nolan Stansbury, Prince of Wales, 2013, by Pableaux Johnson

Dancing in the Streets has been a milestone in our programming, but the show has also been a turning point in our approach to partnership and community. Although THNOC's holdings abound in photographs and historical items related to the clubs, this exhibition would not be possible without the collaboration between curators and the second line community itself, specifically two institutions devoted to the history and culture of Black masking and parading traditions—the Backstreet Cultural Museum, founded by Sylvester Francis, and the House of Dance and Feathers, founded by Ronald W. Lewis. As museum directors, authors, and longtime parade participants, Francis and Lewis worked alongside their fellow culture bearers, building collections and telling the stories of those practicing and preserving the culture. Both museums loaned images and pieces of parade regalia to display in the exhibition.

Curators had just begun building this partnership, initiating a number of important loan items, when the pandemic arrived. Lewis died of COVID-19 shortly after, on March 20, 2020. Several months later, on September 1, Francis passed away from appendicitis. The exhibition is dedicated to their memory.

Lewis and Francis were not only vital culture bearers and museum curators; their work has provided a model of community relationship building. Both men worked with the nonprofit publisher Neighborhood Story Project (NSP) to turn their and their community's stories into publications: the NSP worked with Lewis to create his book, *The House of Dance and Feathers: A Museum by Ronald W. Lewis* (2009), and with Francis on the collaborative ethnography *Fire in the Hole: The Spirit Work of Fi Yi Yi and the Mandingo Warriors* (2018). Following the examples of these partnerships, THNOC built *Dancing in the Streets* in collaboration with the NSP and more than thirty club founders, presidents, longtime members, and others represented in the photographs on display.

This book, a companion publication to the exhibition, has sought to achieve a similar depth of engagement with the city's social aid and pleasure clubs, as well as with the existing scholarship on the subject. Author and photographer Judy Cooper first conceived of the book more than a decade ago and spent years developing relationships with club leaders, conducting interviews, and showing up faithfully for the parades. A devoted documentarian of the second line tradition, Cooper insisted on profiling every active club in the city, casting a spotlight on each individual group in a way that has never previously been put into print. Her essays have drawn from foundational research and writings by Sidney Bechet, Louis Armstrong, Helen Regis, Rachel Breunlin and the Neighborhood Story Project, Eric Waters and Karen Celestan, and Claude Jacobs, as well as historical newspaper accounts, photographic archives, and copious interviews with current club members. She also called on leading scholars of New Orleans music, dance, and history to contribute essays. After the arrival of the novel coronavirus, Cooper reached out to second line chronicler Charles "Action" Jackson, of WWOZ's *Takin' It to the Streets*, to add an epilogue addressing the effects of the pandemic on the tradition.

This book was always intended to be both a history of New Orleans's second line tradition as well as a snapshot in time of the current parading scene. The events of

2020 have made that snapshot more poignant and bittersweet than we could have ever anticipated. A whole year without second line parades used to be unthinkable; now it's another part of normal life in New Orleans put on hold by the pandemic. Suspended, yes, but not gone. As seen in these essays and accompanying photographs spanning nearly eighty years of practice, Black New Orleans's culture of mutual aid and community-based parading has survived going on two centuries, weathering generational challenges from the Great Depression to Hurricane Katrina. When it's safe to do so, social aid and pleasure clubs will return to the streets in triumph, and we will all be the better for it.

February 2021

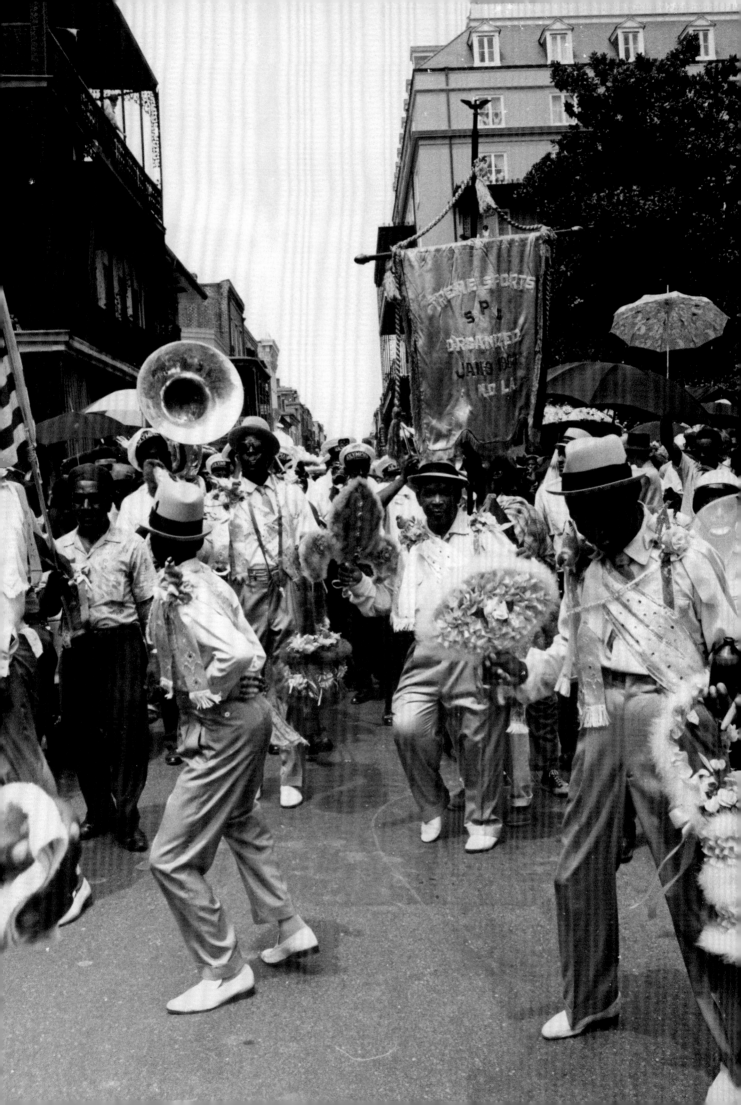

HISTORY

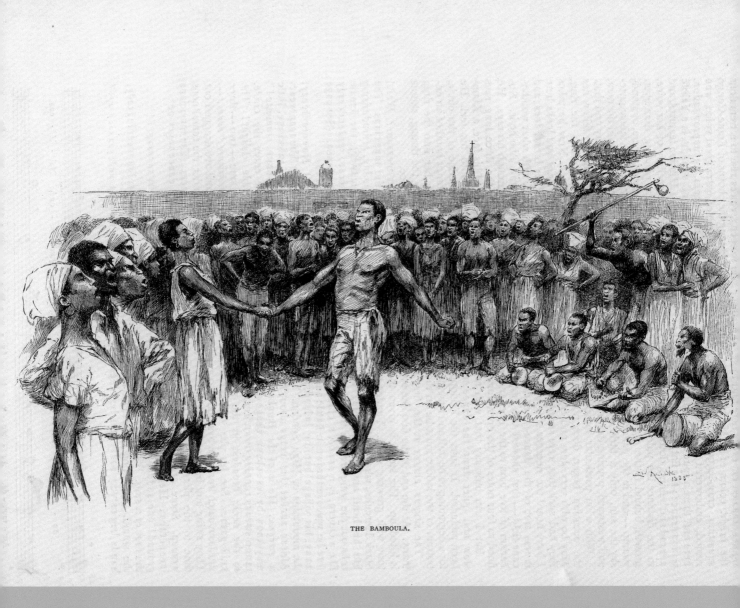

THE BAMBOULA.

CONGO SQUARE AND THE ROOTS OF SECOND LINE PARADING

FREDDI WILLIAMS EVANS

New Orleans's Congo Square is a figurative point of origin and literal point of reference for much of the city's indigenous African American cultural practices. At the historic location, African cultural expressions were concentrated, synthesized, and perpetuated over time, forming the core of contemporary New Orleans culture and retaining recognizable characteristics of the original expressions.

Located just outside the French Quarter, Congo Square was one of several locations where enslaved Black people, as well as some who were free, gathered to make music, dance, market, and worship. From the earliest days of the city until 1817, when, by way of a city ordinance, it became their only official meeting place, people of African heritage congregated at Congo Square on Sunday afternoons by the hundreds—some reports say thousands. They played African rhythmic patterns on African-styled musical instruments; engaged in African-based religious practices; performed African songs and dances; and exchanged goods much in the style of West and West Central African marketing. The gatherings took place intermittently until the mid- to late 1850s, when the city's expansion in size, population, and American political influence all led to increased restriction on the activity of Black people, enslaved and free, leading up to the American Civil War.[1]

The cultural practices in Congo Square mirrored those found in the parts of West and West Central Africa and the West Indies, where many of the gatherers had resided before landing in New Orleans. Some had been born and held in bondage in other parts of the African diaspora, including other North American slaveholding territories such as Virginia and Maryland. Some had been born in New Orleans. Haitian immigrants, the majority of whom arrived in the city as a result of the Haitian Revolution, came directly from the island, as well as indirectly via Cuba, where many had initially fled. Those

PRECEDING SPREAD Treme Sports, ca. 1970, by Jules Cahn
OPPOSITE *The Bamboula*, 1886, by E. W. Kemble

immigrants greatly reinforced existing African practices throughout the city, and, over time, those African-derived cultural experiences blended with European-based components to form new styles. At Congo Square, this process occurred over a longer span of time and to later dates, with a more diverse set of participants, than at any other public location in North America. No other site in the United States can claim Congo Square's record as a place where African and African-based cultural practices were perpetuated, preserved, and transformed, and no other city can claim the second line tradition, Mardi Gras Indian tradition, jazz funerals, and other original African American expressions and practices found in New Orleans.

While the term "second line" was not used to reference dances or processions during the antebellum period, eyewitness accounts of the dances in Congo Square and street processions during that time period reveal characteristics of the present-day tradition. Dancing was standard at the gatherings in Congo Square as well as in other parts of the city and state, often accompanied by the waving of handkerchiefs. Architect Benjamin Latrobe, who entered several dance circles in Congo Square in 1819, saw women stepping one behind the other, each holding a coarse handkerchief extended by the corner in her hand.[2] Historian Robert Farris Thompson found in his research that people of Kongo-Angola heritage waved handkerchiefs while dancing as an act of cleansing or purifying the air of evil spirits. (This practice existed in other West African countries as well.) It was symbolic of sweeping problems away and protecting their kinsmen and kinswomen.[3] The significance of Thompson's findings lies in the fact that the majority of Africans brought to Louisiana during the Spanish and early American periods were from the Kongo-Angola region of West Central Africa.[4]

Today, the waving of handkerchiefs is a standard characteristic of second line dancing at weddings and other celebrations in New Orleans, and handkerchiefs are also seen at second line parades. Although social aid and pleasure club members are more likely to carry color-coordinated and elaborately decorated fans while parading—not handkerchiefs—it is not uncommon for members of the crowd, particularly family and friends of club members, to receive and wave souvenir handkerchiefs, often inscribed with the club's name and the date or year.

Another point of African cultural retention in second line parades are the rhythms. In the New World, African polyrhythms were simplified into rhythmic cells; practiced at Congo Square, they became a part of indigenous New Orleans music.[5] The study of Creole slave songs that accompanied the most popular dances in Congo Square, including the Congo dance and the related Bamboula, reveals the African-derived habanera rhythmic pattern and its derivatives. One example is the Congo dance song "Quan' patate la cuite," which, according to the Creole writer Alice Dunbar-Nelson, was so ubiquitous that every child could sing it. New Orleans–born composer Louis Moreau Gottschalk learned the tune from his enslaved nurse of Haitian descent, Sally, and used it as the basis for his piano work *Bamboula: danse des nègres*, op. 2, which helped launch him to international fame.[6]

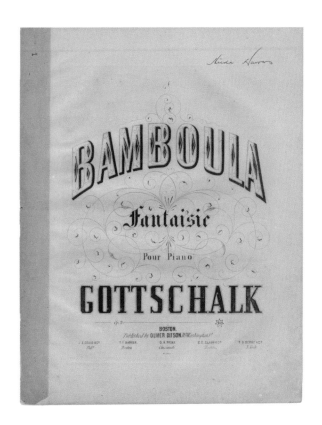

Chief among the habanera's derivatives in use today is the Afro-Cuban *tresillo*, a syncopated three-beat pattern that provides the foundation for countless New Orleans street songs, including the popular Mardi Gras Indian–inspired song "Hey Pocky Way." The significance of this rhythmic pattern in New Orleans street processions and second line traditions is indicated by the many names it carries locally, including the second line beat, the bamboula beat, the street beat, the New Orleans beat, and the parade beat.[7] In addition to the rhythmic cells that live on today, the African-derived music-making techniques associated with those rhythms have also persisted, including improvisation, syncopation, and call-and-response–style singing, chanting, and playing of instruments.

The use of those rhythmic patterns and techniques to accompany street processions is a long-standing tradition for Black people in New Orleans, with available documentation dating back to the early 1800s. Traveler Timothy Flint, who visited the city in 1822–23, observed hundreds of people, male and female, dancing the Congo in one such procession, which he described as part of a holiday celebration.[8] (At the time, "Congo" was used as a general connotation for anything Black or anything connected to African descendants; it could also refer to specific cultural practices that originated with people of Kongo-Angola heritage.) The dancers, Flint wrote, followed the "king of the wake," who wore a crown constructed from "a series of oblong, gilt-paper boxes, tapering upwards, like a pyramid . . . [with] two huge tassels" hanging from the ends. Those who

Bamboula: danse des nègres, op. 2, composed 1848, by Louis Moreau Gottschalk

followed the king wore "peculiar" attire and had their own dance movements, which they accented with flying streamers and jingling bells attached to their garments. Flint described the scene as one of "abandonment to the joyous existence of the present moment."[9] Affirming that such processions were neither new nor reserved for a specific holiday, Flint indicated that he had previously seen groups of Native Americans following merry Black leaders in their dance through the streets.

As the street-procession participants and the Congo Square gatherers were from the same population, the two practices shared cultural components: music, song, and dance were fully integrated, with certain songs accompanying certain dances. Each pairing was associated with specific rhythmic patterns and musical instruments. Both the parades and the gatherings featured improvised dancing, accented by the sound of bells affixed to participants' clothing. Through such street processions, Black New Orleanians transformed their stationary circles into moving linear formations. In a sense, the reversal of this phenomenon occurs during second line parades today: as club members progress through neighborhood streets, it is customary for them to stop every so often and come together in a circle, put down their accessories, and just dance. Second liners then gather around, encircling them in excitement as they show off their fancy footwork.

Such impressive dancing was also an attraction at the gatherings in Congo Square. An 1846 Daily Picayune article describing the scene of the square on Sunday afternoons highlighted a notable "master of ceremonies" who operated his own post, his own little circle, which he surrounded with ropes and posts to keep out the ordinary dancers. As he only admitted the most highly skilled and distinguished dancers into his magic ring, he "exerted himself to the utmost to promote harmony." The master of ceremonies reportedly dressed in a suit of blue and white with a black vest. His accessories included

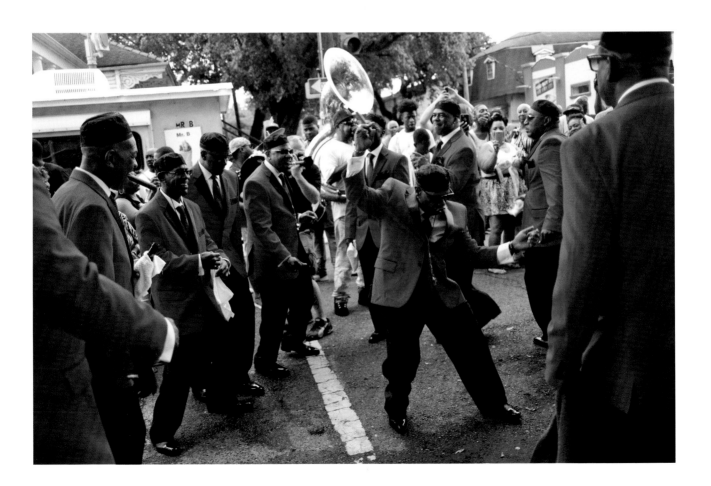

an enormous silver chain, earrings, and a white hat around which he twisted black crepe material.[10]

As some gatherers, like the master of ceremonies, introduced different trends and styles in Congo Square, others perpetuated traditional practices. The same *Daily Picayune* article states that many dancers gathered in circles—accompanied by the banjo, drums, and a cremona (violin)—and performed African dances. Spectators threw dimes to them, which reportedly encouraged them to dance.

Another shared characteristic of the Congo Square gatherings and second line parades is the marketing or economic exchange, which has always been a main feature of such social and recreational events. In 1726, Frenchman and early colonist Antoine Simon Le Page du Pratz noted that enslaved Africans on the west bank of the Mississippi River customarily assembled for dancing and recreation on Sundays throughout the area and that there was always buying and selling. The perpetuation of this African marketing culture presented the opportunity for marketers to earn money and for gatherers to spend money that they had earned during their time off, afforded to them by the *Code noir* of 1724. While market women with colorful tignons wrapped around their heads were not the only ones selling goods, they were the most prevalent and are frequently mentioned in written accounts. They spread their wares on the ground and on stands inside the square. Some sauntered in and out of crowds with their goods in baskets

OPPOSITE Circle dance, Nkrumah Better Boys, 2017, by Judy Cooper
ABOVE Praline seller, ca. 1940, by Joseph Woodson Whitesell

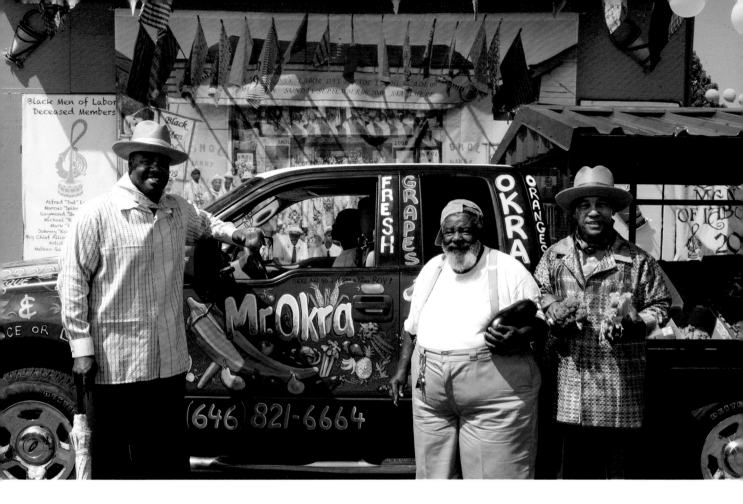

balanced on their heads as they called out their wares with melodic chants. Popular items included pralines, popcorn, peanuts, pecan pies, calas, and molasses candy. There was lemonade, rum, and hot steaming coffee, but, as no strong liquors were allowed, the beverage of choice was ginger beer. Some Black people who were free and onlookers of European descent contributed to the success of the market, but it's important to note that enslaved buyers and sellers were at the foundation of this economic exchange.

This tradition of buying and selling continues at present-day second line parades, and some individuals as well as families rely on these moneymaking opportunities. A requirement since 2012, however, is an annual $25 vendor permit, which resulted from an agreement that the City of New Orleans made with second line clubs and their vendors. Some vendors set up stationary stands along the route, and others use mobile apparatuses, such as ice chests on wheels, that allow them to keep up with the crowd. As in the days of the Congo Square gatherings, pralines, peanuts, and homemade pies prevail. One modern delicacy is Jell-O shots that contain vodka. Although prohibited at the Congo Square gatherings, strong liquors are allowed at second line parades, and an array of options can be found on tables set up along the routes and on the backs of trucks. Pick-up trucks pulling barbecue grills and food trucks with an assortment of offerings are part of the parade scene, as are traditional businesses located along the route—corner stores and bars—that serve as rest and refreshment stops. In contrast to

Bruce Sunpie Barnes (left) and Fred Johnson (right), Black Men of Labor, with Mr. Okra (center), 2010, by Judy Cooper

the dancers in Congo Square, who were replaced when exhausted, members of second line clubs parade on foot the entire miles-long route.

As was true of the Congo Square gatherings, second line parades are entertainment attractions for both locals and tourists. There are, however, those who attend for more than mere entertainment: many photographers, researchers, and other professionals use the parades to make money or advance their careers. Such intentions are not unlike those of circus producers and minstrel performers, like E. P. Christy, who acquired material for his minstrel shows at the Sunday gatherings in Congo Square. The frequency of the parades and the public setting of the streets make the events accessible to everyone, regardless of motive.

Today, fifty-plus social aid and pleasure clubs continue to bring African-derived music and dance to neighborhood streets, festivals, and public events. The clubs' annual parades, traditional jazz funerals, memorial second lines, and other gigs all serve to keep the parading tradition alive. The role of second line parades in perpetuating African-based practices and expressions establishes another link to historic Congo Square, which previously served the same role. Both venues have provided a space for Black New Orleanians to express a range of ideas and concepts that promote cultural identity, celebrate community, establish a sense of belonging, display ingenuity, and embrace the freedom to "do whatcha wanna."

NOTES

1 Freddi Williams Evans, *Congo Square: African Roots in New Orleans* (Lafayette: University of Louisiana at Lafayette Press, 2011), 156–57.

2 Benjamin Henry Latrobe, *The Journals of Benjamin Henry Latrobe 1799–1820: From Philadelphia to New Orleans,* ed. Edward C. Carter II, John C. Van Horn, and Lee W. Formwalt (New Haven: Yale University Press, 1980), 204.

3 Robert Farris Thompson, "When the Saints Go Marching In: Kongo Louisiana, Kongo New Orleans," in *Resonance from the Past: African Sculpture from the New Orleans Museum of Art*, ed. Frank Herreman (New York: Museum for African Art, 2005), 140.

4 Gwendolyn Midlo Hall, *Slavery and African Ethnicities in the Americas: Restoring the Links* (Chapel Hill: University of North Carolina Press, 2005), 70–74.

5 Hall, *Slavery and African Ethnicities*, 107.

6 Alice Dunbar-Nelson, "People of Color in Louisiana: Part I," *Journal of Negro History* 1, no. 4 (Oct. 1916): 361–76.

7 Evans, *Congo Square*, 38.

8 Timothy Flint, *Recollections of the Last Ten Years in the Valley of the Mississippi*, ed. George R. Brooks (1826; repr., Carbondale: Southern Illinois University Press, 1968), 219.

9 Flint, *Recollections*, 219.

10 *Daily Picayune*, March 22, 1846.

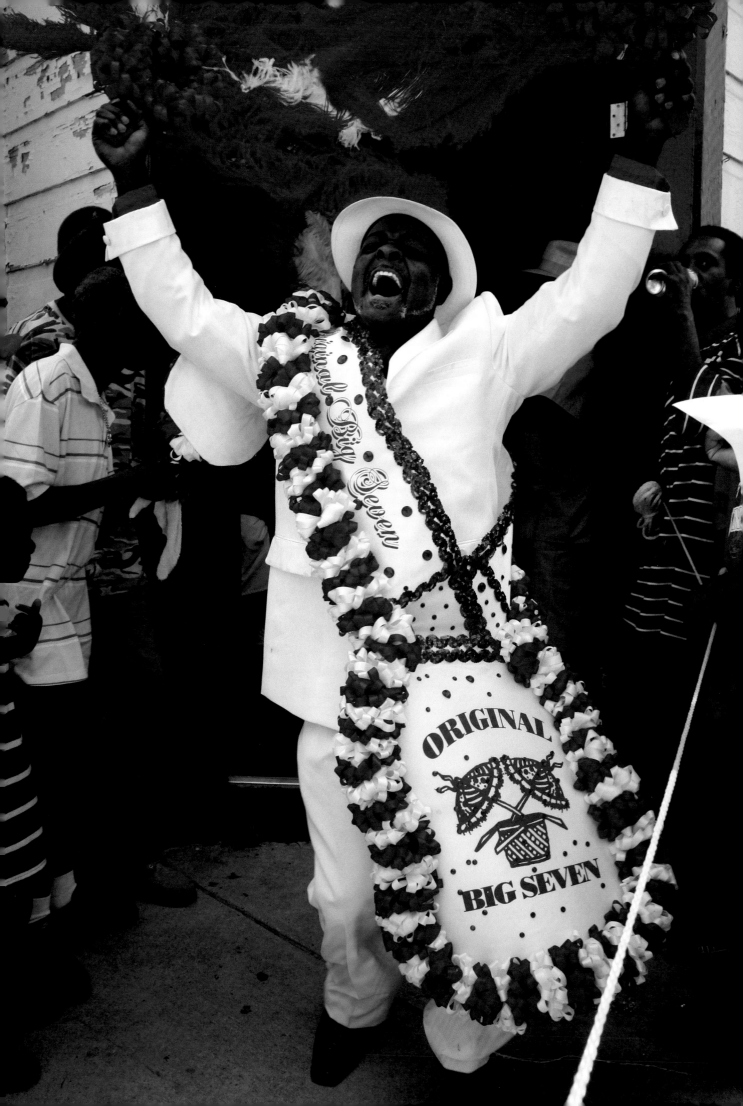

BUILDING A TRADITION

JUDY COOPER

The tuba gives the call, four deep notes, to signal the start of the parade. The eager onlookers strain against the ropes that run from the barroom door out to the sidewalk to provide a path for the club members. The band joins in, the door swings open, and the paraders begin to "come out the door." First to exit is the parade marshal, who gives a shrill blast on his whistle and steps aside. The first club member appears in the doorway in all his finery. His large feathered fans held high, he pauses a moment for all to see his outfit, the signature and pride of his club. After he feels that he has been sufficiently admired, the parader leaps into action, twisting and turning, jumping and squatting as he dances down the path toward the street. Each member of the club follows suit to the screams and shouts of the crowd.

When the last club member emerges, the band falls in behind the marchers, and the crowd—the second line—follows as the parade sets off on its designated route through the streets of the neighborhood. The followers—many of whom are members of other clubs, along with family and friends—dance, jump, and sing as enthusiastically as the club members themselves. For the next four hours, Black music, dance, history, and fashion will occupy the streets.

Every Sunday from late August to Father's Day, a second line parade snakes through the neighborhoods and backstreets of New Orleans. The parades are hosted by social aid and pleasure clubs (SAPCs), civic organizations that have been fixtures in Black New Orleans since the nineteenth century. Each SAPC typically parades once a year on a set date, sometimes on or near the anniversary of the club's formation. The clubs represent uptown and downtown New Orleans, the Ninth Ward, and the West Bank across the Mississippi River. More than a dozen are all male, a few are women only, and many include children. Born out of the funeral parades hosted by benevolent associations in the nineteenth century, the second line tradition has persisted through Jim Crow, wartime, and the flooding of New Orleans after Hurricane Katrina, evolving with

OPPOSITE Ferdinand Snyder comes out the door, Original Big 7, 2009, by Judy Cooper

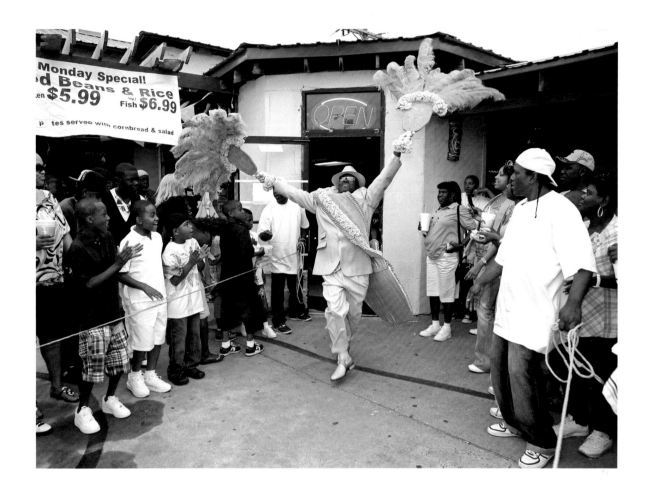

the times while staying rooted to its founding principles of mutual aid and cultural expression.

The term "second line" has several meanings: broadly, it encompasses the entire parade and crowd surrounding it, as well as the action of the participants. Specifically, it refers to the crowd of spectators following alongside and behind the band and club members, who make up what's known as the first line. This blurring of performer and audience, part and whole, runs throughout second line culture. The club's outfits are coordinated, but each member's dance moves and parading style are distinct. Their decorations are all variations on time-honored accoutrements—fans, baskets, umbrellas—but are rendered in a plethora of different, wildly creative ways. The music's unmistakable energy derives from players improvising freely within the collective performance, for hours on end. Everyone unites in celebration as the parade moves through the streets of the city. To be in a second line on a sunny Sunday afternoon, dancing through the streets to the lively music of a brass band, is to revel in life.

Coming out the door, Pigeon Town Steppers, 2009, by Leslie Parr

NINETEENTH-CENTURY FOUNDATIONS

"When I die," said Alfred "Bucket" Carter, "I want a jazz funeral, the whole nine yards."[1] As a lifelong member of the Young Men Olympian Junior Benevolent Association, Carter, who died in 2015, was entitled to a funeral parade hosted by the club. The YMO Jr., as it's commonly known, was formed in 1884 and incorporated the following year, making it the oldest club still in existence. Its funeral processions form the oldest living link to the nineteenth-century origins of the second line tradition.

After emancipation and the end of the Civil War, New Orleans experienced an influx of formerly enslaved residents seeking employment and opportunity in the Deep South's

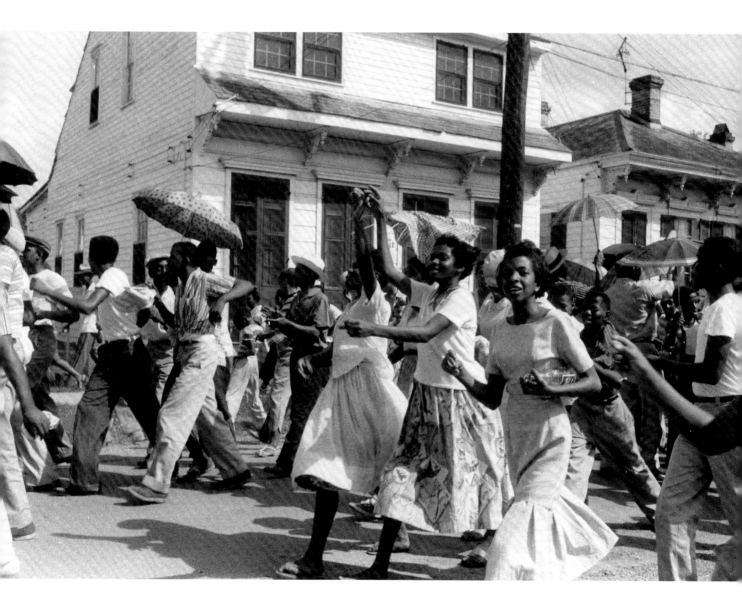

Second line, Caldonia Club funeral, 1958, by Ralston Crawford

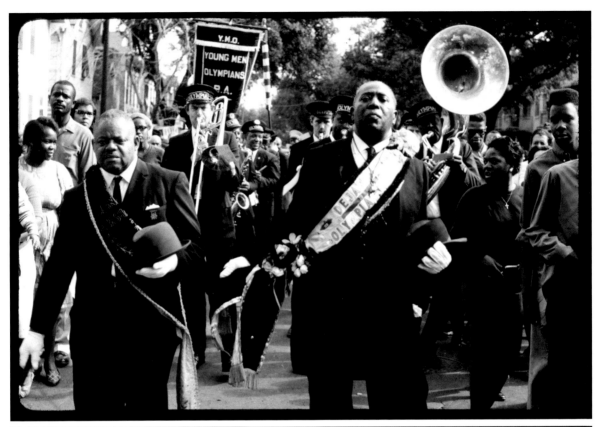

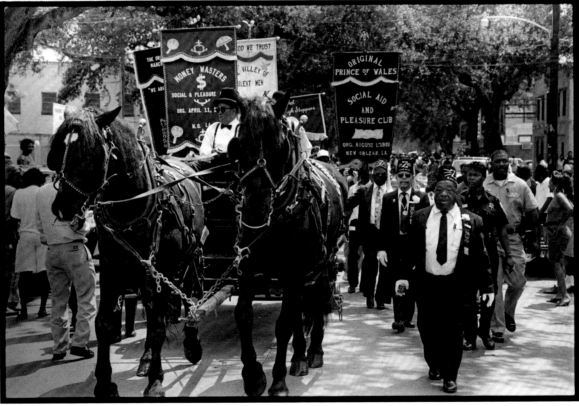

TOP Young Men Olympian Jr., 1967, by Jules Cahn
BOTTOM Gilbert Heedly funeral, 1993, by Michael P. Smith

biggest urban center. Hardship, though, awaited. Most of the newcomers settled in the low-lying area known as the back-of-town. The backswamp environment—with its frequent flooding, stagnant water, and mud—was prone to poor sanitary conditions and disease, made worse by the city's regular outbreaks of yellow fever. The city government made little effort to serve the public-health needs of its growing Black population, which, at the time, was broadly divided into two separate castes—Afro-Creoles and African Americans. Private insurance companies refused to cover them, yet they suffered from a much higher mortality rate than that of the white population. Many families were left destitute when a breadwinner fell sick or died, or when hurricanes or seasonal flooding destroyed people's homes.[2]

Increasingly after the Civil War, Black New Orleanians formed benevolent societies to provide financial, health, and burial services for members. In addition to creating a much-needed safety net, the clubs also allowed formerly enslaved people to celebrate the new social freedoms brought by emancipation. Lodges of national fraternal organizations, such as the Odd Fellows or Knights of Pythias, were also part of this landscape. By the turn of the twentieth century, the city had more than 300 benevolent societies and related groups, and more than 50 percent of the Black population belonged to one.[3] Around the same time a related type of organization took hold, alternately called social and pleasure clubs, aid and pleasure clubs, social aid and pleasure clubs, or some variation thereof. Several of these organizations became quite large, with memberships in the hundreds. For instance, the San Jacinto Social and Pleasure Club, which organized in 1903 and incorporated in 1905, was large and prosperous enough to own a spacious clubhouse that included a dance hall, bar, library, and gym with a boxing ring.[4]

Funerals with music had been a fixture of New Orleans life for whites and Blacks alike since the antebellum era. After the Civil War, thanks in part to a proliferation of military-style bands across the country, the practice of hiring brass bands for funeral processions expanded dramatically, particularly within the Black community. Members of benevolent associations began to adopt a "grandiose ceremonial style" for these parades, in order to give their members "the perfect send-off," writes historian Richard H. Knowles: "Brass band music in association with burials quickly became part of the black folk culture in New Orleans. Within a few years the top bands were playing at least one, sometimes as many as three funerals a day."[5] Over time, a structure for the processions took shape, one that has come to define jazz funerals: club members march in two columns in front of the brass band on the way to the cemetery, swaying side to side in a slow, solemn step. Then, after "cutting the body loose," the band breaks into an upbeat tune—often "Oh, Didn't He Ramble"—and the second line comes to life, as the club members and followers dance in tribute to the life of the deceased.

In his autobiography, *Treat It Gentle*, the legendary jazz clarinetist Sidney Bechet describes the parades as bearing witness:

That music, it was like where you lived. It was like waking up in the morning and eating, it was that regular in your life. It was natural to the way you lived and the way you died. . . . That band it would go back all through the town seeing the places where that man had liked to be before he died. The music it was rambling for him one last time. It was seeing the world for him again.[6]

Musician and storyteller Danny Barker believed that the drama of life and death expressed in jazz funerals was particularly powerful for African Americans of the post-Reconstruction and Jim Crow eras: "Every Black person, they're going to heaven, because they caught hell already. There'd be a ex-slave and all that business, and [the] Depression and all that, so he's going to glory."[7]

The ceremony and celebration of these funeral parades offered club members a chance to be seen and admired one last time—to be "sent off right." Some people even joined more than one association in order to guarantee a big funeral. In a 1989 survey of SAPCs, one man—a member of no less than seven clubs—said, "When I die my funeral will be so long that it will be longer than Martin Luther King's. I will have a dozen brass bands leading my coffin."[8] Though fewer in number today than in past eras, memorial processions still occur regularly. When a noted musician dies, one can expect a large procession attended by enormous crowds, as with the funerals of "Uncle" Lionel Batiste, drummer for the Treme Brass Band, in 2012; Lionel Ferbos, a revered trumpeter who died in 2014 at age 103; and Travis "Trumpet Black" Hill, a popular young trumpeter who died in 2015 of a fatal infection.

The other signature event of the second line tradition is the annual parade, often called the anniversary parade. In the early days, benevolent associations staged formal, almost military-like processions. Held on a Sunday in the summer months, they were typically led by a grand marshal wearing a long, colorful sash over his suit and perhaps a top hat. Next came flag bearers, carrying the association banner and other standards, then the band, followed by the members dressed in uniforms or special suits. The parades attracted followers, but the exuberant dance and participation that defines second lining today did not fully develop until SAPCs began hosting their own annual parades closer to the turn of the century. Year by year, clubs and their annual parades built the second line tradition.

In the early part of the twentieth century, the parades given by the largest clubs were regularly covered by the local press. The Bulls' Aid and Pleasure Club, in particular, was known for its spectacular parades. In a 1916 *Times-Picayune* account, the club is described as an "aristocratic negro organization" that attracted "thousands of the colored population and whites as well" to its "splendid parade," which lasted six hours and featured "novel" electrical lighting:

Five floats, sixty carriages, four bands, a large number of horse riders and man marchers composed the procession, which was headed by the drill team in

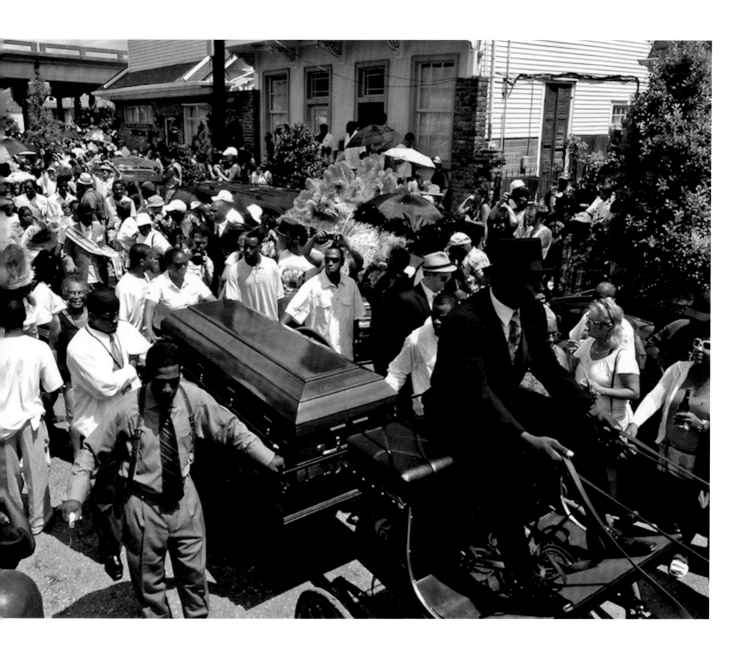

white flannel suits and fezes and marching in perfect precision, forming a cross. . . . The carriages were lighted either with Japanese lanterns or tiny electric bulbs, some of the carriages having as many as thirty to forty of the latter.[9]

The city's major newspapers also covered the Carnival Day parades of the Zulu Social Aid and Pleasure Club, which formed in 1909 out of a loosely organized group of Mardi Gras paraders called the Tramps. The Zulus satirized the pomp and entitlement of the white Carnival parades: the Zulu king wore a lard-can crown and carried a banana-stalk scepter, and his followers wore raggedy pants and shirts. Though the Zulu parade eventually added floats and royalty, becoming one of the best-known of today's major Carnival parades, early iterations more strongly resembled what we think of as a typical second line. Traditionally, Zulu's parade route wound through the backstreets of African

"Uncle" Lionel Batiste funeral, 2012, by Charles Muir Lovell

American neighborhoods, beginning at the New Basin Canal and Claiborne Avenue (near where the Superdome sits today) and stopping at neighborhood bars that had sponsored a float. Because of the frequent stops, the parade back then was often slow and casual.[10] "No parade has more of the Carnival spirit," the *Times-Picayune* reported in 1925.[11]

But there were many other SAPCs forming that had smaller anniversary parades, more similar to the second lines that fill the streets today. In *Treat It Gentle*, Bechet describes the pull of the parades and the makeup of the first and second lines:

> I was always running out to where the music was going on, chasing after the parades. . . . One of those parades would start down the street, and all kinds of people when they saw it pass would forget all about what they was doing and just take off after it, just joining in the fun. . . . In those days people just made up parades for the pleasure. They'd all get together and everyone would put some money into it, maybe a dollar, and they'd make plans for stopping off at one place for one thing, and at some other place for something else—drinks or cake or some food. They'd have maybe six places they was scheduled to go to. And those that didn't have money, they couldn't get in the parade. But they enjoyed it just as much as those that were doing it—more, some of them. And those people, they were called "second liners." They had to make their own parade with broomsticks, kerchiefs, tin pans, any old damn thing. And they'd take off shouting, singing, following along the sidewalk.[12]

Louis Armstrong, who belonged to the Tammany Social and Aid Club as well as the Knights of Pythias, remembered the parades as "an irresistible and absolutely unique experience. . . . Every time one of those clubs paraded I would second-line them all day long."[13] Danny Barker, who grew up watching his grandfather Isidore Barbarin parade with the Onward Brass Band in the early twentieth century, described them as "the greatest real-life free show on earth."[14]

For smaller social aid and pleasure clubs, local media tended to mention parades only when they involved violence. For example, a *Daily Picayune* article from 1890 describes a "small-sized riot . . . between a crowd of negroes and whites" that broke out when "young white hoodlums" attacked a procession heading down Washington Street (now Washington Avenue), led by the Onward Brass Band. The ensuing melee involved "rocks, bricks, and clubs," with "men, women, and children . . . running from all directions to escape the flying rocks and brickbats." Although the account describes a casual parade (to serenade a band member's mother) rather than a full-scale anniversary parade, several details resonate: a Sunday afternoon procession, headed by an established brass band, with a fully engaged audience: "the usual crowd of negroes who follow parades of this kind," who "took charge of the sidewalk as is their custom."[15]

In addition to providing early documentation of the hallmarks that define second lines today, the article's depiction of racial violence highlights the risk that Black marching

OPPOSITE Louis Armstrong as king of Zulu, 1949, by Bob Ostrum and Bob Stearns

clubs often undertook by parading through the city. In the Jim Crow era, parades "defied segregation" and "oriented African Americans toward each other . . . within public spaces where they were now free to gather," writes ethnomusicologist Matt Sakakeeny.[14] He links the parades' political subtext—their "politics of pleasure and festivity"—to more explicit forms of social protest, in that they use the occupation of public space to assert a message. "While official marches, social movements, and parades all stake claims on public space . . . parade participants in New Orleans 'speak'" not through political signs and chants but through music, dance, improvisation, and other "practices linked to black expressive culture."[17]

Reverently remembered by Barker, Bechet, and Armstrong, the parades of the early benevolent associations and SAPCs helped to define the tradition's first golden age. As the twentieth century progressed, though, the immediate need for the clubs dwindled, prompting a slow but steady reframing of the tradition around cultural heritage rather than economic necessity.

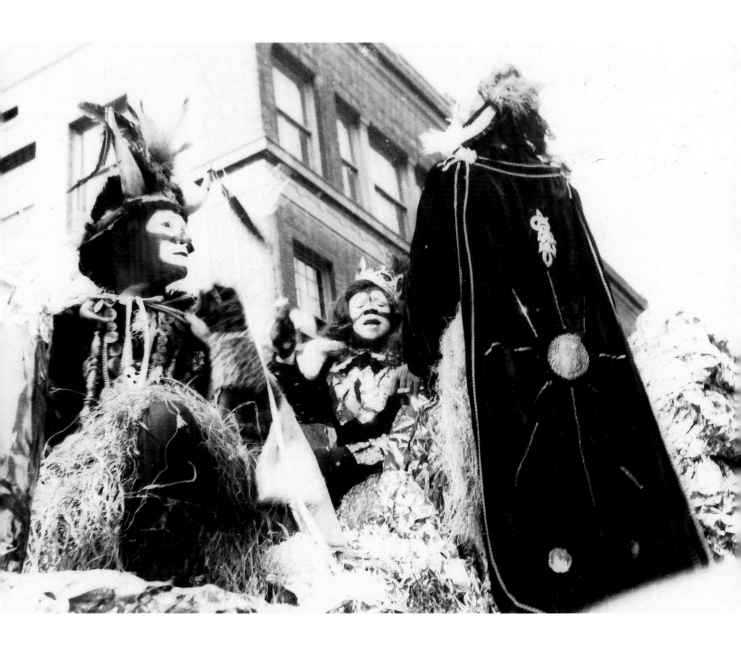

MIDCENTURY AND CIVIL RIGHTS ERA

In the 1930s, during the administrations of president Franklin D. Roosevelt and populist Louisiana governor Huey P. Long, health services and access to insurance began to expand. Charity Hospital, New Orleans's primary source of medical care for African Americans, moved to a newly constructed, much bigger building in 1939. The city's benevolent associations, which had served an essential role in the late nineteenth and early twentieth centuries as support groups within the Black community, began to diminish in number and importance.

The Bulls, known for their elaborate parades throughout the 1910s and '20s, seem to have disbanded sometime after 1931.[18] In contrast, Zulu grew in stature during this time, putting on larger and larger Mardi Gras parades. (In 1949, Louis Armstrong returned to his hometown to reign as Zulu king.) Other clubs, including the Wolves Aid Social and Pleasure Club and the Merry-Go-Round Social and Aid Club, continued into the mid-twentieth century. During this time, new organizations formed, including the Prince of Wales, which was founded in 1928 and continues to this day. The first of the women's clubs, the Ladies Zulu, formed in 1933 and lasted into the 1990s.[19]

Articles in the Black-owned *Louisiana Weekly*—the main source for local media coverage of the clubs during this period—suggest that anniversary parades had become the primary focus of club activity. Unlike the massive processions of the Bulls and the Zulus, which featured many large floats, most of these annual parades were smaller affairs with one or two bands—much like the majority of second lines that happen today.

The Jolly Bunch Social and Pleasure Club, which formed in 1941 and incorporated in 1947, became a leader of the second generation of SAPCs and remained so through the rest of the twentieth century. Among old-timers today, it's often the first club mentioned when discussing parades from back in the day. Robert Williams, for example, was a member of the Jolly Bunch from the 1960s to the '80s. By the time he joined, the club had several divisions: the Directors, the First Division, the Second Division, and the Puppets. The club members wore simple shirts, pants with suspenders, and hats, and each division chose its own colors and decorations. Some carried decorated baskets and large, plumed fans, while others carried decorated umbrellas. Mounted on horseback, the Directors led the parades, which lasted eight hours, starting and ending at the Tulane Club, a bar on Gravier Street near St. Joseph Catholic Church. There was also the Ladies' Jolly Bunch, whose members rode on convertibles in the annual parade.[20]

Over the course of the 1950s and '60s, a wave of renewed interest in traditional jazz, perhaps best represented by the 1961 establishment of Preservation Hall, brought a new audience to second line parades. Nationally known photographers such as Ralston Crawford and Lee Friedlander began to document the tradition. Over the following decades, local photographers—chief among them Jules Cahn, Michael P. Smith, the husband-and-wife team of Keith Calhoun and Chandra McCormick, and Eric Waters— also started following the parades. From then on, with countless more professional and

amateur photographers catching the bug, the visual record of the second line tradition has been rich, inclusive, and abundant.

Despite the surge of documentary interest, the number of parading clubs at mid-century was small in comparison with that of the previous generation. Principal groups of the 1950s included the YMO Jr., Wolves, Merry-Go-Round, Prince of Wales, Original Square Deal Boys, Caldonia Club, Tulane Club, and Jolly Bunch. The '60s saw the creation of the Treme Sports, founded by members of the recently disbanded Caldonia Club, and the Sixth Ward Diamonds.

In 1956, a city ordinance forever changed the way clubs organize their parades. It required an official permit for any parade or procession that would disrupt the flow of traffic. Regulations specific to second line parades remain in place to this day: the organization has to submit for approval the date, route, and start and end times; the total number of hours, not to exceed four; and the total number of parading persons and vehicles. The permitting office charges a fee, determined by the New Orleans Police

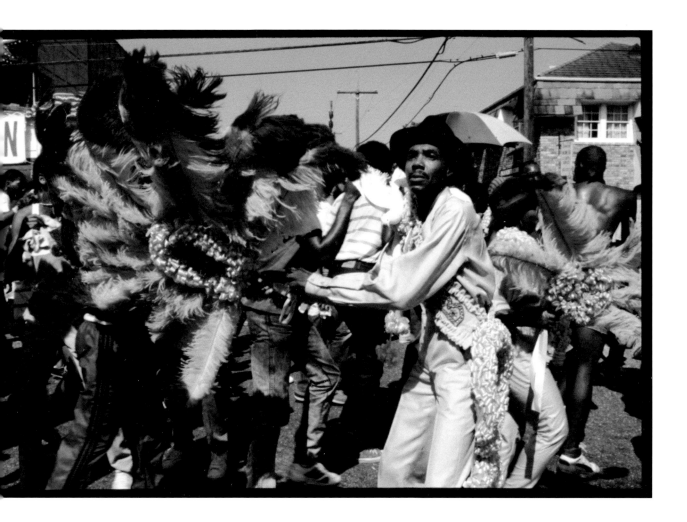

Robert Williams, Jolly Bunch, 1987, by Michael P. Smith

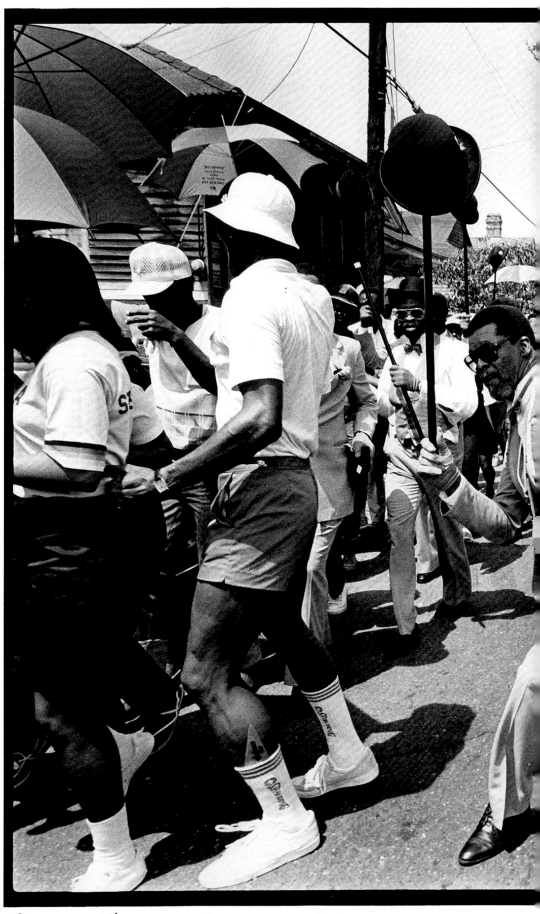

Avenue Steppers Marching Club

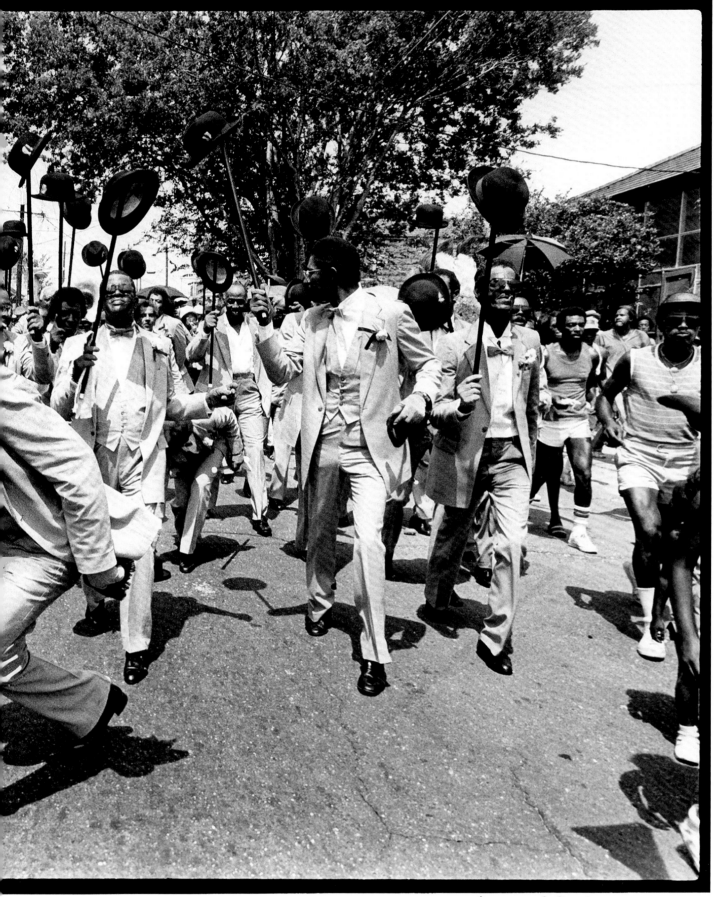

2101/23 Michael P. Smith, 1982

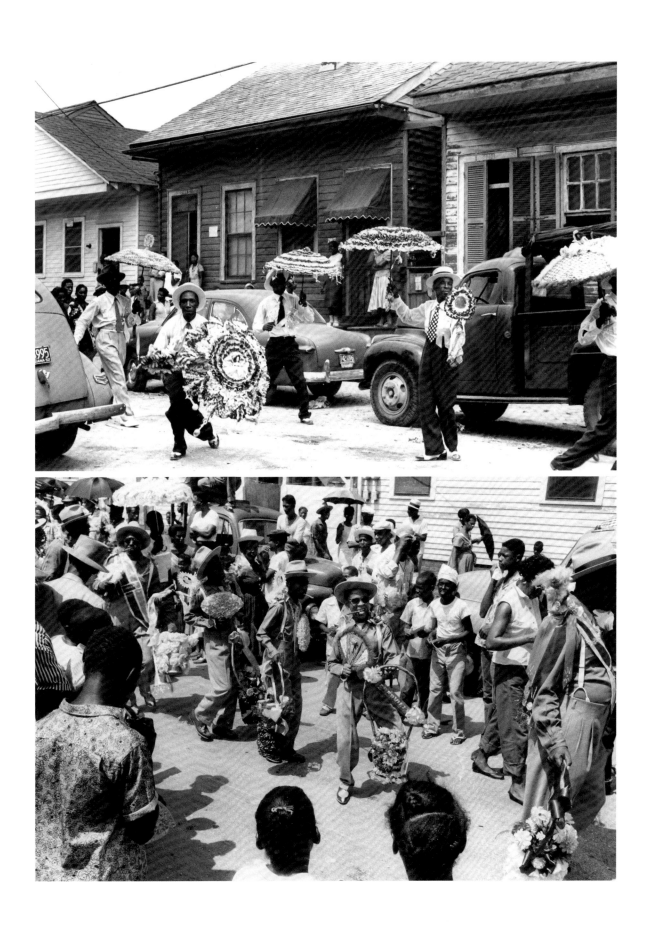

PRECEDING SPREAD Avenue Steppers, 1982, by Michael P. Smith
TOP Jolly Bunch parade, 1958, by Ralston Crawford
BOTTOM Original Square Deal Boys parade, 1952, by Ralston Crawford

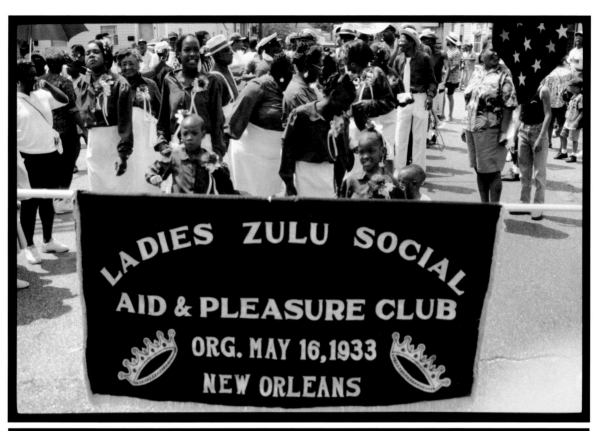

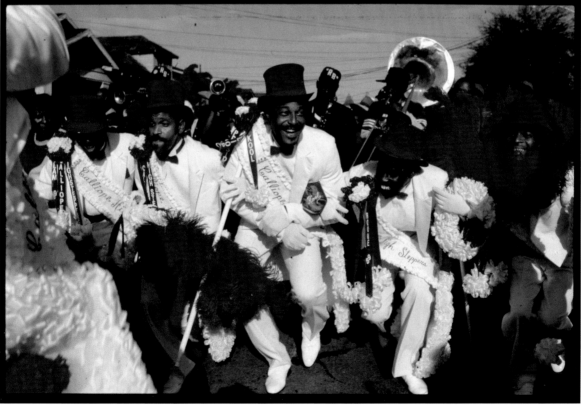

TOP Ladies Zulu, 1993, by Michael P. Smith

BOTTOM Johnnie "Kool" Stevenson (center) at the Calliope High Steppers' first annual parade, 1989, by Michael P. Smith

Department (NOPD) superintendent, to cover the cost of the police detail. Though unofficial parades still happen—often birthday and memorial second lines that traverse neighborhood backstreets—gone are the days of large, spontaneous parades like those described by Bechet. The fee has to be paid before the permit can be issued, and more than one parade has been canceled because a club could not come up with the required amount. (More information about the parading season as it exists today is discussed in "Community on Parade," p. 169.)

In 1970, Jerome Smith, a prominent civil-rights activist, founded the Bucket Men, the parading component of the Tambourine and Fan, a youth mentorship organization that he and Rudy Lombard, another activist, had founded two years earlier. While the name refers to the Mardi Gras Indian—also known as Black Masking Indian—and SAPC traditions, the organization focuses on mentorship in education and sports. "I saw the parade as a moving classroom," Smith said in a 2015 interview. "We had boards and fans with pictures of the Freedom Riders."[21] Many of the participants became fixtures within the community, including Fred Johnson, president and cofounder of the Black Men of Labor; Victor Harris, also known as Spirit of Fi Yi Yi, big chief of the Mandingo Warriors; Melvin Reed, decorations designer for the Black Men of Labor; Adrian "Coach Teedy" Gaddies, decorations designer for a number of clubs; Bernard Robertson, a founder of Sudan; and the late Allison "Tootie" Montana, big chief of the Yellow Pocahontas.[22] The Bucket Men paraded for about ten years before disbanding, but the Tambourine and Fan continues its work, still under Smith's dedicated leadership.

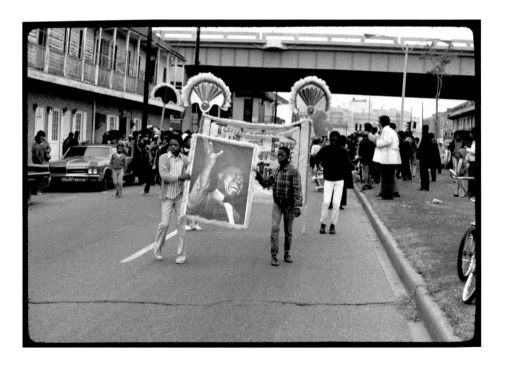

Tambourine and Fan, 1971, by Jules Cahn

JAZZ FEST AND THE SAPC RENAISSANCE

Beginning in the 1970s and continuing through the turn of the century, the SAPC community experienced unprecedented growth, a phenomenon that unfolded against a backdrop of expanding educational and professional opportunities for Black people in New Orleans. The founding of the New Orleans Jazz and Heritage Festival, in 1970, is often credited as the catalyst for this growth spurt. Equally central to the story are the consolidated gains of the civil rights movement and the mixed blessings of New Orleans's burgeoning tourism economy.

From the beginning, Jazz Fest—originally called the New Orleans Jazz Festival and Louisiana Heritage Fair—sought to honor the "heritage" part of its title by including local bearers of Black New Orleans culture. Organizer George Wein, who also founded the Newport Jazz Festival, wanted to do something different with the New Orleans showcase—to highlight the local traditions and cultures that had been integral to the birth of jazz. He tapped two young jazz archivists, Quint Davis and Allison Miner, who worked for Richard B. Allen at Tulane University's Hogan Jazz Archive, to recruit local groups that represented the full history of New Orleans music. As Davis said, "Really the name is backwards—it should be the Heritage of Jazz Festival."[23]

In just two years, the festival outgrew its original home in Beauregard Square (now named Louis Armstrong Park). The move to the New Orleans Fair Grounds in 1972 presented festival organizers with new opportunities for including local cultural groups—namely, its social aid and pleasure clubs. The city's Mardi Gras Indians have performed at the festival since its first year, but organizers realized no portrait of New Orleans's music culture would be complete without the social aid and pleasure clubs. "The real taproots of the jazz street culture are the Mardi Gras Indians and the jazz procession, whether it is for funerals or second line parades," Davis said.[24]

Davis met with Alfred "Bucket" Carter and Norman Dixon Sr., both longtime members of the YMO Jr., to discuss having second line parades at the Fest. An agreement was reached, and Dixon was tapped to organize the parades. Because Dixon drove all over town as a deliveryman, he was able to stop at the club members' homes to sign them up. In 1975, the YMO Jr. became the first club to parade at Jazz Fest, followed the year after by the Scene Boosters. The club was founded in 1973 by Baptiste Giles Jr. and Percy Lewis, big chief of the Black Eagles Mardi Gras Indians, as a booster club for the Scene Highlighters, formed a year earlier by Percy's son Wardell Lewis Sr. The two clubs paraded together for several years. When the Scene Highlighters disbanded, the Scene Boosters grew and soon became one of the largest and most active of the uptown clubs. The festival had expanded to two weekends at that point, so the YMO Jr. and the Scene Boosters alternated weekends, holding one parade a day, an arrangement that continued for three years.

The exposure that Jazz Fest provided for the clubs was part of a larger transition in the city's economy toward tourism over the course of the 1970s and '80s. To a

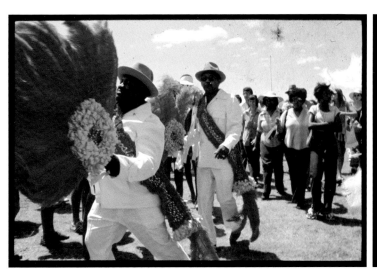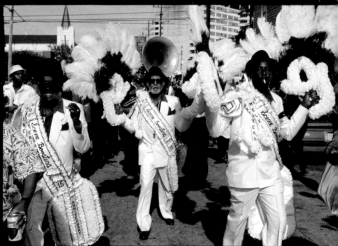

national audience, Jazz Fest presented the clubs reverently as "living ethnological exhibits," or "living exhibitions," according to Helen A. Regis and Shana Walton in their groundbreaking 2008 study, "Producing the Folk at the New Orleans Jazz and Heritage Festival."[25] New Orleans was on its way to building what is now known as the cultural economy, and because of Jazz Fest's role as "gatekeeper to larger markets . . . consequently (almost inevitably) it exerts a magnetic or even a distorting effect on local music and community traditions."[26]

One effect of this influence is suggested by the number of clubs that cropped up parallel to the growth of Jazz Fest, including the Fun Lovers (1973), a ladies' club that paraded with the Scene Boosters; the Money Wasters (1974), one of the largest downtown clubs; Kool and the Gang (1975), which paraded as a kids' division of the Scene Boosters; and the Original Four (1979), which started as a division of the YMO Jr. In 1979, the number of clubs participating in Jazz Fest expanded to seven, adding the Fun Lovers, Theme Boosters, Money Wasters, and two recently formed ladies' groups—the Burgundy Ladies and the Calendar Girls. In response to all the new clubs, Jazz Fest expanded its parade roster, adding new groups every year of the 1980s, so that, by the 1990s, multiple clubs were parading two or three times per day of the festival.

This increase in national and international attention also led to lucrative performance contracts, both domestically and abroad. In 1976 the Scene Boosters were invited to Washington, DC, to perform at the Festival of American Folklife (now known as the Smithsonian Folklife Festival). Wardell Lewis Sr., founder of the Scene Highlighters, the Nkrumah Better Boys, and the Men Buckjumpers, which have all paraded at Jazz Fest,

LEFT Scene Boosters at Jazz Fest, 1978, by Michael P. Smith
RIGHT Scene Boosters, 1988, by Michael P. Smith

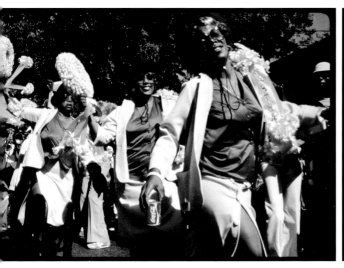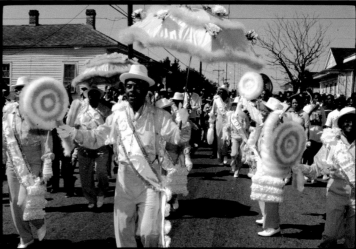

said he has performed in Ireland, France, and Portugal through his SAPC and Jazz Fest affiliations. Linda Tapp Porter, president of the Lady Buckjumpers, said that her club has traveled often with the Rebirth Brass Band (Porter's longtime partner is Rebirth tuba player Phil Frazier), to places such as New York, Baltimore, and Germany.[27] In addition, the money that clubs receive as compensation for their Jazz Fest performances helps to offset the high cost of putting on their annual parades.

Other clubs that first hit the streets from the late 1970s through the '80s include the Gentlemen of Leisure (1977), the Ninth Ward Steppers (1980), the Avenue Steppers (1981), the Golden Trumpets (1982), Sudan (1983), the Lady and Men Buckjumpers (1984), the Second Line Jammers (1984), the Valley of Silent Men (1985), the Calliope High Steppers (1989), the Lady Jetsetters (1989), and the Westbank Steppers (1989).

By the end of the twentieth century, there were more clubs than available parade dates. Often, a second line Sunday featured two parades, one uptown and another downtown. This bounty fostered even more competition among the clubs and rewarded the dedicated second liner: according to Edward Buckner of the Original Big 7, many spectators would start with one parade, then switch halfway through to the other.[28]

To kick off the new century, four new clubs were founded in 2000 alone: the C.T.C. Steppers, the Divine Ladies, the New Generation, and Family Ties. Then came the Undefeated Divas in 2001, the Men of Class and VIP Ladies and Kids in 2003, Keep 'N It Real and the Uptown Swingers in 2004, and We Are One in the spring of 2005. By the fall of that year, though, the tradition—indeed, the entire city—would be facing a dramatic threat to its survival.

LEFT Fun Lovers, 1979, by Michael P. Smith
RIGHT Golden Trumpets, 1992, by Michael P. Smith

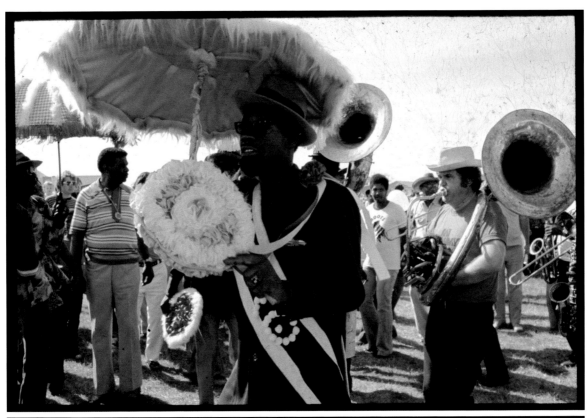

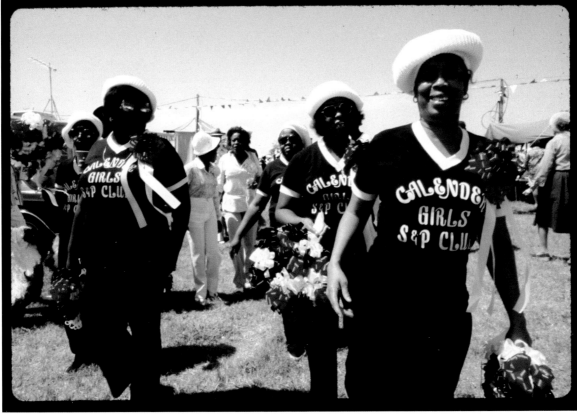

TOP Norman Dixon Sr. with the Young Men Olympian Jr. at Jazz Fest, 1978, by Michael P. Smith
BOTTOM Calendar Girls at Jazz Fest, 1979, by Michael P. Smith
OPPOSITE The Furious Five, Young Men Olympian Jr., at Jazz Fest, 2012, by Eric Waters

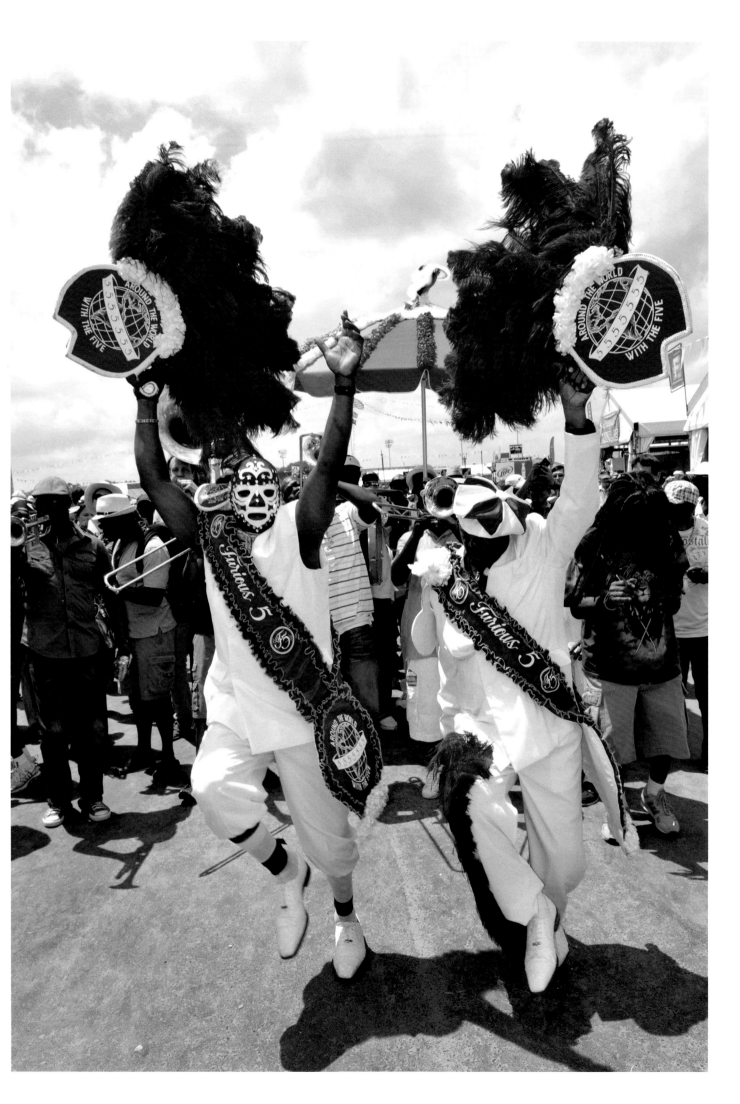

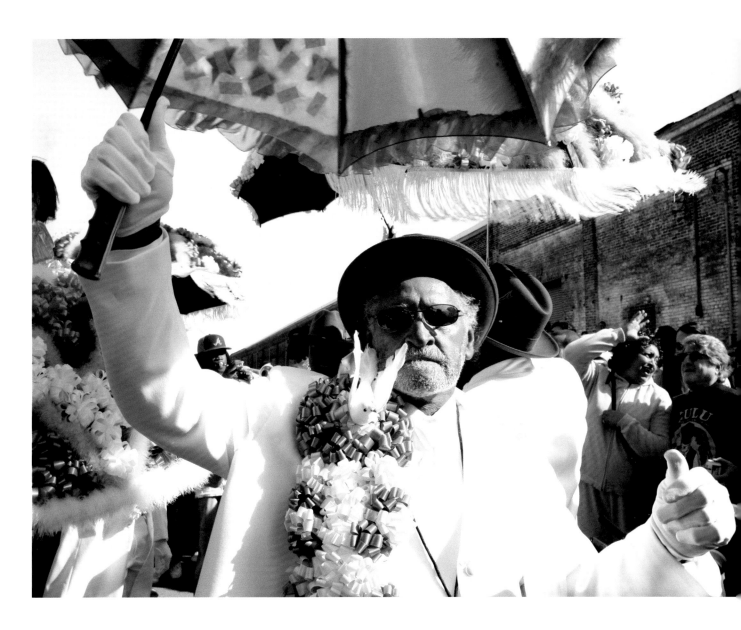

CHALLENGES POST-KATRINA

On August 29, 2005, Hurricane Katrina arrived, dealing a catastrophic blow to New Orleans in its aftermath. Several levees failed, prompting 80 percent of the city to flood. Thousands of buildings were inundated, and more than 1,800 people died in the floodwaters. The entire population of Orleans Parish was ordered to evacuate, and the National Guard was brought in to assist. Not until around early October were residents allowed to return, and only to certain neighborhoods. By December, according to one estimate, only 18 percent of the population had returned.[29]

As evacuated residents began to venture back, Joe Stern, a longtime member of the Prince of Wales, decided to go forward with plans for the club's annual parade, which had missed its traditional date of the second Sunday in October. Like many club members, Stern worried about the future of the city's second lines and was determined to show

Sidney "Lil Bruh" Morris, Prince of Wales, at the club's first parade post-Katrina, 2005, by Judy Cooper

that they would not die. Given the club's uptown route near the river, in one of the few areas that had not flooded, the Prince of Wales was particularly well situated to the task.

"We had some money in the bank from our missed parade," Stern said. "And Meyer the Hatter had a deposit for our hats. He gave us a real good deal on the hats. But we didn't have suits, so we finally decided to rent white tuxedos."[30] Club members offset the white with blue hats; blue shoes, purchased in Atlanta by Stern's daughter; and umbrellas decorated by the members themselves with blue, white, and yellow bows. Rebirth Brass Band, some of whose members had also been able to return, agreed to provide the music. Although the Rock Bottom Lounge, on Tchoupitoulas and Peniston Streets, was the traditional starting point, the club decided to come out at Tipitina's, the well-known music venue nearby.

On the bright, sunny Sunday of the parade, December 18, it seemed as though everyone who had any connection to the music world or to the SAPC community turned out to celebrate the occasion. Everyone was smiling, but some also had tears in their eyes. The parade stopped at the Rock Bottom Lounge, at the home of long-deceased member Charlie Wright, and at the Purple Rain Bar on Washington Avenue, but skipped several of the club's usual stops, which had not yet reopened. Along with the Black Men of Labor's November 26 parade, which was sponsored by director Spike Lee for inclusion in his documentary *When the Levees Broke: A Requiem in Four Acts*, the Prince of Wales second line was the only anniversary parade to happen in the fall of 2005.

On Sunday, January 15, 2006, Martin Luther King Jr.'s birthday, thirty-two clubs united to show their strength in the aftermath of disaster with We Are One: The Social Aid and Pleasure Club All-Star Second Line. Organized by the New Orleans Social Aid and Pleasure Club Task Force, the parade was put on to showcase the clubs' solidarity and to provide an opportunity for members of the community to connect with friends they had not seen since the storm. Eschewing their usual fashions, the clubs all wore black pants with black T-shirts bearing "ReNew Orleans" on the front and a list of the participating clubs on the back.

The parade began outside of the Backstreet Cultural Museum, the official repository for the cultural history of the SAPCs, and followed a fairly traditional downtown route through the Sixth and Seventh Wards. It had been a joyous affair, but its ending set off a crisis that reverberated throughout the city: one block from North Broad Street, where the parade had just ended, shots rang out among the bystanders, and three people were wounded. Although neither the victims nor the shooters were directly linked to any of the clubs, post-Katrina anxieties about crime rates prompted some people to call for an end to second line parades altogether.

Three days later, the NOPD suddenly raised the parade permit fee from $1,200 to $4,445, citing an increased need for security because of the threat of violence. The New Orleans Social Aid and Pleasure Club Task Force negotiated with the police department about the decree, pointing out that the permit fee for predominantly white Carnival organizations—who put on much larger parades—was only $750. After the American

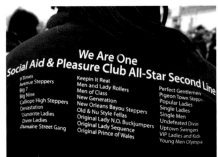
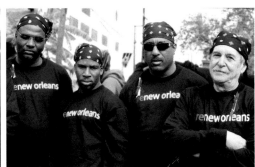

Civil Liberties Union (ACLU) got involved, the NOPD lowered the fee. In March, however, a shooting during a parade of the Single Men killed a bystander, and the fees went back up, to $3,790. In November, the ACLU filed suit in federal court against the police department, claiming that the NOPD's increased fees violated club members' right to free speech as expressed through their parades.

Few clubs were able to parade in 2006. Many members had lost their homes and jobs to the storm and had not yet returned to the city. Even those who had managed to make it back to New Orleans found the expense of putting on a parade prohibitive. Local organizations stepped in to help support the tradition. The New Orleans Musicians Hurricane Relief Fund, also known as Sweet Home New Orleans, sponsored bands for club parades at this time. Jazz Fest pledged to maintain gigs for the clubs. Norman Dixon Jr., who had taken over Jazz Fest parade coordination from his father, received a lot of calls from displaced club members. "Everybody was basically trying to get back home," he recalled. "They were calling to see how they could stay a part of Jazz Fest. They wanted to remain a part of that great New Orleans tradition. 'Norman, can we come down?' they would say. 'We lost everything, but can we come to Jazz Fest? Can we just throw something together?' I knew them and trusted them. I knew they weren't going to come out raggedy." Any club that had paraded at the Fest before was welcome to participate in 2006, and more than twenty answered the call. The outfits and decorations were less elaborate than usual, but, Dixon added with pride, "every group turned out nice."[30]

Among the clubs that managed to put on an annual parade that year, Katrina was a common theme. The Valley of Silent Men hosted its parade on August 29, the one-year anniversary of the storm. The club marked the occasion in tongue-in-cheek fashion by carrying fans in the shape of a hurricane. The downtown-based Sudan adopted a particularly resourceful strategy by choosing "Rebuilding New Orleans" as its theme; forgoing their usual, extravagant style of outfits and decorations, members paraded in work clothes and carried hammers and saws.

The most dramatic parade of 2006 featured the Big Nine, from the Lower Ninth Ward—the first second line in the neighborhood, which had been all but obliterated, since the storm. On its regular December parade date, the Big Nine succeeded in assembling a

LEFT We Are One T-shirt, 2006, by Judy Cooper
RIGHT Members of Prince of Wales (left–right: Demetrius Thomas, Keith Gardner, Walter Andrews, and Joe Stern) at the We Are One second line, 2006, by Judy Cooper

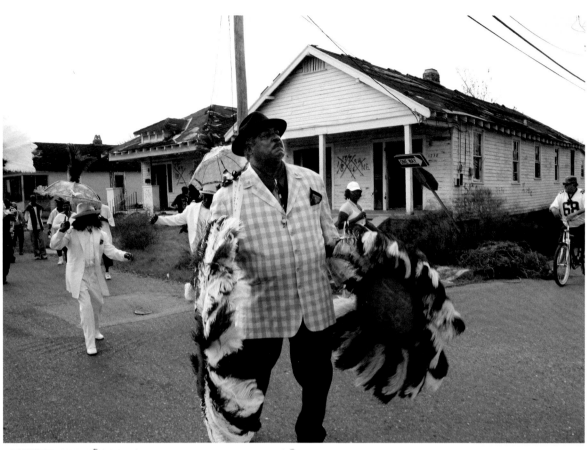

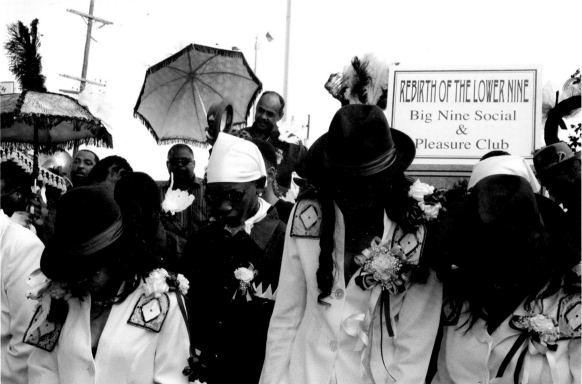

TOP Robert Starks leads the Big Nine on Forstall Street, 2006, by Judy Cooper
BOTTOM The Big Nine stops for a moment of prayer, 2006, by Judy Cooper

sizable group of paraders to participate. As the parade proceeded up Forstall Street, the abandoned houses gave silent witness. Upon reaching North Claiborne Avenue, the marchers stopped at a recently dedicated memorial to the victims of the flood, to pray and pay tribute. When the solemn moment ended, just as with a jazz funeral, the band picked up its tempo, and club members resumed their dancing. "Our community was being written off, and we stood up as an organization and said, 'We gonna show the world that we still exist,'" wrote Ronald W. Lewis, a founder of the Big Nine, in *The House of Dance and Feathers*.[32]

The conflict over permit fees came to a head in the spring of 2007. The Pigeon Town Steppers, who host their anniversary parade on Easter Sunday, faced the prohibitively high permit fee of $7,560 from NOPD for providing security on a holiday. The ACLU stepped in once more and filed suit in federal court, seeking a restraining order against the police department that would bar it from charging "arbitrary and unreasonable fees." A hearing was scheduled for the Wednesday before Easter.

The New Orleans Social Aid and Pleasure Club Task Force sent out an urgent plea to all its members to assemble in Lafayette Square, across from the courthouse, at a press conference preceding the hearing. "Please come out and join us in our fight to 'Save our Culture,'" the flier exclaimed. "Due to the increased permit fees the second line culture is in danger of becoming extinct!!!!!" Many members of the community responded to the call and showed up wearing shirts representing their clubs—Nine Times, VIP Ladies and Kids, the Original Four, the Dumaine Street Gang, and others.

To the great relief of the club members and their supporters, a settlement was reached, and the fee for all SAPC parades was reduced to $2,413—still double what the Pigeon Town Steppers had paid the previous year but a far cry from the exorbitant amount NOPD had originally quoted. On a chilly, gray Easter Sunday, the club supplied its own sunshine, resplendent in creamy yellow and sky blue outfits with fans and streamers made by Kevin Dunn, who had come back to town just to make the decorations. The club led a large crowd through the streets under the triumphant theme "Back by Popular Demand."

As the city's recovery progressed and more people returned home, the SAPC scene saw an increase in activity during the 2007–8 parade season. Many of the older clubs had been able to regroup and were joined by three new ones—Good Fellas, Women of Class, and Ladies of Unity. By the following season, the parade calendar was filled with thirty-seven clubs, the maximum allowed by the police department, and it remained full until the arrival of the COVID-19 pandemic. Newer clubs who wanted to hit the streets had to parade with an established group, hiring their own bands and dressing in their own regalia. The promise remains that the ones who stay on the scene the longest will be first in line to pick up a parade date when an older club retires.

On May 12, 2013, only forty-five minutes into the annual Mother's Day parade of the Original Big 7, two gunmen at the corner of Frenchmen and North Villere Streets in the Seventh Ward fired directly into the crowd. People started falling, and the crowd ran

in every direction to escape the gunfire. Although ten uniformed officers were guarding the parade, they were not able to catch the suspects, who fled on foot. A total of nineteen people were wounded by gunfire, some seriously, and another was injured by a fall during the melee. Again, the clubs found themselves associated with violence, defending their tradition.

Edward Buckner, president of the Original Big 7, wrote a letter published in the *Times-Picayune* expressing deep sorrow for the violence and maintaining that the second line tradition was not responsible for it. Days after the shooting, the police arrested nineteen-year-old Akein Scott and his brother, Shawn Scott, twenty-four. The brothers were only there to seek revenge against a thirty-five-year-old bystander whom they shot three times but did not kill. "We are a cross-generational organization, ages five to seventy. Our young people grow up in this culture, are fed by it, and feel loved, supported, and connected in ways that build neighborhood security," Buckner wrote. "That's real crime prevention."[33]

As the following Sunday's parade approached, hosted by the Divine Ladies, concern mounted about its attendance. The turnout, however, was tremendous. Members of the other clubs could be identified by the logos on their shirts. Eager spectators from all sections of the community jammed the sidewalks. Three local television stations sent camera crews and reporters, interviewing people who voiced their support for the

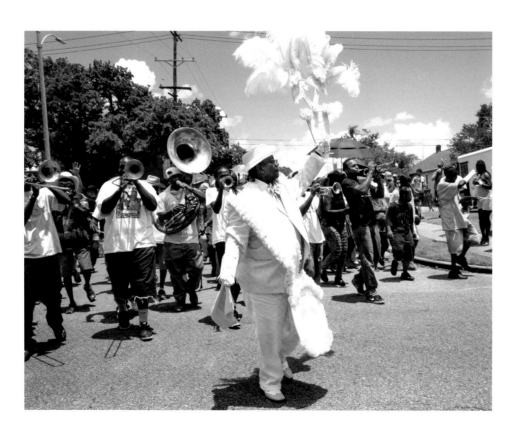

Edward Buckner of the Original Big 7, with the TBC Brass Band, 2013, by Judy Cooper

clubs. Deborah "Big Red" Cotton, a writer who had become an important chronicler of the second line tradition, was gravely wounded in the Mother's Day shooting. But instead of nurturing resentment, she went on to correspond with Akein Scott. "We can no longer take the position, 'Lock them up and throw away the key,'" she said of the two brothers. "We have to ask, 'How can we be our brothers' keepers?'"[34] Four years after the incident, in May 2017, Cotton died of the ongoing complications from her injuries. She was fifty-two.

Two weeks after the shooting, on Saturday, June 1, the Original Big 7 was able to host a make-up parade. Joined by NOPD Superintendent Ronal Serpas and City Councilwoman Susan Guidry, the club members gathered together in the living room of Buckner's house to pray before the start of the parade. Dismas Johnson, the club's business manager, gave an emotional appeal for forgiveness toward the two young shooters and their senseless act of violence, and he reiterated the club's determination to carry on the second line tradition. On arriving at the corner of Frenchmen and North Villere, the parade paused, and club members formed a circle, some kneeling, others bowing in remembrance of the twenty people wounded on Mother's Day. The next day's *Times-Picayune* featured on its front page a photograph of this moment with the headline "Second Line: Second Chance."

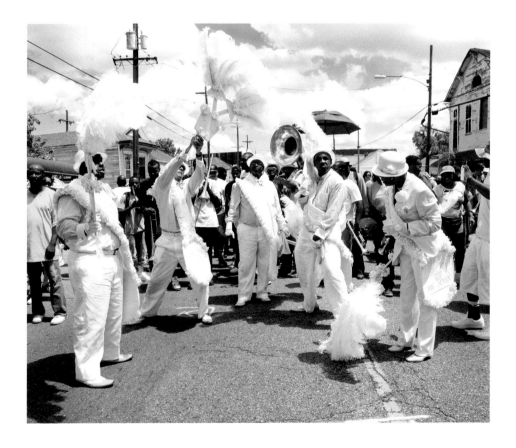

Members of the Original Big 7, 2013, by Judy Cooper

THE PANDEMIC

Storms, violence, public and political scrutiny—the SAPC second line tradition has weathered them all, and in March 2020, it faced a new challenge in the form of the COVID-19 pandemic. The city was barely two weeks out from Mardi Gras—full, as usual, with local and out-of-town revelers mingling en masse along the parade routes and in the French Quarter—when New Orleans Mayor LaToya Cantrell responded to the earliest confirmed cases in the city by canceling several large events for the coming weekend, including the scheduled March 15 parade of the Single Men, which would have celebrated its twenty-fifth anniversary. One week later, Governor John Bel Edwards issued a statewide stay-at-home order to mitigate the accelerating spread of the novel coronavirus. Since then, there have been many permutations in the reopening of businesses and schools, but the effect on the second line tradition has stayed the same: no annual parades and, with just a few exceptions, no jazz funerals.[35]

In addition to the disappearance of second lines from the streets, the SAPC community experienced the loss of several prominent members and supporters. Ronald W. Lewis, cofounder of the Big Nine and creator of the House of Dance and Feathers museum, died March 20 of complications from COVID-19. (More about Lewis's tremendous legacy can be found in "Heritage on Display" on p. 299.) His funeral normally would have included members of all his affiliated groups in full regalia, including the Big Nine, the Choctaw Hunters, and the North Side Skull and Bone Gang, but because of COVID restrictions the burial was private.

Just three days after Lewis's death, the coronavirus claimed the life of Theresa Elloie, owner of the beloved Central City bar Sportsman's Corner, which has long played a significant role in the SAPC and Mardi Gras Indian communities. (See more in the "Routes" chapter, p. 127.) Leona "Chine" Grandison, owner of the Candlelight Lounge, famed music bar in Treme, died of COVID-19 on April 9. Larry Hammond, former Zulu king, passed away March 31. According to a story published by the Associated Press in October 2020, Hammond is one of eight members of the club to die from the respiratory illness.[35] And on September 1, the second line community lost another giant with the passing of Sylvester Francis, not from COVID-19 but rather a ruptured appendix. A long-time chronicler of the tradition and former member of the Gentlemen of Leisure, Francis founded the Backstreet Cultural Museum in Treme in 1999, making it the first cultural institution in New Orleans to focus on the city's Black parading traditions. Also lost in the fall of 2020, though not necessarily from COVID-19, were Ezell Hines, founder and president of the Uptown Swingers, on November 1; Anthony "Tony" Hookfin, founder and CEO of the Men of Class, on December 3; and Louis "Big June" Price Jr., longtime member and original Big Shot of the Dumaine Street Gang, on December 17.

Amid these sad, uncertain times, the mood among the clubs has been one of forbearance and hope. "We're doing ok," is the refrain heard from club presidents on *Takin' It to the Streets*, Charles "Action" Jackson's WWOZ podcast, which he has continued to

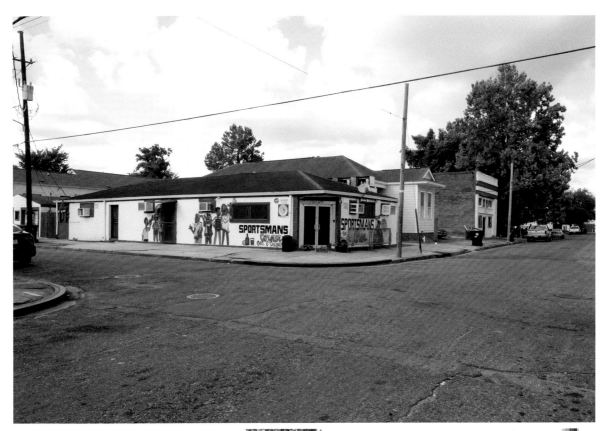

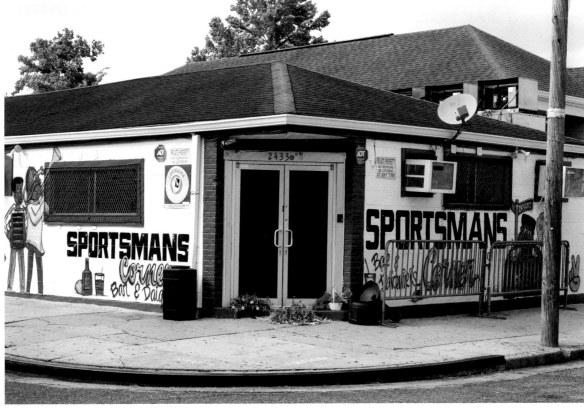

TOP Empty streets around Sportsman's Corner, 2020, by Judy Cooper
BOTTOM Remnants of a memorial to Theresa Elloie in front of the Sportsman's Corner, 2020, by Judy Cooper

produce throughout the pandemic. Each week, he has interviewed (by phone) a representative of the club that normally would parade that Sunday. "So how are you all doing during this pandemic?" he asks. Oscar Brown, vice president of Nine Times responded philosophically: "It's a struggle for everybody. It's not just a Nine Times thing, it's a worldwide thing. We are just trying to stay close, to be a family. To care for our community and our neighborhood."[37] Wendell Jackson, president of the Original Four, exhorted his fellow second liners to "keep their head up, because this will pass. I can't wait for us to get back out there because this is our culture, and we should never let it down."[38] Tyrone Brooks, president of Family Ties, was even more upbeat: "We'll get back to it soon. Our time is coming. Get ready to rumble! The New Orleans way!"[39]

According to Norman Dixon Jr., the word from NOPD is that parades will not resume until a vaccine is widely available. If all goes well, a new season can begin as scheduled in late August 2021. "I'm just moving forward until next year, and I pray to God we're able to keep everything going and we're able to come out the doors next year," said Raynold Fenelon, president of Good Fellas. One suggestion circulating in the community is to hold a giant multiclub jazz funeral once the city has lifted the ban on parading, to honor all those who died during the pandemic.[40]

With the streets empty, so to speak, Action Jackson has helped fill the void. Early in the pandemic, Jackson decided that the second line community needed some kind of event on Sunday to take the place of the normal parades. He teamed up with Derrick Tabb of Rebirth Brass Band, cofounder of the Roots of Music youth education program, to produce Secondline Sunday, a two-hour broadcast every Sunday on Facebook Live featuring photos and video footage of second lines past. Many club members and followers of the parades tune in every week. (More about the clubs' responses to the pandemic is discussed in Jackson's epilogue, p. 281.)

The full effects of the pandemic on second line culture will not be known for years to come, but it is safe to say that the tradition is not going anywhere. Even in this suspended state, it remains a living tradition, constantly evolving. The social aid and pleasure clubs of New Orleans have survived by staying rooted in their illustrious past while also looking toward the future, always thinking about the next generation and the next parade—the colors, the outfits, and the glory of coming out the door and dazzling the crowd. Now, more than ever, this resilience will serve the clubs well, as they wait for the day when they can hit the streets again.

NOTES

1 Alfred "Bucket" Carter, interview with Judy Cooper, June 2012.

2 Claude Jacobs, "Benevolent Societies of New Orleans Blacks during the Late Nineteenth and Early Twentieth Centuries," *Louisiana History* 29, no. 1 (Winter 1988): 21–22; Harry Joseph Walker, "Negro Benevolent Societies in New Orleans: A Study of Their Structure, Function, and Membership" (master's thesis, Fisk University, 1937).

3 Jacobs, "Benevolent Societies," 22.

4 The Hogan Archive of New Orleans Music and New Orleans Jazz at Tulane University has in its photography collection several works from the 1920s by Villard Paddio that show the exterior and interior of the San Jacinto clubhouse on Dumaine Street. The collection

also includes a 1956 photo by Ralston Crawford of the same building with this description: "The exterior of the San Jacinto hall, where many bands played and recorded music."

5 Richard H. Knowles, *Fallen Heroes: A History of New Orleans Brass Bands* (New Orleans: Jazzology Press, 1996), 12. More information about New Orleans's long history of public processions accompanied by bands can be found in David Ake, *Jazz Cultures* (Berkeley: University of California Press, 2002); Rudi Blesh, *Shining Trumpets* (New York: Knopf, 1946); and John Rublowsky, *Black Music in America* (New York: Basic, 1971).

6 Sidney Bechet, *Treat It Gentle* (1960; repr., New York: Da Capo, 2002), 217.

7 Danny Barker, interview with Michael White, July 21–23, 1992, transcript, p. 13, Smithsonian Jazz Oral History Program.

8 William Jankowiak, Helen Regis, and Christina Turner, *Black Social Aid and Pleasure Clubs: Marching Associations in New Orleans* (New Orleans: Jean Lafitte National Historical Park and the National Park Service, 1989), 32.

9 *Times-Picayune*, July 3, 1916.

10 In describing the route of Zulu for the year that Louis Armstrong was king, a speaker was quoted by the *Times-Picayune* as saying, "King Zulu will follow his usual route. That means all over town" (February 19, 1949).

11 *Times-Picayune*, February 25, 1925.

12 Bechet, *Treat It Gentle*, 61.

13 Louis Armstrong, *Satchmo: My Life in New Orleans* (1954; repr., New York: Da Capo, 1986), 29.

14 Danny Barker, *A Life in Jazz*, illustrated ed. (New Orleans: The Historic New Orleans Collection, 2016), 61.

15 "Brickbatting a Negro Procession: Young White Hoodlums Bring On a Riot in Which Several Persons Are Injured," *Daily Picayune*, January 13, 1890.

16 Matt Sakakeeny, "'Under the Bridge': An Orientation to Soundscapes in New Orleans," *Ethnomusicology* 54, no. 1 (Winter 2010): 5.

17 Sakakeeny, "'Under the Bridge,'" 13.

18 Ann Woodruff, "Society Halls in New Orleans: A Survey of Jazz Landmarks, Part I," *Jazz Archivist* 20 (2007): 24. According to Woodruff, the Bulls sold their clubhouse at 1913 Harmony Street to the Elks in 1938. The Elks used the hall for several years before renting it to the Young Men Olympian Jr. in the early 1980s. In a phone conversation on December 27, 2020, YMO Jr. President Norman Dixon Jr. confirmed that his organization used Elks Hall for meetings and as the starting point for their parades until they moved into their own building at South Liberty and Josephine Streets in 2004.

19 Much of the information about the dates of the older clubs can be gleaned from photographs that feature their banners. A number of these images can be found in the Hogan Jazz Archive at Tulane University and The Historic New Orleans Collection.

20 Robert Williams, interview with Judy Cooper, 2011.

21 Jerome Smith, interview with Judy Cooper, February 2, 2015.

22 Jerome Smith (February 2, 2015), Fred Johnson (January 16, 2014), and Bernard Robertson (May 2014), interviews with Judy Cooper. For more on the legacy of the Bucket Men and the activist work of Jerome Smith, see Bruce Sunpie Barnes and Rachel Breunlin, eds., *Talk That Music Talk: Passing on Brass Band Music in New Orleans the Traditional Way* (New Orleans: University of New Orleans Center for the Book, 2014); and Mick Burns, *Keeping the Beat on the Street: The New Orleans Brass Band Renaissance* (Baton Rouge: LSU Press, 2008). The artistic lineages stemming from Tambourine and Fan are also discussed in Rachel Breunlin and Ronald W. Lewis, *The House of Dance and Feathers: A Museum by Ronald W. Lewis* (New Orleans: Neighborhood Story Project and University of New Orleans Press, 2009).

23 Quint Davis, interview with Judy Cooper, January 31, 2012.

24 Quint Davis, interview with Judy Cooper, January 31, 2012.

25 Helen A. Regis and Shana Walton, "Producing the Folk at the New Orleans Jazz and Heritage Festival," *Journal of American Folklore* 121, no. 482 (Fall 2008): 408. As Regis and Walton point out, Jazz Fest itself described the festival in promotional material as a "living exhibition" (409).

26 Regis and Walton, "Producing the Folk," 401.

27 Wardell Lewis Sr., interview with Judy Cooper, July 4, 2013; Linda Tapp Porter, interview with Judy Cooper, June 2015.

28 Edward Buckner, in conversation with Judy Cooper, 2010 and June 2011.

29 Kevin McCarthy, D. J. Peterson, Narayan Sastry, and Michael Pollard, "The Repopulation of New Orleans after Katrina" (Santa Monica, CA: RAND Gulf States Policy Institute, 2006), xiii.

30 Joe Stern, interview with Judy Cooper, February 2006.

31 Norman Dixon Jr., interview with Judy Cooper, October 14, 2015.

32 Breunlin and Lewis, *House of Dance and Feathers*, 131.

33 Edward Buckner, "Mother's Day Second Line Helps Nourish Not Only the City's Culture but the Younger Generation," NOLA.com *Times-Picayune*, May 15, 2013.

34 Deborah "Big Red" Cotton, quoted in Katy Reckdahl, "Deborah Cotton, Writer Shot in 2013 Mother's Day Second-Line Shooting, Dies at 52," NOLA.com *Times-Picayune*, May 2, 2017.

35 Scheduled club parades that were canceled were Revolution, March 22; Single Ladies, April 5; Pigeon Town Steppers, Easter Sunday, April 12; Ole & Nu Style Fellas, April 19; Original Big 7, Mother's Day, May 10; Divine Ladies and Zulu, May 17; Money Wasters, May 24; Perfect Gentlemen, Father's Day, June 21; and Uptown Swingers, June 28. The Scene Boosters, an old club that had not paraded since Katrina, was scheduled for a comeback on May 31, but it, too, was canceled.

36 Gerald Herbert and Janet McConnaughey, "In New Orleans, Friends Respond as Virus Claims a Zulu King," APNews.com, April 27, 2020.

37 Oscar Brown, interview with Charles "Action" Jackson, *Takin' It to the Streets*, WWOZ.org, December 14, 2020.

38 Wendell Jackson, interview with Charles "Action" Jackson, *Takin' It to the Streets*, WWOZ.org, November 22, 2020.

39 Tyrone Brooks, interview with Charles "Action" Jackson, *Takin' It to the Streets*, WWOZ.org, October 20, 2020.

40 First mentioned by Fred Johnson of the Black Men of Labor, in conversation with Judy Cooper, June 2020, and corroborated by Bernard Robertson of Sudan, in conversation with Judy Cooper, December 27, 2020.

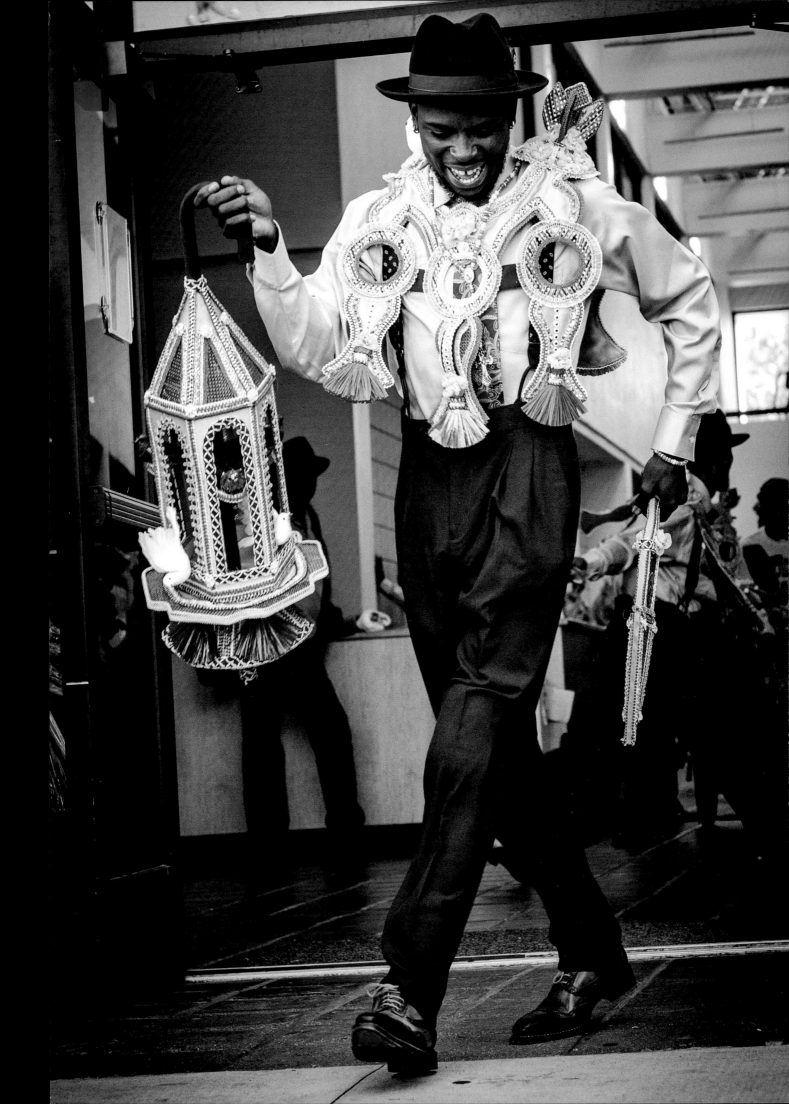

PARADES

THE FINERY

JUDY COOPER

Brightly colored suits, matching hats, fancy shoes, streamers, fans, and umbrellas—no social aid and pleasure club parade is complete without its finery. Powerful aesthetically and historically, the clubs' outfits, accessories, and regalia express both the originality of each club as well as the African American tradition of creative expression and commentary through dress. "We are bringing beauty to the streets," said Wardell Lewis Sr.[1]

The ritual of coming out the door at the beginning of each parade gives the club members a dramatic showcase to reveal their ensembles. They pose, strut, and dance their way onto the sidewalk as the onlookers watch and evaluate. "That boy looks clean!" someone might say in approval. Or, if the club didn't meet the high standards, you might hear, "Why'd they come out all *raggedy* like that?" Each club aspires to have the most eye-popping colors and the best decorations—accessories such as umbrellas, fans, canes, or yokes—and when members from another club attend a parade, they are doubtless watching with a critical eye. Ever-present is the desire to outdo everyone else: "We close out the year; we gonna close it out right," said Ezell Hines, former president of the Uptown Swingers, who parade at the end of June. "Everybody gonna talk about us till next year!"[2]

Like all of the elements of any second line parade, what members wear connects them to a long tradition. The dress of the late nineteenth-century benevolent associations was more formal and less colorful than today—more like uniforms, perhaps with special ribbons or streamers (sashes worn across the body) to give a festive note. For instance, Louis Armstrong described with pride his father's grand marshal uniform in the Odd Fellows parade, with "his high hat with the beautiful streamer hanging down by his side. Yes, he was a fine figure of a man, my dad."[3] Today, the Young Men Olympian Jr. stay true to the style of the old benevolent associations with their first parade of the year. Club members wear a uniform of black pants, a white jacket with the club emblem on

PRECEDING SPREAD Glen Finister Andrews of Sudan, 2014, by Pableaux Johnson
OPPOSITE Alligator shoes, Pigeon Town Steppers, 2011, by Judy Cooper

the pocket, and a black fez with a white tassel. White gloves and a black cane complete the ensemble. They march down the street in two parallel lines and only break into a dance step on occasion.

The SAPCs of the early twentieth century tended to wear simpler outfits: shirts and pants with colorful accents provided by suspenders, hats, and shoes. The decorations were not as elaborate, either. There might be a small basket decorated with ribbons and filled with dolls, flowers, or cigars to give to spectators. Also popular were simple paper or woven-fiber fans, like the ones found in every church in the South before the age of air conditioning, as well as decorated umbrellas and walking canes, sometimes wrapped with colored ribbons.

Today, though, color is king. The decorations are now explosions of texture and pattern, adorned with ostrich feathers, dozens of bows, rhinestones, and luxurious trim. Variations on the standard template—suits with color-coordinated hats and shoes—abound. Some present-day clubs stay close to the simpler fashions of the early twentieth-century SAPCs by wearing shirts and pants instead of suits. Clubs also sometimes choose deliberately retro looks, as with the Ole & Nu Style Fellas' 2013 ensemble of old-fashioned golf pants and matching caps. Whatever the theme, the clubs' finery is part of how SAPC members express their unmistakable extravagance and creativity.

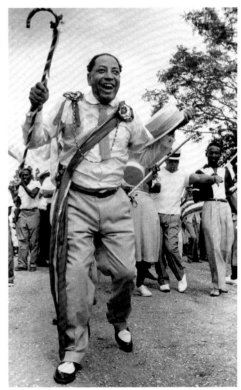 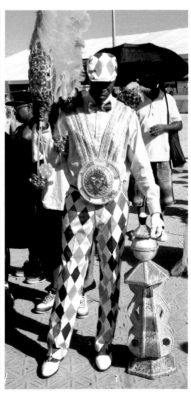

"Bringing beauty to the streets" (left–right): Young Tuxedo Brass Band at Young Men's Protective Association of Algiers parade, 1956, by Ralston Crawford; Monk Boudreaux and John "Quartermoon" Tobias of the Young Men Olympian Jr. at Jazz Fest (detail), 1980, by Michael P. Smith; Tyrone "Trouble" Miller Jr. of the Ole & Nu Style Fellas, 2014, by Judy Cooper

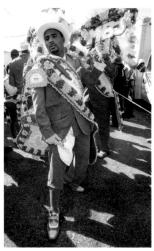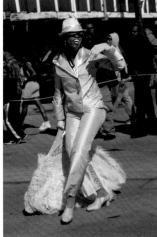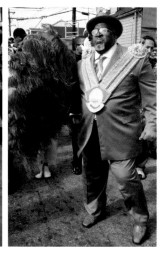

THE COLORS

Red, hot pink, turquoise, light blue, lime green, gold, purple, and more, in dazzling combinations: designing the outfits and decorations begins with the choice of colors—usually two, sometimes three—which remains a closely guarded secret until the day of the parade. As Linda Green of the Lady Rollers said, "A lot of people don't know how to coordinate colors, but when you do it right, the colors *shout*."[4] Each organization has a club color combination that they typically reserve for special anniversary years.

With some clubs, the annual choice of color is a democratic, sometimes difficult one made at a regular club meeting, often soon after the current season's parade is done. "We butt heads," said L. J. Goldstein, member of Treme Sidewalk Steppers.[5] With other clubs, the decision is made by one member, usually the president. For their inaugural parade in 2006, the Men of Class wore peach, cream, and lime. Anthony "Tony" Hookfin chose the combination, which, he said, some of the members didn't like. "You can't be scared to wear color in a second line parade," Hookfin told them.[6]

Byron Hogans met similar resistance from his fellow Dumaine Street Gang members when he suggested pink as the color of their suits in 2007. Longtime member William Batiste Sr. admitted that he "cussed him out" and firmly refused to wear pink, but Hogans countered, "Why don't you wait to see how it all comes together." For the big reveal, they all trooped over to Adrian "Coach Teedy" Gaddies's house, and when he brought out a finished suit with the accompanying decorations, Batiste "was speechless," he said. "Now I have made that suit my 'breast cancer' suit."[7] Batiste wears it every year when he performs at the Susan G. Komen New Orleans Race for the Cure.

In the case of the Black Men of Labor's 2013 outfits, the fabric and color selection held great symbolic importance, marking the club's twentieth anniversary. "We decided early on to use African themes and African elements in our outfits," said cofounder and

ABOVE Bold colors worn by the clubs, by Judy Cooper (left–right): Ernest Williams, Men Buckjumpers, 2013; Renata Hampton, Lady Buckjumpers, 2013; William Jones, Dumaine Street Gang, 2007
FOLLOWING SPREAD Black Men of Labor, 2013, by Judy Cooper

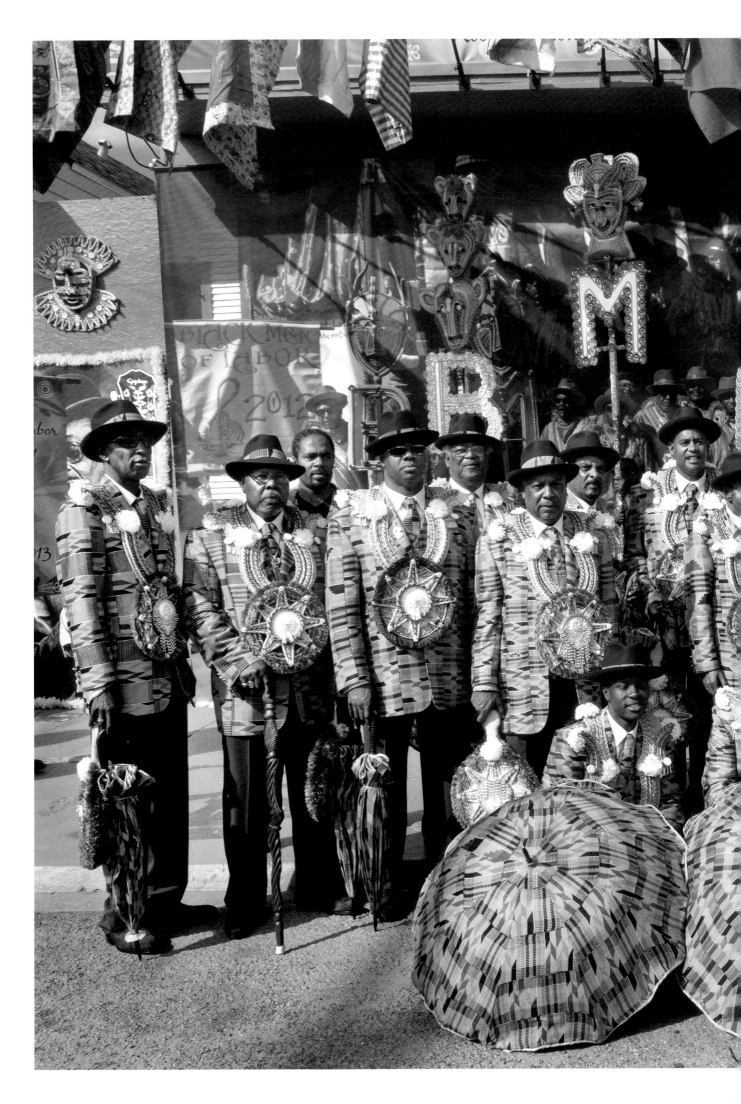

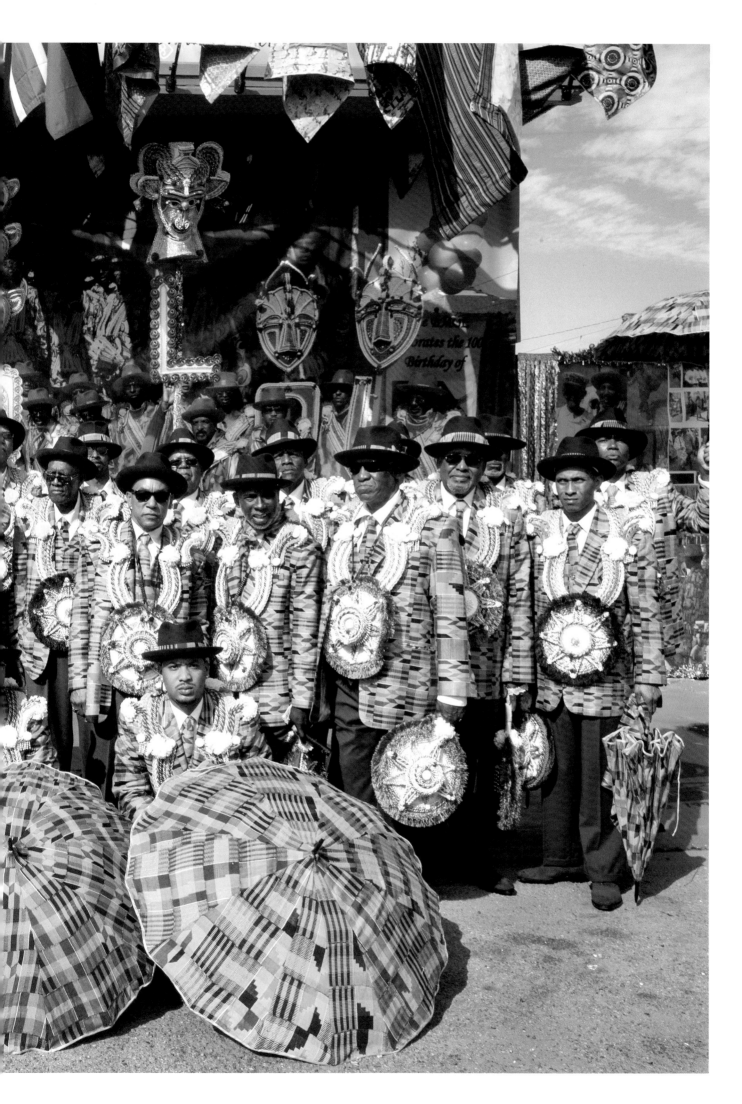

president Fred Johnson.[8] Accompanied by Abdullah Diaw, then the owner of a fabric store in New York, and Todd Higgins, a fellow member of the club, Johnson went to a small village in Ghana to purchase 800 yards of kente cloth. The brightly patterned textile, which is intended for sacred occasions, holds meaning in all its colors—black for maturity and connection to ancestors; gold for royalty, wealth, and spiritual purity; maroon, representing Mother Earth; green, for vegetation, growth, and spiritual renewal; and blue, representing peace, harmony, and love. Johnson sent some of the fabric to Italy to have jackets custom made and brought the rest back to the United States, where Viet Tran, a New Orleans tailor who has resided in Houston since Katrina, made vests and additional jackets. These garments have become the club uniform for official occasions, such as funerals.[9]

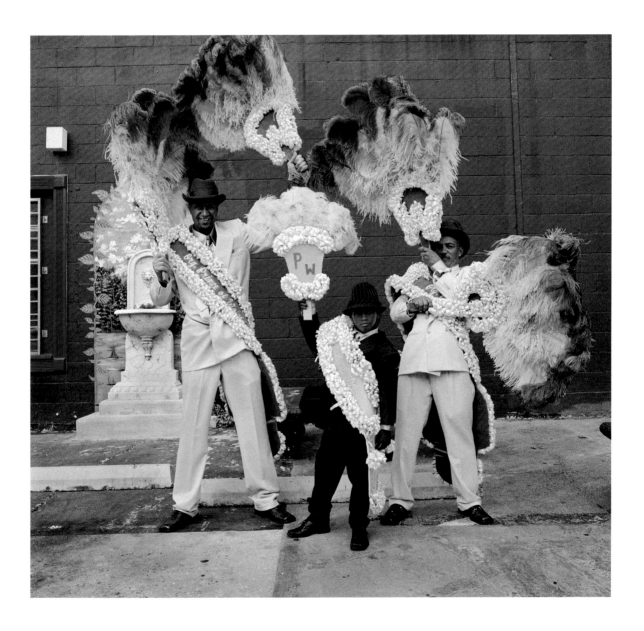

Young and old Prince of Wales members, 2004, by Judy Cooper

THE MAKERS AND PURVEYORS

According to Wardell Lewis Sr., the old-time second line clubs had their suits custom made by local tailors, a number of whom had shops on South Rampart Street. This practice continues among several present-day clubs, including Sudan, which buys the fabric and has shirts made by Bernadine Leboeuf, and the Divine Ladies, who use dressmaker Gerry Bryan.

Other clubs order their suits from local retailers such as Rubensteins, a family-owned store in operation since 1924, and Step 'N Style on the West Bank. Several clubs patronize Upscale Menswear out of Atlanta. Increasingly, suits are ordered online. In any case, they are never bought off the rack, not only because of the number required but, perhaps most of all, because of the unusual colors the clubs like to wear.

Almost all of the club members wear hats—men, women, and even the children. The dominant source has long been Meyer the Hatter, located just off Canal Street on St. Charles Avenue. Founded in 1894, it is the oldest family-owned haberdasher in the country, the largest in the South, and the first to cater to both whites and African Americans. Toward the rear of the store, one display case is adorned with photos of second line clubs sporting Meyer hats. Sam Meyer, grandson of the shop's founder, who has worked at the store since serving in World War II, has sold to the SAPCs for decades. He said they typically prefer pinch-front, snap-brim fedoras in felt or beaver. "They are not cheap hats," he added.[10]

The women's hats come from a variety of sources and tend to be more varied in style than the men's. Linda Green of the Lady Rollers prefers an extra-wide brim, which she can manage because she rides in a convertible (rather than dances) in the parade. Green has purchased some of her hats from Henri the Hat Man, who has a workshop on St. Philip Street. In 2015, the VIP Ladies and Kids had its hats made by Donna Vinci, a national brand known for its flamboyant church hats and suits. For their twenty-fifth anniversary, the Lady Buckjumpers started the day in extravagant feathered headdresses.

Sam Meyer of Meyer the Hatter, 2014, by Judy Cooper

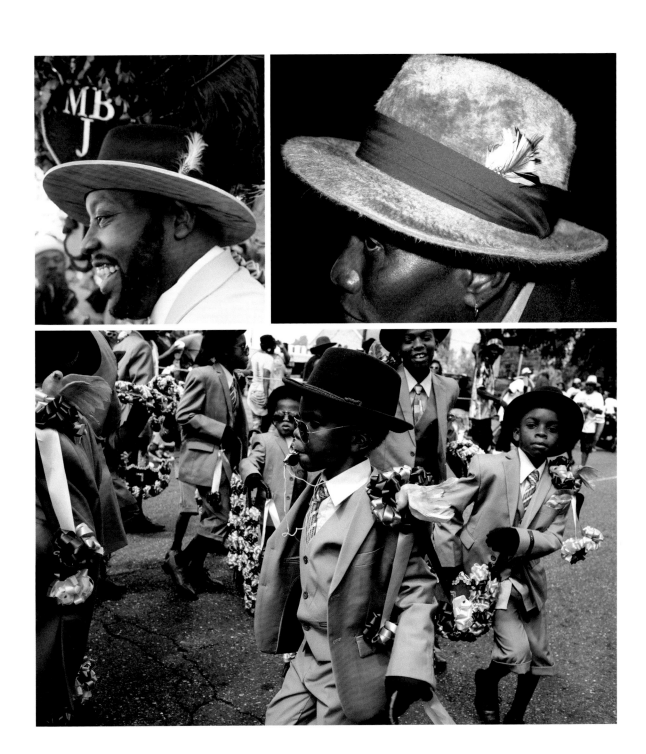

Haberdashery (clockwise from top left): wood brim, Men Buckjumpers, 2019, by Judy Cooper; blue mohair, James "Yam" Harris, Men of Unity, 2019, by Judy Cooper; classic fedora, New Look division, Young Men Olympian Jr., 2016, by Leslie Parr

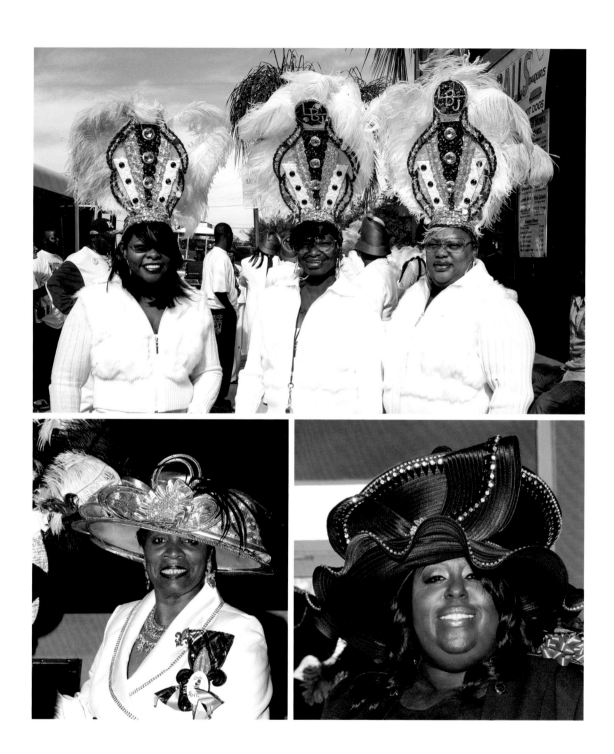

ABOVE Ladies' hats and headpieces, by Judy Cooper (clockwise from top left): Lady Buckjumpers, 2009; Tamara Jackson Snowden, VIP Ladies and Kids, 2016; Linda Green, Lady Rollers, 2015
FOLLOWING SPREAD Janitra "Chi" Miles, Divine Ladies, 2015, by Pableaux Johnson

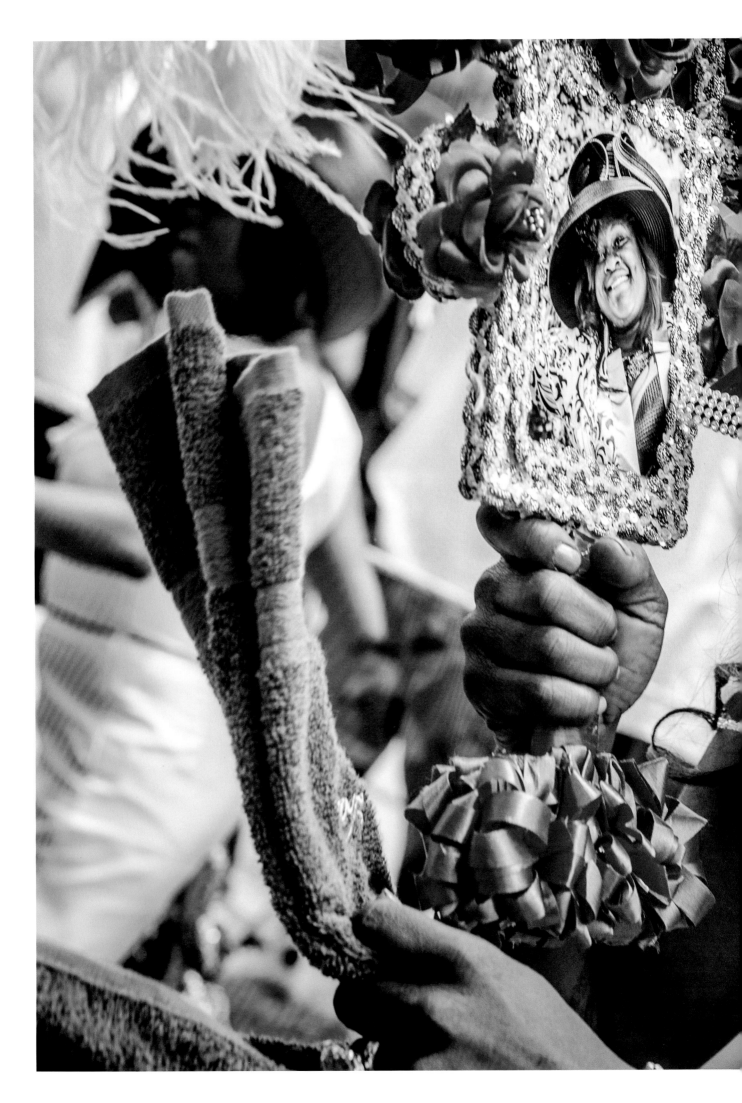

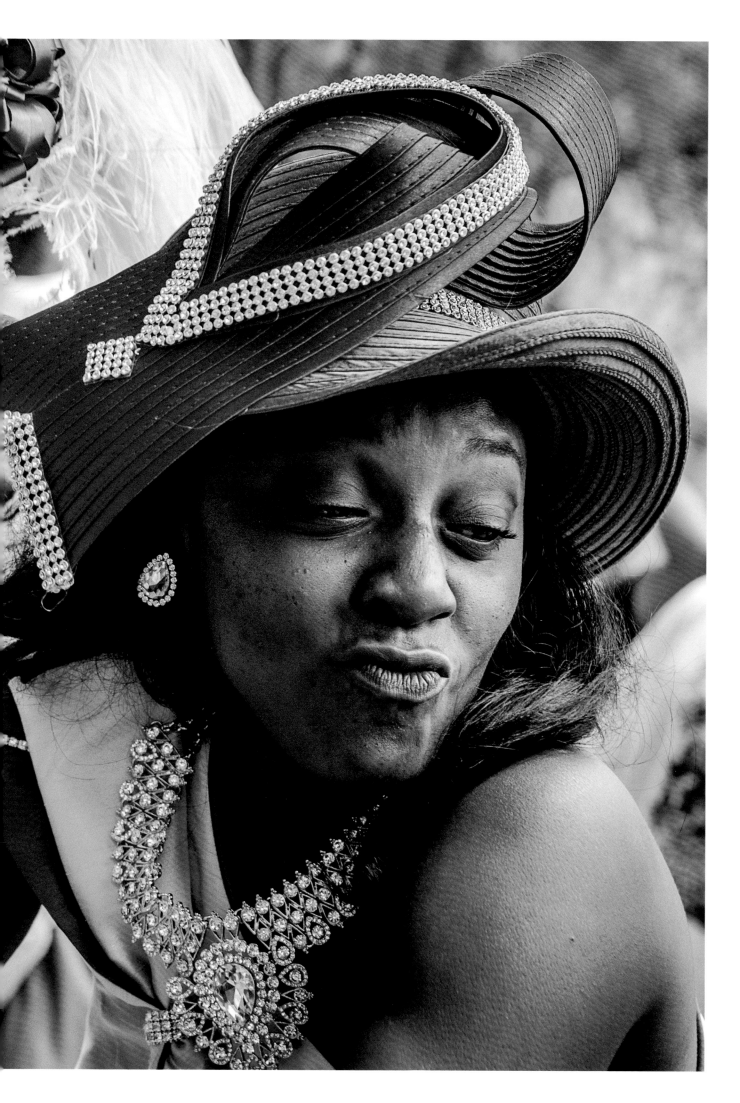

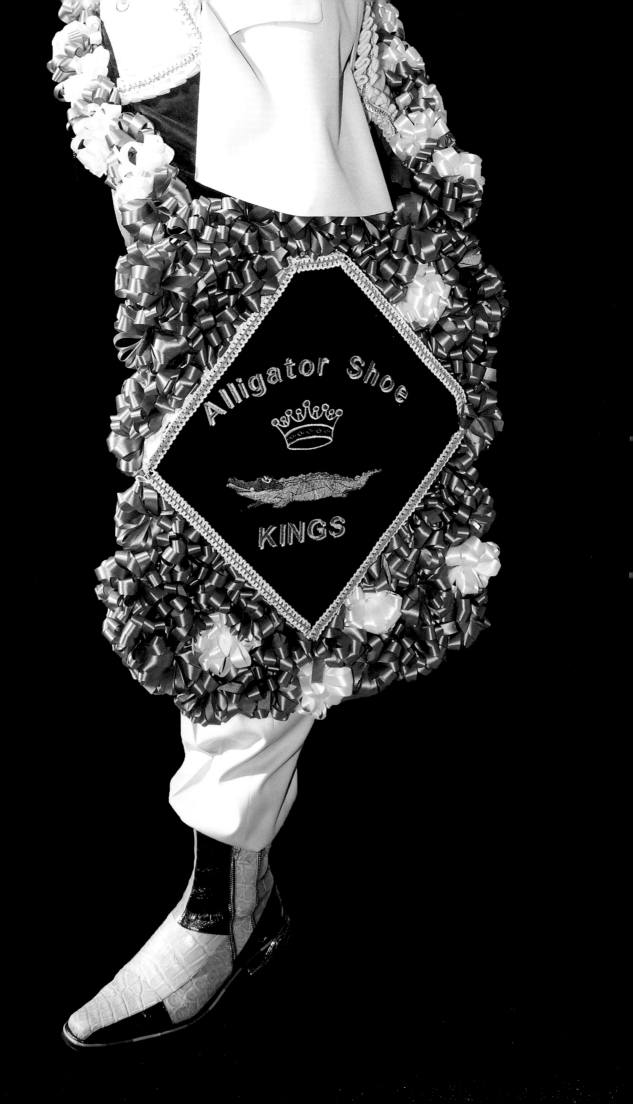

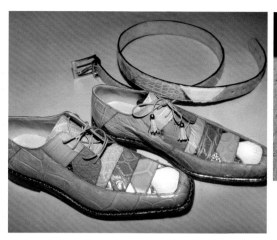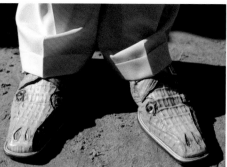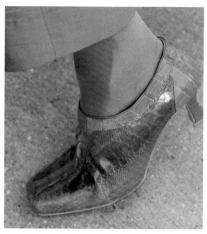

A club's regalia is never complete without specially selected shoes. They are "the first thing [people] see when you come out the door," said Joe Stern of Prince of Wales.[11] According to Andre Rubenstein, who co-owns Rubensteins with his brother, David, shoes are "the focus of the whole outfit."[12] The clubs tend to favor alligator shoes, or "gators," as they're called. Rubensteins orders from shoemakers in Spain and Italy, brands such as Mezlan and Mauri. The shoes are custom made according to the club's own design, sometimes featuring intricate patterns and more than one color. The results are, understandably, expensive: one pair can cost over $1,000. They're also time consuming to produce—overseas orders take at least two months to arrive, leading more than one club to postpone their parade because the shoes didn't arrive in time.

Members of the Pigeon Town Steppers always wear two-toned alligator shoes. For the club's 2014 parade, an image of the shoes served as the main logo on the fans and streamers. The same year, the C.T.C. Steppers sported custom-made shoes and belts in pink and lavender, to match their outfits, bearing the club's initials. The boys in the parade wore white shoes that had been painted to match the men's. In 2017, the Men Buckjumpers proclaimed themselves "Alligator Shoe Kings" and sported three-toned alligator boots to prove it. But the Uptown Swingers might hold the record for the number of different colors on a shoe, with the eight-toned pairs they wore in 2015. Not to be outdone, Tyrone "Trouble" Miller Jr., who is responsible for every aspect of the Ole & Nu Style Fellows' outfits, designed custom shoes made in Italy by Tullio, which featured an imitation alligator eye on the side.

In 2013 the Lady Rollers worked with Rhonda Findley, owner of Funrock'n on Magazine Street, to order boots from Turkey adorned with the hand-stitched embroidery style known as suzani. That same year, the Divine Ladies donned a virtual rainbow of colors for their suits, and each lady had shoes to match, ordered from the West Bank retailer City of Angels. Unlike the men, though, many of the women cover the miles of their parade routes in heels. In 2010, the boots worn by the Ladies of Unity had such

pointed heels that they got stuck in cracks in the street. The fancy boots had to be abandoned before the parade had gone two blocks.

Several of the clubs present a king and/or queen who wears a different outfit from the rest, often topped by a large headdress. Several local craftsmen, including Nicholas "Norman" Nero and Wardell Lewis Sr., specialize in designing and fabricating these headpieces. It is hard to know when this custom began, but it was likely borrowed from Mardi Gras parades, Zulu in particular. The practice has been documented as early as the 1960s, in images of the Jolly Bunch parades by the photographer Jules Cahn.

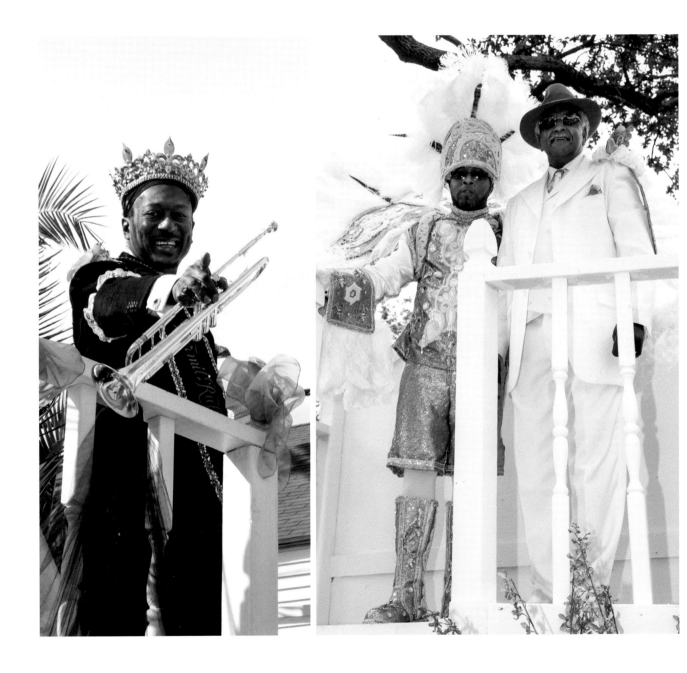

LEFT Kermit Ruffins, king of the Lady Buckjumpers, 2010, by Judy Cooper
RIGHT Wardell Lewis Jr., king of the Lady Buckjumpers, with Wardell Lewis Sr., who made his headdress, 2011, by Judy Cooper

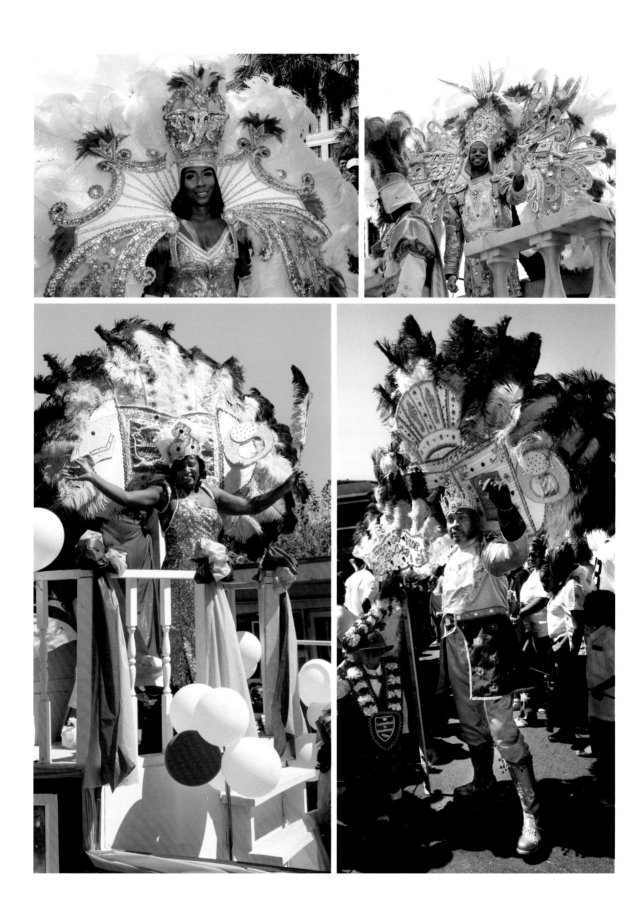

Royalty (clockwise from top left): Shawanda "Twin" Hill, Treme Sidewalk Steppers, 2018, by Judy Cooper; Troy "Trombone Shorty" Andrews, king of the Treme Sidewalk Steppers, 2018, by Charles Muir Lovell; Byron Hogans, king of Family Ties, 2011, by Judy Cooper; Cherlyn Brooks, queen of Family Ties, 2011, by Judy Cooper

THE DECORATIONS

Carried high at the front of every SAPC parade, the club banner, featuring the club's logo, motto, and date of incorporation, evokes the organization's history and identity. Carrying the banner is an important job, performed by "someone who won't leave it on the ground because, for us, our banner is just like carrying the American flag," Ronald W. Lewis writes in *The House of Dance and Feathers*.[13]

Most of the banners are made by Jack and Cheryl Matranga of Pennant Shop Inc., a local family business founded in 1932. Pennant Shop makes the banners "from scratch," Jack Matranga said, working from a drawing of the club logo, the motto, and a color selection.[14] Matranga embroiders the club logo onto a patch using a special, hundred-year-old sewing machine that has to be guided by hand.

TOP Sudan's baskets, designed by Adrian "Coach Teedy" Gaddies, 2018, by Judy Cooper
BOTTOM Banners in different stages of design, by Judy Cooper (left–right): Jack Matranga of Pennant Shop Inc. holds a design for the Nkrumah Better Boys, 2014; C.T.C. Steppers logo, 2014; C.T.C. Steppers banner, 2016

In contrast to the clubs' new outfits every year, in most cases the banner remains the same, serving as a testament to the club's history. (Notably, Matranga didn't receive many requests to remake banners after Katrina: "The clubs wanted to use their old ones even if they were stained," he said.)[15] One exception lies with the Black Men of Labor, who have a new banner made for each parade, to be carried alongside large, totem-like sculptures of the initials—B, M, O, L—topped by animal heads.

Bows are an important element used in many different types of decorations, found on streamers, yokes, fans, baskets, and more. Made from loops of ribbon, second line bows are rolled from a machine, with each loop opened up and shaped by hand. "Busting bows is almost as important as like an Indian sewing beads on their patches," said Henri Devezin, who designs for the Undefeated Gents.[16] Wynoka "Nokie" Boudreaux Richardson, daughter of big chief Monk Boudreaux of the Golden Eagles, has demonstrated bow making and other second line craftwork at Jazz Fest, giving festivalgoers a glimpse of the hours of work that go into making club regalia. She learned from her father, whose sewing and decorating skills serve him well both as an Indian and as a fabricator of second line decorations, which he makes for several clubs.

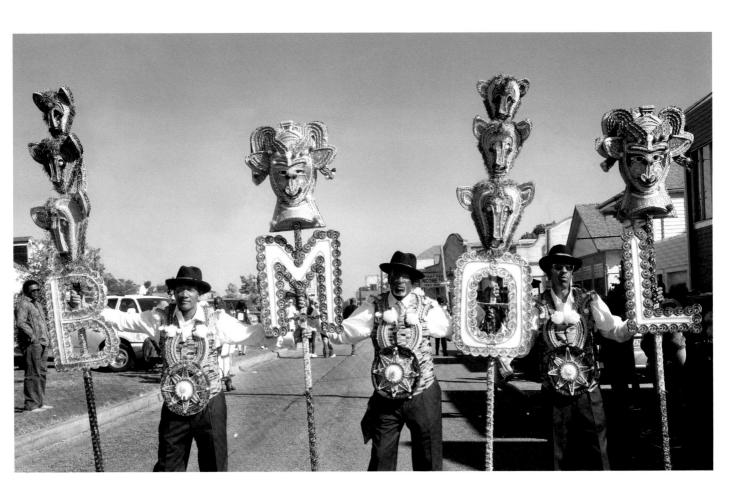

Black Men of Labor totem staffs, 2015, by Judy Cooper

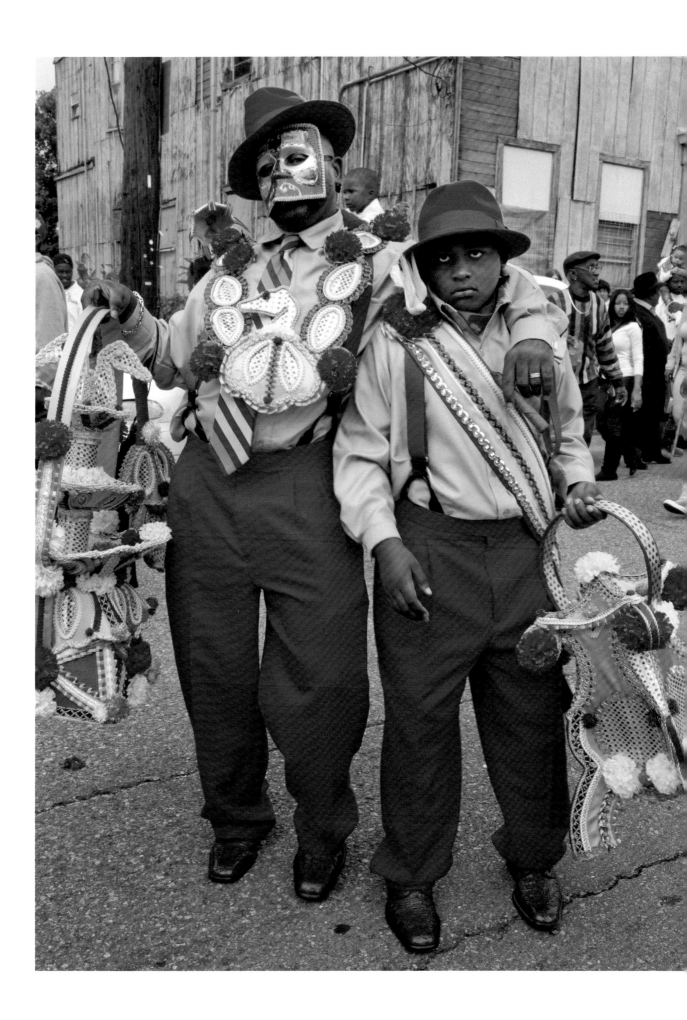

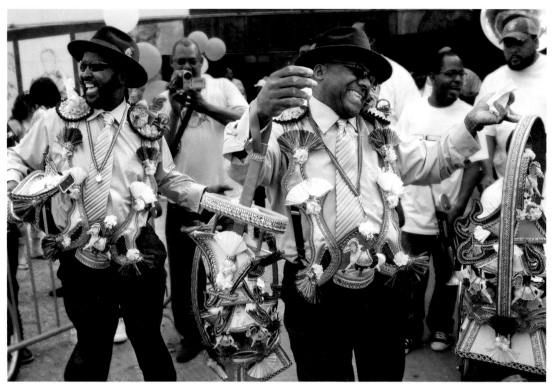

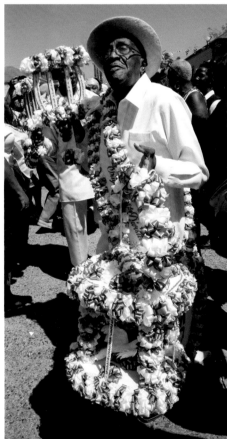

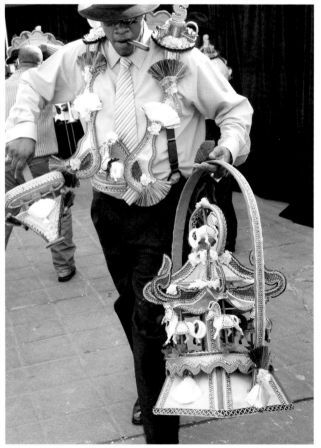

OPPOSITE Arthur Williams (left) and Dorian Jones (right) showing off baskets, yoke, and streamer made
by Adrian "Coach Teedy" Gaddies, Sudan, 2010, by Judy Cooper
ABOVE Baskets, by Judy Cooper (clockwise from top): Adrian "Coach Teedy" Gaddies (left) and
David Crowder (right), Sudan, 2011; Mario Harris, Sudan, 2011; Alfred "Bucket" Carter, Young Men
Olympian Jr., 2012

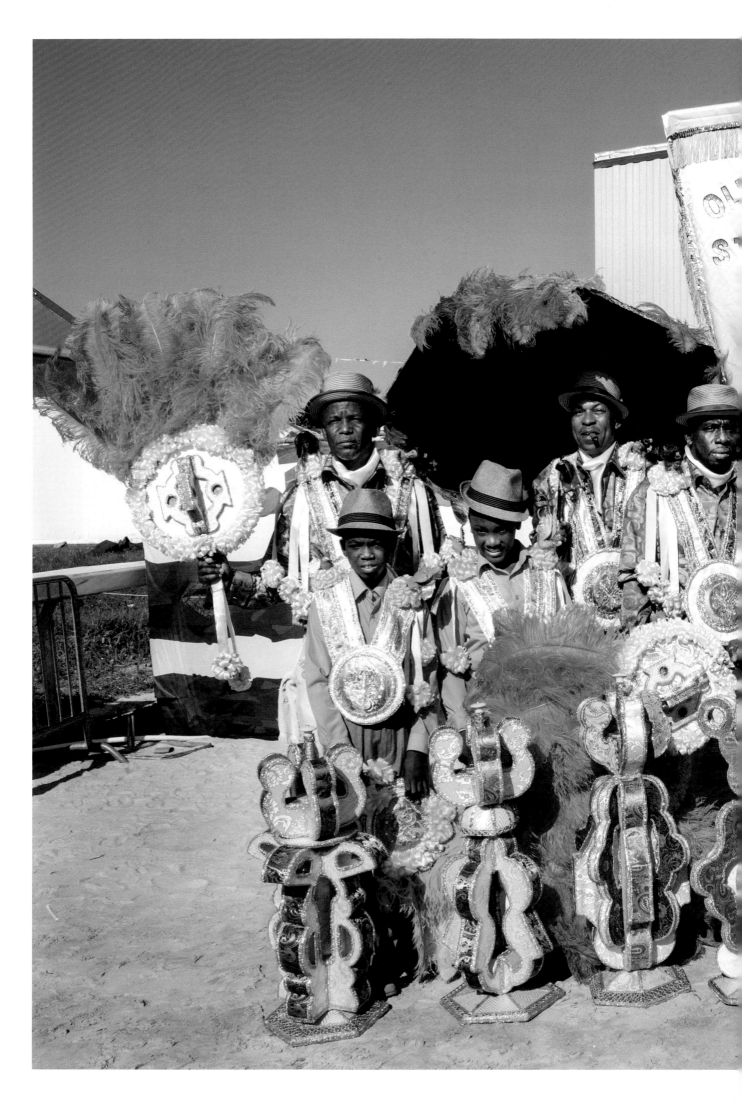

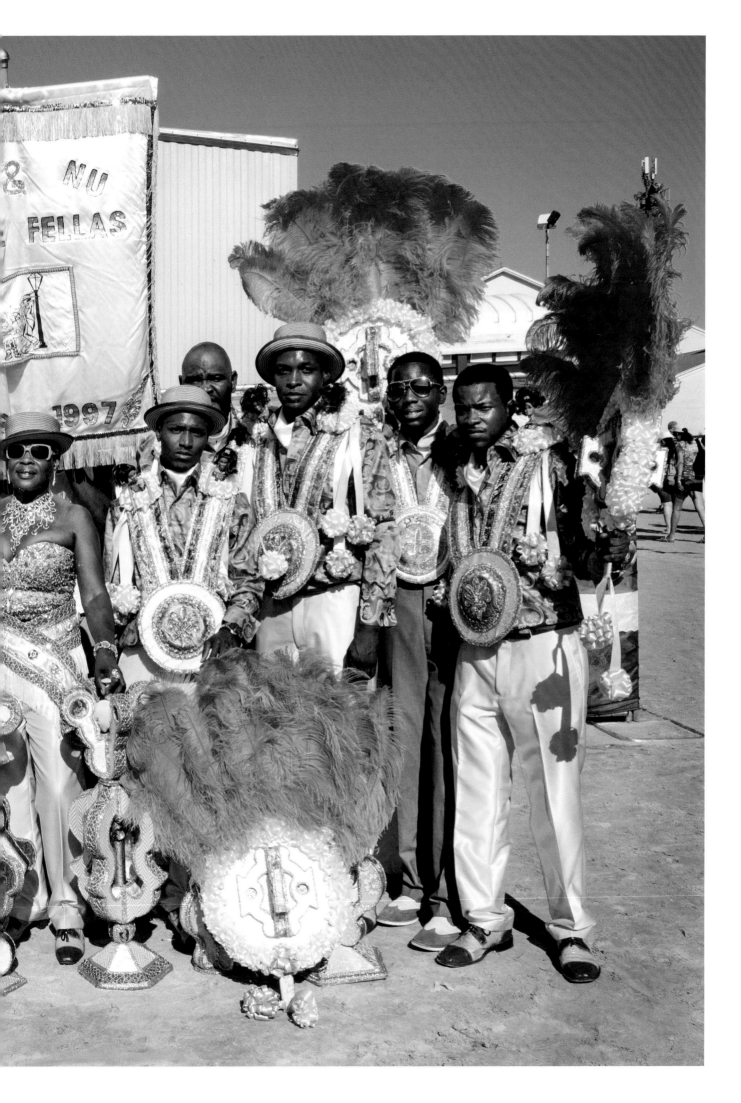

Today's clubs have created many variations of the traditional basket, some so ornate and sculptural that they hardly resemble baskets at all. They're especially important to Sudan's decorations, even appearing as part of the club's logo. The club incorporates several different basket designs for each parade, all made by Adrian "Coach Teedy" Gaddies, who also makes decorations for the Dumaine Street Gang and is part of the network of makers who have shared and passed on their expertise. He learned from Melvin Reed, designer for the Black Men of Labor, and Reed got his start with Jerome Smith of Tambourine and Fan and the Bucket Men. Both Smith and Reed learned from Allison "Tootie" Montana, the legendary Mardi Gras Indian.[17]

Sudan's thirtieth-anniversary parade featured an unusual three-dimensional set of decorations—life-size replicas of musical instruments, including two jewel-encrusted violins and an upright bass mounted on wheels. The club was inspired by the 2009 parade of the Black Men of Labor, which honored the centennial birthday of banjo and guitar player Danny Barker with a banjo decoration made by Reed. In their 2017 parade, the Old & Nu Style Fellas carried the theme of musical instruments a step further: each parader carried a replica of a band instrument—trumpet, saxophone, guitar, and even a piano—to form the Ole & Nu Style Fellas Band, as they called it. Another notable sculptural decoration was the large doll carried by Wardell Lewis Jr. in the 2015 C.T.C. Steppers parade, dressed to match the members of the club.

PRECEDING SPREAD Ole & Nu Style Fellas at Jazz Fest, 2015, by Judy Cooper
ABOVE Ole & Nu Style Fellas Band, 2017, by Judy Cooper (left–right): Tyrone "Trouble" Miller Jr. and Troy Dickerson; Sue Press and brother Gus Lewis; Denzel Audrey

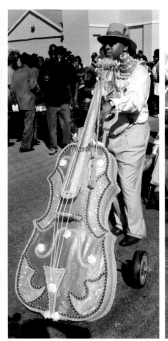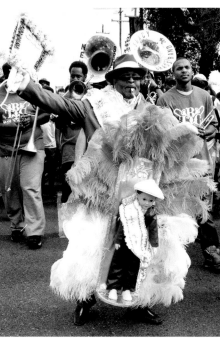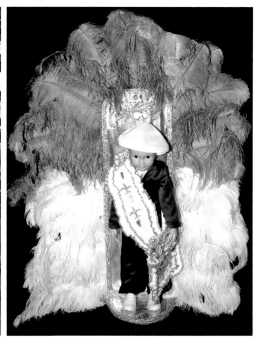

The Ole & Nu Style Fellas have made fanciful variations on canes their signature decoration. Trouble Miller is responsible for the designs, but all the club members pitch in to help construct them—usually three or four different versions for each parade. "We are up all night for days before our parade," said club cofounder Sue Press.[18] The canes are all designed to stand alone, so that members can dance without them falling. (Press's husband, cofounder Darryl Press, often rests his beer can in the top of his cane.) For the 2016 parade Miller took inspiration from the world of technology: on top of each cane was a life-size replica of some kind of camera, from antique models to modern video cameras. He fashioned the replicas out of cardboard, then covered them with silk and brocade and studded them with rhinestones. Additionally, each parader wore another camera decoration around his or her neck. One member carried a large replica boombox, and Darryl Press sported a small television that held his beer can. One of the faux video cameras had a real camera inside it that recorded the parade.

While downtown clubs tend to feature three-dimensional decorations—baskets, umbrellas, and canes—the uptown clubs favor more two-dimensional elements, such as streamers and fans. Kevin Dunn, one of the primary decorations craftsmen on the scene, makes streamers for a number of clubs, including the Original Four, of which he is a founding member. According to Dunn, today's streamers evolved from a simple ribbon sash worn by the early clubs, bearing the club name or logo. Most modern streamers are distinguished by large medallions featuring the club logo and/or motto for the parade.

Innovative decorations, by Judy Cooper (left–right): David Crowder with Ole & Nu Style Fellas Band upright bass, Sudan, 2013; Wardell Lewis Jr., C.T.C .Steppers, 2015; C.T.C. Steppers doll, 2015

Dunn's streamers incorporate velvet, satin, a lot of ribbon, embroidery, and sequins, all sourced from Jefferson Variety Store, the family-owned business that has long serviced New Orleans's SAPCs and Mardi Gras Indians.[19]

Use of ostrich feathers for the fans is another practice borrowed from the Mardi Gras Indians. When a parader first comes out the door and pauses for effect and admiration, he holds his fans high, the giant plumes forming a majestic crown. As he dances down the street, he waves in coordination with his steps—so much so that, at a distance, a second line parade is often heralded by the flash of colorful feathers in the air.

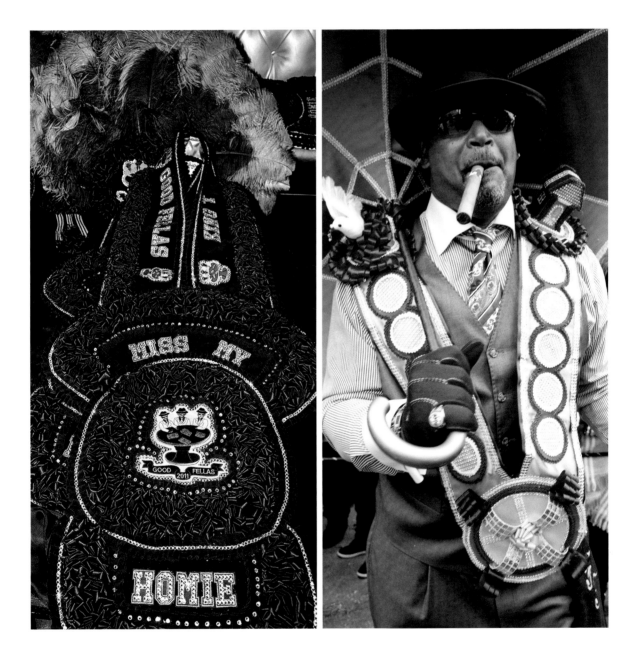

LEFT Good Fellas streamer, 2011, by Judy Cooper
RIGHT Yoke worn by Albert Fournette, Family Ties, 2015, by Judy Cooper
OPPOSITE "All We Do Is Win Win Win" streamer and fans made and displayed by Kevin Dunn, Original Four, 2010, by Judy Cooper

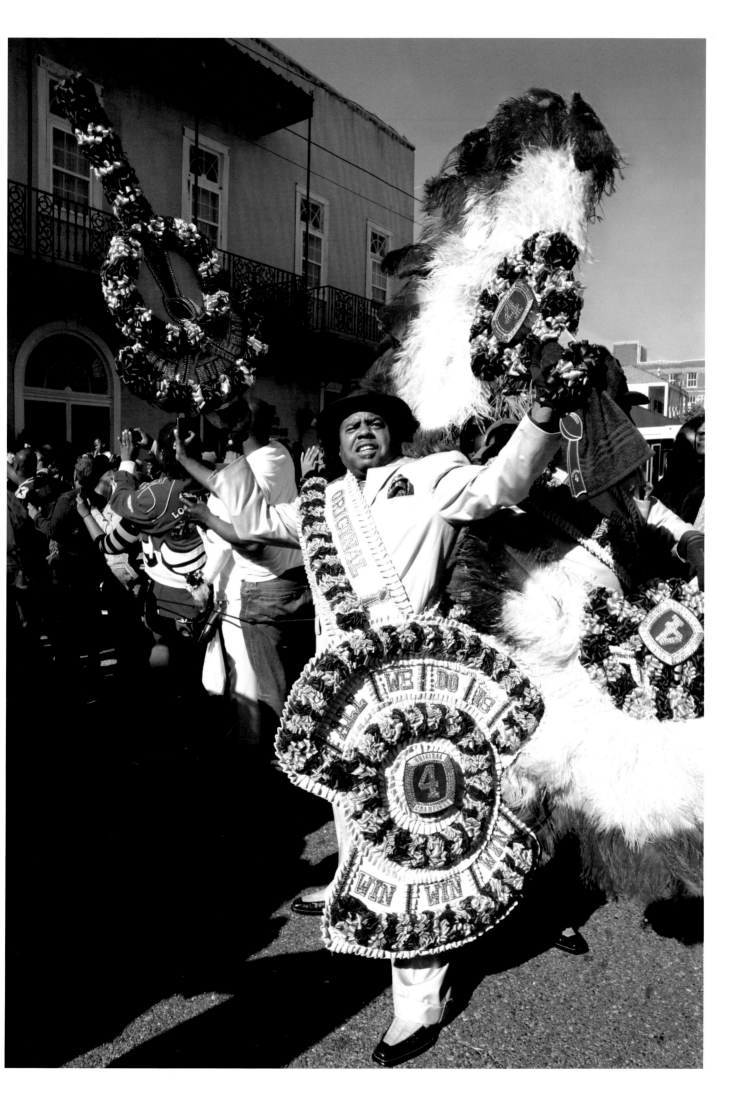

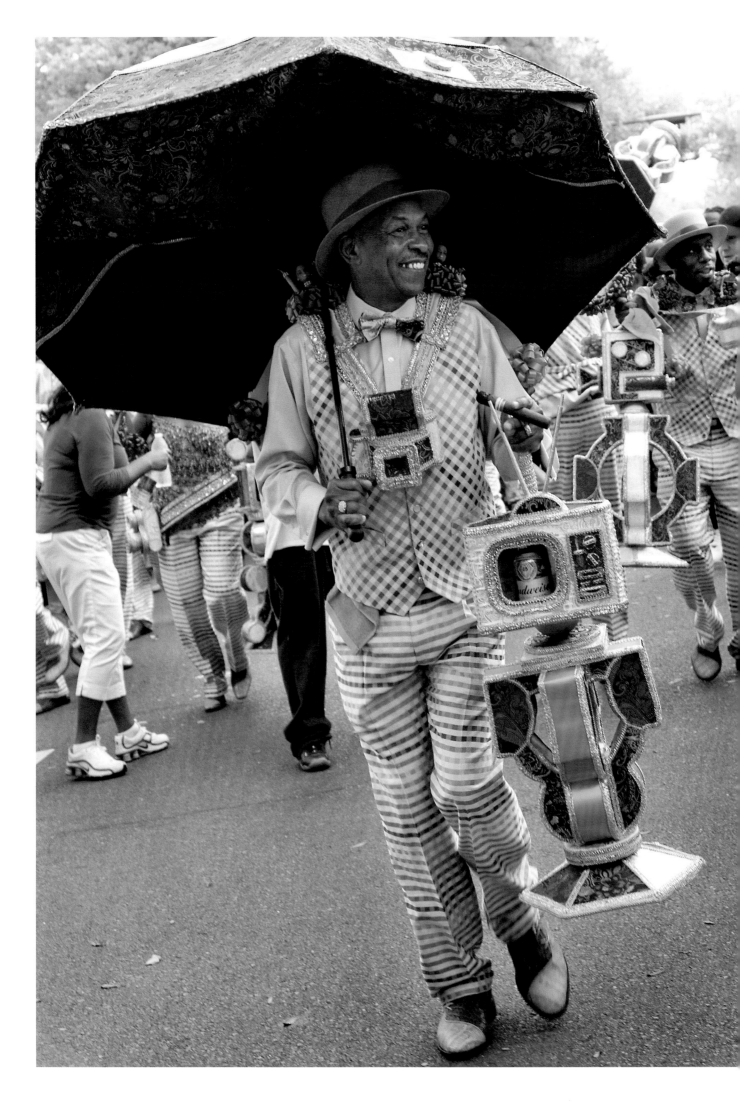

Umbrellas have always been an important element of the parades. Both Wardell Lewis Sr. and Ronald W. Lewis (no relation) have associated them with African traditions signifying royalty. The Black Men of Labor, who deliberately reference African customs in their parades, often sport umbrellas made from the same kente cloth used for their outfits. Among the more unusual umbrellas are those carried by the Dumaine Street Gang and by Sudan, all made by Gaddies.

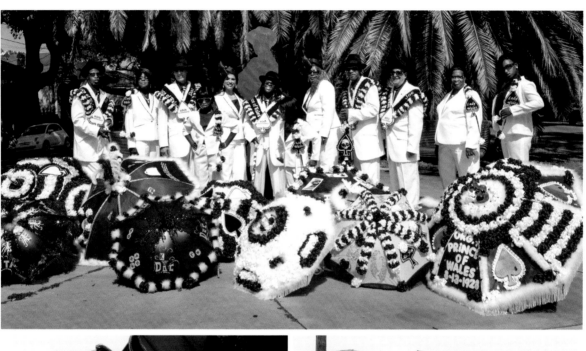

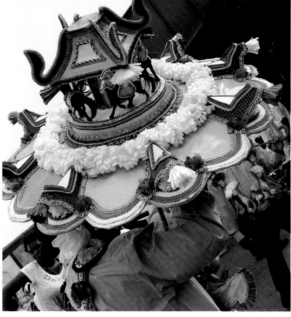
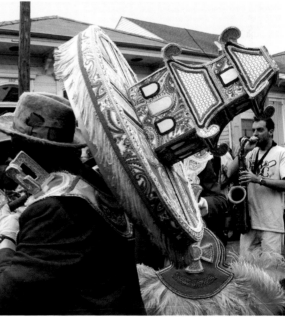

OPPOSITE Darryl Press's beer-can-holding cane and coordinating outfit, designed by Tyrone "Trouble" Miller Jr., Ole & Nu Style Fellas, 2016, by Judy Cooper
ABOVE Extravagant umbrellas, by Judy Cooper (clockwise from top): Prince of Wales umbrellas made by club members for the club's eighty-fifth anniversary, 2013; pagoda umbrella made by Adrian "Coach Teedy" Gaddies, Dumaine Street Gang, 2013; carousel umbrella made by Gaddies, Sudan, 2011

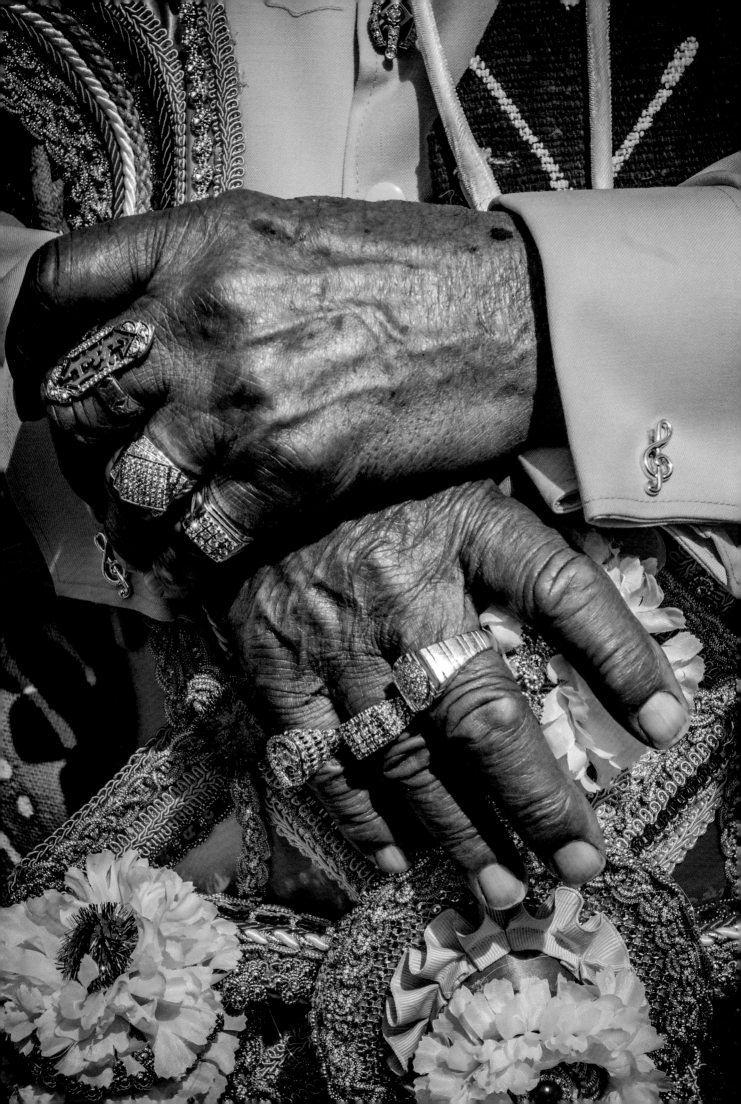

EXTRAVAGANCE AND STYLING OUT

In addition to signaling the celebratory nature of the parades, the clubs' finery is also a symbol of financial success and prestige. It is not by accident that the clubs often choose opulent materials like leather, alligator, and fur. In 2011, to celebrate its tenth anniversary, Family Ties went all out and augmented simple shirts and pants with mink vests, mink hats, and custom alligator boots topped with a mink cuff around the ankle. The medallion on their fans proudly proclaimed their motto, "Committed to Excellence." The cost of the outfits was even listed on the route sheet: mink vest, $1,000; Mauri gator boots, $1,400; mink hat, $300; Mauri gator belt, $250; pants, $200. But the next phrase revealed the true source of their pride: "A Sunday with the Family . . . PRICELESS!"

In recent years, some of the clubs have instituted a new practice of changing outfits in the middle of the parade. It is unclear who started the trend, but the Revolution were among the first to "put their stamp on it," said Joseph "Joe Black" Baker. Several other clubs, including the Original Four, Ole & Nu Style Fellas, Original Big 7, Undefeated Divas, and Keep 'N It Real, have adopted the practice, first coming out in ordinary but color-coordinated street clothes, then, at the second or third stop, changing into their full outfits with accessories. Sue Press of the Ole & Nu Style Fellas says the practice builds the momentum of the parade; on the club's 2015 route sheet, the outfit change is referred to as a "transformation."

For their thirtieth anniversary, the Original Four wore two complete outfits—one with the motto "Strictly Business." The club members dressed in black pinstripe suits and carried imitation briefcases covered in velvet and adorned with sequins. Sometimes clubs that don't normally change outfits will do so on an anniversary year, as with the Lady Buckjumpers' thirtieth-anniversary extravaganza, which necessitated two complete costume changes. The second outfit included a cut-out tommy gun that the ladies pointed at spectators as they came out. The third and most elegant outfit included a full-length leather duster, fur hat, and alligator shoes, all in blue and white, the club colors.

Though clubs unofficially compete to make the biggest impression when they come out the door, each display of style and flair reinforces the cultural power of the entire SAPC scene. With their colorful extravagance, second line parades allow each member to shine, both for him- or herself and for the tradition. "You parade up the street, and everybody's calling your name, wanting to take a picture with you with your fancy suit," writes Ronald W. Lewis in *The House of Dance and Feathers*. "A cigar in your mouth, hat ace deuce. Stick your feet out and show them a beautiful pair of shoes. You are signifying, *Before I go back to the normal life, I am the big shot for a day*."[20]

NOTES

1 Wardell Lewis Sr., interview with Judy Cooper, July 4, 2013.

2 Ezell Hines, interview with Judy Cooper, June 6, 2015.

3 Louis Armstrong, *Satchmo: My Life in New Orleans* (1954; repr., New York: Da Capo, 1986), 29.

4 Linda Green, interview with Judy Cooper, September 2014.

5 L. J. Goldstein, interview with Judy Cooper, January 2014.

6 Anthony "Tony" Hookfin, interview with Judy Cooper, November 2013.

7 William Batiste, interview with Judy Cooper, September 2015.

8 Fred Johnson, interview with Judy Cooper, January 16, 2014.

9 Fred Johnson also tells the story of the Black Men of Labor's twentieth-anniversary ensembles in Bruce Sunpie Barnes and Rachel Breunlin, eds., *Talk That Music Talk: Passing on Brass Band Music in New Orleans the Traditional Way* (New Orleans: University of New Orleans Center for the Book, 2014), 69–72.

10 Sam Meyer, interview with Judy Cooper, July 12, 2014.

11 Joe Stern, in conversation with Judy Cooper, September 2014.

12 Andre Rubenstein, interview with Judy Cooper, July 12, 2014.

13 Rachel Breunlin and Ronald W. Lewis, *The House of Dance and Feathers: A Museum by Ronald W. Lewis* (New Orleans: Neighborhood Story Project and University of New Orleans Press, 2009), 160–61.

14 Jack Matranga, interview with Judy Cooper, June 18, 2014.

15 Matranga, interview with Cooper.

16 Henri Devezin, interview with Charles "Action" Jackson, *Takin' It to the Streets*, WWOZ.org, October 27, 2019.

17 Bernard Robertson, interview with Judy Cooper, May 2014. For more about the network of artisans who have passed on the tradition, see Breunlin and Lewis, *House of Dance and Feathers*, 78, 165, and Barnes and Breunlin, *Talk That Music Talk*, 70.

18 Sue Press, interview with Judy Cooper, July 31, 2014.

19 Kevin Dunn, interview with Judy Cooper, July 31, 2011. Dunn's work and artistic influences are also discussed in Breunlin and Lewis, *House of Dance and Feathers*, 170–71.

20 Breunlin and Lewis, *House of Dance and Feathers*, 160–61.

OPPOSITE Brian Combs, a Big Stepper, Young Men Olympian Jr., 2011, by Judy Cooper
FOLLOWING SPREAD Sudan members in prayer, 2015, by Ryan Hodgson-Rigsbee

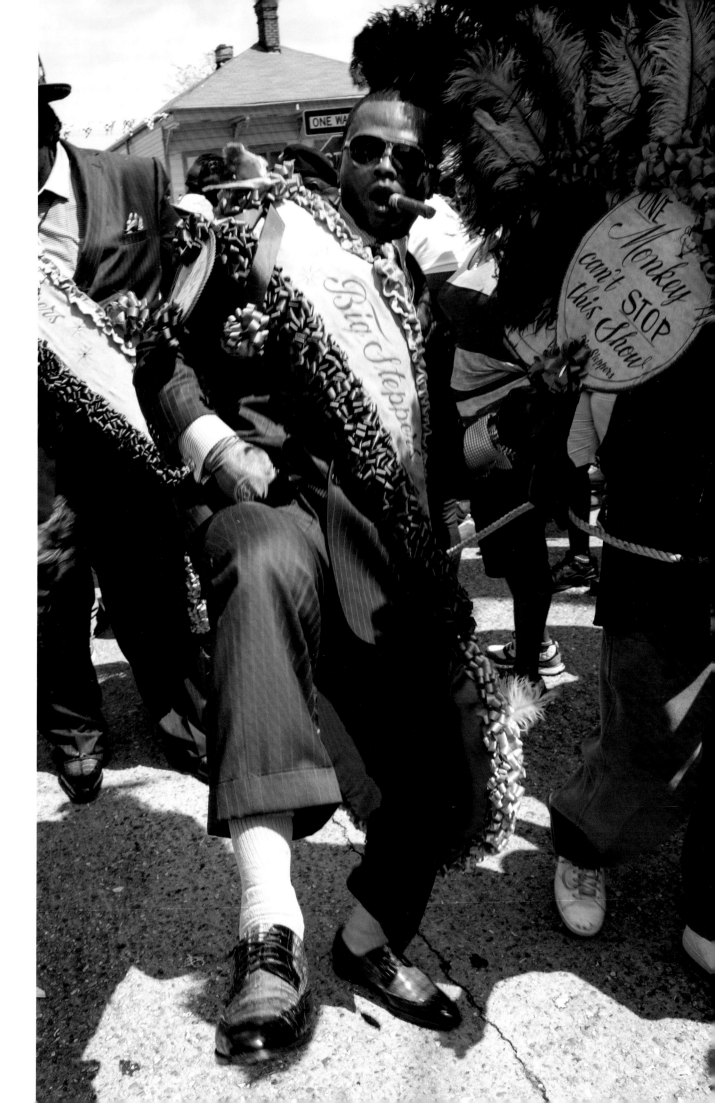

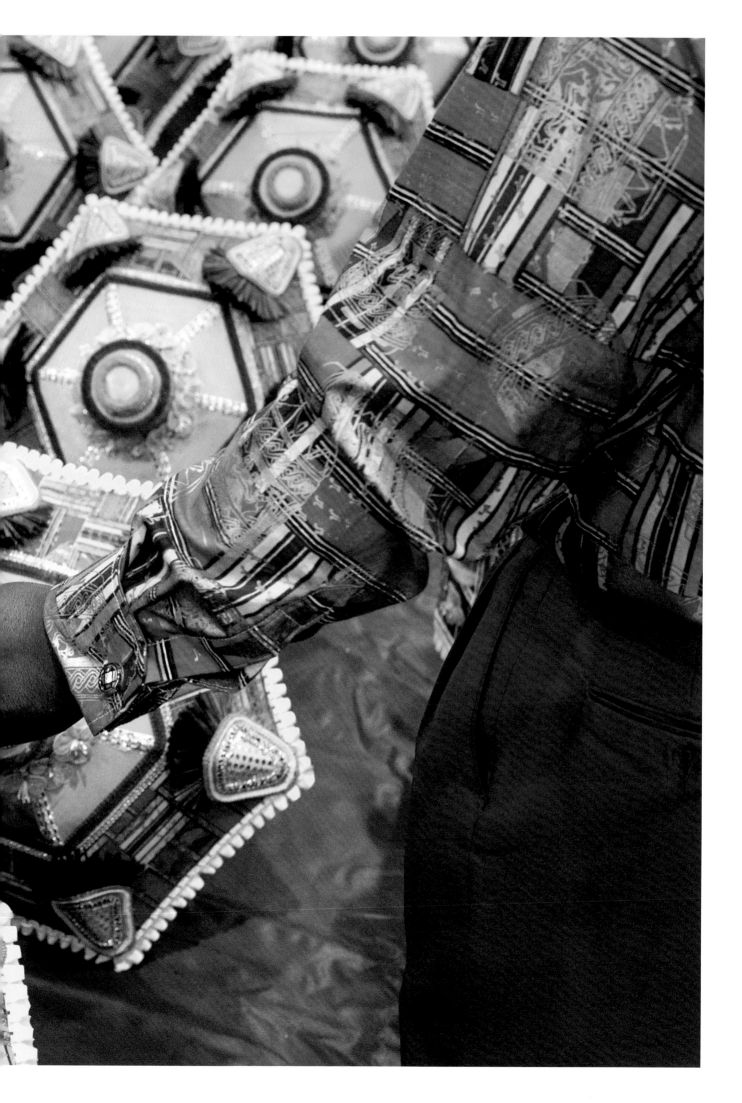

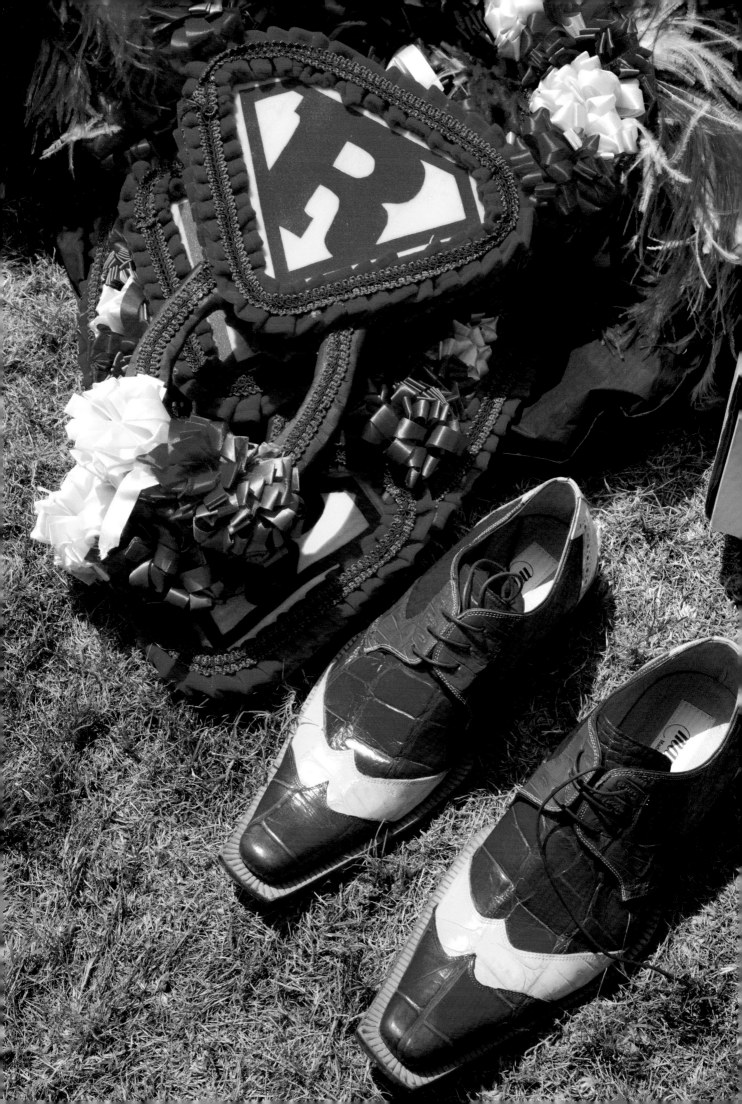

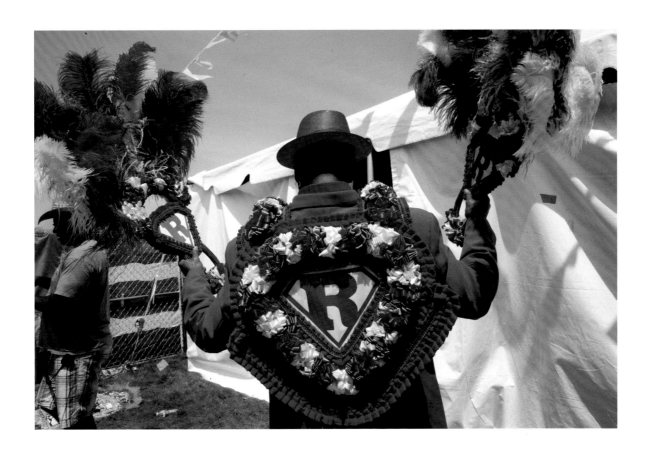

OPPOSITE AND ABOVE Revolution in Superman colors, 2014, by Judy Cooper

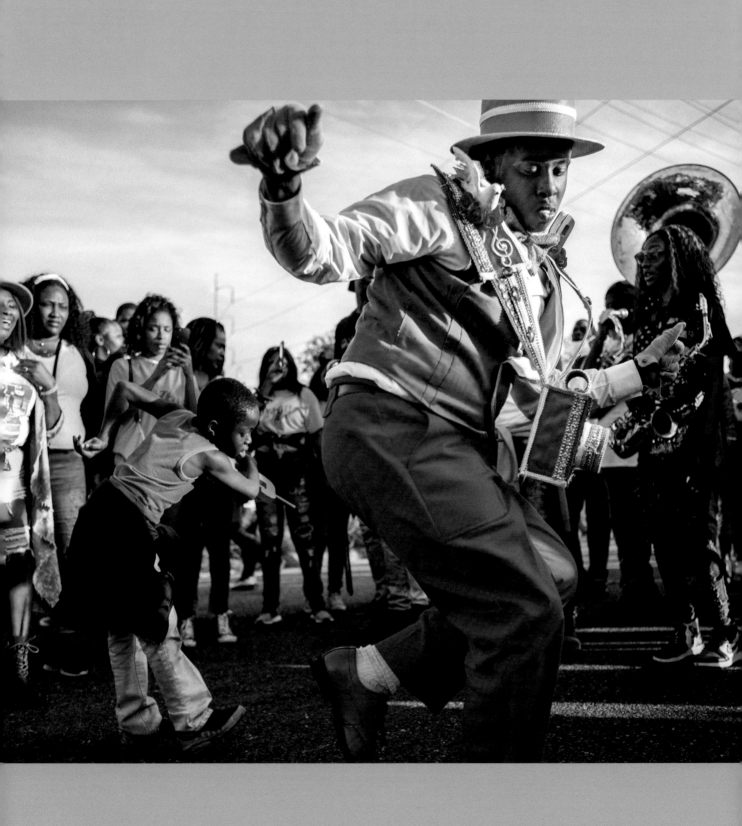

THE DANCING

RACHEL CARRICO

Second lines have been called "church for dancers." As important as the outfits and decorations are, the parade is still very much about the dancing. As a verb, "second lining" can refer to any action done while participating in the parade, such as walking, chanting, or playing a tambourine. But the term also names a specific dance form that has developed in conversation with brass band music during the past one hundred and thirty (or more) years. Although it has changed over the decades, its core characteristics remain: second line dancing is improvisational, footwork-heavy, and individually executed yet collectively experienced.

Today, second liners showcase a range of danced movements, including stepping, buckjumping, and footwork. "Stepping" is a buoyant, smooth, high-knee strut; "buckjumping" is when dancers turn up their energy, dropping to the ground, turning flips, and leaping in the air; and "footwork" describes the intricately rhythmic movement patterns dancers execute with their feet. Though each element is important to second lining, many participants claim that footwork is paramount. According to Terry Gable, member of the Original Big 7, "some people be doing what they do"—grooving along without a particular concern for their dance performance—"and then they have some people that have *footwork*, and it becomes an art."[1] In a 2013 interview with WWOZ DJ Charles "Action" Jackson, Dumaine Street Gang member Rodney Armstrong proclaimed that in order to parade with a social aid and pleasure club, one must have footwork: "Anybody can dress up and walk a parade. Come on, you got to have at least some kind of footwork with you. You got to be able to move your feet. . . . You got to have that footwork."[2] Leander "Shack" Brown, who produces the annual Big Easy Footwork Competition, suggests that footwork is so important to second lining because it is a forward-moving dance form.[3] Other Black dance forms, such as tap and house, share second lining's focus on rhythmic footwork, but second lining is unique in its requirement that dancers' feet

OPPOSITE Lonzell Stirgus, Nine Times, 2018, by L. A. Reno

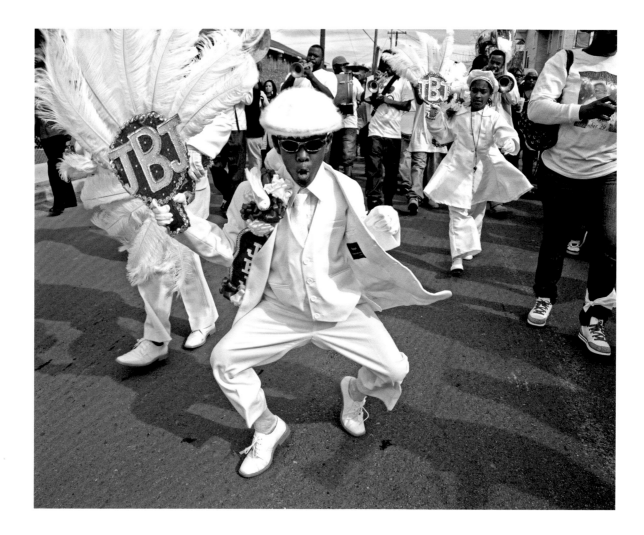

display rhythm and style while simultaneously moving their bodies forward, typically for a distance of three to five miles.

Many factors shape a second line dancer's style. One example is neighborhood allegiance; footwork is often aligned with downtown in general, the Sixth Ward in particular, while buckjumping is often associated with uptown dancers (although these attributions shift depending on who is talking and which neighborhood they call home). Joseph "Joe Black" Baker, CEO and founder of the downtown-based Revolution, describes Ninth Ward dancers as "jookers," or dancers who privilege rhythmic sophistication over speed. "It's not just in dancing fast, it's dancing to the beat," he says. "It's the rhythm of it, and that's what the Ninth Ward bring."[4] A second liner's performance might also differ depending on his or her generation. Speaking of second lining in the 1940s and '50s, former Jolly Bunch member Joseph "Papa Joe" Glasper proclaimed, "We weren't 'buckers,' we were 'steppers' then. We could dance to any tune they would play without getting all sweaty."[5] Ronald W. Lewis, cofounder of the Big Nine, concurred. In his book

Junior Buckjumpers, 2009, by Leslie Parr

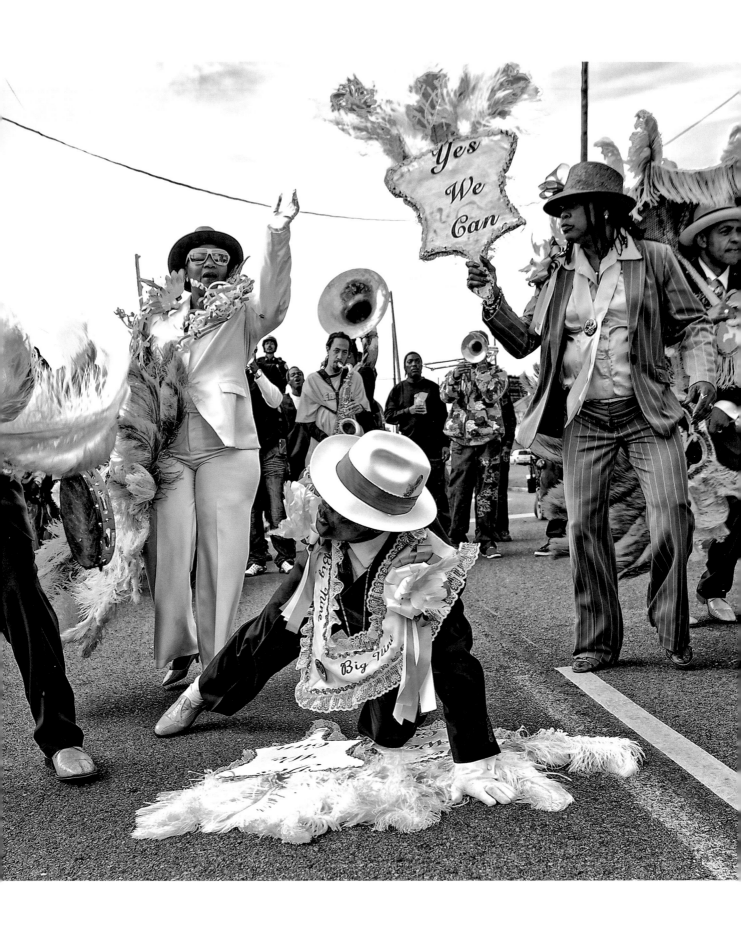

"Yes We Can," Big Nine, 2008, by Brad Edelman

The House of Dance and Feathers: A Museum by Ronald W. Lewis, he reflected on second lining of the pre–civil rights era: "Back then, the movement of the people was more flowing. They had a suavey type of style to the dance."[6]

Beyond neighborhood and generation, gender is another facet of second line performance. Although men and women both second line, men are often the more visible dancers, grabbing attention with daredevil stunts such as dancing atop roofs and overpasses. Furthermore, excellent footwork and buckjumping are often seen as masculine. Women who second line well are sometimes said to "dance like dudes," meaning that they emphasize nonstop, high-energy footwork over softer movements of the torso and hips. In the words of Terrinika Smith, member of the Jazzy Ladies, female footwork artists "can't really dance like a female, because you're not going to get no kind of recognition. If you dance like a man, like a boy, they going to know who you is."[7] Some

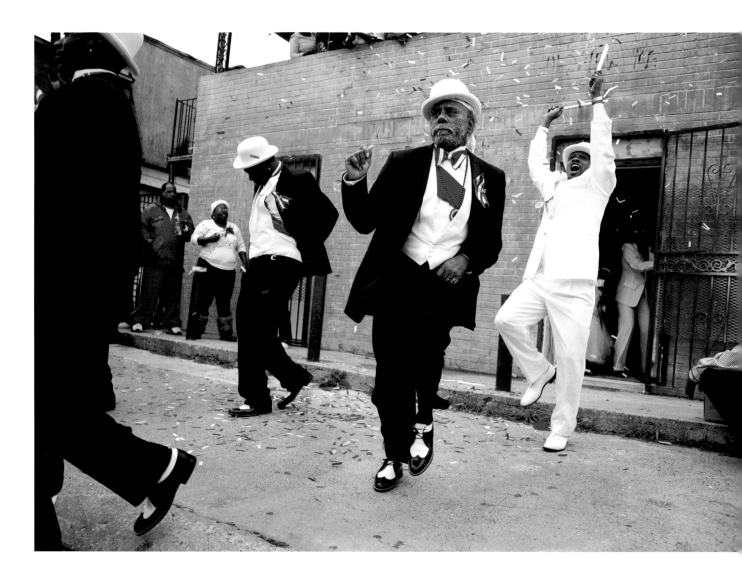

Nine Times, 2009, by Leslie Parr

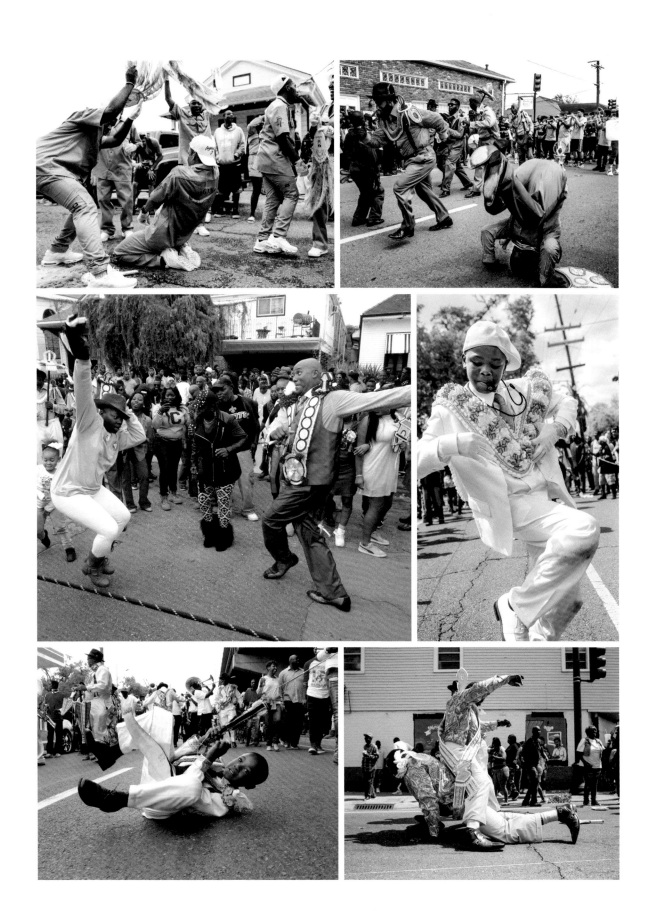

Stepping, buckjumping, and footwork (clockwise from top left): Members of the Original Big 7 cheer on Leo Gorman (center) as he drops to his knees, 2019, by L. A. Reno; Chosen Few, 2015, by L. A. Reno; C.T.C. Steppers, 2018, by Pableaux Johnson; Chosen Few, 2019, by L. A. Reno; Sudan, 2016, by MJ Mastrogiovanni; Chosen Few, 2015, by MJ Mastrogiovanni

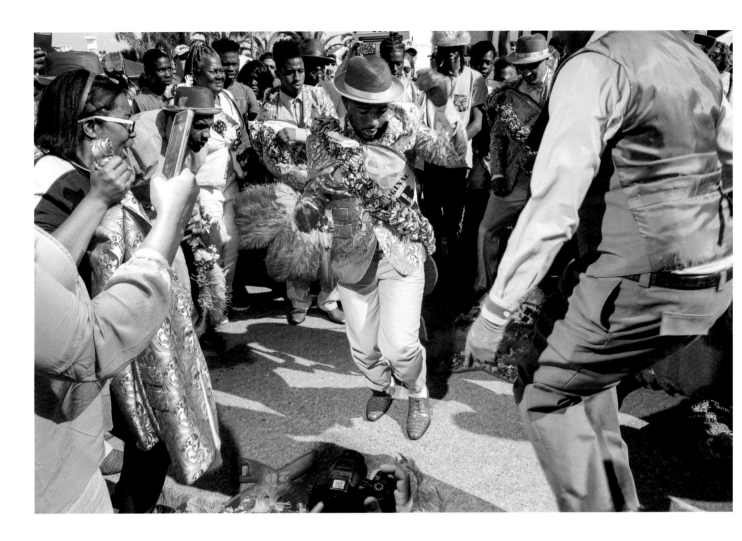

women inspire awe with a dangerous yet distinctly feminine feat: doing footwork in high heels. Whether dancing in sneakers or heels, female footwork fanatics challenge the notion that dancing well means dancing like a dude.

As a living tradition, second lining absorbs elements of popular culture and other local performance conventions into its basic framework. It is not unusual to see second liners include b-boy-style spins and freezes; popular dances like the dougie or the stanky leg; a tap-dance-style flourish borrowed from a Nicholas Brothers film; the pelvis-shaking done to New Orleans bounce music; or a standard pose from the Mardi Gras Indian repertoire. Like the brass band music that accompanies it, second lining is a sturdy tradition that can bend with the times while staying consistent through multiple generations.[8]

Malcolm Atkins of the Original Big 7 at Jazz Fest, 2017, by Ryan Hodgson-Rigsbee

THE FIRST AND SECOND LINES

The dancing at each second line begins when the hosting club "comes out the door" to kick off its parade. One by one, each man, woman, and child dramatically steps through the door of someone's house or a neighborhood establishment, revealing him- or herself to the awaiting public. As each member takes the spotlight, he or she is expected to show off their best dance moves. During this time, second liners momentarily act as spectators, shouting their encouragements, recording the scene with their smartphones, and demanding more from the club members: "Buckjump! Feetwork! Roll! Knock at them!" No matter how they dance outside the ropes during the rest of the year, once a second liner comes out with a club, they become a first liner, or main liner. As the hundreds to thousands of second liners fall in behind the band, alongside the ropes, or on the sidewalk, the four-hour, forward-moving dance party begins.

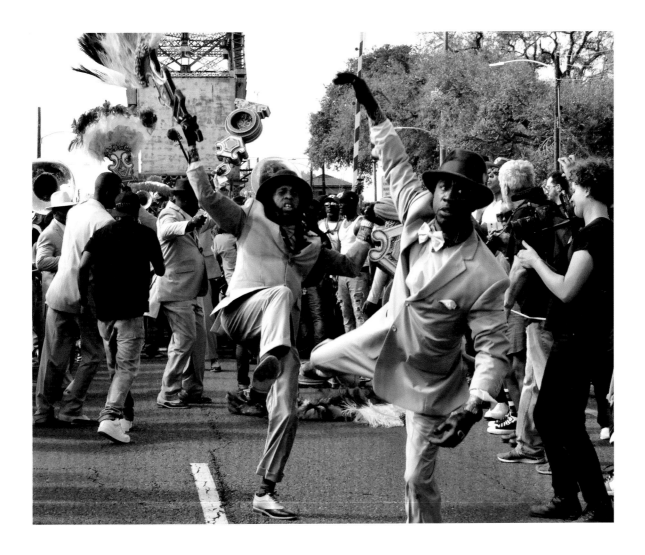

ABOVE Walter Fair (front) and Demond Melancon (back) of the C.T.C. Steppers dance their way over the Industrial Canal on St. Claude Avenue, 2017, by MJ Mastrogiovanni
FOLLOWING SPREAD Treme Sidewalk Steppers on North Claiborne Avenue, 2016, by Ryan Hodgson-Rigsbee

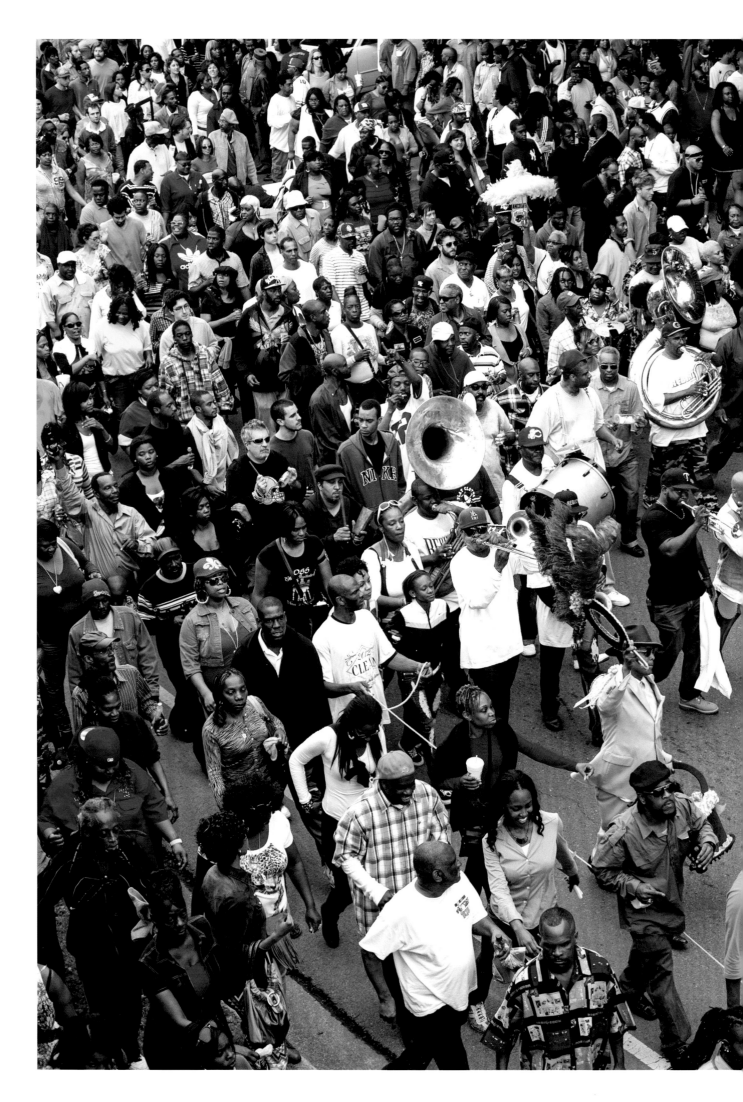

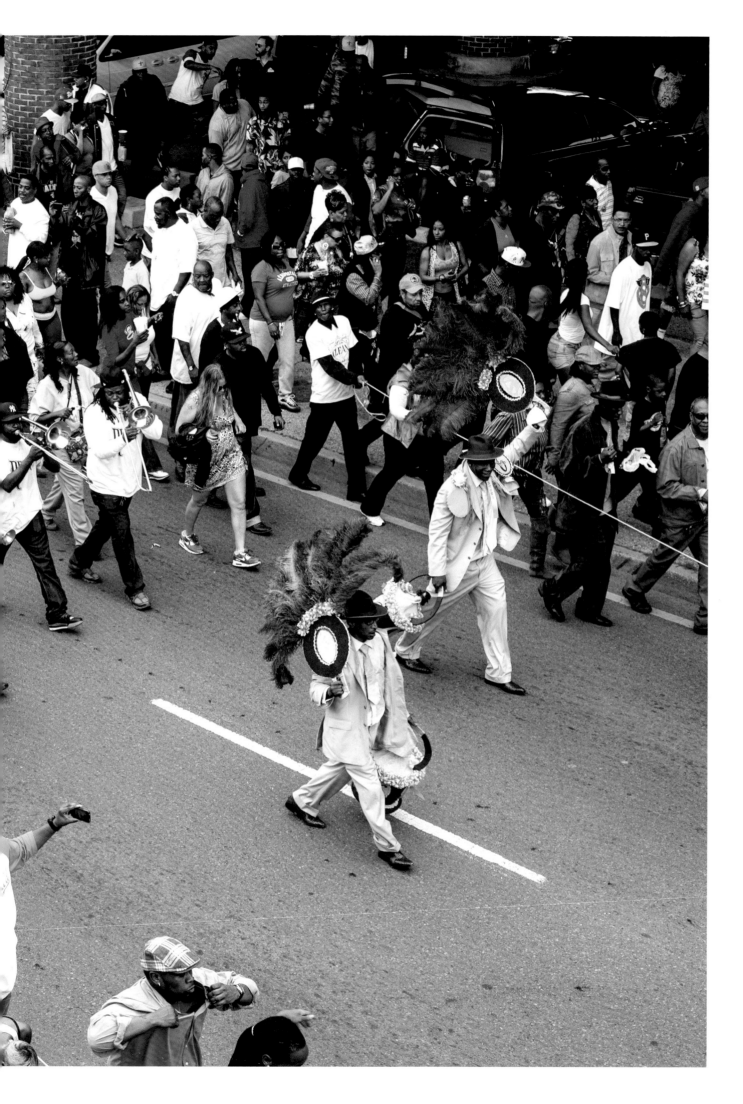

Although the parading club is expected to dance with as much energy, variety, and stamina as possible, the first line is rivaled by another show—some would say the *real* show—happening simultaneously on the sidewalk. The name of the Treme Sidewalk Steppers, a downtown club known for its excellent dancers, nods to the sidewalk as a place of prestige for dance-focused paraders. Those who dance on the sidewalk are known as sideliners, and they execute some of the most intricate, athletic, and quickly moving footwork seen at the parade. "Everyone at the second lines knows that all . . . the real dancers are on the sidewalk," said Rodrick "Scubble" Davis, two-time Big Easy Footwork Competition champion. Davis prefers the right side of the sidewalk, as it offers more opportunities for improvising with the environment, climbing atop porches and other elevated structures. Perhaps most important, it's tradition: "As a kid I started on the

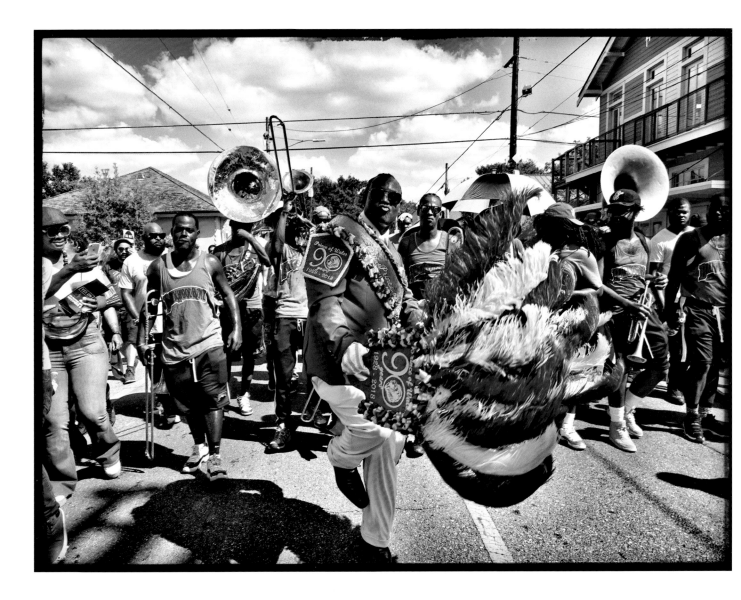

Darryl Kieffer, Prince of Wales ninetieth anniversary parade, 2018, by MJ Mastrogiovanni

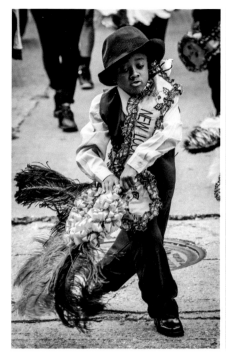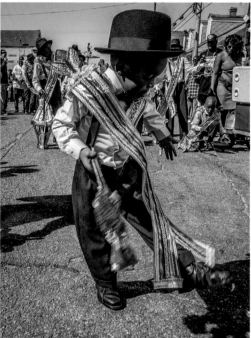

sidewalk," following his uncles and other mentors, he said. "That's where it all started." Plenty of other second liners share Davis's preference, but the sidewalk's prestige may be shifting; many younger second liners prefer to dance alongside the ropes and refer to the sidewalk as a space reserved for "senior citizens."

Whatever their ages, the sideliners dance in incredibly close quarters on crowded sidewalks, swerving nimbly around porch railings, trash cans, and other obstacles along the way. "When you see it coming down the sidewalk," Terry Gable said, "and you see thirty, forty, fifty people—them people coming toward you, the band blowing, everything hyped up, people moving and swinging and spinning around and breaking down and doing their thing—it's some of the prettiest shit in the world." Indeed, second liners' ability to dance fully in crowded, constricted spaces, all the while maintaining the forward movement of the parade, is one of the most stunning aspects of second line dance performance.

Some dancers escape the tight spaces on the street and sidewalk by dancing high above the crowd, jumping onto porches, cars, trucks, and even rooftops as they follow the parade. Gerald Platenburg, a longtime dancing legend, can often be seen on the street and in the air. "I always liked to be on the sideshow—dancing on the sidewalk, jumping on cars or on the railing of the project, sliding on poles, and just going wild," he says in *Coming Out the Door for the Ninth Ward*. "Sometimes that stuff get me and I'll be in a whole other world. The music just possess me."[11] When Platenburg and others dance on rooftops, expectations for showmanship increase. Just about every Sunday, Scubble

LEFT New Look division, Young Men Olympian Jr., 2015, by Pableaux Johnson
RIGHT Roman Gettridge, Sudan, 2014, by J. R. Thomason

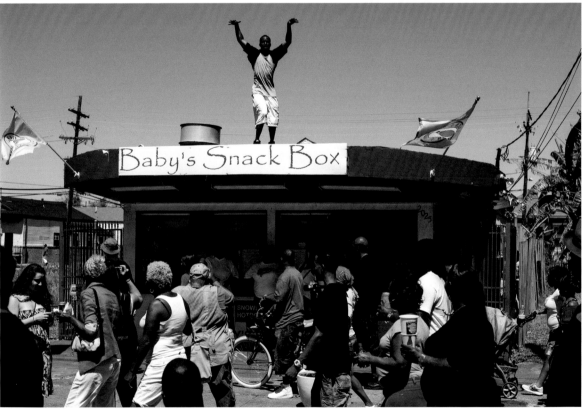

TOP Footwork on a bus, 2019, by L. A. Reno
BOTTOM Dancing on Baby's Snack Box, 2012, by Ryan Hodgson-Rigsbee

Davis can be found dancing atop school buses, transformer boxes, billboards, and the like. As he put it, "When you climb on stuff, you can't get up there and just be waving your hands. You got to cut up. Because you've got everybody's whole, undivided attention."[12] Dancing on elevated stages has been a mainstay of second line choreography for decades. Alan Lomax's film *Jazz Parades* features footage of second liners dancing atop cars, telephone poles, and houses in the early 1980s. The film even highlights a dancer who earned the moniker "Spiderman" for his frequent aerial feats. While Lomax's film provides some of the oldest documented examples of second lining up high, it has likely been happening for far longer.[13]

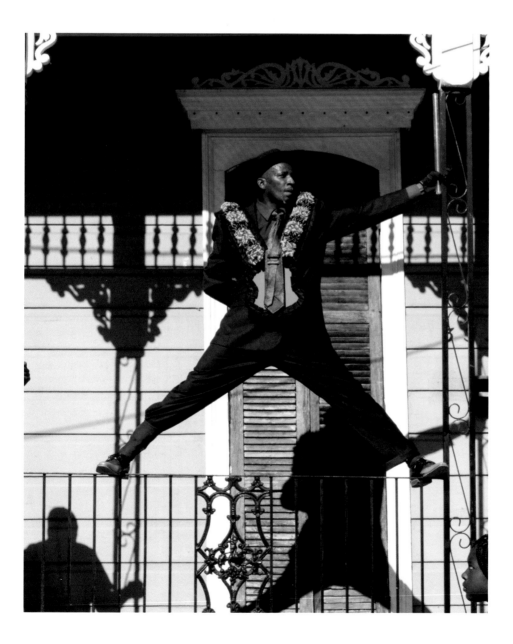

Gerald Platenburg dances atop a porch railing, Nine Times, 2017, by Judy Cooper

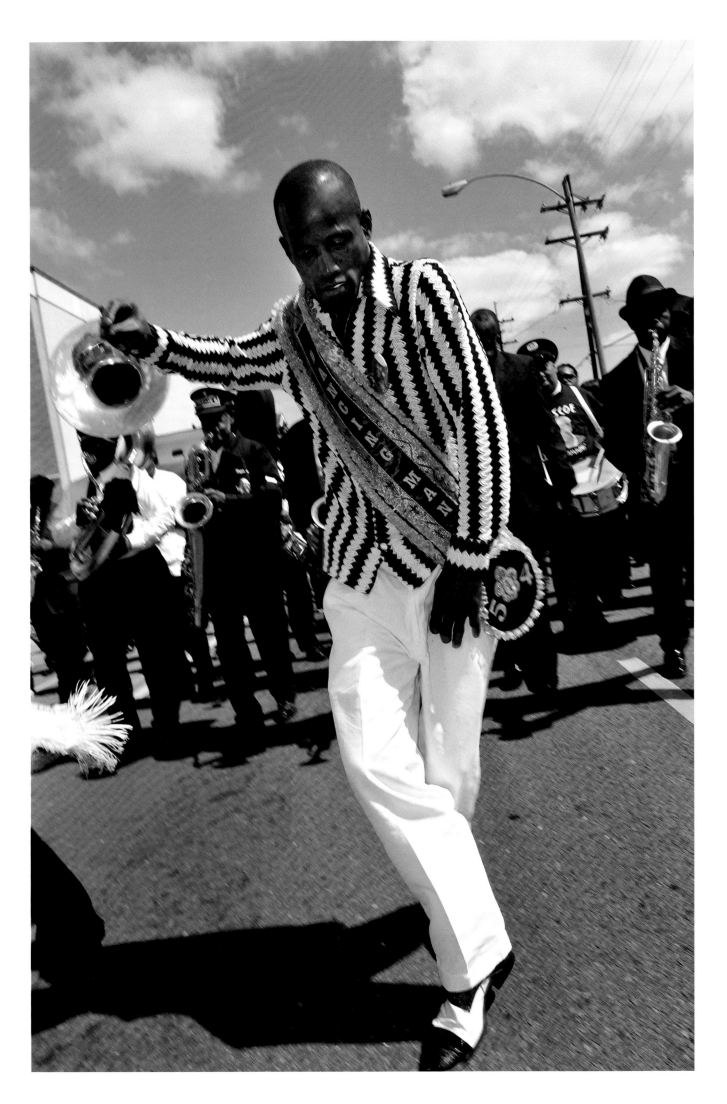

DO-WHATCHA-WANNA AND REHEARSAL

As an improvised dance form, second lining celebrates originality. Second liners prize a dancer who liberally expends energy, releases bodily tension, displays a confident attitude, showcases a variety of moves, and sensitively plays with the music's rhythms in a unique personal style. Paraders are usually less concerned with the dancers' steps than with the way they perform them—and, at the heart of it, why they are dancing in the first place.

Second liners dance for many reasons: to forget their daily problems, affirm connections with their communities, get some exercise, attain spiritual transcendence, experience joy, neutralize anger, mourn the dead, celebrate their neighborhoods, and achieve notoriety as famed footwork artists.

Second lining's shared concern with form and approach is a common concept in many African diaspora forms. As scholar Brenda Dixon Gottschild explains, "Contentwise, any dance can capture the spirit. It is not a matter of what a dance is about—*the what*—but the dancing body's performance, the living dance in the present moment—*the how*— that is the essential ingredient."[14] Even though second lining is a specific, coherent, and legible dance form that is historically rooted and aesthetically sophisticated, what it *is* matters less to dancers than what it *does*.

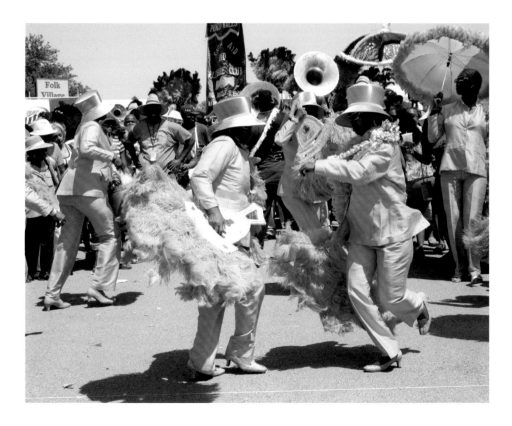

OPPOSITE Darryl "Dancing Man 504" Young, 2011, by Eric Waters
ABOVE Lady Buckjumpers at Jazz Fest, 2008, by Judy Cooper

Within the basic patterns of footwork that carry over from generation to generation, second liners harness the dancing to express themselves. Dancers commonly invoke the title of the popular Rebirth Brass Band song "Do Whatcha Wanna" to explain the importance of self-expression and improvisation. "You just listen to the music and let your feet take the lead," said Wallace Patterson, who has been parading for fifty years.[15] For Tamara Jackson Snowden, president of the VIP Ladies and Kids, learning to second line was "natural," she recalled. "It was just natural. It was natural. It kind of goes back to that Rebirth song, 'Do Whatcha Wanna.' You just basically do what you want do, do what you feel. You know, second line—there's no particular way to second line. It's all about the individual's expression, and just following and keeping up with the rhythm and the beat."[16]

Second liners refine their abilities to keep up with the beat and express their individuality every time they dance together, at Sunday second lines, weeknight brass band shows, or SAPC gatherings. Clubs occasionally hold practices for their members so that they will be able to perform precise formations and enviable footwork inside the ropes on parade day. The demanding crowd expects the main liners to dance for four straight hours, exuding as much energy as physically possible and displaying as much rhythmic precision and variety as they can muster. In *Coming Out the Door for the Ninth Ward*, Troy Materre describes going with his mother to a practice of the Seventh Ward High Steppers in a barroom when he was a kid: "Second line music blared from the jukebox while the kids rehearsed outside. The neighborhood would gather around and make them do all kinds of routines. People loved to see the little kids second line."[17] A number of clubs have kids' divisions, and the spectators, many of whom are the parents, cheer particularly loudly as the kids—some as young as four and five—come dancing out the door.

Although many clubs today have dispensed with organized rehearsals, the Lady Buckjumpers still rehearse. In the month before their annual November parade, the group convenes for a practice session every Sunday, usually meeting in the yard of the club's president, Linda Tapp Porter, or in her sister's yard. When Porter tells someone that the Buckjumpers have practice, she usually gets a disbelieving and even disapproving response: "Y'all *practice*?!"[18] Such a reaction illustrates the widespread belief among second liners that rehearsal is unnecessary for (even contradictory to) dancing prowess. Since the vast majority of second liners hone their skills in informal, communal, and familial settings, the notion of an organized practice can seem unusual. It might even conjure up images of slick dance studios with shiny mirrors and polished floors, where masters teach footwork to outsiders; such a situation would certainly contradict the way that second line knowledge is typically gained—through communal and intergenerational networks. If rehearsals are commonly understood as venues for perfecting predetermined choreography, then they may seem incongruous with perfecting improvisation and individual style—the top two criteria used by second liners to judge each other's performances. However, second liners are always practicing, even if they don't

OPPOSITE Shawn "Big Daddy" Bass, Pigeon Town Steppers, 2016, by Pableaux Johnson

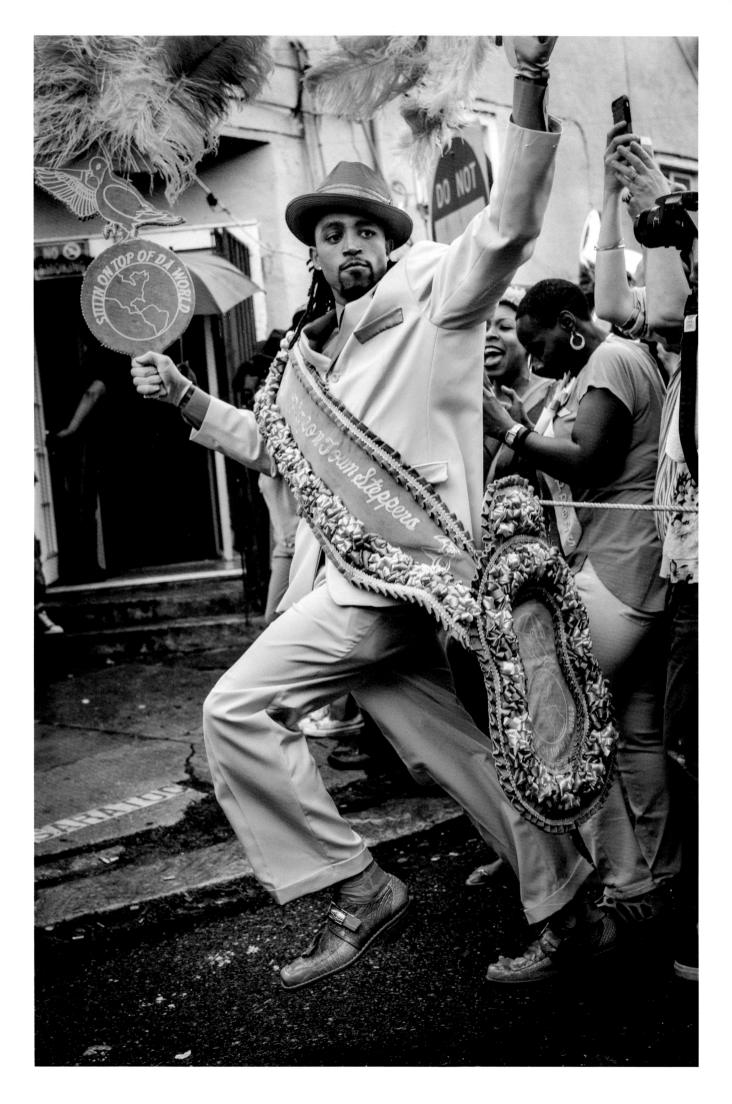

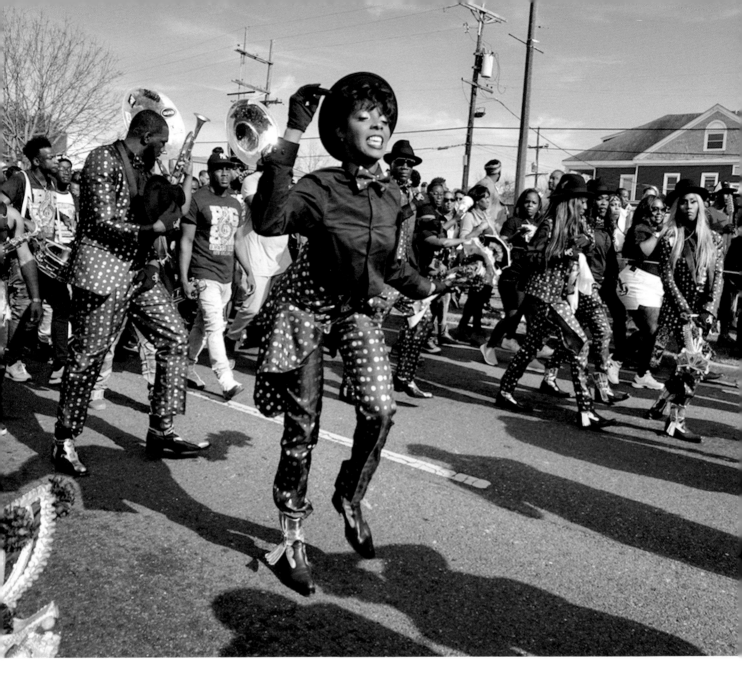

call it that, and the Lady Buckjumpers' reputation as excellent dancers depends in part on their dedication to practice.

The club has long been distinguished by its performance of short, unison phrases at several moments throughout the parade. Porter explains that they have several sets of named routines, which a designated captain calls out during the parade. The women spend most of the parade moving forward, loosely arranged in two single-file lines stretching from the banner carrier in front of them to the band behind them. When the captain calls out "Inside," the Buckjumpers move to one long line in the middle of the street and then come back into their two lines; "Outside" is when they dance away from the center of the street; in "Criss-Cross," they stand across from a partner,

Brandi Charlot, Treme Sidewalk Steppers, 2019, by Charles Muir Lovell

put their arms up, and do-si-do; and then there is "Circle," which they can perform when the parade's forward motion pauses. Everybody circles up, throws down their fans and/or hats, and takes turns, one or two at a time, improvising in the center as the others on the outer ring encourage them. The circle dance provides an excellent example of how do-whatcha-wanna skills, in addition to choreographed formations, can be polished through practice or rehearsal.

Many clubs in addition to the Lady Buckjumpers incorporate the circle dance into their parades. Its popularity evidences the importance of circular formations in many African diaspora dances, from the b-boy cypher to the ring shout to the circle dances performed at Congo Square in the nineteenth century.[19] (Freddi Williams Evans discusses this cultural link in her essay, p. 23.) Black-music theorist Samuel Floyd argues that the ring dance of Congo Square eventually "straightened itself to become the Second Line of jazz funerals . . . where the ring was absent because of the necessity of the participants to move to a particular remote destination (the return to town from the burial ground)."[20] Even though the parade moves in a line, it can still be imagined as a narrow circle that orbits around the band. Small circles constantly form when the procession pauses: a small group of dancers, either behind the band or stationed peripherally in a parking lot or driveway, will often widen into a circle and encourage/challenge one or two dancers in the center by clapping, shouting, or even playing cowbells and tambourines. This is often the domain in which children's footwork skills are honed, as they step into the center of the temporary ring and perform their best moves to the supportive yet demanding comments of onlookers. Once the procession starts moving again, the ring dissolves back into the line, and the collective of many mini-collectives moves forward once again, all dancers orbiting around the band and moving in close proximity to one another. The band organizes the crowd to move with the music, unified by the beat. Across disparate time periods, places, and contexts, the circle—be it the imagined circle of the entire second line or the club's momentary formation—embodies African-derived performance imperatives, such as improvisation, collective participation, a blending of sacred and secular, and the interdependence of dance and music.[21]

The impromptu circles that emerge during each parade provide an excellent example of the informal settings in which second liners learn, perfect, expand, refine, and pass on their second line choreographies. Learning, practicing, and coaching others in second line technique occurs in many domains: in the home, where mothers and grandfathers encourage their children to hone their dance skills in kitchen-floor competitions; at nightclubs and club-sponsored dances, where individuals steal each other's moves; and on the sidewalk, where mentoring relationships develop among intergenerational side-liners. Kenneth Washington, former member of the Young Men Olympian Jr., recalls, "I used to come up in the Magnolia Project. My mom and them, on a Friday night, they'd get a couple of friends by the house. They'd pay us, [say], 'Come on inside and second line.' And yeah, we'd go against each other. We'd get on the middle of the floor, and we'd jump, we'd jump! And they'd give the winner twenty, twenty-five dollars."[22] Such

kitchen-floor battles reveal the importance of competition, which pushes second liners to improve their skills and refine their personal styles.

Today, many of the clubs host dances on a Friday or Saturday night throughout the year as fundraisers. The dances are usually well attended, not just by the members of the hosting club, but also by their families, friends, and members of other clubs. They're excellent occasions for the dancers to showcase their best moves—and steal moves from others. Also popular prior to the pandemic was the Wednesday-night set played by the TBC Brass Band at Celebration Hall on St. Bernard Avenue in the Seventh Ward. A small but dedicated group of "footwork junkies," to use Scubble Davis's term, packs the dance floor each week.[23] They are usually joined by members of the club that is to parade the following Sunday. To promote their upcoming parade, club members might wear matching shirts, distribute route sheets on the tables, and sometimes decorate a table of honor reserved for their members and supporters. A television in the back of the room plays footage from the club's parade the previous year, which adds to the pep-rally atmosphere.

Second lining is not learned formally, in a classroom setting, but in the "alternative academies" of New Orleans's streets, homes, and nightclubs.[24] When second liners improvise with brass band musicians, they call upon months, years, or decades of rehearsal executed in the company of family, friends, and fellow club members. Wynton Marsalis, one of New Orleans's best-known jazz musicians, describes this practice in the film *Faubourg Tremé: The Untold Story of Black New Orleans*: "Musicians are improvising, and dancers are improvising. And they're doing something they've been doing a long time. So they have to feel it, not only as this moment—here's something that never happened—it's a moment that's always happened."[25] In other words, though second lining is not an exact replication of codified steps, it is rich with technique and history. Do-whatcha-wanna is actually a tremendously complex undertaking. But no matter what steps second liners choose—stepping, buckjumping, or jooking—and no matter where they dance—in the first line, on the sidewalk, or on a rooftop—they contribute to the parade's overall effect: producing joy through sweat and rhythm.

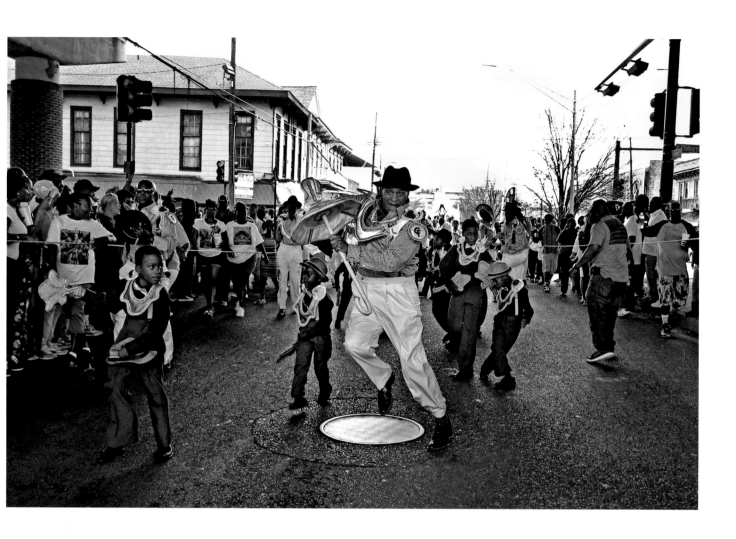

NOTES

1 Terry Gable, interview with Rachel Carrico, January 24, 2014.

2 Rodney Armstrong, interview with Charles "Action" Jackson, *Takin' It to the Streets*, WWOZ.org, December 1, 2013.

3 Leander "Shack" Brown, interview with Rachel Carrico, December 16, 2015.

4 Nine Times Social and Pleasure Club, *Coming Out the Door for the Ninth Ward*, 2nd ed. (New Orleans: Neighborhood Story Project, 2007), 100.

5 Geraldine Wyckoff, "Jolly Bunch: A Venerable Social Aid and Pleasure Club Ready to Parade Again," *Gambit*, September 11, 2001.

6 Ronald W. Lewis, qtd. in Rachel Breunlin and Ronald W. Lewis, *The House of Dance and Feathers: A Museum by Ronald W. Lewis* (New Orleans: Neighborhood Story Project and University of New Orleans Press, 2009), 154.

7 Terrinika Smith, interview with Rachel Carrico, August 8, 2014.

8 Matt Sakakeeny, *Roll With It: Brass Bands in the Streets of New Orleans* (Durham and London: Duke University Press, 2013), 20.

9 Rodrick "Scubble" Davis, interview with Rachel Carrico, January 16, 2014.

Chosen Few, 2015, by Charles Muir Lovell

10 Terry Gable, interview with Rachel Carrico, January 24, 2014.

11 Gerald Platenburg, qtd. in Nine Times, *Coming Out the Door for the Ninth Ward*, 118.

12 Rodrick "Scubble" Davis, interview with Rachel Carrico, January 16, 2014.

13 Alan Lomax, *Jazz Parades: Feet Don't Fail Me Now* (New York: Association for Cultural Equity, 1990), 3/4 inch videotape, Folkstreams, http://www.folkstreams.net/film,126.

14 Second lining's shared concern with form and approach is a common concept in many African diaspora forms. Brenda Dixon Gottschild explains that Africanist epistemologies define dance as a spiritual practice at the center of life, and this shapes valuations of dancing. Brenda Dixon Gottschild, *The Black Dancing Body: A Geography from Coon to Cool* (New York: Palgrave Macmillan, 2003), 280.

15 Wallace Patterson, interview with Judy Cooper, September 2015.

16 Tamara Jackson Snowden, interview with Rachel Carrico, April 21, 2014.

17 Troy Materre, qtd. in Nine Times, *Coming Out the Door for the Ninth Ward*, 47.

18 Linda Tapp Porter, interview with Rachel Carrico, August 12, 2014.

19 On ring dances in Congo Square, see Freddi Williams Evans, *Congo Square: African Roots in New Orleans* (Lafayette: University of Louisiana at Lafayette Press, 2011), 9, 89. For a movement analysis of the ring shout, see Gottschild, *Black Dancing Body*, 144, 273–77. For an examination of the ring shout's contribution to both the social and theatrical dance traditions of the US, see Katrina Hazzard-Donald, "Hoodoo Religion and American Dance Traditions: Rethinking the Ring Shout," *Journal of Pan African Studies* 4, no. 6 (2011): 194–212.

20 Samuel A. Floyd Jr., "Ring Shout! Literary Studies, Historical Studies, and *Black Music Inquiry*," *Black Music Research Journal* 22 (2002): 51.

21 According to dance theorist Kariamu Welsh-Asante, the circle embodies "holism," a core value of African dance forms, in which the parts are not emphasized beyond the whole, and neither is the individual emphasized beyond the collective. Kariamu Welsh-Asante, "Commonalities in African Dance," in *African Culture: The Rhythms of Unity*, ed. Molefi Kete Asante and Kariamu Welsh-Asante (Westport, CT: Greenwood, 1985), 76–77.

22 Kenneth Washington, interview with Rachel Carrico, May 22, 2014.

23 Rodrick "Scubble" Davis, interview with Rachel Carrico, January 16, 2014.

24 Daniel Fischlin, Ajay Heble, and George Lipsitz, *The Fierce Urgency of Now: Improvisation, Rights, and the Ethics of Cocreation* (Durham: Duke University Press: 2013), 142.

25 Dawn Logsdon, dir., and Lolis Eric Elie, writer, *Faubourg Tremé: The Untold Story of Black New Orleans* (San Francisco: California Newsreel, 2007), DVD.

OPPOSITE Fast footwork, Men Buckjumpers, 2009, by Judy Cooper

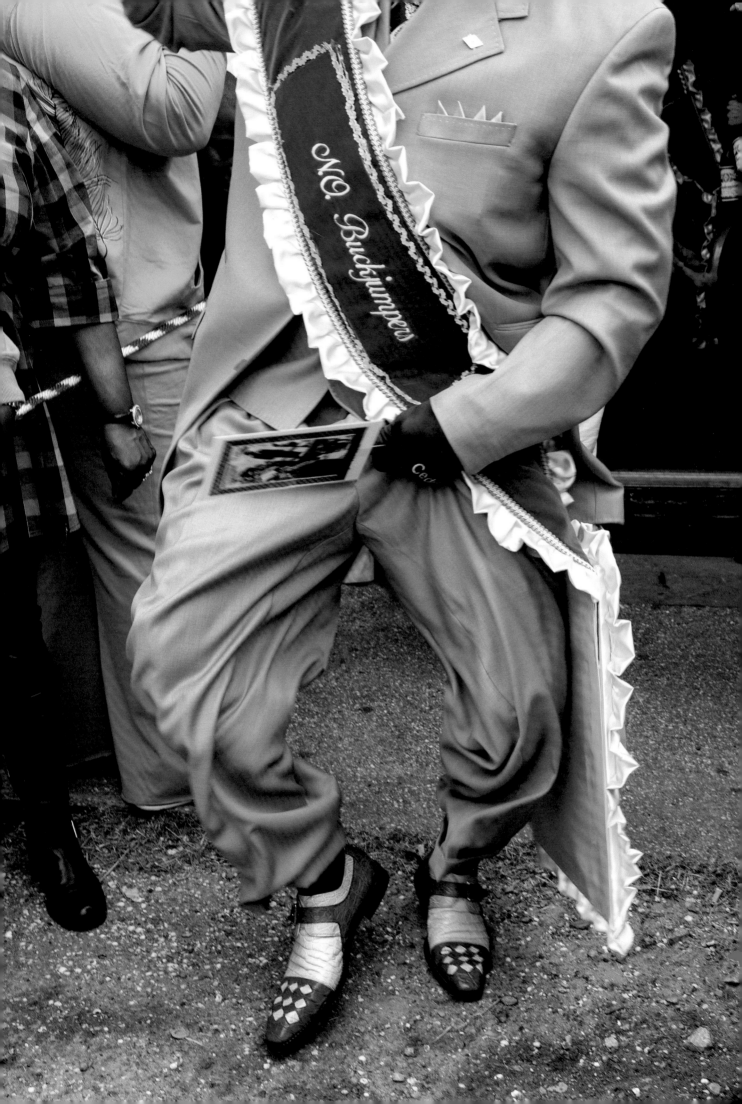

THE ROUTES

JUDY COOPER

Second lines express an almost existential meaning: during the violent, restrictive regimes of white supremacy and Jim Crow segregation, they were one way that African Americans claimed public space. The early second line parades, writes Michael G. White, were "a form of protest: a show of strength and unity and a defiant march toward freedom and democracy in a society where such assemblies would normally be discouraged or illegal."[1] The occupation of the city's public corridors by African Americans making merry through their own cultural expression remains significant today. A second line parade can be seen as a uniquely creative version of a peaceful demonstration.[2]

SAPCs have always been intentional about designing their parade routes. Most routes stay within the neighborhood that the club represents, and along the way the parade will make a series of stops—most of them are social and practical, for rest and relaxation; some are reverential, to honor a bygone member or salute a friend of the club; and all are meaningful. Neighborhood bars are beloved institutions throughout New Orleans, nightly gathering places for area residents, and during second line parades they play a major role as hosts of parade stops. Second lines also make stops at other neighborhood businesses—barbershops, beauty salons, snoball stands, and event halls. What's more, other clubs will often sponsor a stop along the route to show their support. All these relationships reinforce the clubs' ties to the community.

For all of the commonalities that give coherence to the form and tradition of second lines, there are some distinctions among the parades that occur uptown, downtown, and on the West Bank. For instance, Phil Frazier, one of the original members of the Rebirth Brass Band, has identified a difference in the kind of music requested by the uptown and downtown clubs. In *Coming Out the Door for the Ninth Ward*, Frazier remarked, "Uptown people more like a fast pace: ba, ba, ba. But downtown they like the music nice and groovy. Sometimes we'll flip the script and play it fast downtown and break down,

OPPOSITE Rose Tavern, 2011, by Leslie Parr

127

play it slower tempo uptown."[3] At one downtown parade, a club member commented on the music, saying, "What's that they playing? Sounds like uptown music." When the tune changed and the tempo slowed, he added, "That's better."[4]

In order to inform the public about where to catch the parades, the clubs all distribute route sheets—typically a single typewritten sheet of paper with occasional decorative elements. It gives the parade's starting and stopping points and lists all the stops in between, often including turn-by-turn directions. Clubs traditionally would bring a stack of route sheets to the parade happening the week or so before theirs and distribute them to the crowd. In the past these sheets—along with word of mouth—were the main sources of information. For someone outside of the second line community, parade information was hard to find.

That's no longer the case. Since the early 2000s, every Friday the Treme-based Backstreet Cultural Museum has emailed the route of each upcoming parade to its long list of subscribers. (For more about the Backstreet and its late founder, Sylvester Francis, see p. 299.) In 2012, Charles "Action" Jackson began interviewing members of the clubs and talking about upcoming parades on community radio station WWOZ. His podcast and webpage, *Takin' It to the Streets*, grew out of a series of on-air Friday-afternoon chats with his friend, the longtime Q93 radio host DJ Slab 1. "And we start doing it every Friday, big time, you know?" Jackson said. "That was the thing." In 2012, WWOZ pitched him on starting his own show. "Slab, by him being the host over there [on Q93], he couldn't do both radio stations. So, me and him talk, and I say, 'I'll give it a shot.' Me and [WWOZ DJ] Ariana Hall created a website called *Taking It to the Streets*. I liked that title because of the Rebirth Brass Band song, 'Take It to the Streets.'"[5] Ever since, he has posted interviews with club members and route information on the site.

Partly as a result of this expanded spotlight, the audience for second line parades has grown and diversified. Fifteen or twenty years ago, a typical second line was attended almost entirely by African Americans—often family and friends of the parading club, members of other clubs, folks from the neighborhood, and other second line followers. After Katrina, with the rise of digital information sharing, a new audience began to appear, including recent transplants interested in the local culture and traditions.

Nevertheless, the parade routes continue to honor New Orleans's tradition of African American community building, business ownership, and fellowship. The celebration of these Black spaces confers its own power, one that goes beyond geography. "For many," writes White, "the streets of New Orleans [are] transformed from being a connector between physical places to being a collective passageway to a spiritually free dimension."[6]

OPPOSITE Avenue Steppers route sheet, 1983

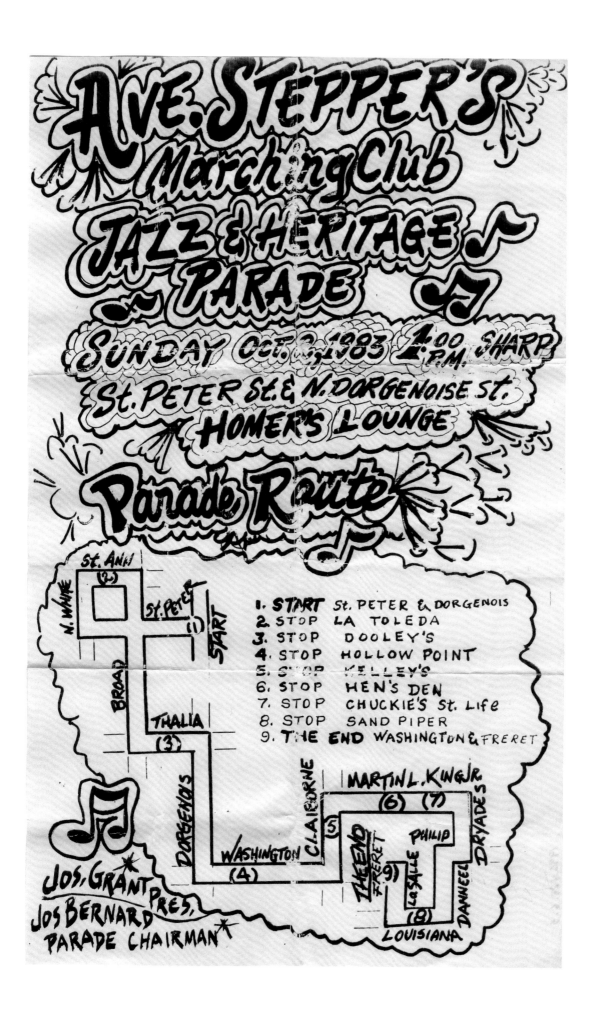

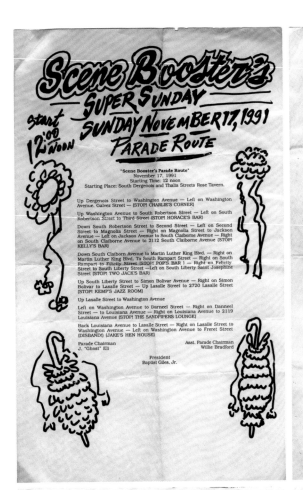
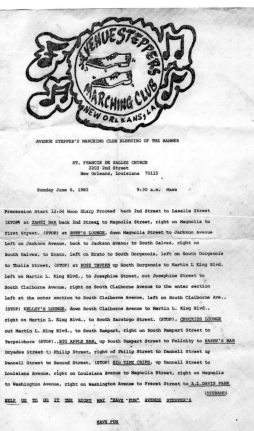

Parade route sheets (clockwise from top left): Scene Boosters, 1991; Avenue Steppers, 1982; Original Four, 1992; the Second Line Tradition Coalition's tribute to Gilbert Heedly, 1992

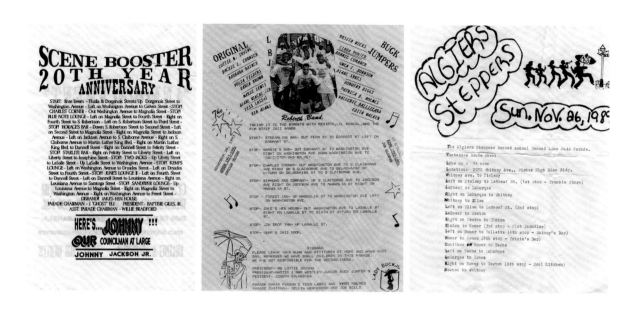

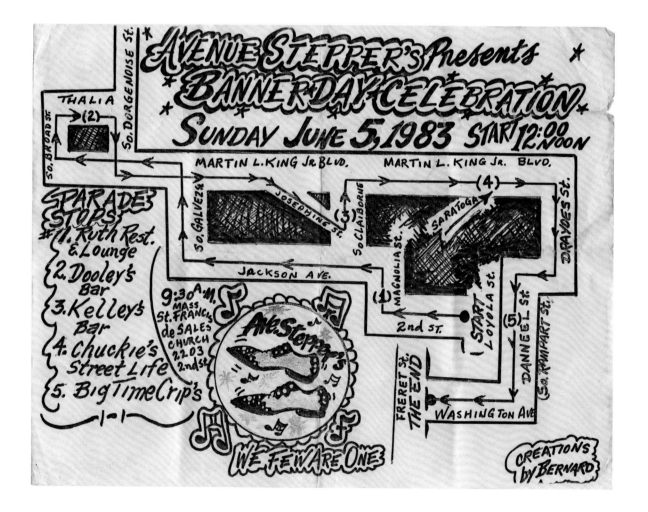

Parade route sheets (clockwise from top left): Scene Boosters' twentieth anniversary, 1993; Men Buckjumpers and Lady Buckjumpers, 1993; Algiers Steppers, 1989; Avenue Steppers Banner Day Celebration, 1983

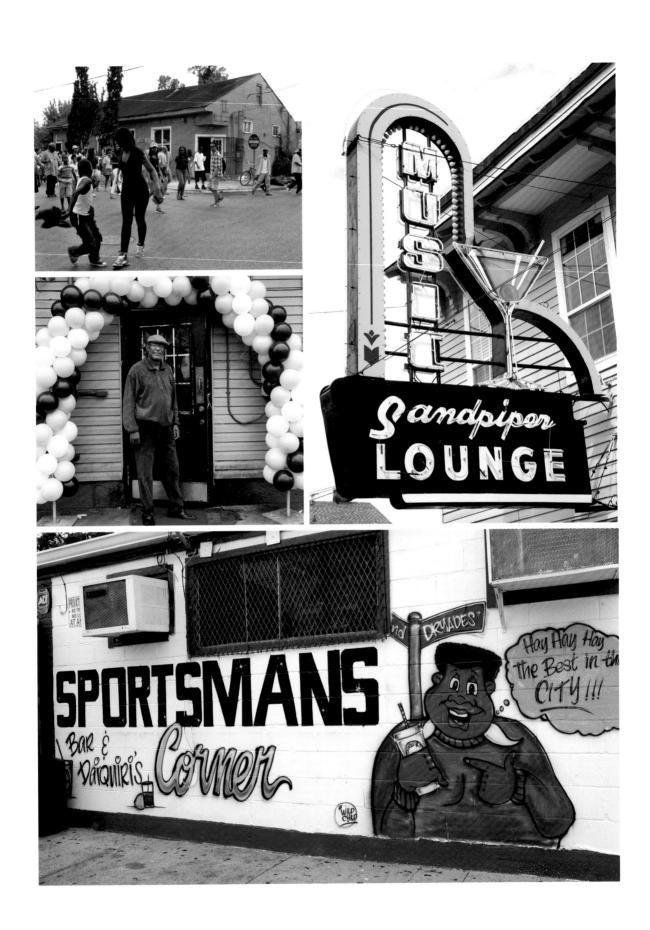

Frequent stops along the parade routes, by Judy Cooper (clockwise from top left): Purple Rain Bar, 2014; Sandpiper Lounge, 2008; Sportsman's Corner, 2019; Frank Charles III in front of Silky's, 2013

UPTOWN

Of the thirty-five parades that took place during the 2018–19 season, twenty wound through uptown New Orleans. The uptown parades usually stay in the area known as Central City, bounded by Martin Luther King Jr. Boulevard, St. Charles Avenue, Louisiana Avenue, and Earhart Boulevard. The epicenter of the uptown routes has always been the intersection of Washington Avenue and La Salle Street. That corner is the site of A. L. Davis Park, formerly Shakspeare Park, which was the starting point of many of the old parades, including those of benevolent associations, Masonic lodges, and Sunday school groups.[6] It is also still the gathering place for the uptown Mardi Gras Indians on two of their biggest occasions, St. Joseph's Night and Super Sunday.

A bar named Kemp's, located on La Salle near the corner of Washington, was a popular stopping place for the uptown parades, as well as Mardi Gras Indian celebrations, until the owner, Dorn "Pappy" Kemp, died in 2000. The Purple Rain Bar, another favored stop, is located a few blocks down Washington. The corner of Second and Dryades Streets, sometimes simply referred to as "Second and D," has seen a number of establishments that have long served both the clubs and Mardi Gras Indians. The current one is the Sportsman's Corner, which has seen many clubs come out its door and is a major meeting place for the Indians on Mardi Gras Day. It was founded by Louis Elloie in the 1960s "for the adventure" and became not just a neighborhood watering hole but also a regular meeting place for all kinds of clubs. His daughter, Theresa Elloie, took over the business after his death in 2008. She passed away from COVID-19 in March 2020.[8]

Tapps II and Fox III, located kitty-corner from each other on Washington at South Rocheblave Street, are frequent starting and stopping points for the uptown parades. Silky's, on Magnolia Street, is a favorite of the Lady and Men Buckjumpers and is owned by one of the club's cofounders, Frank Charles III. Other frequent stops along the uptown routes include the Sandpiper Lounge and the Big Man Lounge, both on Louisiana Avenue. The Prince of Wales always starts its parade at the Rock Bottom Lounge, near the river on Tchoupitoulas Street—a nod to the club's history, as it was first formed at a bar nearby named the Anchor Inn. The Pigeon Town Steppers, a club based out of New Orleans's Seventeenth Ward, typically stops at the Maple Leaf Bar, on Oak Street, and the Broadway Bar, on Broadway Street.

Gentrification, a growing trend and concern post-Katrina, has changed the landscape of some of the city's historically majority-Black neighborhoods, both uptown and downtown. Some neighborhood bars that had been owned by African Americans have been bought and refashioned by white owners. One such establishment, the Turning Point on Washington Avenue, became Verret's Bar and Lounge in 2013 and has remained a stopping point for several clubs, including the Divine Ladies, Prince of Wales, and Uptown Swingers. Pop's House of Blues on Dryades Street closed and has reopened twice under white ownership—first as the Black Label Icehouse, and then, in 2017, as the Portside Lounge. It also continues to host second line parades.

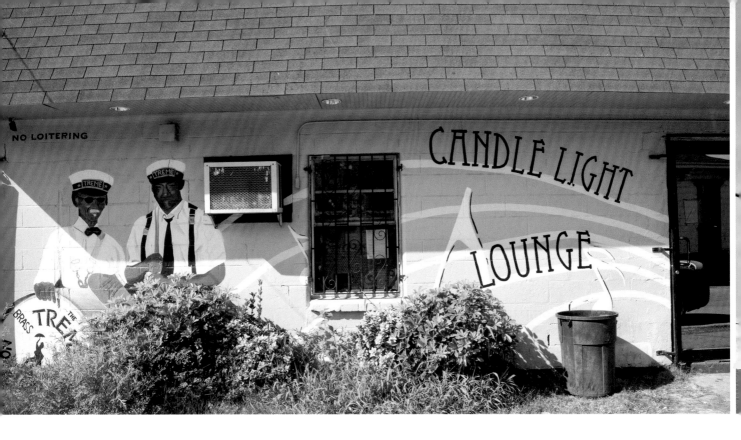

DOWNTOWN

Seven of the downtown clubs parade mostly in the Sixth and Seventh Wards, which include the Treme neighborhood and the St. Bernard Avenue and Broad Street corridors. An important landmark for the downtown parades is the Treme Recreation Community Center, which the Dumaine Street Gang, Sudan, and, sometimes, Treme Sidewalk Steppers use as their starting point. The nearby Candlelight Lounge, home base for the Treme Brass Band, is a frequent second line stop. Its owner, too, was a casualty of the first wave of the pandemic: Leona "Chine" Grandison, who opened the lounge in 1985 with her brother, passed away April 9, 2020.

Two important downtown bars owned by women have played a big role in second line culture. Seal's Class Act, on the corner of North Miro Street off St. Bernard Avenue, has seen many a parade come and go, and proprietor Cecile "Seal" Dalton also hosts an Easter parade. Further down St. Bernard sits the former site of the Next Stop Bar, which reopened in 2017, under white ownership, as the Goat. Former owner Justine Simpson served as queen in several second lines and was famous for throwing out dollar bills as she entered her bar at the end of the parade. Clubs that formerly started their parades or stopped at the Next Stop—the Big Nine for one—have moved to nearby bars like the Other Place Lounge.

Another bygone establishment in Treme, Joe's Cozy Corner, was an anchor of the neighborhood and remains an important landmark in the city's cultural history. Located

PRECEDING SPREAD Seal's Class Act, 2011, by Judy Cooper
ABOVE Candlelight Lounge, 2012, by Judy Cooper

on the corner of South Robertson Street and Ursulines Avenue, it was known in the 1960s as Ruth's Cozy Corner and served as the home base of the Sixth Ward Diamonds. Later purchased and renamed by Joseph "Papa Joe" Glasper, it became more entrenched as a neighborhood institution. Throughout the 1990s and early 2000s, kids from the neighborhood would come by before and after school at Joseph A. Craig Elementary to get treats from Papa Joe, and he often provided them with school supplies. In addition to serving as a regular stop for second line parades, Joe's Cozy Corner was a daily gathering place for neighborhood residents and local musicians, who also played there. Trumpeter Kermit Ruffins often worked the barbecue grill out front; bass drum player "Uncle" Lionel Batiste built a shoeshine stand on the sidewalk; and members of the well-known Andrews family—Glen David (trombone), James (trumpet), and Troy "Trombone Shorty" (trombone), who grew up in the surrounding blocks—were constantly in and out of the bar. The rich history of Joe's Cozy Corner was cut short dramatically in 2004, when Papa Joe shot and killed a man who was selling beer on the street outside the bar, without a permit, after the funeral of brass band musician Anthony "Tuba Fats" Lacen. Glasper was arrested, convicted of manslaughter, and imprisoned. The bar subsequently lost its liquor license and closed.[9] In 2017 it reopened as a cafe and Turkish bakery, named Fatma's Cozy Corner in a nod to the building's history.

As both a musician and bar owner, Kermit Ruffins has a long history with the city's second line clubs. In 2014 he reopened the Mother-in-Law Lounge on North Claiborne Avenue, which was a popular nightspot in the 1990s under the ownership of R&B singer

LEFT Pop's House of Blues, 2014, by Judy Cooper
RIGHT Young Men Olympian Jr. at Ruth's Cozy Corner (detail), 1980, by Michael P. Smith

Ernie K-Doe and his wife, Antoinette K-Doe. Now called Kermit's Tremé Mother-in-Law Lounge, it has become a regular stop for several of the downtown parades. Sweet Lorraine's Jazz Club on St. Claude Avenue is the traditional start for the Black Men of Labor and serves as a stop for other parades. The Ooh Poo Pah Doo Bar, named for the 1960 song by Jessie Hill, quickly established itself as an important club on the music and second line circuit in 2013, but closed suddenly three and a half years later. It soon reopened as Jokers Wyld and Mickey's Playhouse and continues to serve as a stopping point for several clubs. Justine Simpson, former owner of the Next Stop, has become the manager of this bar. The Carver Theater, a historic former movie theater, performance venue, and major hub of African American life, reopened in 2014 and has been embraced by the SAPC community, serving as a starting point for several second line parades, an event hall for dances hosted by the second line clubs, and an auditorium for memorials and funerals, as well as a concert hall.

Because of the sustained depopulation of the Lower Ninth Ward since Hurricane Katrina, the Ninth Ward clubs now parade on both sides of the Industrial Canal—the dividing line between the upper and lower parts of the ward. Only two bars on the lower side remain active in the culture, Mercede's Place on Burgundy Street and the former Mickie Bee's Lounge on St. Claude, which was taken over by Kermit Ruffins in 2019 and renamed Kermit's 9th Ward Juke Joint.

One important stop for the Big Nine is the House of Dance and Feathers, a museum dedicated to Black parading traditions established by Big Nine cofounder and president Ronald W. Lewis in 2003. Lewis, who also masked Indian with the Choctaw Hunters and belonged to the North Side Skull and Bone Gang, opened his museum to present and preserve the history of those traditions in his own neighborhood. "When you see there's something missing in your community, you want to contribute to make it whole," he said in the introduction to the museum monograph he cowrote with Rachel Breunlin of the Neighborhood Story Project in 2009, which he dedicated to the people of the Lower Ninth Ward and "to all survivors of Hurricane Katrina."[10] The Big Nine typically finishes its parade at the museum. (For more about the museum and Lewis, see p. 300.) Lewis died of COVID-19 in March 2020.

THE WEST BANK

This area across the river is home to only one parading club, the Westbank Steppers, but it's still "the Best Bank," said club founder and president Henry "Pal" Alexander.[11] The club only stops at a couple of bars, including Sheila's Fantasy, which hosts the practices of the Mohawk Hunters, the West Bank's only Mardi Gras Indian crew. In addition to serving as the home base of the Steppers, the Manicure Record Shop, owned by Alexander, is a landmark in the city's music history: it served as the headquarters of Manicure Records and its production company, both run by Alexander and Bobby

TOP Jokers Wyld and Mickey's Playhouse, 2017, by Judy Cooper
BOTTOM House of Dance and Feathers, 2010, by Judy Cooper

Marchan, the legendary gender-bending soul singer famous for performing at the Dew Drop Inn in the 1960s. Through Manicure, Marchan and Alexander recorded and helped to promote a number of local rap and bounce artists in the early 1990s.[12]

THE CANAL STREET BORDER

Historically, the divide between uptown and downtown has been associated with rivalry and even violence among the clubs. Fights would break out if a group from one side of town crossed Canal Street, the dividing line, and went to a parade on the other side. According to Jelly Roll Morton, who, like Louis Armstrong and Sidney Bechet, followed the parades in his youth, "Whenever a parade would get to another district the enemy would be waiting at the dividing line. If the parade crossed that line, it meant a fight, a terrible fight."[13] As Leslie Parr writes in her study of the second line tradition, "Some families, such as musician Danny Barker's, refused to let their children second line because of the danger involved in crossing into hostile neighborhoods and being met with knives, baseball bats, and other bludgeons."[14]

The city's imposition of a four-hour time limit for second line parades was driven in large part by the desire to decrease opportunities for violence, and that change has curtailed much of the boundary crossing.[15] Today, though, there are a few clubs whose parades cross town—always peacefully. The Original Four often start their parade on North Rampart Street at Armstrong Park and proceed across Canal to uptown. The Perfect Gentlemen begin on Canal then parade through the Central Business District, not a typical stomping ground for SAPCs, further uptown to Central City. The historic uptown-downtown rivalry has died down, due in part to the diffusion of the city's Black population into more distant areas, such as Gentilly, New Orleans East, and the West Bank. Membership of each club is no longer limited to its associated neighborhood, although most clubs continue to parade in their traditional areas.

NOTES

1 Michael White, "New Orleans's African American Musical Traditions: The Spirit and Soul of a City," in *Seeking Higher Ground: The Hurricane Katrina Crisis, Race, and Public Policy Reader*, eds. Manning Marable and Kristen Clarke (New York: Palgrave MacMillan, 2008), 93.

Westbank Steppers route sheet, 2015

2 For a further discussion of the political and transformative impact of SAPCs on the neighborhoods they traverse, see Helen Regis, "Second Lines, Minstrelsy, and the Contested Landscapes of New Orleans Afro-Creole Festivals," *Cultural Anthropology* 14, no. 4 (November 1999): 472–504.

3 Nine Times Social and Pleasure Club, *Coming Out the Door for the Ninth Ward*, 2nd ed. (New Orleans: Neighborhood Story Project, 2007), 155.

4 Askia Bennett, conversation with Judy Cooper at Ole & Nu Style Fellas parade, April 2015.

5 Charles "Action" Jackson, interview with Molly Reid Cleaver, November 18, 2020.

6 Michael G. White, "The New Orleans Brass Band: A Cultural Tradition," in *The Triumph of the Soul: Cultural and Psychological Aspects of African American Music*, ed. Ferdinand Jones and Arthur C. Jones (Westport, CT: Praeger, 2001).

7 Gregg Stafford, interview with Judy Cooper, May 2014.

8 Ramon Antonio Vargas, "Theresa Elloie, Bar Owner and Elaborate Corsage Creator, Dies of Coronavirus at 63, Son Says," NOLA.com *Times-Picayune New Orleans Advocate*, March 27, 2020; "Sportsman's Corner: A Neighborhood Cornerstone," ViaNolaVie.com, October 30, 2012.

9 Katy Reckdahl, "Down on the Corner," *Gambit Weekly*, May 18, 2004. For more on the legacy of Joe's Cozy Corner and the historical importance of the Treme neighborhood, see Matt Sakakeeny, *Roll With It: Brass Bands in the Streets of New Orleans* (Durham and London: Duke University Press, 2013), 31–33; Rachel Breunlin, "Papa Joe Glasper and Joe's Cozy Corner: Downtown Development, Displacement, and the Creation of Community" (master's thesis, University of New Orleans, 2004); and Dan Etheridge et al., "Can't Let It Go: Neighborhood Change and the Candlelight Lounge in Historic Tremé," report conducted by Tulane City Center and Cornerstones, 2014.

10 Rachel Breunlin and Ronald W. Lewis, *The House of Dance and Feathers: A Museum by Ronald W. Lewis* (New Orleans: Neighborhood Story Project and University of New Orleans Press, 2009), 2.

11 Henry "Pal" Alexander, interview with Charles "Action" Jackson, *Takin' It to the Streets*, WWOZ.org, 2016.

12 Alison Fensterstock, "How Queer Tastemakers, Movers and Shakers Shaped the Music of New Orleans," NPR.org, June 19, 2020.

13 Alan Lomax, *Mister Jelly Roll: The Fortunes of Jelly Roll Morton, New Orleans Creole and "Inventor of Jazz"* (1950; repr., Berkeley: University of California Press, 1973), 12.

14 Leslie Gale Parr, "Sundays in the Streets: The Long History of Benevolence, Self-Help, and Parades in New Orleans," *Southern Cultures* 22, no. 4 (Winter 2016): 21.

15 William Jankowiak, Helen Regis, and Christine Turner, *Black Social Aid and Pleasure Clubs: Marching Associations in New Orleans* (New Orleans: Jean Lafitte National Historical Park and the National Park Service, 1989), 57.

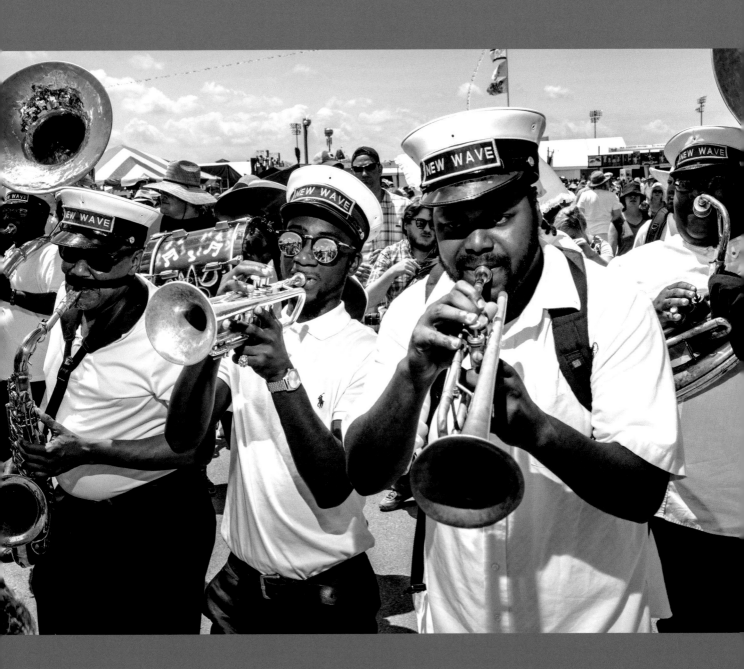

THE MUSIC

MICHAEL G. WHITE

To a segment of New Orleans's African American population, brass bands have been a vital part of community life for over a century, serving as an important source of celebration, bonding, strength, pride, and both individual and collective self-expression. Though brass bands did not originate in New Orleans and are not exclusive to African Americans, New Orleans's brass band tradition bears the rich legacy of the city's distinctive musical identity, one forged from Black creative input across a variety of musical activities. Today, brass bands carry that identity forward: as one of the most visible parts of New Orleans culture, they are heard locally at parades and funerals and internationally at festivals and in concert halls.

The earliest brass bands appeared in New Orleans—as elsewhere—during the late eighteenth and early nineteenth centuries, to accompany army units and ethnic militias, including some made up of free Blacks. These groups played marches, light classical pieces, dirges, and dance music for parades, balls, funerals, and other events. The city's growing demand for theater and for classical musicians led to an influx of highly trained European professionals, who also taught music and played in marching bands. Throughout the nineteenth century, many in the privileged class of Creoles of color took lessons from the newcomers, receiving a formal education in European classical music and becoming performers, composers, and music teachers. The Civil War brought about a great increase in brass bands, which were used to accompany both Union and Confederate troops.

Many musicians continued to perform in civic bands after the war. During the last two decades of the nineteenth century, when the United States counted more than ten thousand brass bands, New Orleans claimed the largest number. The city's love of music, parades, and dancing, combined with the rise of dozens of Black benevolent organizations, helped to maintain and support brass band activities. Popular groups of

OPPOSITE New Wave Brass Band at Jazz Fest, 2018, by Ryan Hodgson-Rigsbee

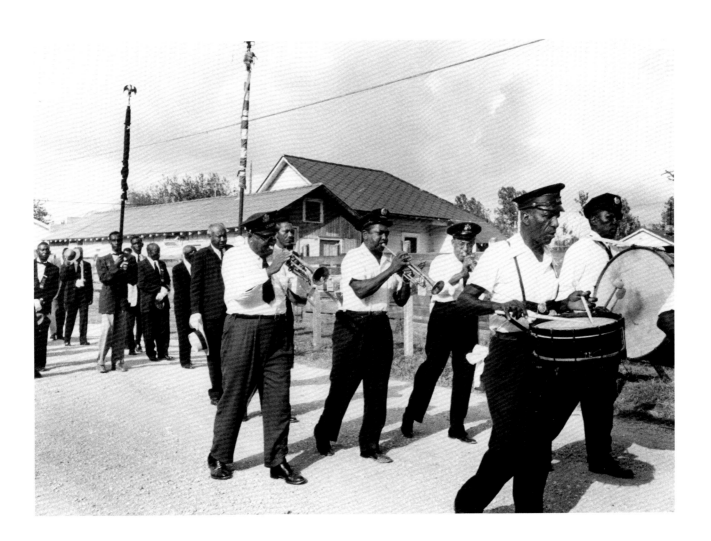

the 1880s and '90s, such as the Pickwick, Excelsior, and Onward Brass Bands, were known for a high level of musicianship and strict reading of the same written arrangements used by their white counterparts across the nation.

At some point during the 1890s, New Orleans's cultural obsession with celebration fused with the social intensity of the local Black struggle for freedom and equality post-Reconstruction. The most significant result was jazz—a revolutionary new music characterized by democratic ideals such as free expression, equal participation, and diversity. Largely resulting from a cultural merger between Blacks and Black Creoles, jazz combined European harmonic concepts and instruments with the call-and-response, syncopated rhythms, bent tones, vibrato, and emotional expressiveness of West African–influenced Black folk music. Legendary cornetist Buddy Bolden and others were the first to apply a looser, improvised, more personal approach to playing marches, blues, hymns, rags, and popular dance songs. The new style took hold in both smaller dance ensembles and ten- to twelve-piece brass bands. Collective improvisation within specifically defined roles became the typical approach among a growing number of trained readers and self-taught improvisers. In brass bands, three trumpets maintained the melody, often in harmony; two trombones played rhythmic punctuations and sliding "tailgate" fills;

Eureka Brass Band at an Algiers funeral, 1956, by Ralston Crawford

a clarinet freely danced and sang around the melody; two lower brass instruments (an alto horn and a baritone horn) played harmonic and rhythmic phrases; a sousaphone varied the basic "um-pah" rhythm around the songs' structure; a snare drum played press rolls and accents; and a bass drum carried the syncopated New Orleans parade beat that varied accents in unusual places. Saxophones, which played riffs and harmonies, replaced the lower brass horns by the 1930s. Because of the competitive nature of the music, coupled with its functional usage and a critical public, jazz and brass bands rapidly developed the new style, generating legendary players and groups in the process.

Although the popularity of local white bands mostly died out by the 1920s, mirroring a national trend, the Black New Orleans brass band tradition grew and further developed its distinctive sound. Musical families and neighborhoods generated a steady stream of players, and the parades and funerals of social clubs and benevolent associations, along with church processions and other community street parades, provided bands with continuous sponsorship. Several older groups lasted into the first decades of the twentieth century as newer ones, such as Oscar "Papa" Celestin's Tuxedo Brass Band, also found regular work in community activities. Many New Orleans musicians who migrated north during the 1910s and '20s and influenced the direction of American

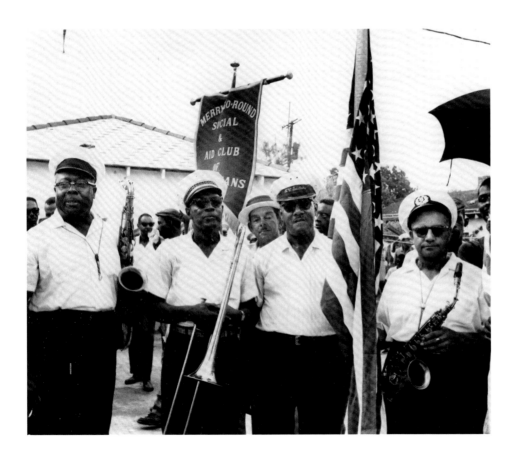

Young Tuxedo Brass Band members at a parade of the Merry-Go-Round Social and Aid Club, 1961, by Ralston Crawford

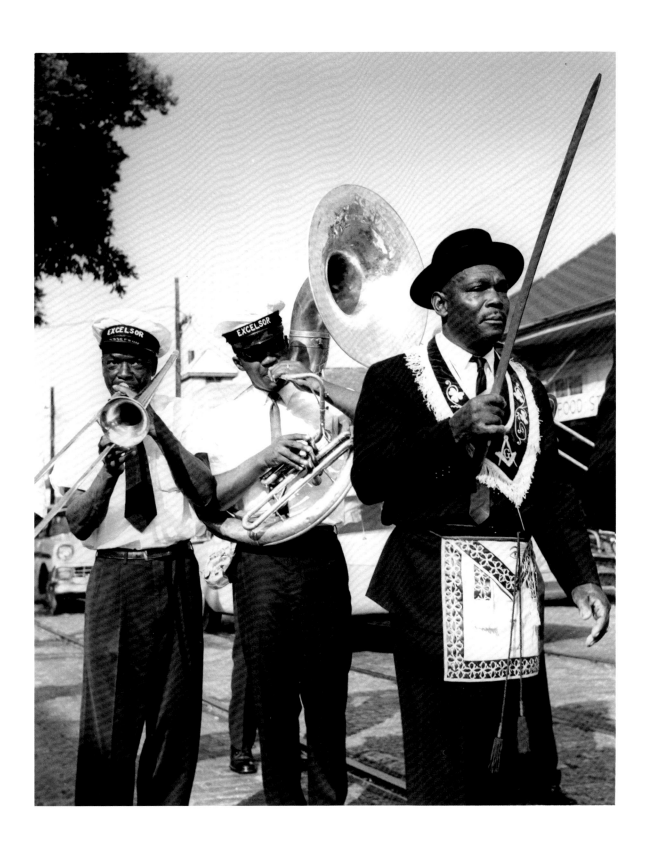

Members of the Excelsior Brass Band, ca. 1960, by Jules Cahn

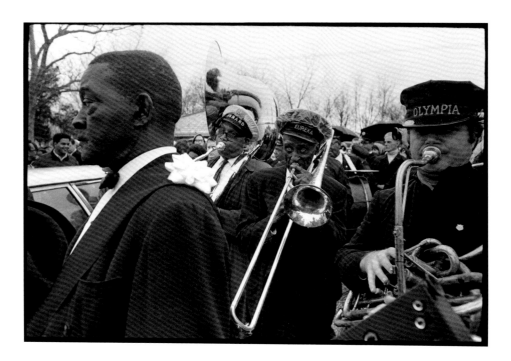

music—King Oliver, Louis Armstrong, and Sidney Bechet, among others—got some of their early training and experience in street parades and funerals.

The bands' repertoire consisted of improvised jazz versions of marches ("Panama," "High Society," "Bugle Boy March"); church hymns; blues songs ("St. Louis Blues," "Whoopin' Blues," "Victory Bounce" [a.k.a. "Joe Avery's Piece," "Joe Avery's Blues," or "Second Line"]); old popular songs ("Over the Waves," "Margie," "When You're Smiling"); and a number of other jazz and folk songs. For Baptist church parades—Sunday morning processions to celebrate religious holidays, pastors' anniversaries, or the founding of a new church—bands played improvised jazz versions of up-tempo hymns such as "Lord, Lord," "Over in the Glory Land," "Bye and Bye," and "When the Saints Go Marching In."

Though jazz mainly functioned as dance music, its democratic nature paralleled Black aspirations, making it a good match for progressive-minded social organizations; brass bands improvising in community parades provided both a means of celebration and a show of strength and unity. Improvisation by musicians and second liners also channeled spiritual release. Still today, the intensity that builds from constant creative interaction between brass bands and dancers often erupts into a euphoric dimension in which a sense of total freedom, equality, and limitless power—a spiritual redefining of earthly reality—seems to overtake many of the participants.

Members of the Olympia, Eureka, and Onward Brass Bands at the funeral of jazz clarinetist George Lewis, 1969, by Michael P. Smith

TRADITIONAL-JAZZ REVIVAL AND BRASS BAND EVOLUTION

During the early 1940s, a revival of outside interest in authentic New Orleans jazz led to the earliest brass band recordings. Historian William Russell's 1945 recording of Bunk Johnson's Brass Band and jazz writer Rudi Blesh's recording of the Original Zenith Brass Band, cut the next year, were both made by pickup groups specially assembled for the sessions and released in limited numbers. The first documentation of an authentic working brass band came in 1951, when college students Alden Ashforth and David Wyckoff recorded the Eureka Brass Band. Formed in 1920, the Eureka—led by longtime trumpeter Percy Humphrey—had been the most popular group and a standard bearer for decades. Wider brass band exposure came in 1958, when the major label Atlantic Records released *Jazz Begins*, featuring the Young Tuxedo Brass Band. Clarinetist John Casimir founded the Young Tuxedo in the late 1930s, and the group remained among the most visible parading bands for over forty years. *Jazz Begins*, as well as Atlantic's 1962 recording of the Eureka, gave a worldwide audience a taste of the exciting sounds that had continued underground in Black New Orleans street processions since the early days of jazz. The recordings also reflect the practice, even among the most traditional groups, of incorporating popular songs. Along with brass band standards, the Eureka recorded the swing-era favorite "Oh, Lady Be Good!" and the Young Tuxedo cut a rousing traditional-jazz version of Shirley and Lee's rhythm and blues hit "Feel So Good."

During the early 1960s, a focused effort to make New Orleans a major international tourist destination included showcasing local brass bands as symbols of the city's festive, unique culture. In a rather ironic move for a racially divided city in which Black jazz had often been ignored, tourism leaders promoted Harold Dejan's newly formed Olympia Brass Band as "cultural ambassadors," leading to previously unheard-of exposure and much more work over the next two decades—large conventions, business openings, international tours, airport greetings, television commercials, promotional ads, major sports events, and feature films. As the Olympia became a brand name defining the genre of New Orleans brass band music for much of the world, the group's overwhelming success set the tone for major stylistic changes to come during the late 1970s and '80s. Some re-formed groups, like legendary drummer Paul Barbarin's Onward Brass Band, also gained a degree of visibility in both community and commercial arenas.

In the economically driven spheres of business and tourism, brass bands often became scaled-down showpieces—smaller ensembles, flashy-colored uniforms, merchandise, more exaggerated stage antics, and an increasingly limited repertoire of only the simplest and most familiar songs. A few historic groups, like the Onward, Excelsior, and Imperial, were reestablished mainly because of the new commercial opportunities. Although these groups contained many brass band veterans, the older men largely avoided long, grueling parades in favor of the shorter, less-strenuous work of festival appearances and gigs in large air-conditioned hotels and convention rooms. By the 1970s there were about a half dozen regular brass bands and a few pickup groups playing in community and

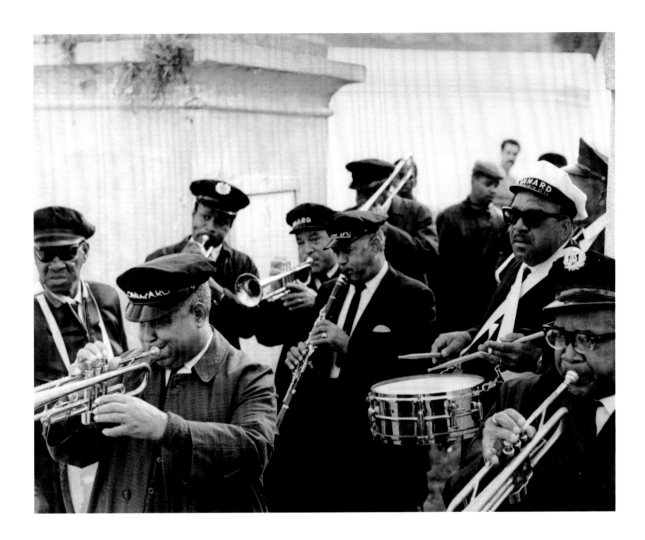

commercial jobs. Older groups like the Eureka had stopped parading and were only seen at a rare festival or public concert, while others disappeared altogether. The Olympia had become the most popular band in social club parades and funerals, though the ages of its members—and the increase in outside work—began to limit its appearances on the streets.

As several brass band veterans died, retired, or settled into less strenuous, more lucrative work, younger generations came to fill the void. Many youngsters got their start in traditional jazz in trumpeter Ernest "Doc" Paulin's brass band. Paulin, a veteran of local parades and dances for many decades, emphasized the professional and musical values of the brass band tradition, especially as they related to punctuality, neat uniformed appearance, and strong ensemble playing. During the late 1970s, Paulin's band was among the most visible groups in community functions, playing social club parades, church parades, funerals, and political rallies. Those were the last years in which the traditional jazz style dominated brass band playing and Black community parades.

Onward Brass Band, ca. 1970, by Jules Cahn

Other young musicians began as members of the Fairview Baptist Church Christian Band, a kids' group formed during the 1970s by veteran musician Danny Barker in an effort to teach young people about their jazz heritage. The Fairview rehearsed weekly and played in a number of parades and other events, and at one point regularly performed at the French Market on weekends. The group spawned several generations of professional musicians, a number of whom have gone on to international renown. Starting in the late 1970s ex-members of the Doc Paulin and Fairview bands maintained brass band musical traditions in the community along with the Olympia and Young Tuxedo by either joining these groups or by forming offshoot bands, like the Majestic, Pin Stripe, Tornado, and Chosen Few Brass Bands.

Since its start in 1970, the New Orleans Jazz and Heritage Festival has presented most of the city's brass bands in small parades on the grounds, as well as onstage. The Olympia, Eureka, Young Tuxedo, Onward, and other groups began to adapt the parade style to a stage-show format by adding vocals and featured solos to what had previously been mainly an all-instrumental, ensemble approach. Under the direction of assistant bandleader / trumpeter Milton Batiste, the Olympia departed from tradition and began to play rhythm and blues songs, in rhythm and blues style. The band's small-label recordings of Professor Longhair's "Mardi Gras in New Orleans," Smokey Johnson's

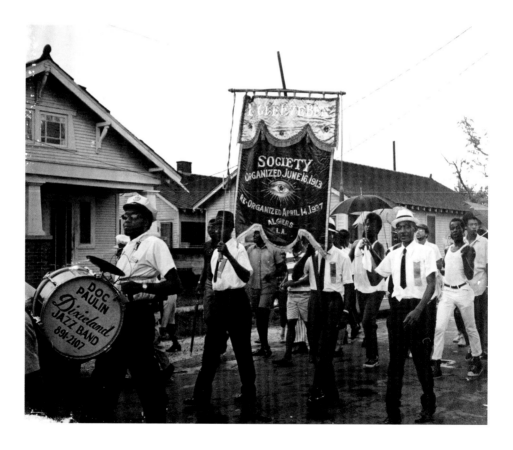

Doc Paulin Dixieland Jazz Band, ca. 1975, by Jules Cahn

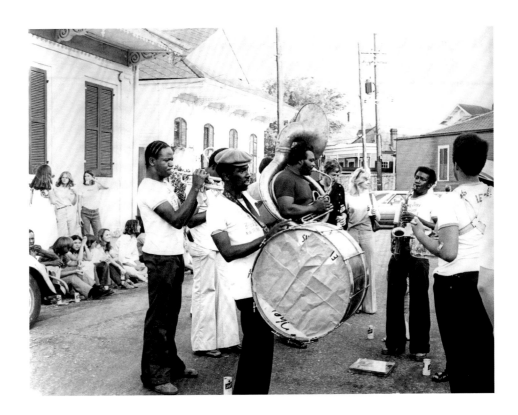

"It Ain't My Fault," and the Dixie Cups' "Iko Iko"—all featuring Batiste's trumpet, vocals, and tambourine—became local radio and jukebox favorites, as well as new brass band standards.

In the mid-1970s young trumpeter Leroy Jones and several other first-generation Fairview members formed the Hurricane Brass Band, which introduced a new look, sound, and attitude to the tradition. The Hurricane dressed in blue jeans and T-shirts instead of uniforms, did not wear band caps, and featured Jones's blazing modern jazz solos on top of riffing horns playing traditional jazz standards and contemporary radio hits like the Nite-Liters' "K-Jee" and the Meters' "Hey Pocky Way." The Hurricane was a popular "new thing" in street parades until Jones moved toward a solo career and began playing in Bourbon Street nightclubs.

In 1977 drummer Benny Jones Sr. and several ex-Hurricane members formed the Dirty Dozen Brass Band, a seminal group that forever changed the sound, image, and direction of New Orleans brass bands. The Dozen (which actually consisted of eight instruments—two trumpets, a trombone, two saxophones, a sousaphone, a snare drum, and a bass drum) blended contemporary and traditional jazz, rhythm and blues, funk, Mardi Gras Indian music, and school band influences. Faster tempos, catchy melodies, funky riffs, swinging sousaphone lines, and modern jazz–style solos helped make the group popular among younger social clubs and second liners. While the Dirty Dozen was known for unique versions of "Li'l Liza Jane" and "Blue Monk," it was even more

Hurricane Brass Band, with Leroy Jones on trumpet and Anthony "Tuba Fats" Lacen on tuba, ca. 1975, by Jules Cahn

successful with trademark original songs, like "Blackbird Special" and "My Feet Can't Fail Me Now." The Dozen's success soon spread beyond local street parades to nightclubs, festivals, concert halls, international tours, and major label recordings.

FUNK, GROOVE, AND TODAY'S BRASS BAND LANDSCAPE

By the early 1980s the Dirty Dozen's success began to keep them on the road, opening the door for new, young, modern-style brass bands to fill the void in community parades. Though there were still a few newer traditional bands and some older groups that were developing a more modern style of their own, the time was ripe for brass band music to further evolve. In 1982 brothers Phil and Keith Frazier and trumpeter Kermit Ruffins, then teenagers, formed the Rebirth Brass Band. Though heavily influenced by the Dozen,

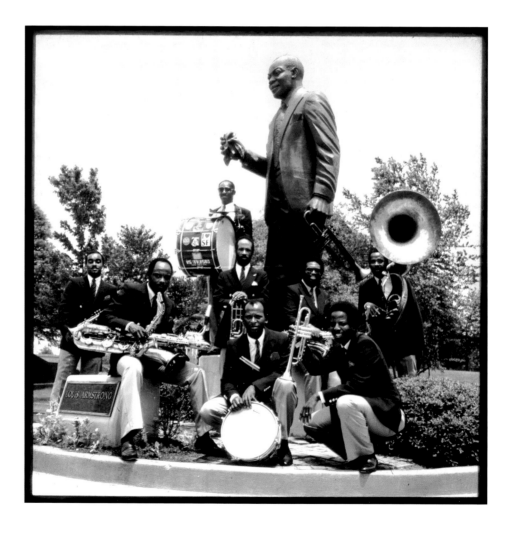

Dirty Dozen Brass Band, ca. 1990, by Michael P. Smith. Front row, left–right: Roger Lewis (baritone sax), Jenell Marshall (snare drum), Gregory Davis (trumpet); second row, left–right: Efrem Towns (trumpet), Charles Joseph (trombone), Kevin Harris (tenor sax), Kirk Joseph (sousaphone); rear: Benny Jones Sr. (bass drum)

the Rebirth soon created a more laid-back, funky style that eventually added influences from the emerging genre of hip-hop. The band composed and recorded a number of original songs, like "Feel Like Funkin' It Up" and "Leave that Pipe Alone." Rebirth's "Do Whatcha Wanna" became a major local hit and has become a staple of New Orleans party music, played during Mardi Gras, at sporting events, and by school marching bands across the nation. Though the Rebirth also began a steady touring schedule, it remained the most popular and visible brass band in community parades and funerals for many years. The group's continued success culminated in 2011, when it became the first New Orleans brass band to receive a Grammy Award, for its album *Rebirth of New Orleans.*

Over the 1990s a resurgence in the number of parading social clubs, combined with further increases in tourism and the popularity of brass bands, led to an explosion of new young groups. Continuing the tradition of New Orleans musical dynasties going back to the Tios, Humphreys, and Barbarins of the nineteenth and early twentieth

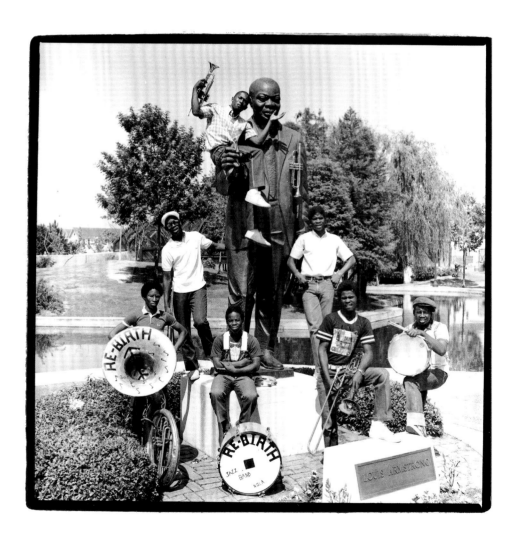

Rebirth Brass Band, 1984, by Michael P. Smith. Front row, left–right: Phil Frazier (sousaphone), Keith Frazier (bass drum), Keith "Wolf" Anderson (trombone), Kenneth Austin (snare drum); back row, left–right: Reginald Stewart (trombone), Gardner Ray Green (trumpet); on statue: Kermit Ruffins (trumpet)

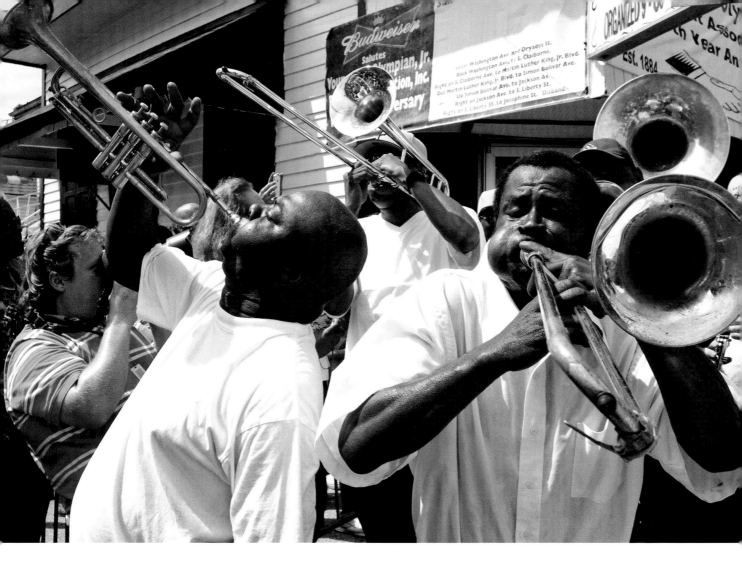

centuries, families like the Paulins, Josephs, Joneses, and Andrewses have produced dozens of professional musicians who are active on all levels of the brass band scene.

While most of today's younger bands have continued in the groove-based funk/rap style pioneered by the Dirty Dozen and Rebirth, several have emerged with their own unique sound and repertoire, including the New Birth, Soul Rebels, Coolbone, Hot 8, Lil' Rascals, Stooges, Baby Boyz, and To Be Continued (TBC) Brass Bands. With some exceptions, these bands have continued to draw on current hip-hop, modern jazz, rhythm and blues, and contemporary themes, often incorporating group rapping into community street processions.

A number of groups attempt to cover both the traditional and modern styles by performing funk in community events and traditional jazz songs (commonly called "traditionals") for tourism-related and commercial jobs—often wearing street clothes or casual band uniforms for the community gigs and the more formal "black and white" for commercial jobs. As modern attitudes about jazz funerals have changed from the days when slow dirges always preceded upbeat, joyous music, many contemporary bands (often dressed in street clothes) follow the requests of families or clubs and forgo slow

Band for Young Men Olympian Jr. parade, 2011, by Leslie Parr

hymns altogether, favoring the modern, rousing funk style during the entire procession. As styles and practices have grown, bands display a range of musical standards: because of a decline in the old system of mentorship between veteran and young musicians, some groups are never coached in musicality and technique and are content to meet the lowest expectations of the tourism market.

The Original Pinettes Brass Band is among the more unusual of today's popular contemporary groups. Founded in 1991 from band students at the all-female St. Mary's Academy, the Pinettes soon became a regular fixture at SAPC parades. After Hurricane Katrina, which displaced and scattered members all around the country, bandleader Christie Jourdain reformed the group, pivoting it toward stage performances. In 2013 the Pinettes put out their first recording, *Finally*, and also won the Red Bull Street Kings battle of the brass bands.

The Paulin Brothers Brass Band is a continuation of the group led for many decades by Doc Paulin and consists mainly of his sons and grandsons. While the group still plays occasional community parades, it is also active in festivals, concerts, parties, weddings, and concerts. One of the hottest bands on the streets today is the TBC Brass Band, which formed in 2002 from a group of G. W. Carver High School students. For a number of years the TBC was a popular tourist attraction, as the group played for tips on a heavily trafficked Bourbon Street corner in the French Quarter. In recent years the band has become one of the most requested and popular groups in second line parades. Often

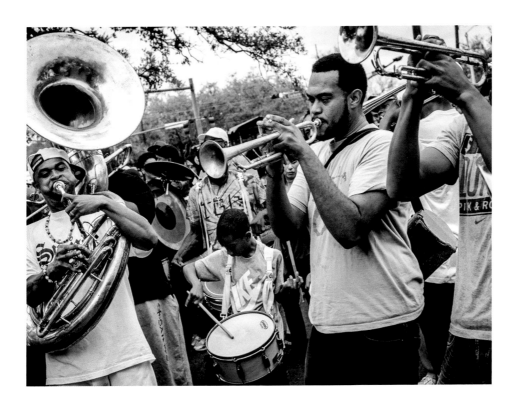

TBC Brass Band, 2014, by Pableaux Johnson

using more members than other brass bands, the TBC has made several recordings and regularly appears as a stage show at local festivals.

The New Breed Brass Band is among the newest groups to make a mark on the scene. Organized in 2013, the band first performed in the Nine Times's annual parade. According to drummer Jenard Andrews, the band focuses on adding a stronger popular-music flavor to the prevailing funk style. Like many newer groups, the New Breed is visible in community parades as well as onstage, often touring as an opening act for the popular New Orleans funk artist Troy "Trombone Shorty" Andrews and his band, Orleans Avenue.

For most of the twentieth century, brass bands provided part-time work that was always supplemented with other types of musical engagements or, most often, with work from other professions altogether. The idea of a musician making a living entirely from brass band work was unheard of, even among the best groups. Today, however, there are scores of musicians whose primary means of employment is playing in brass bands. Many groups have managers, websites, CDs and videos (sometimes self-produced), and a vision of success that extends far beyond local community parades and funerals.

The brass band industry has become international in scale, and some of today's bands eschew the flooded local market, with its relatively low pay, in favor of more lucrative stage shows and international touring. Several groups that were once popular in community parades—the Dirty Dozen, Rebirth, Stooges, Hot 8, and Soul Rebels—now

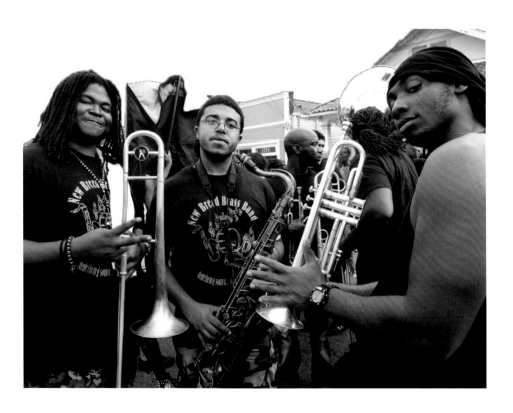

Members of the New Breed Brass Band, 2013, by Judy Cooper

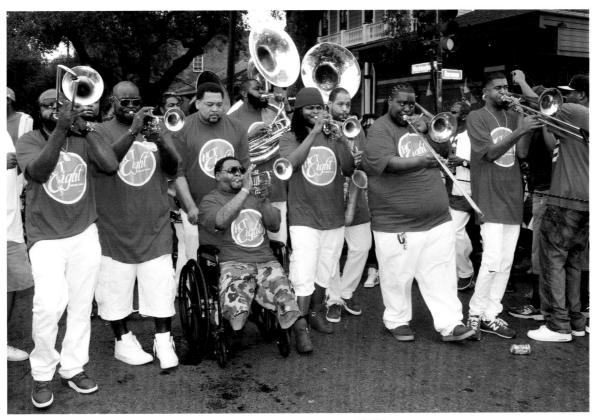

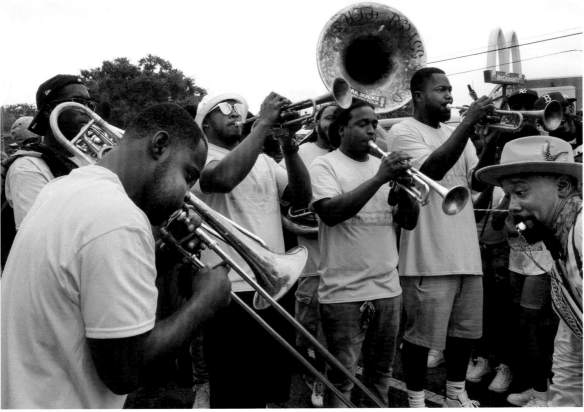

TOP Hot 8 Brass Band at a parade of the Lady Rollers, Christmas Day, 2016, by Judy Cooper
BOTTOM Da Truth Brass Band with Family Ties, 2017, by Judy Cooper

maintain heavy touring schedules and have largely or entirely disappeared from the streets. The few traditional groups, like the Young Tuxedo and Liberty Brass Bands, only perform a small number of special engagements, with individual members occasionally appearing on the streets in musicians' jazz funerals.

The brass band tradition has always reflected and been influenced by social conditions and factors that affect community life. The post-Katrina era in New Orleans has been marked by concern about the survival of the city's unique indigenous cultural traditions. In some ways it can never be the same place as before. The harsh realities of global warming, coastal erosion, rising tides, a sinking city, and a future with more severe storms on the horizon can no longer be ignored or forgotten. As New Orleans's population and historically African American neighborhoods are being gentrified, the city's long-term racial divide and economic imbalances continue to roll along like a Carnival parade.

In spite of all of the issues plaguing New Orleans, the tenacious spirit of its citizens who have returned is boldly evident. Social club parades, jazz funerals, Mardi Gras Indians, jazz, and brass bands continue to be a vital part of local Black life and survival.

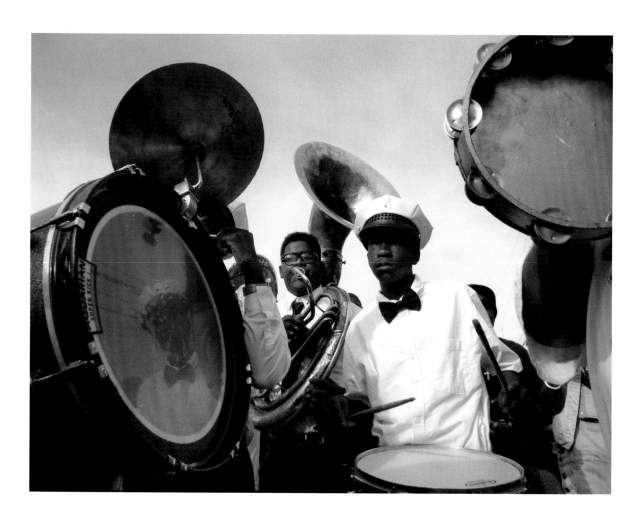

ABOVE Jawansey Ramsey (snare drum) with the New Orleans Young Traditional Brass Band for Black Men of Labor parade, 2015, by MJ Mastrogiovanni
OPPOSITE Dr. Michael White (clarinet) with the Treme Brass Band for Black Men of Labor parade, 2016, by Judy Cooper

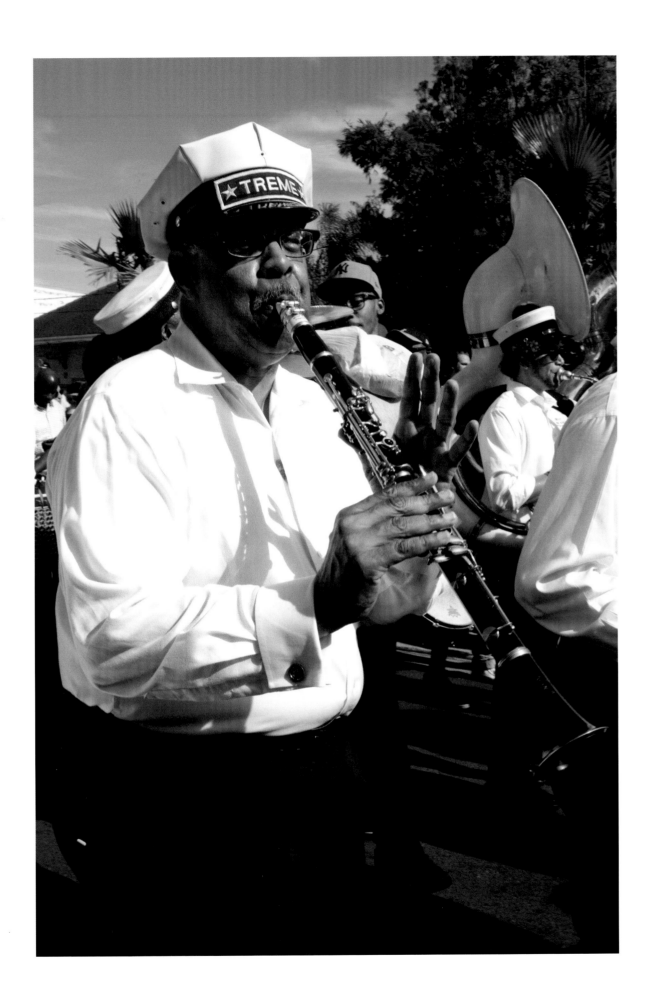

Brass bands are as popular as ever, visible throughout the city and around the world. Today there are over two dozen brass bands and nearly sixty parading social clubs in the city. The New Orleans brass band tradition has survived; what direction it will take next remains to be seen.

A positive factor in nurturing the tradition for younger generations has been the start of several programs by the New Orleans Jazz National Historical Park and the New Orleans Jazz and Heritage Foundation. Featuring workshops and a school band competition, the programs have helped to form new young bands. Several members of established funk-style groups have sought mentorships with older, traditionally oriented musicians in an effort to learn about brass band history and incorporate traditional music into their repertoires.

The New Orleans brass band has always addressed the spirit, condition, and needs of the people of its time. During the mid-nineteenth century it served a military function, helping Black soldiers go to war in service of their country. In the late nineteenth century it became a source of pride and visibility for a people attempting to share in the nation's professed ideals of freedom and equality. In the early twentieth century, jazz—a voice of freedom and collective community celebration—became the dominant style among brass bands and remained so for nearly eighty years. The need for self-expression in a changing world following the intense counterculture movement of the 1960s and '70s contributed to a modern evolution and eventual renaissance of brass bands. The music changed to incorporate a variety of local and popular styles into a dominantly modern, yet still uniquely New Orleans, type of musical expression. The increasingly rare traditional style still produces magical, exciting moments, but it is uncertain if it will continue to exist in its birthplace in the next twenty or thirty years. New Orleans brass bands have adapted to historical, social, and cultural changes for more than a century, and they will continue to do so in the evolving post-Katrina landscape, sharing their unique yet universal expressions of the human condition for many generations to come.

Note: A portion of this essay appeared as part of the liner notes accompanying the 2015 recording New Orleans Brass Bands: Through the Streets of the City *(Smithsonian Folkways 40212). Special thanks goes to Smithsonian Folkways Recordings and director Daniel Sheehy for permission to use this material.*

OPPOSITE Free Spirit Brass Brand logo, 2015, by Judy Cooper

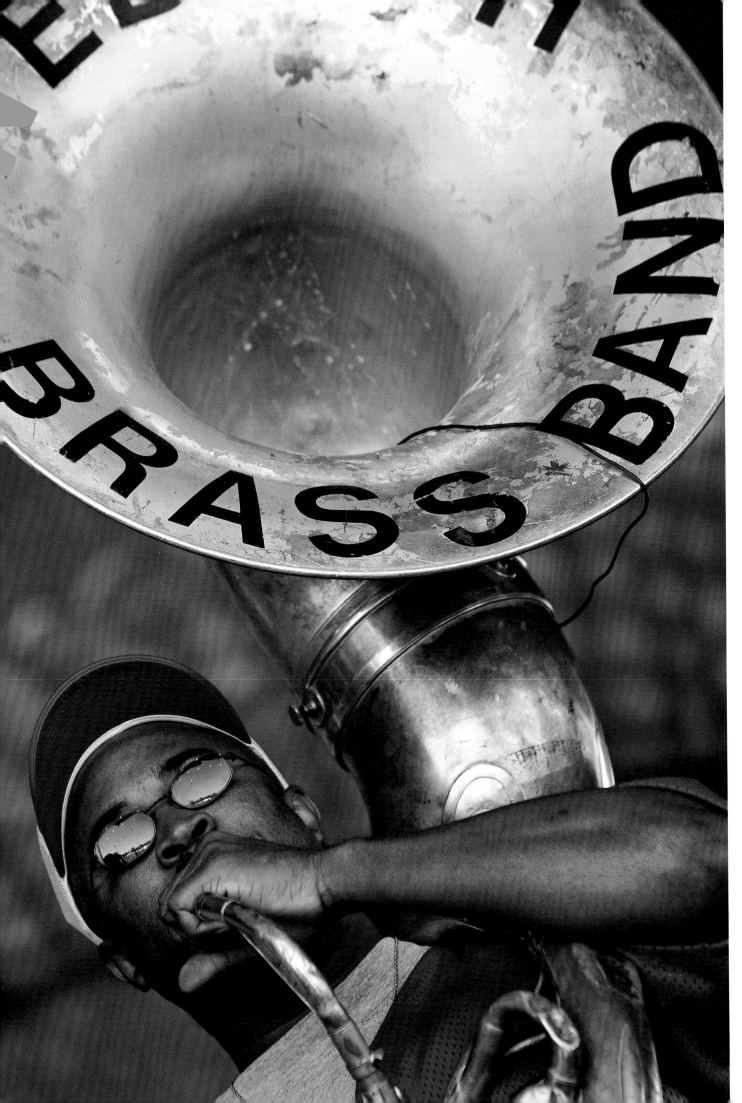

FURTHER READING

White, Michael G. "Dr. Michael White: The Doc Paulin Years." *Jazz Archivist* 23 (2010): 2–20.

———. "New Orleans's African American Musical Traditions: The Spirit and Soul of a City." In *Seeking Higher Ground: The Hurricane Katrina Crisis, Race, and Public Policy Reader*, edited by Manning Marable and Kristen Clarke, 87–106. New York: Palgrave Macmillan, 2008.

———. "The New Orleans Brass Band: A Cultural Tradition." In *The Triumph of the Soul: Cultural and Psychological Aspects of African American Music*, edited by Ferdinand Jones and Arthur C. Jones, 69–96. Westport, CT: Praeger, 2001.

FURTHER LISTENING

Currently available CD reissues of early and definitive recordings by each group

Bunk's Brass Band and Bunk's Dance Band. *Bunk's Brass Band and 1945 Sessions*. American Music AMCD-6, 1992.

Dirty Dozen Brass Band. *My Feet Can't Fail Me Now*. Floating World / Retroworld FLOATM 6046, 2011.

Eureka Brass Band. New Orleans Funeral and Parade: *The Original 1951 Session*. American Music AMCD-70, 1992.

———. *The Music of New Orleans, Vol. 2: Music of the Eureka Brass Band*. Folkways FW02462, FA 2462, 1958.

[Harold Dejan's] Olympia Brass Band. *The Olympia Brass Band of New Orleans*. GHB BCD-108, 2005.

Rebirth Brass Band. *Feel Like Funkin' It Up*. Rounder CD 2093, 1989.

———. *Rebirth of New Orleans*. Basin Street BSR 1202-2, 2011.

Various artists [Hot 8, Liberty, and Treme Brass Bands]. *New Orleans Brass Bands: Through the Streets of the City*. Smithsonian Folkways SFW40212, 2014.

Young Tuxedo Brass Band. *Jazz Begins: Sounds of New Orleans Streets—Funeral and Parade Music*. Collectables, 2007 [originally released 1958 as Atlantic 1297].

OPPOSITE Phil Frazier with the Rebirth Brass Band at Jazz Fest, 2005, by Brad Edelman

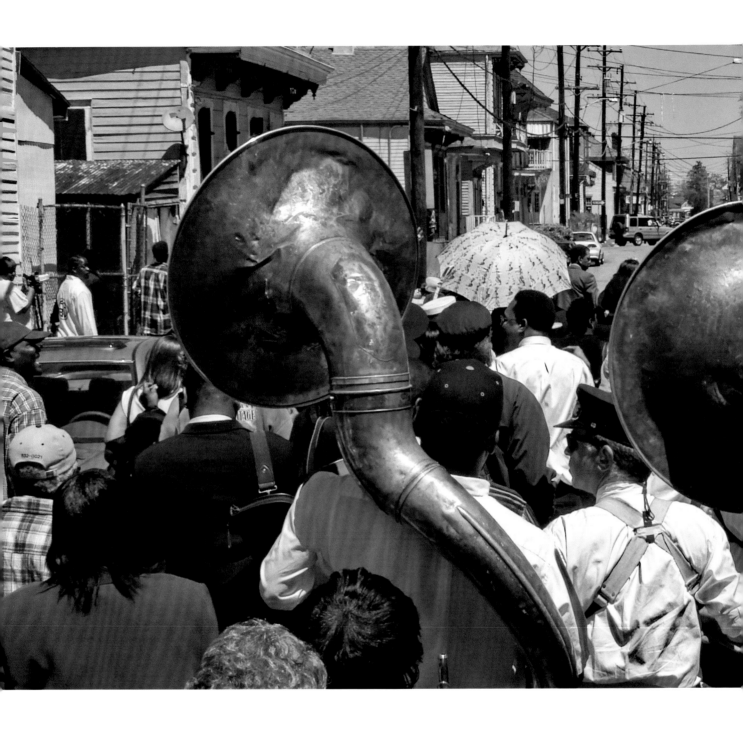

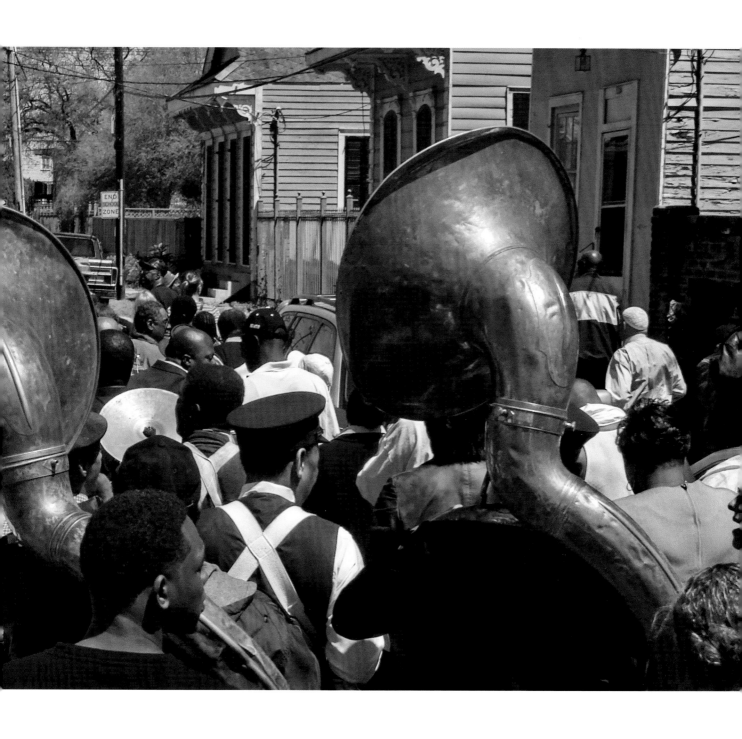

Tubafication, 2005, by Brad Edelman

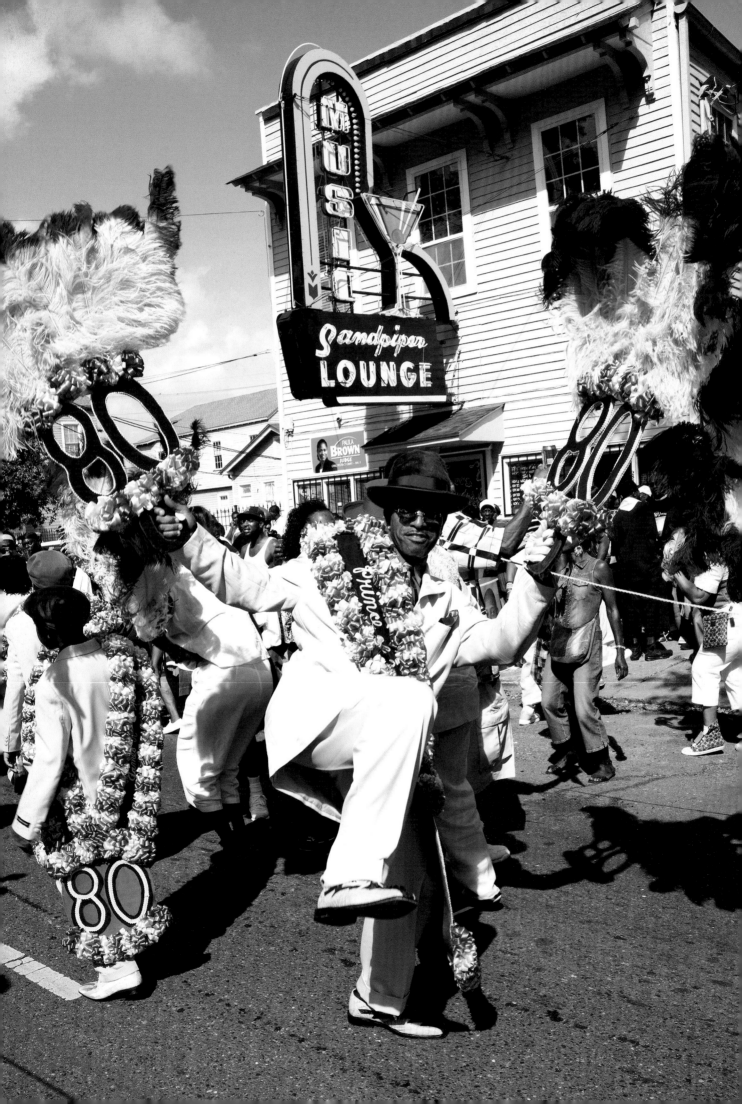

CLUBS

This section features profiles of all the clubs that paraded or were scheduled to parade in the 2019–20 season, which was interrupted by the onset of the pandemic. The profiles are organized into two subsections. The first comprises clubs with their own parade dates; the second is made up of clubs that parade as guests of other groups. Both sections are organized chronologically, by founding date. Unless otherwise noted, the quotations featured in the profiles, which begin on p. 180, are from interviews conducted by Judy Cooper and from Charles "Action" Jackson's WWOZ podcast, *Takin' It to the Streets*. Many thanks to DJ Action Jackson for his faithful documentation of voices from the second line community.

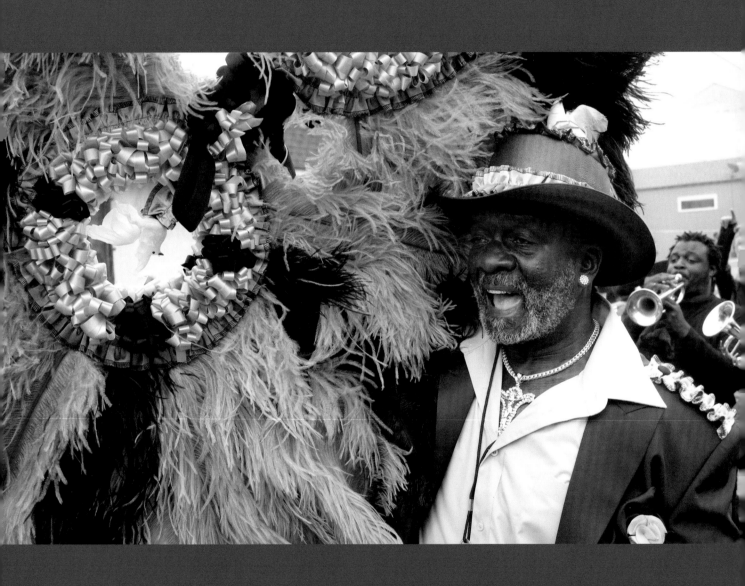

COMMUNITY ON PARADE: SOCIAL AID AND PLEASURE CLUBS TODAY

JUDY COOPER

New Orleans's social aid and pleasure club parade season spans late August to late June, comprising thirty-seven Sundays authorized by the police department. Two Sundays for Mardi Gras and two for Jazz Fest are excluded from the schedule. Because of the NOPD's regulation permitting only one parade per Sunday, some clubs do not have their own day and must parade with another, more established club. Two clubs have two parades during the season: the Young Men Olympian Jr., who usually have an anniversary church service and small, formal parade two weeks before their main parade, and the Perfect Gentlemen, who host a Father's Day second line in addition to their main parade, on the first Sunday in January.

NOPD Sergeant Richard Blackman, who manages the second line parade schedule, holds a meeting every August, at which he distributes the schedule to the presidents of all the parading clubs. (See p. 303 for the 2019–20 schedule.) The general rule is that the clubs parade on the same Sunday every year. For example, the Valley of Silent Men kick off the season on the last Sunday in August, and the Uptown Swingers end it on the last Sunday in June. New clubs can talk to Sgt. Blackman at the preseason meeting about getting a possible parade date in the future, and they must also send him a letter of request. When a date becomes available, he assigns it on a first-come, first-served basis. Some clubs have been waiting for years to get their own date. The Scene Boosters, an old club that had stopped parading after Katrina, finally got back on the schedule in 2019, when the Bayou Steppers lost their late-May date due to inactivity.

Clubs without a dedicated date often arrange to join another club's parade. The guest club hires its own band, chooses its own outfits and decorations, and parades as

PRECEDING SPREAD Alvin "Quiet" Epps at the Sandpiper Lounge, Prince of Wales eightieth anniversary, 2008, by Judy Cooper
OPPOSITE Jack Humphrey of the Young Men Olympian Jr., 2015, by Charles Muir Lovell

a separate unit. It also pays a fee to the hosting club to help cover the cost of the permit. Some established groups, such as the Dumaine Street Gang and the Perfect Gentlemen, allow two or even three other clubs to parade with them.

The number of clubs waxes and wanes through the years. Some older groups retire because of declining membership or illness of key members. Some newer clubs fold for a variety of reasons, such as a downturn in the local economy or trouble establishing group cohesion. The SAPC scene saw a dramatic increase in activity in the 1980s and '90s, with the number of clubs peaking at the end of the century. (Two representative lists of parading clubs from those decades can be found on pp. 301–2.) A number of the clubs born in the late twentieth century did not survive far into the twenty-first. A comparison of the rosters from 1997 and today shows about twenty-five clubs from the first list that are not on the second. But a number of new clubs have emerged to take the place of the old ones—many of them formed by members of disbanded outfits or by a club member who simply wanted to strike out on his own. As Raynold Fenelon, founder of the Good Fellas, put it, "I just wanted to see if I could do it."[1] Tyrone "Tuffy" Nelson, founder of the now-defunct Nuthin But Fun, said, "I wanted my own umbrellas—I wanted to express my own creativity."[2]

Almost as a matter of necessity, the founders of new clubs have previous parading experience. Fenelon, for example, had paraded with the Original Four, the Perfect Gentlemen, and Family Ties before founding Good Fellas. The founder, who usually becomes president or CEO, needs to know what it takes to put on a second line parade, including filing the parade permit request, hiring the band, and ordering the outfits and decorations in a timely manner—all while managing the club's finances. Both Joseph "Joe Black" Baker of the Revolution and Raphael Parker of Nine Times credit Waldorf "Gip" Gipson III, leader of the Young Men Olympian Jr.'s Fifth Division, known as the Furious Five, for showing them how to run a club.

As with any other organization, a good leader inspires respect, confidence, and loyalty. Conversely, nothing will break up a club faster than an overly autocratic president or one who is not aboveboard with the finances. The longevity and size of a club are a testament to the strength of its leader. Longtime leaders include Norman Dixon Jr., president of the YMO Jr., Linda Tapp Porter of the Lady Buckjumpers, Byron Hogans of the Dumaine Street Gang, and Fred Johnson of the Black Men of Labor. There are many others.

Only the YMO Jr. has a written charter outlining the structure of the club, dues, rules of membership, and parade lineup. Many clubs are officially registered with the state as nonprofit organizations, but their structural organization is rather loose. They all have at least one leader—a president and/or CEO. Some of the larger clubs have additional officers, such as vice president and business manager. New members typically pay an initiation fee and monthly dues after that. Regular meetings are held, often once a month, to discuss plans for the annual parade, including outfits, decorations, bands, and route. In some clubs, the president alone decides on the color and type of outfit

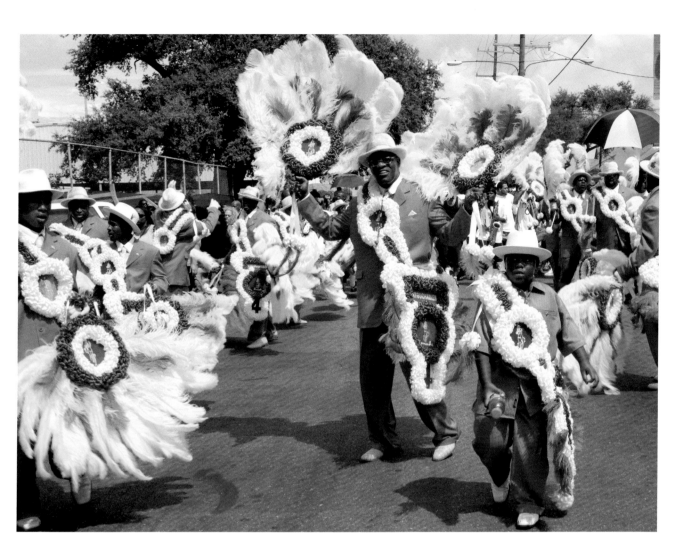

and decorations. In others, these decisions are made democratically. Other events are planned at the monthly meetings, specifically fundraising activities such as raffles, dances, and bus excursions. Many clubs hold meetings at their favorite bar, or "home base." After the business discussion, the members relax and enjoy the stated purpose of these social and pleasure clubs—brotherhood, fellowship, and fun.

PRIDE OF PLACE AND COMMUNITY TIES

When talking to social aid and pleasure club members about the parading tradition, "community" and "culture" are the two dominant refrains. The scene continues to flourish because of the social networks, shared practices, and history unifying SAPC members across club affiliation. Cultural memory is fundamental to these unifying elements, from the tradition's roots in racial oppression and struggle to its expressive applications in music, dance, and fashion. Every week, the social aid and pleasure clubs of New Orleans connect the past and present in a celebration of Blackness. This wellspring survives because of the strong social fabric underlying the tradition.

Norman Dixon Jr. and Norman Dixon III with the Young Men Olympian Jr.'s Third Division, 2007, by Judy Cooper

While race is a defining element of SAPC history and culture, class has been a more complicated factor. The second line community is largely made up of working-class African Americans. They are longshoremen, tradespeople, construction workers, custodial and food service workers, and cabdrivers. Middle- and upper middle-class African Americans joined organizations such as the Young Men Illinois and the Autocrat Social and Pleasure Club, both of which continue to this day; their activities include formal balls, where members' daughters are presented as debutantes. Most of these clubs, however, do not second line. Fred Johnson, president of the Black Men of Labor, speculated in *Talk That Music Talk: Passing On Brass Band Music in New Orleans the Traditional Way* that, perhaps, dancing in the streets was considered undignified once one reached a higher social status: "I had observed that many middle-class black folks felt that once you got to a certain quality of life, you don't need to participate anymore—you are beyond that, you are above that."[3]

One club that bridges the divide is Zulu, whose membership includes the movers and shakers of the local African American community—lawyers, bankers, business owners, and politicians. An invitation to the Zulu Coronation Ball, a large, glittering affair held during Carnival, is one of the most prized invitations in town. The Zulu parade, no longer the ad-hoc affair it once was, is now an accepted and recognized part of mainstream Mardi Gras culture, making it one of only a few big parades put on by

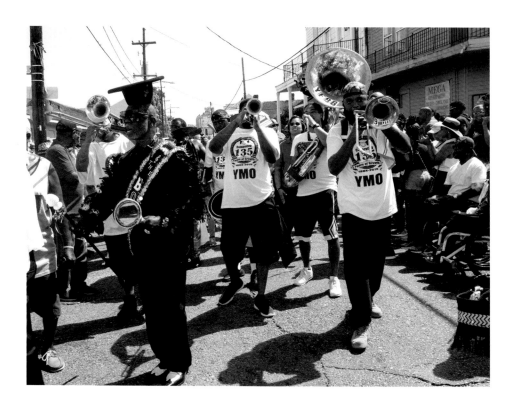

Gregg Stafford with the Young Men Olympian Jr. in Central City, 2019, by Judy Cooper

majority-Black organizations. Despite its large cultural capital, Zulu continues to honor its SAPC roots by hosting a true second line parade in the spring, after Mardi Gras.

Race and class alone do not explain the second line tradition: it is, resoundingly, a product of place. Most of the members of the community, from the beginning to the present day, are native New Orleanians. They have grown up surrounded by jazz and brass band music, *their* music, and by the regular Sunday parades. Like Louis Armstrong and Sidney Bechet before them, many current club members can recall vivid childhood memories of watching parades go through their neighborhoods.

In the early days, the social aid and pleasure clubs were truly local organizations, identified with the particular neighborhood in which most of the members lived. The YMO Jr. was born over a century ago in the same Central City area that still serves as its base. In *Coming Out the Door for the Ninth Ward*, Gipson, leader of the YMO Jr.'s Furious Five, explains: "The parade circuit is a neighborhood culture, and each neighborhood has their own active things. You raise your funds in your neighborhood, and when you parade you try to stay in your neighborhood. You got to show your loyalty. You got all your older ladies who line up, and people come out of church. . . . This parade been in this area for one hundred and some years."[4] The Prince of Wales, another old club, born on Tchoupitoulas Street near the wharves where some of the founders worked, still start their parade on Tchoupitoulas.

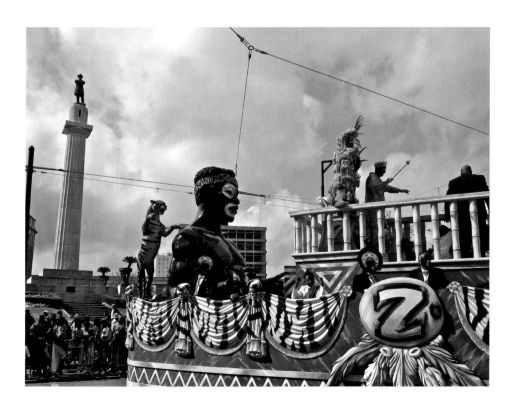

Zulu parade, 2017, by Charles Muir Lovell

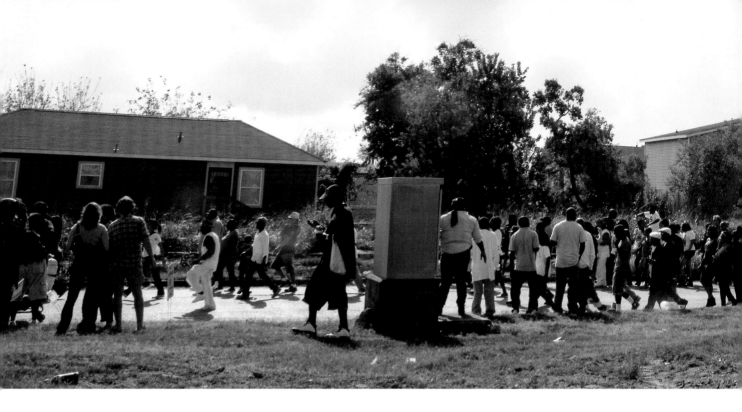

The names of many clubs reference their neighborhood origins: Dumaine Street Gang, Pigeon Town Steppers, Treme Sidewalk Steppers, Original Big 7 (from the Seventh Ward), Big Nine (from the Ninth Ward), and Westbank Steppers. A number of clubs have come out of the city's housing projects, such as the Calliope High Steppers; the Original Big 7, which had many members from the St. Bernard project; and Nine Times, which came out of the Desire project.

Neighborhood schools have also played crucial roles in the development of many clubs. Most of the members of Nine Times attended G. W. Carver High School, and Booker T. Washington High School, near the Calliope project, is the alma mater of a number of important members of the second line community, including Alfred "Bucket" Carter, Norman Dixon Sr., and Naomi "Shorty" Gibson. Most of the members of Family Ties, a club from the Sixth Ward, attended either John McDonogh or Joseph S. Clark high schools, and the club often shows allegiance by starting their parade at one of the schools.

As indicated by the name, Family Ties represents another important thread running through the SAPC community. In early twentieth-century New Orleans, family and neighborhood were closely intertwined. Though the rise of African American suburbs over the latter half of the century sent more Black New Orleanians to new neighborhoods such as Pontchartrain Park and New Orleans East, the historic neighborhoods have retained much of their family cohesiveness, whether in place or in pride. For instance, the Dumaine Street home of Sue Press and her husband, Darryl Press, is the center of the club universe for the Ole & Nu Style Fellas. Their decorations, designed by Press's son Tyrone "Trouble" Miller Jr., are fabricated in a small building behind the

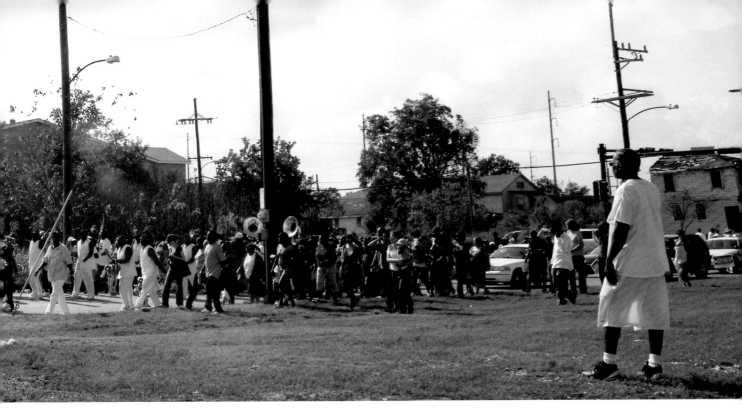

house. According to Family Ties president Tyrone Brooks, ninety percent of his club's members are related to one another by blood or marriage, many tracing their roots to a founding family that lived on Ursulines Street in the Sixth Ward. Their parade continues to follow a route through the Sixth and Seventh Wards, though the family members don't all still reside in that same area.

Family participation is multigenerational. Many of today's club members began as kids, parading with their parents. Antoinette "Net" Devezin of the Undefeated Divas began parading in the Treme Sports with her father, who now rides in her parade. Devezin's husband, Kevin "Too Low" Devezin, is head of the Undefeated Gents, and their two children also participate. Norman Dixon Jr., president of the YMO Jr., started parading as a small child with his father, Norman Dixon Sr., and the lineage continues. The younger Dixon proudly states that his son, at age six months, became the all-time youngest member of the club. As many second liners attest, the children represent hope for the future and the continuation of the culture. The YMO Jr. calls its kids' division the New Look. The Uptown Swingers, another family group, was until recently headed by Ezell Hines, whose father was a grand marshal for the YMO Jr. Hines, who passed away in November 2020, started parading at age five, and he dedicated his life to passing down the tradition to the next generation, teaching the children how to sew and "bust" bows for the club decorations.

Fluidity of membership between clubs is another part of the SAPC social fabric: many club members have belonged to more than one club through the years. Family members may be in different clubs at the same time. This comity is best demonstrated by the practice of clubs hosting stops at parades: members gather at a certain point on

Nine Times parading in the Desire neighborhood, 2011, by Judy Cooper

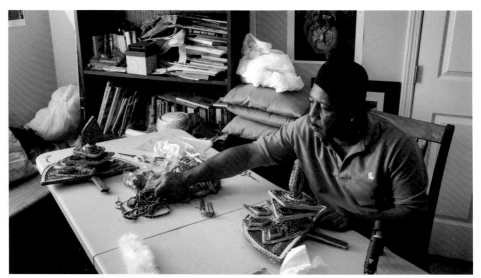

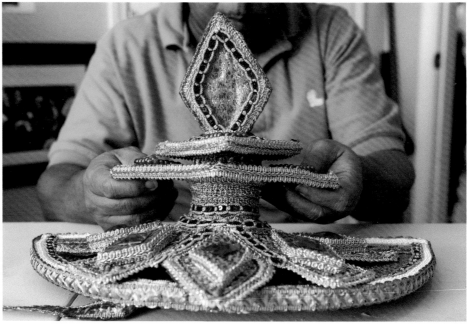

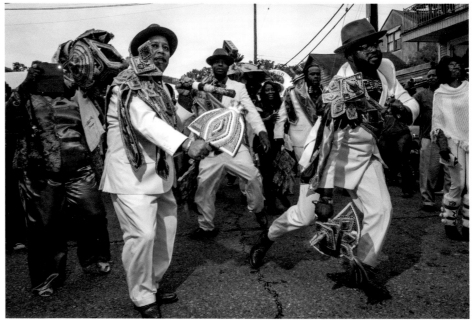

the parade route, often wearing their club T-shirts, with drinks and snacks to give to the parading club when it passes by. According to the route sheet for a recent Dumaine Street Gang parade, various stops were hosted by Ole & Nu Style Fellas, Family Ties, Sudan, Undefeated Divas, and Nine Times. The Dumaine Street Gang will undoubtedly return the favor and host a stop for each of these clubs when they parade. Bernard Robertson of Sudan has close ties to Fred Johnson of the Black Men of Labor, stemming from their mutual involvement in Jerome Smith's Tambourine and Fan. Robertson regularly serves as a banner carrier for the Black Men of Labor parade, and the Black Men of Labor reciprocate by hosting a stop for Sudan during their parade. Whether hosting a stop or not, clubs show their support for one another by coming out to the parades; members stand by the ropes, shout encouragement, and give high fives as the paraders come dancing out the door.

Despite the differences in the practices of the SAPCs and the city's Mardi Gras Indians, many of the participants are the same. Some second liners have belonged to Indian gangs or continue to do so, and vice versa. Monk Boudreaux is a perfect example of someone with a foot in both cultures: big chief of the Golden Eagles, he has also paraded with the Young Men Olympian Jr. His daughter Wynoka "Nokie" Boudreaux Richardson, a founder of the Ladies of Unity, also masks Indian. Joe Stern, president of the Prince of Wales, dons a skull and bones outfit and parades with Boudreaux on Mardi Gras Day, St. Joseph's Night, and Super Sunday. Nelson Thompson, one of the founders and presidents of the Money Wasters, and Wendell Jackson, president of the Original Four, also masked Indian. Wardell Lewis Sr., a founder of the Scene Highlighters and the Men Buckjumpers, was spy boy for his father's gang, the Black Eagles. Edgar Jacobs Jr., the Choctaw Hunters' big chief, is also a member of the Big Nine. Almost every social aid and pleasure club has a member currently or previously active in Mardi Gras Indian culture.

Perhaps the most important aspect of this cross-pollination is in the creation of the clubs' decorations. Monk Boudreaux has made the decorations for several clubs, including the YMO Jr., the Prince of Wales, and the Westbank Steppers. Melvin Reed, who designs and fabricates the decorations for the Black Men of Labor, learned how to sew from Allison "Tootie" Montana, big chief of the Yellow Pocahontas. Reed, in turn, taught Adrian "Coach Teedy" Gaddies, who designs for his club, Sudan, as well as for the Dumaine Street Gang.

Two second line clubs, the YMO Jr. and the Lady Buckjumpers, participate in Super Sunday, the big gathering of the uptown Mardi Gras Indians that takes place on or near St. Joseph's Day in A. L. Davis Park on the corner of Washington and La Salle. A music stage is set up, and food booths ring the perimeter of the park. The Indians gather in the park and spread their regalia on the grass for all to admire. The atmosphere is like that of a music festival, with a performance stage and food booths—two of which are run by the YMO Jr. and the Lady Buckjumpers.

OPPOSITE Big Chief Tyrone "Pie" Stevenson of the Monogram Hunters creating decorations for Spirit 2 Da Street, 2015, by Ryan Hodgson-Rigsbee (top–bottom): putting it together, almost ready, and on the streets

The demographics of the second line community are beginning to diversify, particularly since Hurricane Katrina, which prompted a heightened appreciation of New Orleans's unique culture among longtime residents and newcomers alike. The followers at the second line parades started to include more white faces. And, rather than watching it pass by, they participated, dancing and marching with the second line. While club membership remains overwhelmingly Black, some clubs have become more diverse in recent decades. Linda Green, "The Ya-Ka-Mein Lady," is proud that her club, the Lady Rollers, has both white and Black members: "I like to call it salt and pepper," she said, while noting that the club's membership policy has received some criticism.[5] Green also invites some of the dance groups that participate in Mardi Gras parades, like the Pussyfooters or the Party Line Steppers, to join the Lady Rollers' parade.

Regardless of family, neighborhood, or school, love of the tradition is what binds the SAPC community together. As more than one club member has said, "I am addicted to parading." The Sunday parades are a way of life: club members who come out for other club parades do so not only out of friendship but also out of sheer love of the second line tradition. They help fill the streets at the starting point and press against the ropes in anticipation. They help create the palpable sense of excitement as a club comes out the door and the parade takes off. It is this weekly ritual, this lasting and fervent community participation in the culture of second lining, that offers the strongest hope for its continued survival.

NOTES

1 Raynold Fenelon, interview with Charles "Action" Jackson, *Takin' It to the Streets*, WWOZ.org, November 7, 2020.

2 Tyrone "Tuffy" Nelson, interview with Judy Cooper, 2014.

3 Bruce Sunpie Barnes and Rachel Breunlin, eds., *Talk That Music Talk: Passing On Brass Band Music in New Orleans the Traditional Way* (New Orleans: University of New Orleans Center for the Book, 2014), 68.

4 Nine Times Social and Pleasure Club, *Coming Out the Door for the Ninth Ward*, 2nd ed. (New Orleans: Neighborhood Story Project, 2007), 147.

5 Linda Green, interview with Judy Cooper, September 2014.

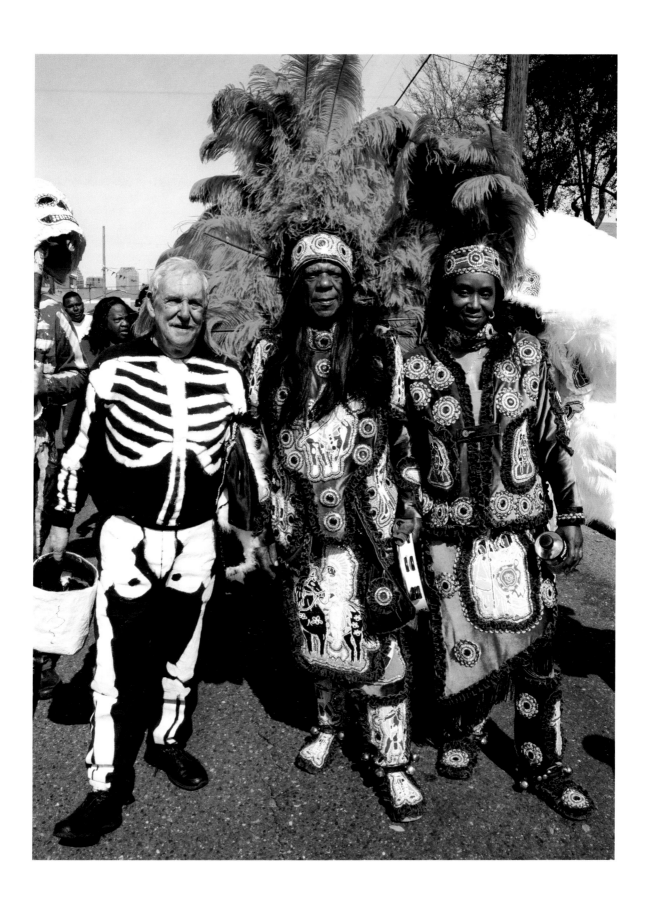

Joe Stern, Big Chief Monk Boudreaux, and Queen Chellene Boudreaux at Super Sunday, 2015, by
Judy Cooper

YOUNG MEN OLYMPIAN JUNIOR

BENEVOLENT ASSOCIATION

Neighborhood

Uptown (Central City)

Parade Day

Second Sunday in September
(small anniversary parade); fourth
Sunday in September (full parade)

Motto

In Unity, In Strength

The Young Men Olympian Jr. is the oldest of New Orleans's traditional parading clubs. With more than a hundred members, it is also the largest. As a benevolent association, the organization strives to reflect its origins in social welfare by maintaining a long list of charitable and community-oriented activities. The banner's logo—two doves and two clasped hands, the symbol of brotherhood—illustrates this commitment to service.

Unlike most of the social aid and pleasure clubs, the YMO Jr. has a written constitution, a copy of which is presented to every member. Current president Norman Dixon Jr. believes the constitution, which codifies the benefits and rules of membership, is a main factor in the organization's longevity and stability. There are more than twenty officers, including Norman, Vice President Waldorf "Gip" Gipson III, and Grand Marshal Jerome "DJ Jubilee" Temple.

The YMO Jr. is so large that it has six divisions, with a separate leader for each: the Body; the First Division; the Second Division, known as the New Look, made up of the junior members of the club; the Third Division, or the Big Steppers; the Fourth Division, called the Untouchables; and the Fifth Division, known as the Furious Five.

In addition to being the oldest and largest of the parading clubs, the YMO Jr. is also the most traditional. There are no women members. Their parades do not have a king or queen, and they do not use floats or other vehicles except for a few cars for some of the older members.

The YMO Jr. is one of only two clubs to have two parades during the annual season. The smaller of the two, the anniversary parade, follows the customs of the early parades of the old benevolent associations. Scheduled two weeks before the big parade, it is always preceded by a church service that looks both backward and forward: the club memorializes members that died the preceding year and swears in the new officers for the coming season. After the service, the parade forms just outside the church, with members dressed in black pants, white jackets with a black-and-white YMO Jr. patch, a ribbon, fezzes, and white gloves. They sometimes carry black canes, but there are no other decorations, such as sashes, fans, or feathers. There is only one band, and the members mostly march along without breaking into fancy dance steps. They often pass Lafayette Cemetery No. 2 on Washington Avenue, where the club has two crypts. When the club passes the cemetery, the band plays a dirge, and the members do the "funeral" step, slowly swaying side to side.

The second parade is a totally different story. Each division parades as a separate entity and chooses its own outfits and decorations. The clubhouse, located at the

OPPOSITE YMO Jr. (clockwise from top left): Nigel Malik Pleasant, 2011, by Charles Muir Lovell; the Furious Five, 2011, by Judy Cooper; Lionel Brown, Herbert Gettridge, and Tom Landry in front of the clubhouse, 2010, by Judy Cooper; Pastor Keane leads the anniversary parade past Lafayette Cemetery No. 2, 2014, by Judy Cooper

corner of South Liberty and Josephine Streets, has two entrances, allowing the different divisions to come out of alternate doors, each with its own band. Accompanied by a large, enthusiastic crowd, the big parade follows a traditional route through Central City, starting and ending at the clubhouse. Stops include the Sportsman's Corner, at Second and Dryades Streets, and Club Bali, on Martin Luther King Jr. Boulevard.

The YMO Jr. was the first club to parade at the New Orleans Jazz and Heritage Festival and has been an important part of the Fest ever since. Longtime member Norman Dixon Sr. served as the original coordinator of the second line parades at Jazz Fest and held the position until his death. His son Norman Dixon Jr. inherited the role.

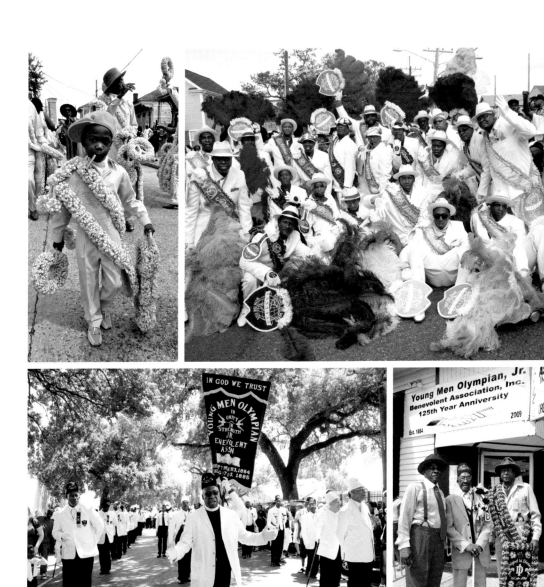

ZULU

SOCIAL AID AND PLEASURE CLUB

<div style="text-align: right">

1909/16

</div>

Neighborhood

Downtown (Sixth Ward)

Parade Day

Third Sunday in May

(anniversary parade);

Mardi Gras Day

(Carnival parade)

The second oldest of the present-day social aid and pleasure clubs, Zulu began around the turn of the twentieth century as a group of men called the Tramps, who paraded on Mardi Gras Day. Legend has it that the group saw a comedy skit, called "There Never Was and Never Will Be a King Like Me," about an African tribe, the Zulus. The men were so enthralled that they decided to change their club name.

The newly christened Zulus first paraded in 1909, unveiling the satirical style that has become their trademark. Playing off the royalty of the white Carnival krewes, the king wore a lard-can crown and carried a banana-stalk scepter. A few years later, Zulu featured its first float, built out of dry-goods boxes on a wagon and pulled by mules. In 1916, the club incorporated. Over the following century, the parade grew in size and popularity, becoming one of the most anticipated events of the Carnival season. It is the first parade to roll on Mardi Gras Day, preceding even the so-called King of Carnival, Rex, down St. Charles Avenue.

Today, Zulu's membership numbers in the thousands, counting among its ranks some of the most affluent and socially and politically connected African Americans in the city. The club has its own clubhouse on North Broad Street at the corner of Orleans Avenue.

In addition to putting on its Mardi Gras parade, Zulu also observes the parading tradition of the social aid and pleasure clubs with a smaller anniversary parade during the regular second line season. In recent years, the anniversary parade has become a vehicle for politicking by the club's candidates for king, Big Shot, and other important personages for the next year's Mardi Gras parade.

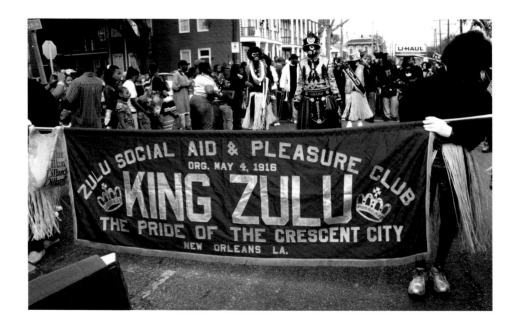

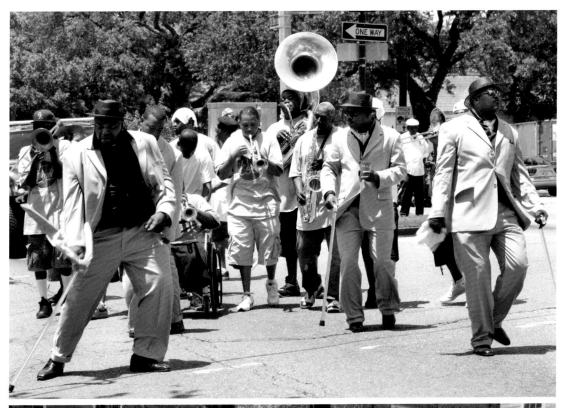

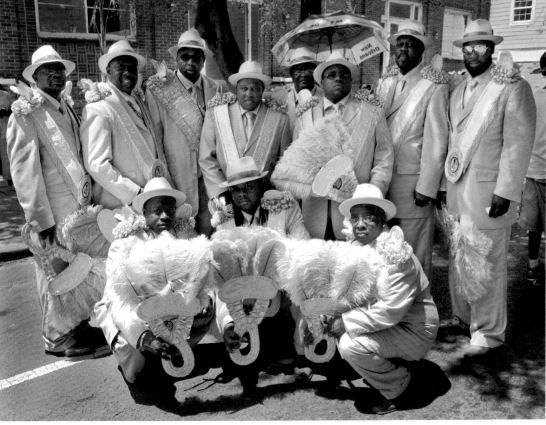

OPPOSITE Zulu's banner leads the club's Mardi Gras parade, 2007, by Judy Cooper
ABOVE Zulu, 2010, by Judy Cooper (top–bottom): dancing with the Hot 8 Brass Band; apricot yokes with white doves

ORIGINAL PRINCE OF WALES

SOCIAL AID AND PLEASURE CLUB

1928

Neighborhood

Uptown

Parade Day

Second Sunday in October

The Prince of Wales was founded by a group of men who lived uptown near the Mississippi River, many of them employed as longshoremen and railroad workers. Legend has it that they formed the club in a bar on Tchoupitoulas Street called the Anchor Inn. The name of the club was inspired by the label on J&B scotch bottles—a favorite drink of the original members—which bears a list of English royalty, including the Prince of Wales. The members had heard that the prince was a sharp dresser, and they liked that association. The year after forming, in 1929, the club received a city charter "for the social, aid and pleasure of its members."

According to Joe Stern, who joined in the late 1980s and is currently CEO, the club resumed parading following a long hiatus when some of the old members were invited

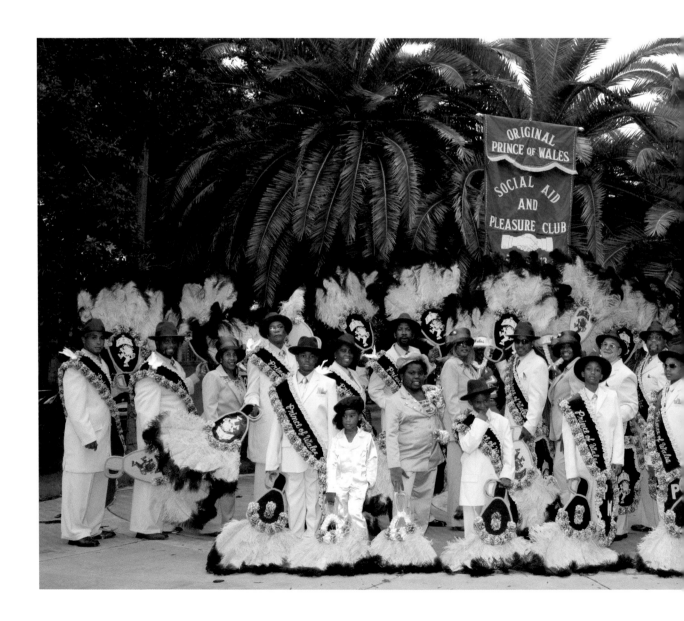

to march with Zulu. They enjoyed it so much, they decided to regroup and bring the Prince of Wales to the streets again. A women's division, the Lady Wales, was founded in 1995.

The Anchor Inn no longer exists, but the club still begins its annual parade on Tchoupitoulas Street, at the Rock Bottom Lounge. A queen rides a float at the beginning of the parade, sometimes accompanied by a king. In recent years, the club has made its final stop at Commander's Palace, the famed fine-dining restaurant in the Garden District. The 2019 parade commemorated the four hundredth anniversary of the arrival of enslaved people in the United States, with the theme "1619 to 2019: And Still We Rise." According to Stan Taylor, the club's business manager, the theme had local relevance, given the city's struggles with gentrification and equity. "A lot of people are trying to write off New Orleans . . . but still we rise."

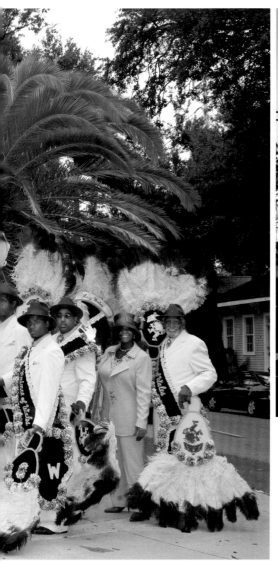

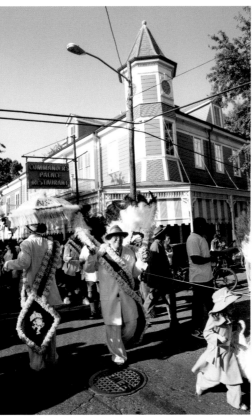

LEFT Prince of Wales, 2009, by Judy Cooper
RIGHT Leaving Commander's Palace, 2010, by Judy Cooper

SCENE BOOSTERS

MARCHING CLUB

Neighborhood

Uptown

Parade Day

Last Sunday in May

In 1972, Wardell Lewis Sr. founded a club called the Scene Highlighters. A year later, his father, Percy Lewis, and Baptiste Giles Jr. started the Scene Boosters as a booster club for the Highlighters. When the two clubs paraded together, the Scene Highlighters came out of Scene, a bar near the corner of La Salle Street and Washington Avenue, and picked up the Boosters at the Hideaway, further down Washington. The Boosters outlived the Highlighters and continued parading until 2007. After more than a decade on hiatus, the club planned a comeback for the 2019–20 season. Alas, the coronavirus pandemic cut those plans short, but the Boosters hope to make their return to the streets once second line parades are allowed to resume.

The Boosters were the second club to parade at Jazz Fest, beginning in 1976, one year after the Young Men Olympian Jr. For several years, the two clubs alternated weekends at the Fest. The Boosters maintained a presence at Jazz Fest even throughout the club's street hiatus.

Like the YMO Jr., the Scene Boosters has been a feeder club, giving many other founders and members their start in the second line tradition. Naomi "Shorty" Gibson of the Lady Jetsetters, Terrence Williams of the New Generation, and Travis Lyons of the Perfect Gentlemen all started out in the Boosters' kids' division, Kool and the Gang, formed by Johnnie "Kool" Stevenson.

Members of the Scene Boosters have been witness to a lot of second line history and tradition. Harry Wilson, the current president, grew up watching his father and uncle parade with the Jolly Bunch. Another longtime member was Johnny "Too Thin" Smith Sr., who was in the Boosters for forty years and the YMO Jr. for seventy-five, having first joined the benevolent association at age five. He passed away in 2019 and was given a traditional YMO Jr. funeral.

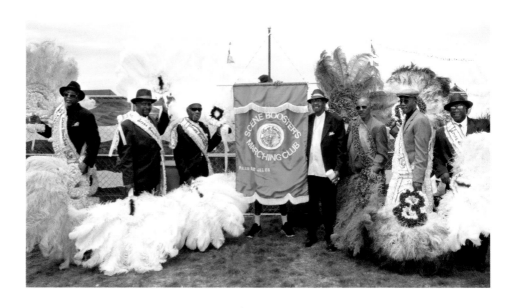

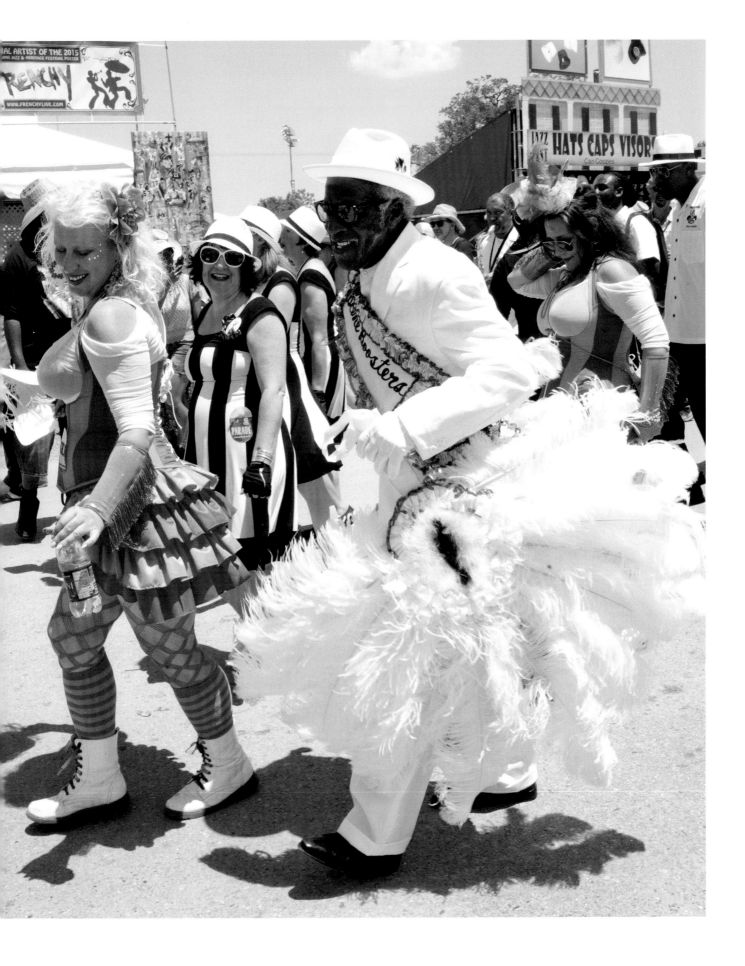

OPPOSITE Scene Boosters at Jazz Fest, 2014, by Judy Cooper
ABOVE Harry Wilson dancing with members of the Pussyfooters marching group at Jazz Fest, 2015, by Judy Cooper

MONEY WASTERS

SOCIAL AID AND PLEASURE CLUB

Neighborhood
Downtown (Treme and
Seventh Ward)

Parade Day
Last Sunday in May

Cofounders Benny Jones Sr., Louis Fritz, Curtis Watson, and Andrew Green had all been part of the Treme–based Sixth Ward Diamonds, and in forming their own club they took inspiration from SAPC history, adopting the name Money Wasters from a bygone club from the 1920s. Benny was the club's first president, followed by Cornell Thompson, and, later, his brother, Nelson Thompson, who brought the Money Wasters into the present era.

The club was large from the beginning. Founding member Anthony Bennett remembers that the first parade featured ten divisions, which included four other participating clubs, a mounted division with five or six horseback riders, and one hundred children. For some time, the Money Wasters were one of the largest clubs in the city, rivaling the YMO Jr. and the Jolly Bunch. Several of the newer downtown clubs saw the Money Wasters as their inspiration.

The club initially formed as a men's organization with a large children's division, and the Lady Money Wasters came along soon after. Lois Nelson, of the Andrews musical family, was one of the first Lady Money Wasters. For both the ladies' and men's divisions, the club colors are naturally green and white, the color of money.

For parades, the club first came out of Felton's Lounge on Orleans Avenue, then, for many years, used their clubhouse on St. Philip Street. More recently, the parade has started at the Charbonnet-Labat-Glapion Funeral Home in Treme—a fact that might seem strange to someone unfamiliar with the intertwined histories of SAPCs and jazz funerals. Many funerals for SAPC members originate at Charbonnet. Owner Louis Charbonnet III has been a member of the Money Wasters since the 1980s and reigned as king in 1992.

The Money Wasters were one of the first clubs to parade at Jazz Fest and continued to do so until Katrina. As with many other clubs, the 2005 flood dealt them a near-fatal blow. In addition to losing the club banner and all of their decorations for the 2006 parade, many members were unable to return to the city right away. They had to give up their date that year, but, with Nelson Thompson at the helm, were able to regroup and parade in 2007. After Nelson's death, in 2014, his funeral took the place of that year's parade. A large floral display in green and white, sent by the club, bore the letters M and W separated by a dollar sign. Nelson's vintage green Cadillac

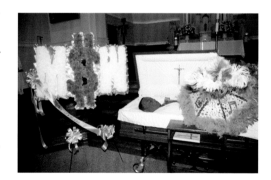

Nelson Thompson's funeral, 2014, by Judy Cooper

convertible, of which he had been immensely proud, was parked in front of the church, sporting a large dollar sign on the hood. A traditional funeral procession followed the mass.

Without Nelson's leadership, the club was not able to organize a parade in 2015, and some feared the Money Wasters would dissolve completely. Once again, though, the members were able to regroup, and the club resumed parading in 2016.

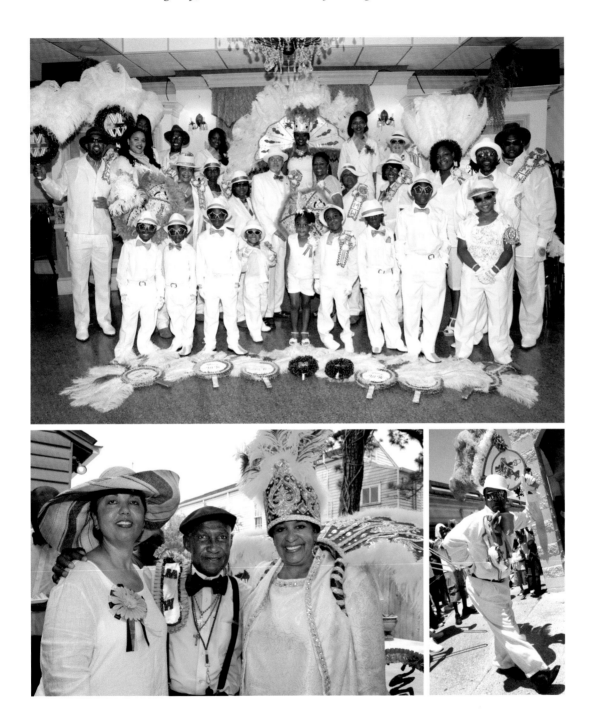

Money Wasters, by Judy Cooper (clockwise from top): at the Charbonnet Funeral Home, 2012; coming out the door, 2010; Dr. Jarrett Johnson, Ralston Andry, and Queen Ada Robertson, 2016

ORIGINAL FOUR
SOCIAL AID AND PLEASURE CLUB

1979

Neighborhood
Uptown

Parade Day
Fourth Sunday in October

Motto
Here to Stay

The Original Four has a reputation for being a well-dressed club, thanks in large part to the influence of several founding members—cofounder Kevin Dunn, now a professional designer and fabricator of decorations for many second line clubs; Kevin's brother, Carlos Dunn, another cofounder, who masks Mardi Gras Indian; and Wendell Jackson, who also masks Indian. All three were members of the YMO Jr. together, in the Fourth Division, and the Original Four's name is an homage to those roots. Early on, the founders wanted an emphasis on visual presentation. The logo on the banner reflects this aesthetic interest: it shows a second line man in full dress having his outfit brushed clean by a woman. As Wendell, president since 1985, says: "We give them the beauty, the creativity."

For their decorations, the Original Four favor streamers, sticks (canes), and fans. Kevin Dunn still makes the decorations, even though he has had to stop parading for health reasons. The club is known for changing decorations during the course of the parade; after Hurricane Katrina, members started changing outfits, as well. For their thirty-fifth anniversary, all the decorations featured a large clock with the hands pointing to 4:35.

Though they consider themselves an uptown club, they traditionally start their parade downtown at Armstrong Park, then cross Canal Street and finish uptown.

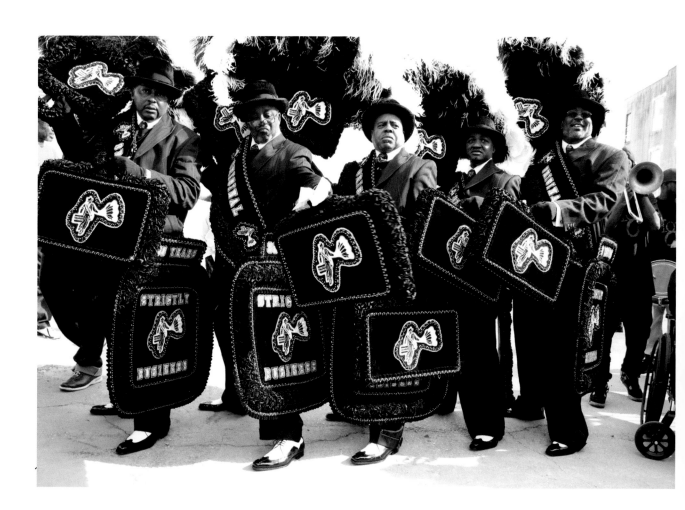

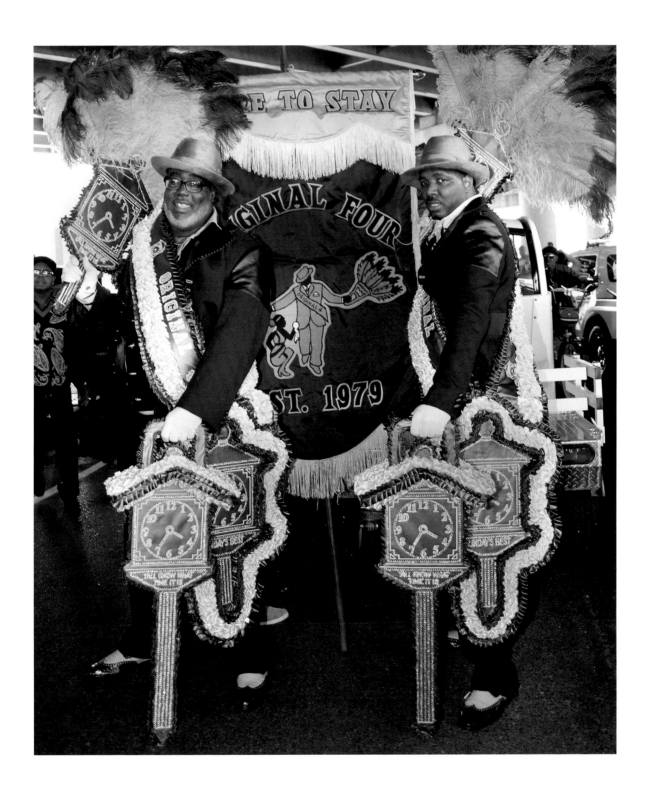

OPPOSITE "Strictly Business" (left–right): Gerald Belonga, John Spoon, Kevin Dunn, Steven Fredrick, and Wendell Jackson, 2009, by Judy Cooper

ABOVE Wendell Jackson and Herbert "Hollywood" Thomas, 2015, by Judy Cooper

SUDAN

SOCIAL AID AND PLEASURE CLUB

1983

Neighborhood

Downtown (Treme and Sixth Ward)

Parade Day

Second Sunday in November

"We always come out smiling," says Bernard Robertson, one of the founders of Sudan. "We are showing our footwork and our pretty white teeth. A chill goes through your body when you come out the door."

The club was established by Bernard, Adrian "Coach Teedy" Gaddies, David Crowder, Kenneth Dykes, and Archie Chapman as an outgrowth of the Tambourine and Fan and its related parading group, the Bucket Men. In search of a distinctive name for the club, Bernard found inspiration when he saw the word "Sudan" in big letters on a map of Africa. When he researched the country, he read about a tribe of men who danced from village to village spreading peace. Sudan adopted both the name and the mission, of dancing to spread peace and joy through the neighborhood.

The Sudan members keep their outfits simple—shirts and pants, like the Bucket Men—but go all out for their accessories. Coach Teedy and David, who learned from Melvin Reed of Tambourine and Fan, make all the decorations—always variations on the basket, umbrella, and fan. These items are featured on the club's banner, superimposed over an image of Africa.

Their parade follows a regular downtown route, starting at the Treme Recreation Community Center and making certain traditional stops, including Sweet Lorraine's Jazz Club and the family homes of founders Archie Chapman and Kenneth Dykes. In keeping with the mission of Tambourine and Fan, Sudan is intent on nurturing the SAPC tradition among younger generations, and one of the club's two divisions includes a number of children.

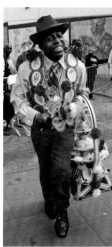

ABOVE Sudan on parade, by Judy Cooper (left–right): Chris Paul Terro, 2010; Bernard Robertson, Wendell "Creek" Carter, Chris Paul Terro, Keith Ratcliffe, and Kendrick Johnson, 2014; Bernard Robertson, 2010

OPPOSITE Sudan Kids, 2010, by Pableaux Johnson

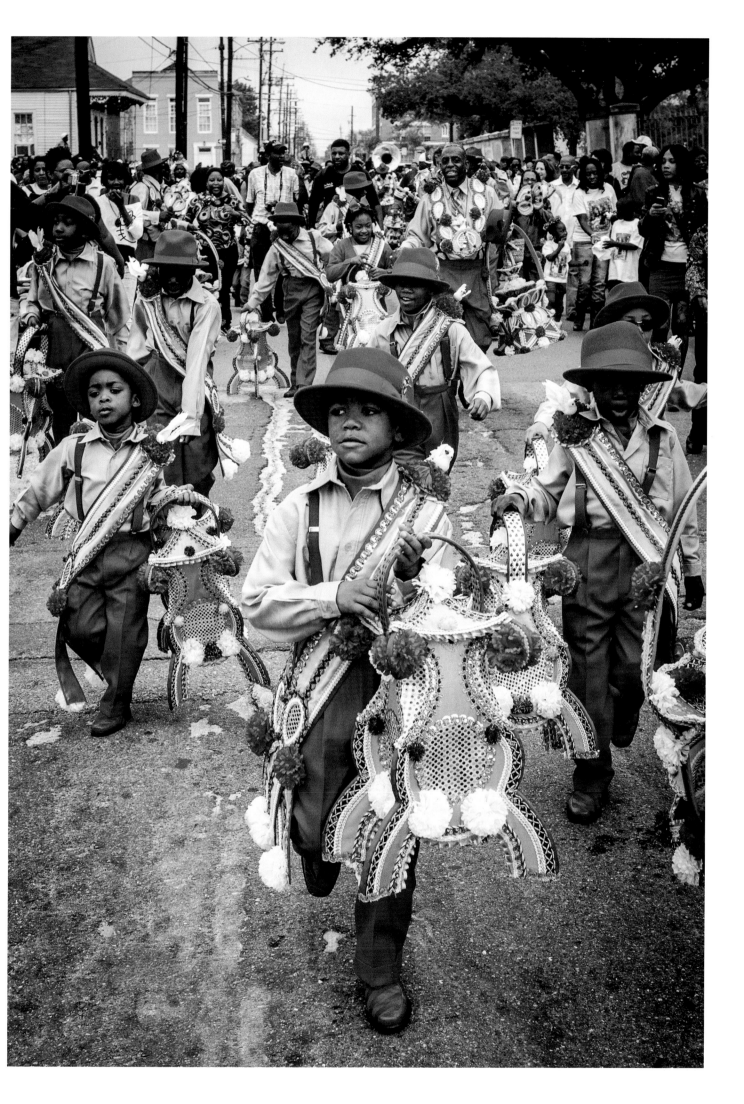

ORIGINAL NEW ORLEANS BUCKJUMPERS AND ORIGINAL NEW ORLEANS LADY BUCKJUMPERS 1984

SOCIAL AID AND PLEASURE CLUBS

Neighborhood
Uptown

Parade Day
Last Sunday of November

Motto

On the Wall

Buckjumping, a familiar term in second line parlance, describes particularly energetic, enthusiastic, and athletic dance moves. Parade spectators always hope to see some buckjumping, especially when the club members first come out the door. True to their name, the Lady and Men Buckjumpers do not disappoint.

Founders Frank Charles III, Lawrence Holmes, and Wardell Lewis Sr. chose the name with the goal of becoming known as a fine dancing club. Wardell had previously organized the Scene Highlighters in 1972, but the club had stopped parading. The men decided to include a ladies' club, so they asked Viola Fielder and Gwendolyn Johnson to recruit members for the Lady Buckjumpers.

Though the men and women have paraded together since the beginning, they have come to function as separate clubs with their own officers, activities, and banners— sometimes even wearing different colors for the parade. Each club also has its own band. Rebirth always plays for the ladies, in part because Linda Tapp Porter, president of the Lady Buckjumpers, and Phil Frazier, leader of Rebirth Brass Band, have been a couple for over twenty years. For their parade, the Men Buckjumpers have a queen,

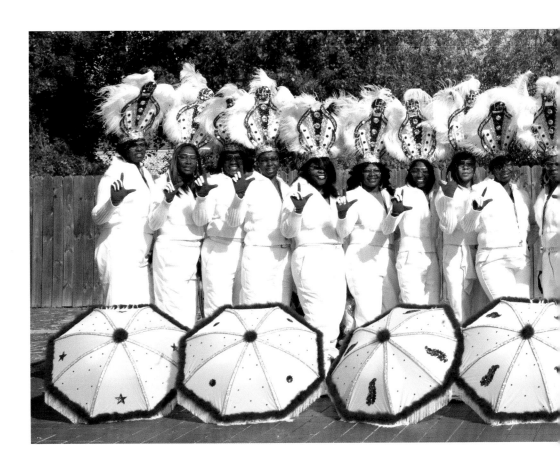

and the Lady Buckjumpers have a king. Trumpeter Kermit Ruffins, one of the founders of Rebirth, was king in 2010.

Many of the original Lady Buckjumpers retired in 2004, with the club's twentieth anniversary, but Linda and her sister, Barbara Rainey, have continued to attract new members, making the Lady Buckjumpers one of the largest female clubs in the city. Like the Men Buckjumpers, they are known for their dancing, both individually and as a group. They often do dance routines choreographed by founder Gwendolyn Johnson.

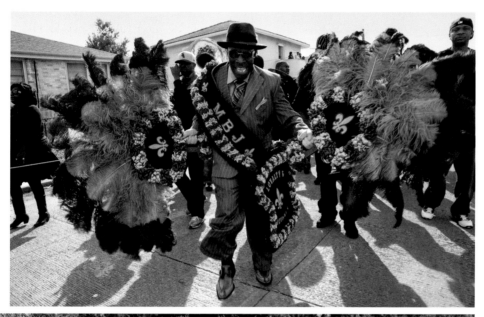

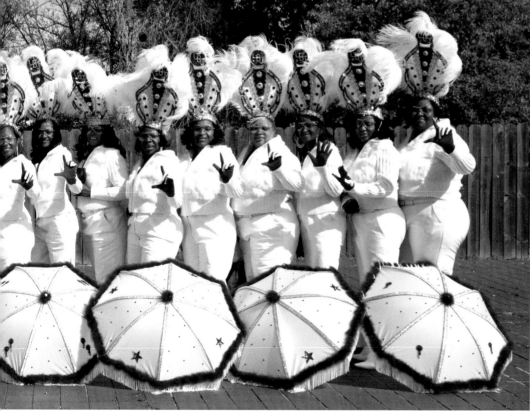

TOP Timothy Scott, Men Buckjumpers, 2011, by Judy Cooper
BOTTOM The Lady Buckjumpers on their twenty-fifth anniversary, 2009, by Judy Cooper

VALLEY OF SILENT MEN

SOCIAL AND PLEASURE CLUB

1985

Neighborhood
Uptown

Parade Day
Late August

Motto
In God We Trust;
Out of the Valley Comes
Those Who Are Chosen
and They Are Here

The Valley of Silent Men was founded on August 20, 1985, by Leon Anderson Sr., Herbert Gettridge, Larry Maxent, and John West. It was Herbert who chose the name out of the Bible, adapting from Ezekiel 37:1–14. In the passage, known as "The Valley of Dry Bones," God breathes life into bones to make them rise as men again.

The Valley has been a men's club since its founding, but the club added one woman, Nicole Lazard, to the roster in 2016. To demonstrate her special role in the club, members call her their First Lady. John West served as president until his death, in 2011, upon which Leon "Smurf" Anderson Jr. took his place.

The Valley's parade kicks off the parading season. In spite of the late-summer heat, the members typically wear suits, in lightweight fabrics and bright colors. In recent years, the club's decorations have been made by various people—Wendell "Creek" Carter, who, like several members of the Valley, is also a member of the YMO Jr., and Terrence Williams of the New Generation. The August 2005 parade was canceled because of Katrina, but the club was able to come back the following year. In honor of the occasion, Creek made the club fans in the shape of a hurricane.

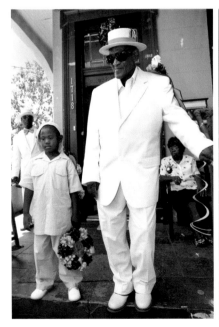 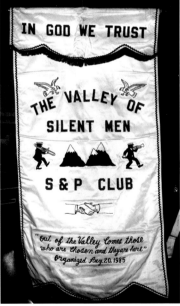

ABOVE Valley of the Silent Men, by Judy Cooper (left–right): John West with his grandson, 2011; the club banner; Calvin "Little Man" Jones coming out of Tapps II, 2013
OPPOSITE In the streets (top) and at Jazz Fest (bottom), 2011, by Judy Cooper

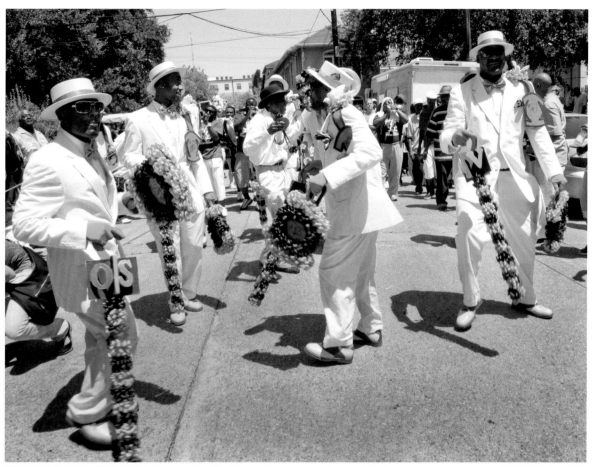

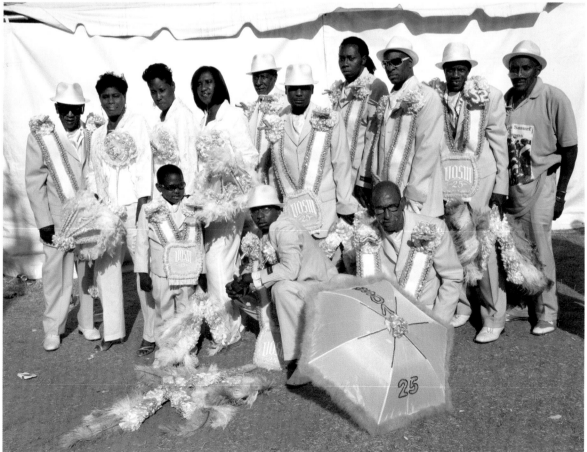

LADY JETSETTERS

MARCHING CLUB

Neighborhood

Uptown (Central City)

Parade Day

Second Sunday in January

Motto

Love, Life, Togetherness

Founder Naomi "Shorty" Gibson, a forty-year veteran of the second line scene, began parading in 1972 with her son in the Scene Highlighters and its auxiliary club, the Scene Boosters. Naomi lived in the B. W. Cooper housing projects—better known by its previous name, the Calliope—and frequented the Rose Tavern, a gathering place for a number of second liners, including Johnnie "Kool" Stevenson, the founder of Kool and the Gang and the Calliope High Steppers. Naomi and Johnnie Kool were great friends and paraded together for years. When he formed the Calliope High Steppers, Naomi paraded alongside with her own club, which she called the Jetsetters.

Naomi describes the Lady Jetsetters as a traditional club. Most of its members are family, including her two sisters, her daughter, and a cousin. Naomi's son, Rocque "Rock" Caston, makes their fans. The Lady Jetsetters sometimes have a king who

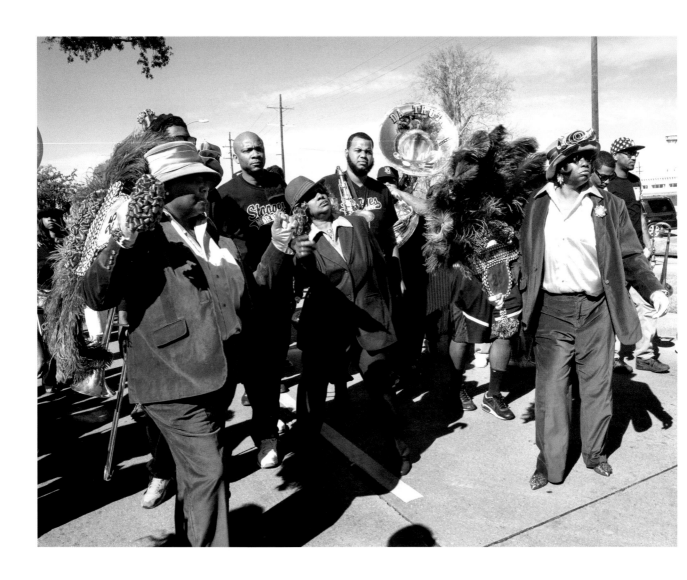

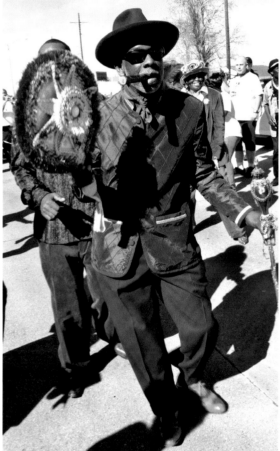

chooses his own outfit and decorations, as well as whether to have a float. Trumpeter Gregg Stafford was king one year and continues to parade with the club.

Naomi retired from the club in 2015. That year's route sheet honored the milestone by describing the parade's theme as "riding off into the sunset," and she and the club members wore cowboy garb. But her family wouldn't let her disappear completely; the following year, she rode in a car.

When asked to describe the essence of second lining, Naomi's response was immediate and emphatic: "Fun, fun, fun!"

OPPOSITE Demetrius Thomas, Joyce Parker, and Creola "Jackie" Moon, 2014, by Judy Cooper
ABOVE Lady Jetsetters, 2014, by Judy Cooper (left–right): Naomi "Shorty" Gibson coming out the door; Gregg Stafford

WESTBANK STEPPERS

SOCIAL AID AND PLEASURE CLUB

1989

Neighborhood
West Bank (Algiers)

Parade Day
First Sunday in December

Motto
They Ain't Heavy

The Westbank Steppers are the only social aid and pleasure club currently based on New Orleans's West Bank, across the Mississippi River. (The area was also home to the Algiers Steppers and the Eagle Eyes, now defunct.) Founder and president Henry "Pal" Alexander has been familiar with second line clubs since his childhood in the Sixth Ward, where he saw the parades of the Jolly Bunch and the Money Wasters. After witnessing a Zulu funeral in the late 1980s, he decided to form a second line club.

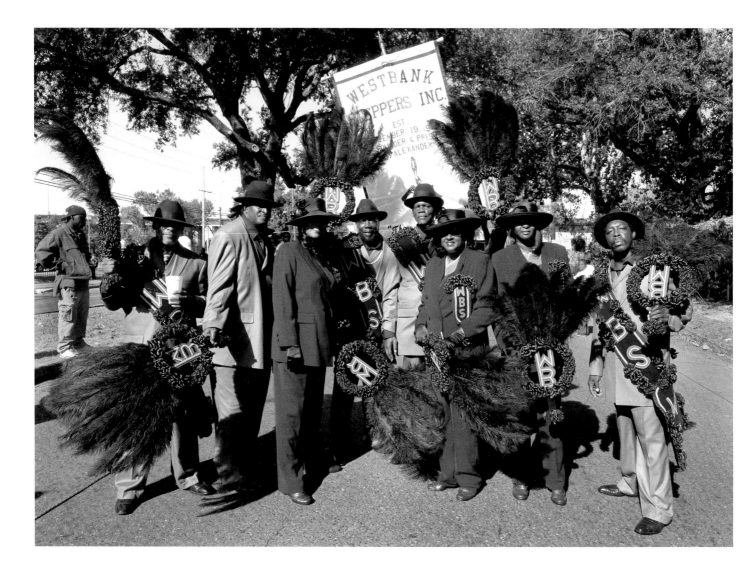

Henry "Pal" Alexander (center, in front of banner), Westbank Steppers, 2013, by Judy Cooper

The club's parade shares a date with the Dumaine Street Gang on the East Bank, presenting a problem for friends of both clubs who want to catch the two parades. A queen rides in a convertible or on a float, and some years they also have a king. Most years, another club rides in a trolley-trailer. The Small Souljas Brass Band, also based on the West Bank, provides the music.

Throughout the club's existence, Pal has been committed to helping his West Bank community by providing free Thanksgiving dinners in advance of the club's early-December parade. When the Steppers were first starting out, Pal told Action Jackson, "I said before we parade, what we oughta do, let's do something for the community. So we started feeding the people . . . and also taking old ladies to the store, make sure they can make their groceries without being robbed, all [wearing] the Westbank Steppers T-shirt, like security—stuff like that. And the rest is history!" Pal shares his commitment to mutual aid with members of other clubs as well, encouraging them to keep that part of the tradition active. "I try to talk to a lot of them, tell them to try to do something in the community. If everybody can do something, just a little something, we stay strong."

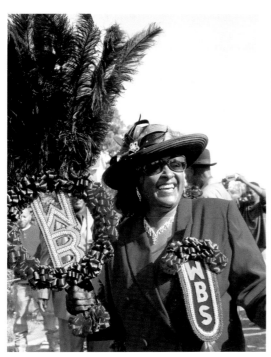
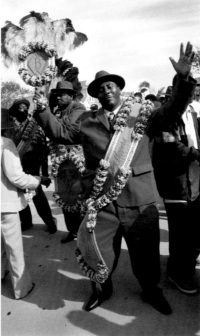

LEFT Mrs. O, 2013, by Judy Cooper
RIGHT Stepping on the "Best Bank," 2011, by Judy Cooper

PERFECT GENTLEMEN

SOCIAL AND PLEASURE CLUB

1991

Neighborhood

Uptown (Central City)

Parade Day

First Sunday in January (anniversary parade); second Sunday in June (Father's Day parade)

Motto

From the Beginning to the End, We Dance Like Perfect Gentlemen

When club president Travis Lyons started parading at ten years old, "I felt like I was one of the hottest dancers on the streets," he said. "I eat, breathe, and sleep this thing. I am addicted to it."

The Perfect Gentlemen is the one club that has two full, four-hour parades in the season: The anniversary parade is held the first Sunday in January, making it the first parade of the calendar year. Another distinction of this parade is its unusual route, typically starting on Canal Street and then proceeding through the Central Business District to the more frequently traversed uptown neighborhood of Central City.

The Father's Day parade, held toward the end of the season, began as a dedication to all fathers missing from their family's lives, whether through death, distance, or incarceration. Members eschew a full outfit, instead wearing shirts and pants or shorts, and the parade follows a standard Central City route.

The Perfect Gentlemen are frequent hosts to clubs in need of a parade date. In the past few years they have been joined by the Men of Unity, the Original Gentlemen Steppers, the Extraordinary Gentlemen, the Sisters of Change, Devastation, the Dignified Achievable Men (DAM), and the Diamond Dynasty.

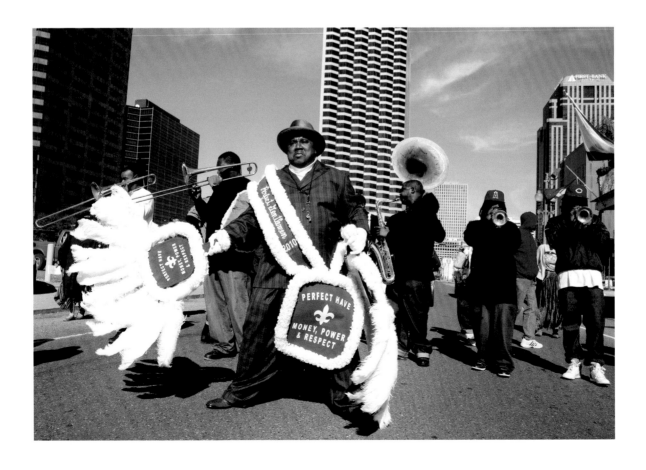

In 2016, Travis decided to form a second line parade of all the SAPC presidents, to bring them together in a show of unity and brotherhood. It took place on Saturday, February 13, preceded by a brief speech and prayer on the steps of City Hall and proceeding uptown from there to A. L. Davis Park.

OPPOSITE Travis Lyons of the Perfect Gentlemen, 2010, by Leslie Parr
ABOVE Travis Lyons's streamer, 2017, by Judy Cooper

ORIGINAL PIGEON TOWN STEPPERS

SOCIAL AID AND PLEASURE CLUB

1994

Neighborhood

Uptown (Pigeon Town)

Parade Day

Easter Sunday

Founded by brothers Sylvester and Joseph "Rollin' Joe" Henry and their friend John "Moosie" Glenn, the Pigeon Town Steppers take their name from their neighborhood, which extends west of Carrollton Avenue to the parish line, bounded by Claiborne Avenue and the Mississippi River. Their parade traverses this area, but also ventures past Claiborne to stop at the Broadway Bar and to pass by the cemetery on Adams Street, where members salute relatives buried there. In 2001, they were joined by the Lady Pigeon Town Steppers, who have paraded with them ever since.

The Pigeon Town Steppers played an important role in the history of second lining as the club that brought suit against the City of New Orleans for charging outrageous parade permit fees after Katrina, a development that threatened to shut down the entire tradition. In 2007 the police department charged the club $7,560 to parade, more than triple what the club normally paid and much more than they could afford. With the help of the New Orleans Social Aid and Pleasure Club Task Force and the ACLU, the Pigeon Town Steppers sued the city and won. Judge Kurt Engelhardt ordered the city to bring the fees back in line with their previous levels.

In keeping with the date of their parade, Easter Sunday, the Steppers typically choose bright colors for their outfits—sky blue and creamy yellow in 2007, lavender and lime green in 2015. For the club's twentieth anniversary, in 2014, members wore two full outfits, the first gold and the second beige and blue with fans featuring a shoe design. Their shoes, always two-toned alligator, are very important to them. In 2015, an alligator head was the design on their fans. Joe Henry, who has used a wheelchair since getting hit by a stray bullet at the age of twelve, decorates his wheelchair to match the outfits, covering both wheels with the club logo or anniversary year.

OPPOSITE Pigeon Town Steppers, by Judy Cooper (clockwise from top left): Gary Henry, 2007; George McGee celebrates the club's twentieth anniversary, 2014; preparing to come out the door, 2016

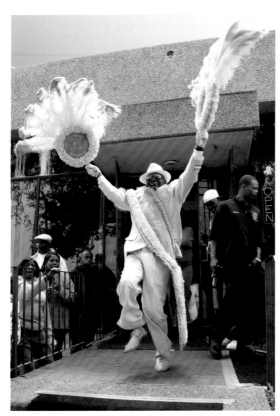
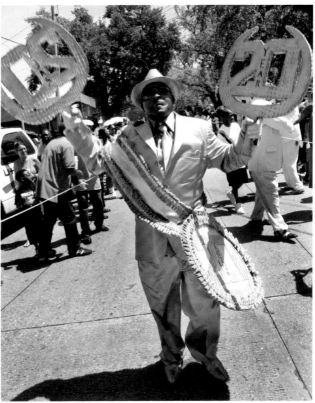
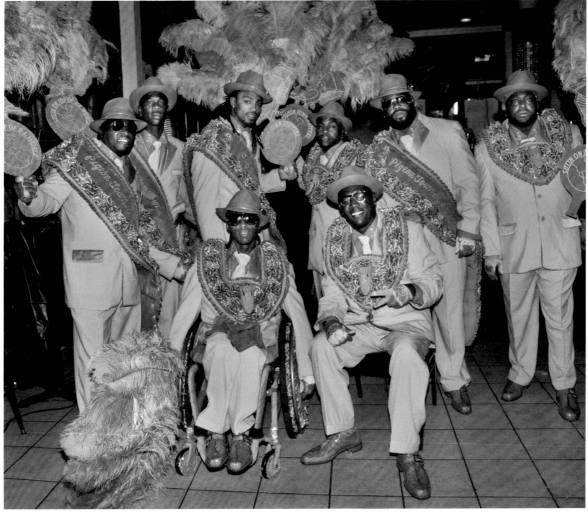

TREME SIDEWALK STEPPERS

SOCIAL AND PLEASURE CLUB

1994

Neighborhood

Downtown (Treme and Seventh Ward)

Parade Day

First Sunday in February

According to club treasurer and business manager Sean Martin, back in the day one could hear a band or see a jazz funeral in Treme almost any day of the week. Sean is one of the club's twenty cofounders, a group of young men and women who lived in the neighborhood and were influenced by its rich musical heritage. They all loved to follow the parades, often dancing on the sidewalk like many other second liners. From those roots, the club and its name were born.

The Sidewalk Steppers take pride in doing things a little differently from the more traditional second line clubs. They like to say, "Other clubs do what they can; we do what they want." In 1998 Sean arrived by helicopter to join the parade, landing in Hunter's Field, at North Claiborne and St. Bernard Avenues. Derrick "Charlie Brown" Walker, who has been president since the club's beginning, likes to end each parade with a dramatic flourish. At Kermit's Tremé Mother-in-Law Lounge, which serves as the club's home base, he gets on the rooftop, takes off his outfit, cuts it up, and throws the pieces to the expectant crowd below. For the grand finale, he puts the remaining shreds in a washtub and sets them on fire.

The club embraces the tradition of social aid—giving away turkeys at Thanksgiving, donating gifts at Christmas, and hosting back-to-school book fairs. After Katrina, club members got together and helped clean up the streets of the neighborhood.

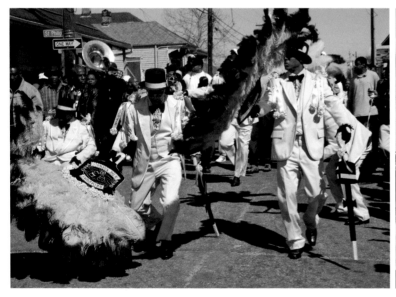

LEFT On the streets of Treme, 2011, by Judy Cooper
RIGHT Derrick "Charlie Brown" Walker's finale, 2015, by Judy Cooper
OPPOSITE Juanita "Nita" McNair, 2007, by Judy Cooper

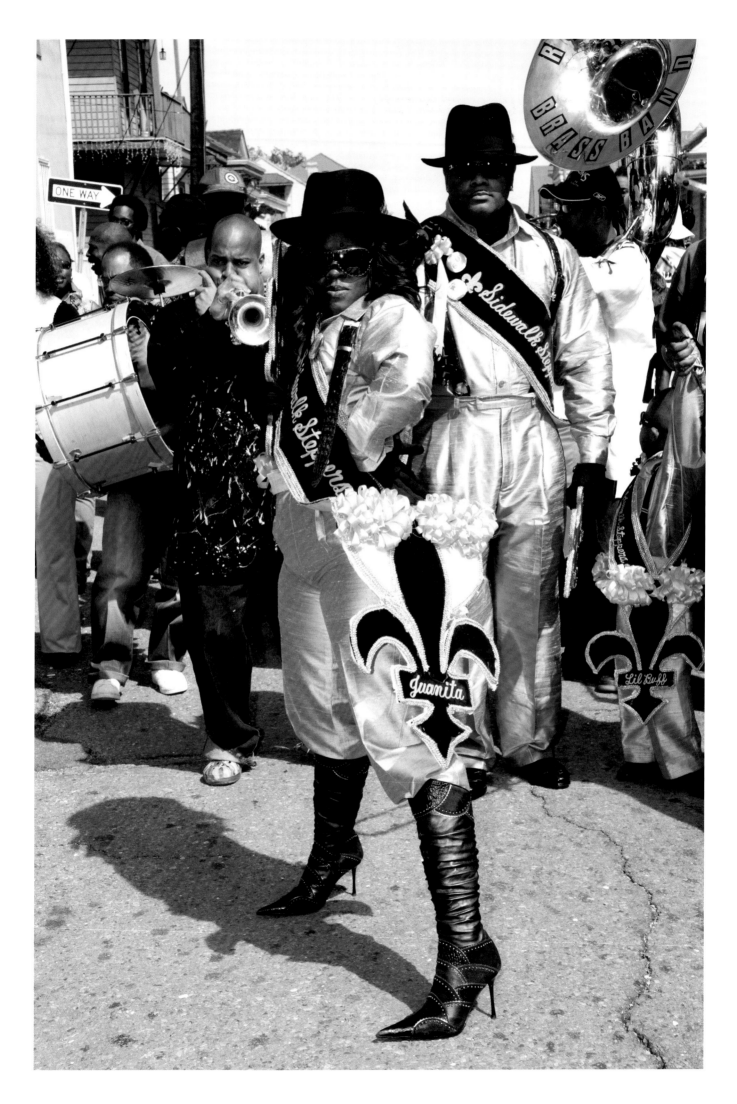

BLACK MEN OF LABOR

Neighborhood

Downtown

Parade Day

Last Sunday in October

In keeping with SAPC history and the origin of second lines in funeral processions, the Black Men of Labor was founded out of a funeral, that of jazz musician Danny Barker. In the 1970s, Barker, a banjo and guitar player, founded the Fairview Baptist Church Christian Band with the mission of teaching young musicians how to play traditional jazz. The band was instrumental in passing on the brass band tradition to the next generation, producing a number of professional musicians including Dr. Michael White, Leroy Jones, and Gregg Stafford. In his old age, Danny had lamented what he saw as the erosion of the tradition; some jazz funerals had become rather raucous affairs, with drunken second liners pouring beer on the coffin and foregoing the traditional dirges. So when he died in 1994, Gregg Stafford and Fred Johnson wanted to give him a dignified jazz funeral.

Appealing to Danny's wife, the singer Blue Lu Barker, Gregg Stafford offered to organize a band. He required them to wear white shirts, black pants, and hats like in the old days. Fred got together a number of men to act as marshals to maintain order. The funeral was so impressive that afterward, according to Fred, the men said, "We have to do this again—but not with a body." Fred, Gregg, and Benny Jones Sr. (leader of the Treme Brass Band) decided to form a club that would respect the old traditions and the old music. They also wanted to highlight the African roots of the tradition. The name, chosen by Fred, was designed to dispel the racist stereotype of Black men as lazy and shiftless.

Their parade begins and ends at Sweet Lorraine's Jazz Club, at the invitation of owner Paul Sylvester. Every year, the club poses for a group photo in front of the venue. The year after Katrina, in 2006, they made a banner of a previous year's photo, to keep the deceased members visible on the day of the parade, and mounted it on the outside of Sweet Lorraine's. Ever since, the group photo is made in front of a mural of the last year's photo, so that the previous group pictures stretch back like a hall of mirrors.

For many years, the club paraded Labor Day weekend, to honor an old tradition of a Labor Day parade by members of local unions. Recently, after Katrina and other storms caused the cancellation of their parade, they decided to move the date to October.

In 2011 the parade honored the fiftieth anniversary of the civil rights–era Freedom Rides, with a dramatic finish. As the group arrived in the street opposite Sweet Lorraine's, they formed a solid line, with the banner directly behind them and the band behind that. The band began to play "We Shall Overcome," and the entire club sang together as they moved forward with slow, measured steps. The whole crowd around them joined in as the club made their triumphal march.

OPPOSITE, TOP Black Men of Labor members serving as honorary pallbearers at the funeral of jazz trumpeter Lionel Ferbos, 2014, by Judy Cooper

OPPOSITE, BOTTOM Fred Johnson leads the Black Men of Labor as they sing "We Shall Overcome," 2011, by Judy Cooper

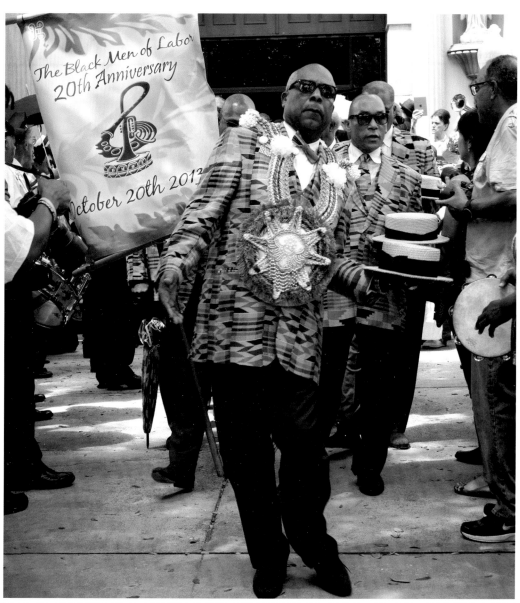

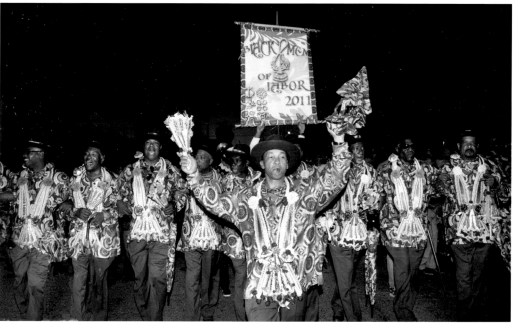

SINGLE MEN

SOCIAL AID AND PLEASURE CLUB

<div align="right">1995</div>

Neighborhood

Uptown

Parade Day

Third Sunday in March

Motto

Building Something New
on an Old Foundation

The Single Men's commitment to tradition is seen in the motto imprinted on their banner. It is accompanied by their logo, which features "The Conductor," wearing a conductor's uniform and holding a large watch.

Founded by Nathaniel Willis (deceased) and Jerry Holmes (retired), the club is anchored by original members Richard Anderson, the treasurer, and Gary Thomas. Alvin Harris serves as president. The club originally had several honorary female members, who formed their own club, the Single Ladies, in 1996. The two clubs usually parade separately.

The Single Men's home base is the Gladstone Bar on Dryades Street near Louisiana Avenue. Members sport the traditional uptown look of color-coordinated suits, shirts, and ties, topped by hats from Meyer the Hatter. "We get 'skins' [alligator shoes] from several companies like Belvedere, Mauri, and Max Leather," says Richard. Green and white are the club colors.

Nathaniel Willis initially made their decorations, which usually include streamers and fans. Eric Larose, a former member, makes them now. Richard believes they're the most important part of the Single Men's ensembles. "You could easily order five, six, seven suits—five, six, seven pairs of shoes," he said, "but it's the decorations, and for us it'd be our streamers, with all the ribbon and colors on it, that really makes us stand out."

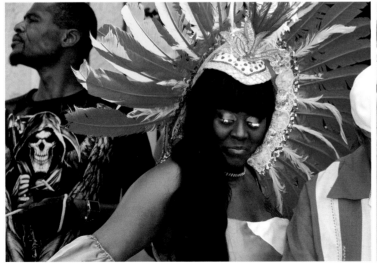 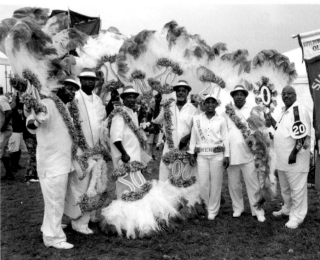

LEFT A member of the royal court, 2012, by Leslie Parr
RIGHT Single Men at Jazz Fest, 2015, by Judy Cooper

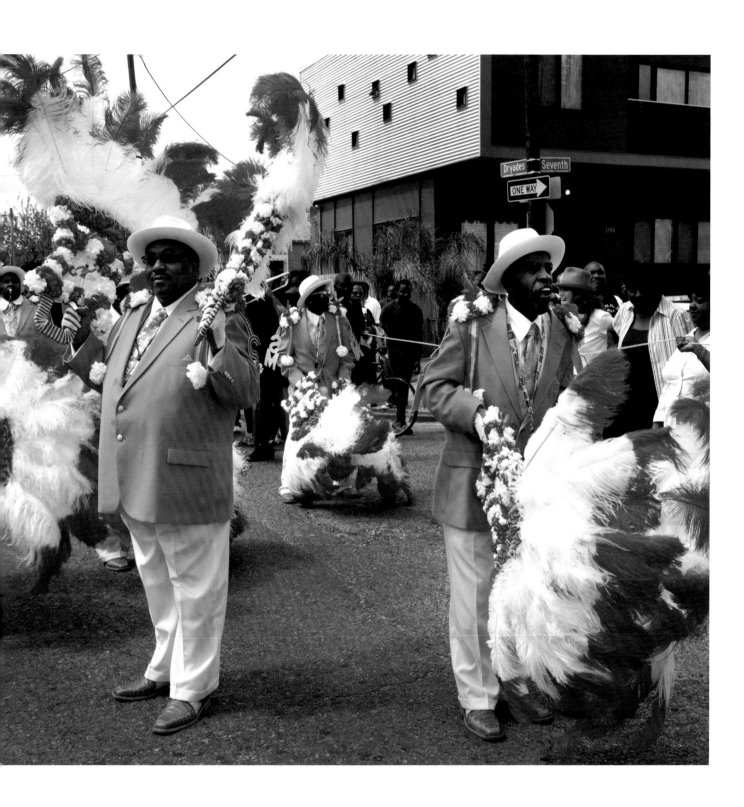

Richard Anderson and Gary Thomas on the streets of Central City, 2012, by Judy Cooper

ORIGINAL BIG NINE

SOCIAL AID AND PLEASURE CLUB

Neighborhood

Downtown (Lower Ninth Ward)

Parade Day

Third Sunday in December

The Big Nine is the oldest of the three parading clubs from the Lower Ninth Ward. Amazingly, all three clubs survived Hurricane Katrina—a testament not only to their determination but also to the strength of the SAPC community.

The Big Nine was organized by a core group of men, including longtime president Ronald W. Lewis, business manager Robert Starks, Edgar Jacobs Jr., Ricky Gettridge, Kenneth Turner, Peter Alexander, Melvin Davis, and Donald Ray Harris. In 2019, Peter took over the reins of president from Ronald.

Their parade usually has two divisions, both of which include men, women, and children. Each division chooses its own colors and outfits. They typically order their clothes locally and favor American-made shoes, by David Eden, in contrast to many of the other clubs, who buy Italian or Spanish brands. According to Ronald, the club's members prefer a dignified look. They make their own decorations. Ronald and Edgar have both masked Indian, so they are well versed in sewing. Edgar's signature decoration is an elaborate umbrella, which he makes every year.

Following Hurricane Katrina, the club was unable to keep its December 2005 parade date, as the neighborhood was devastated and had not even been reopened to residents. Miraculously, the Big Nine was able to parade the following year, even though much of the area was still abandoned. The parade started at Mickie Bee's Lounge on St. Claude Avenue and made its first stop at the Katrina memorial on North Claiborne Avenue,

The Big Nine on parade, by Judy Cooper (left–right): a young parader, 2014; Robert Starks, 2010; Ronald W. Lewis celebrates the club's twenty-fifth anniversary, 2015

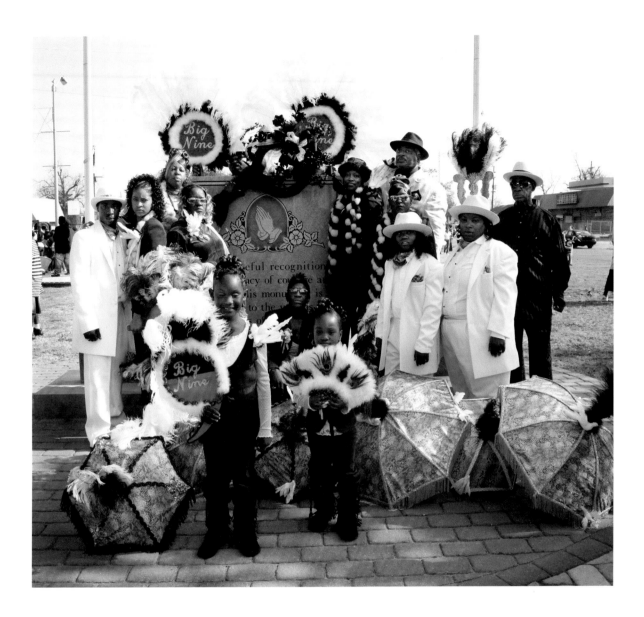

where they offered a prayer for family members and friends lost in the storm. There were few bars or businesses open, so the parade crossed the St. Claude Avenue bridge over the Industrial Canal into the Upper Ninth Ward, which had not flooded as badly. Since that year, the parade has begun on the Upper Nine side of the canal and comes back across the bridge into the Lower Ninth Ward.

There are still only a few bars in the neighborhood, but one of the major stops is at the House of Dance and Feathers, a small museum located behind Ronald's house on Tupelo Street, dedicated to the history of the city's social aid and pleasure clubs and Mardi Gras Indians.

Ronald W. Lewis passed away from COVID-19 on March 20, 2020, dealing a major blow to the entire SAPC community and New Orleans culture at large.

A solemn moment at the Hurricane Katrina memorial in the Lower Ninth Ward, 2006, by Judy Cooper

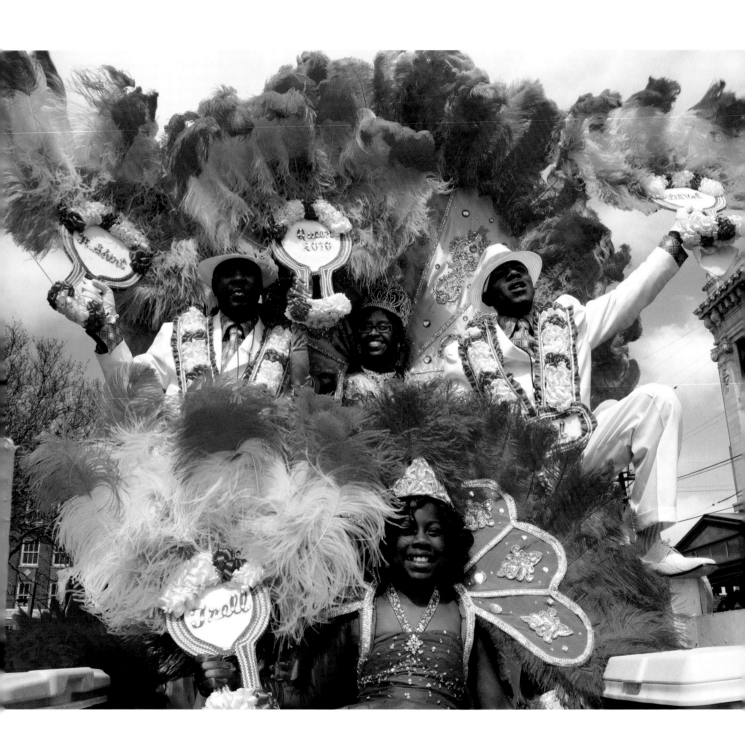

Queen Lynelle "VIP" Jones, flanked by parade dukes Kevin Jones and Val Valentine, 2010, by Judy Cooper

Joseph "Joe Black" Baker started parading as a boy, in 1972, with the Scene Highlighters. After high school, he joined the Furious Five, a division of the YMO Jr., because they were a "hot, hot, hot, good dancin, awesome club," he said in *Coming Out the Door for the Ninth Ward*. A native of the Ninth Ward, Joe Black thought he could bring something to the uptown club: "They was one of the best dancing clubs of all time, and that what brought me with em because I know we had the best footwork in the Ninth Ward. We are more jookers. . . . We added a little more salt to it, a little more pepper, some more pork necks and all of that in there. . . . You add more flavor when you got someone from the Ninth Ward."

Inspired in part by Kevin Dunn's stylish club, the Original Four, Joe Black decided to form his own club so that he could put more emphasis on the clothes. He named it the Revolution, partly to show his new direction and partly as a tribute to Prince, whom he greatly admired. The Revolution always changes outfits mid-parade. The first ensemble is coordinated but casual, while the second is traditional—suits, hats, and custom alligator shoes. Kevin made the streamers and yokes for several years, but recently, the entire ensemble has been designed by Taylor Torrence, a young designer who has introduced a more contemporary look. "It's really coordinated together—your decoration, your suit, your shoes, your hat, and everything," Joe Black said. "Everybody can't dance, but if you come out clean, they will remember you."

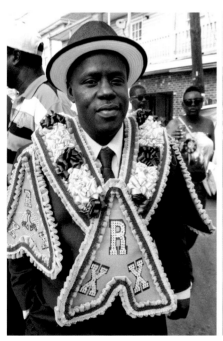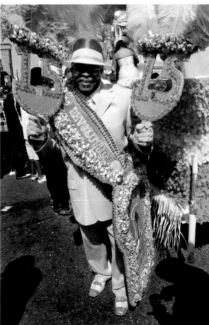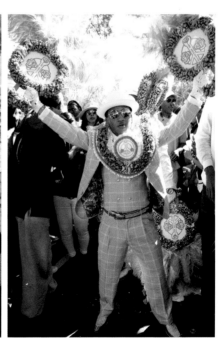

The Revolution in style, by Judy Cooper (left–right): Joseph "Joe Black" Baker, 2015; "King" Mike Allen on the club's fifteenth anniversary, 2010; Rodney Love, 2016

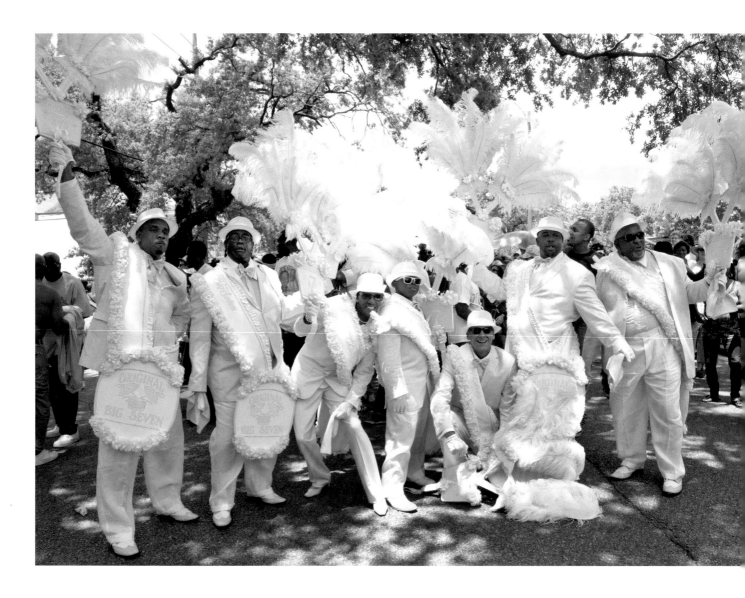

ORIGINAL BIG 7
SOCIAL AID AND PLEASURE CLUB

1996

Neighborhood
Seventh Ward
Parade Day
Second Sunday in May
(Mother's Day)

Named after its neighborhood of origin, the Seventh Ward, the Original Big 7 grew out of the St. Bernard housing project, where many members, including current president Edward Buckner, lived. The club has three divisions: the Big 7, the Kids, and the Snyder Family Steppers.

The club is known for parading on Mother's Day, which Ed has kept a priority out of abiding respect for his late mother, Gwendolyn Johnson. "My mother raised five children," he told Action Jackson in 2019, "so my love forever goes to my mother first, because what she done was so incredible. . . . We got so many women that we got to celebrate in our community."

Members of the Original Big 7 (left–right): Terry Gable, Edward Buckner, Geneva Thomas, Jason Fouchea, Leo Gorman, Dismas Johnson, and George Robicheaux, 2013, by Judy Cooper

The Big 7 usually changes outfits mid-parade. The first is fairly simple—color-coordinated shirts and pants—while the second is the showstopper, typically consisting of a suit, tie, hat, gloves, and shoes. Unlike many of the other clubs, the Big 7 does not always sport alligator shoes. Ed and other members of the club make all the decorations, including sashes and fans.

The Big 7 attracted national attention in the wake of a tragic shooting on Mother's Day 2013, when two gunmen opened fire directly into the second line crowd. Nineteen people were wounded. Ed was adamant that the shooting not come to define the club or the SAPC tradition; he spoke out about the systemic problems that led the two gunmen to turn to violence and proclaimed the SAPC community's commitment to peace and brotherhood. (The shooting and its aftermath are discussed in "Building a Tradition," pp. 56–58.)

The club takes care to check in with its adolescent members, making sure they're doing well in school and organizing events for them. "To be with the kids, it's getting off the sideline and getting in the game," said Ed, who has been a coach with the New Orleans Recreation Department for more than thirty years. "The kids are so important. . . . Everybody can't be saved, but we believe that if you work hard enough, you can save some of them. You've got to put forth the effort, give in kind back to the kids, sit with them, talk with them."

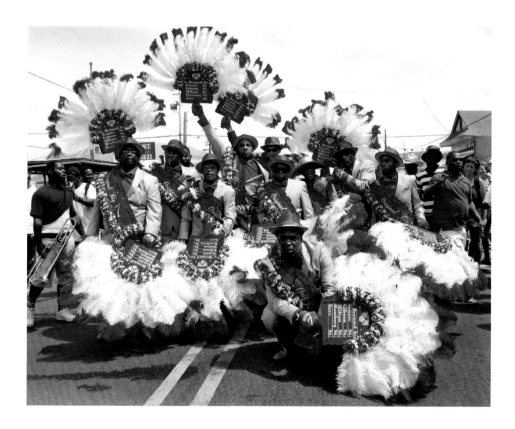

Original Big 7, 2015, by Judy Cooper

LADY AND MEN ROLLERS

SOCIAL AID AND PLEASURE CLUB

1996

Neighborhood

Uptown (Central City)

Parade Day

Fourth Sunday in December

Motto

We Are Going to Stomp This Earth

Linda Green, "The Ya-Ka-Mein Lady," heads up the Lady Rollers. The club grew out of the Men Rollers, formed by Linda's then-husband, Anthony Holmes, and a few friends. Linda and other ladies rode in cars as the Roller Court. After a few years, the club became the Lady and Men Rollers.

When Linda and her husband split up, she kept the Lady Rollers. Their parade is always in late December, the last of the calendar year. In 2016, it fell on Christmas Day, and the Rollers celebrated in style, wearing red and green and featuring a Santa Claus instead of a king.

Linda says she tries not to spend a lot of money on the outfits, but she does like to look elegant. "I like fur," she says. "They call me the fur lady." For the club's twentieth-anniversary parade, in the 2015–16 season, she had sumptuous outfits of crimson and gold made by a local seamstress, Carolyn McNulty. The Lady Rollers usually have a queen who sometimes has a float or rides in a convertible, as does Linda.

The Pussyfooters, a majority-white dance team often seen in Mardi Gras parades, usually joins the Lady Rollers, along with another club, the Party Line Steppers. Poppy Tooker, a local food celebrity, has also participated.

The Rollers' route changes from year to year but always stays uptown. In recent years, they have alternately come out of Tipitina's, the Sandpiper Lounge, and Fox III. One stop that remains constant is Linda's house, on Washington Avenue. The club observes a moment of silence there to honor her deceased son, Mansfield Patterson. At this point in the parade, Linda often exclaims to the participants and observers, "Look up to the sky!"

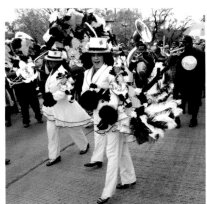 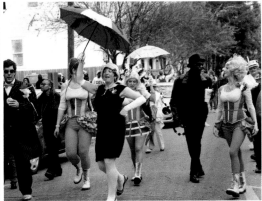

LEFT Jennifer Tramuta leads the Lady Rollers with the Hot 8 Brass Band, 2014, by Judy Cooper
RIGHT The Party Line Steppers and the Pussyfooters on parade with the Lady Rollers, 2014, by Judy Cooper

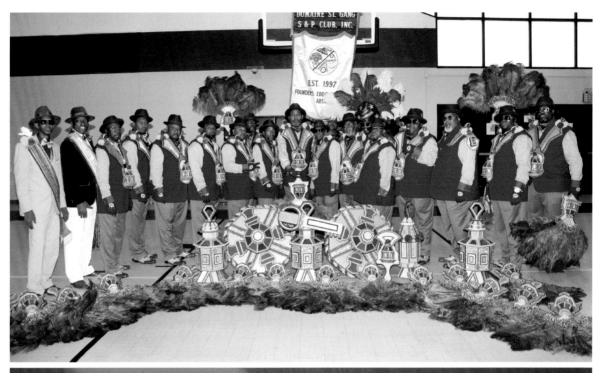

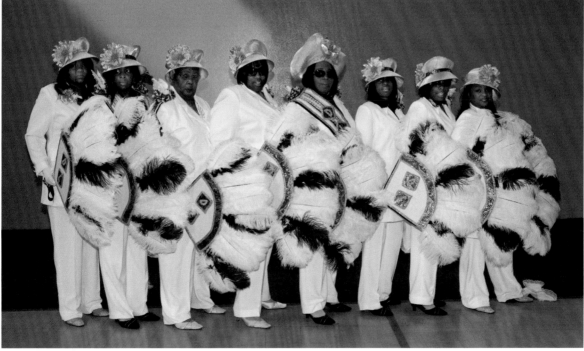

OPPOSITE Dumaine Street Gang on parade, by Judy Cooper (left–right): Byron Hogans and Robert
Javers, 2006; memorial pause on Dumaine Street where it all started, 2014
TOP Dumaine Street Gang, 2016, by Judy Cooper
BOTTOM Dumaine Street Gang Ladies' Auxiliary, 2009, by Judy Cooper

OLE & NU STYLE FELLAS

SOCIAL AID AND PLEASURE CLUB

1997

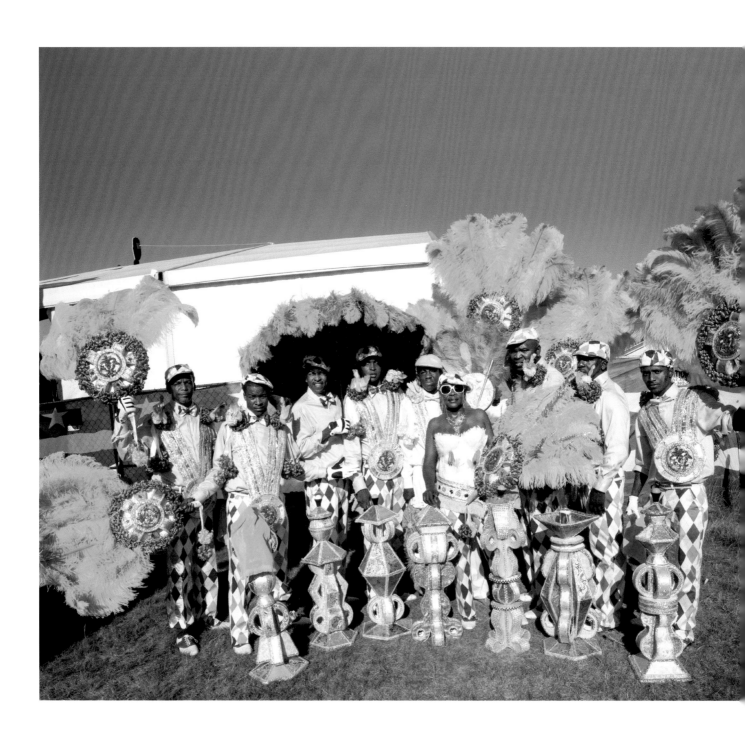

ABOVE Ole & Nu Style Fellas at Jazz Fest, 2014, by Judy Cooper
OPPOSITE Sue Press and son Askia Bennett, 2012, by Judy Cooper

Neighborhood

Downtown (Sixth and Seventh Wards)

Parade Day

Third Sunday in April

Founded by husband and wife Darryl and Sue Press, this downtown club is definitely a family affair. Son Tyrone "Trouble" Miller Jr. is the club president and main designer of the outfits and decorations. Their other son, Askia Bennett, has been parading with the club since he was one year old. Two of Sue's brothers are members, and her mother, Emelda Lewis-Frank, was the "mother" of the club and rode in the parade in a horse-drawn carriage. Emelda died on May 29, 2018, and the club dedicated its 2019 parade to her. Sue is the driving force behind this otherwise all-male club. In a 2016 interview with DJ Action Jackson, Askia described her as "the CEO—the big chief and boss lady who keeps everything rolling."

The club parades in the Sixth and Seventh Wards and has alternated coming out of the Ooh Poo Pah Doo Bar (now closed), Jackie and George Lounge, and the historic Carver Theater. Members change outfits mid-parade, often at Seal's Class Act on St. Bernard Avenue. The "transformations," as the club calls them, serve to build the momentum of the parade and highlight the unveiling of their themes and decorations. Past themes have included golf, paparazzi, brass bands, and radios/stereos. Trouble's handmade decorations, which have replicated vintage cameras, a gramophone, and musical instruments, are "what makes our club unique," Askia said. "We're hands-on, from busting bows to rolling our own ribbon. . . . Everything starts in-house with our club."

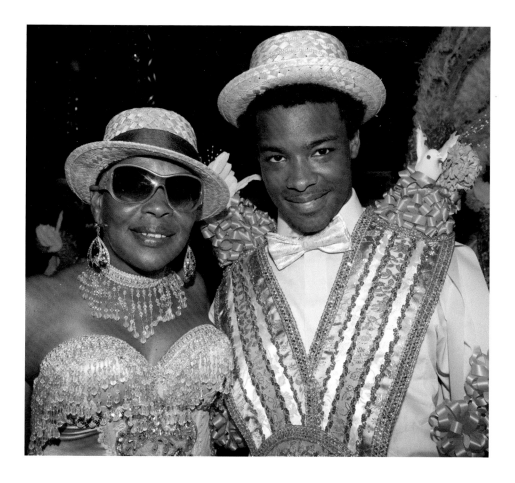

NINE TIMES

SOCIAL AND PLEASURE CLUB

Neighborhood
Downtown (Ninth Ward)
Parade Day
Third Sunday in November

1998

The men of Nine Times could also call themselves "sons of Desire." All five of the original founders and many of the current members grew up in the Desire housing project and formed the club with the express purpose of bringing second line culture to the neighborhood. The Desire projects were demolished beginning in the mid-1990s, but loyalty to the area remains strong. "When we have our parade, it's like a big family reunion for the Ninth Ward," said Raymond Williams. "So many people who are still displaced after Katrina come back to see our parade and to hook up with one another."

The club has three women's divisions—the Original Lady Nine Times, the oldest; the 9 Superior Ladies; and the newest group, the 9 Times Selective Ladies. Its first headquarters was Magee's Lounge on Louisa Street, and the parade began and ended there until Hurricane Katrina. Owner Hollis Magee, who had evacuated to Mississippi, died before being able to come back home, and the bar never reopened.

In 2015, the club members made a bold move in their choice of outfit, coming out in authentic kilts imported from Scotland. The following year, they decided to turn their focus back home: the men dressed like members of the Black Panthers—a nod to when, in 1970, the radical political organization established a short-lived New Orleans chapter in the Desire projects.

As part of a collaboration with the Neighborhood Story Project, the club wrote a book titled *Coming Out the Door for the Ninth Ward*, which was published in 2006. It provides an intimate, moving portrait of the neighborhood and the cultural traditions that have helped members maintain and celebrate their ties to it.

Current president Raphael Parker told Action Jackson in 2020 that the anticipation leading up to parade day never goes away: "There's butterflies you never get rid no matter how many years you've been parading," he said. "If you talk to a lot of members, if you call them about one or two in the morning the night before, I can guarantee you each one of them is up. And their spouses, male or female, is trying to get them to go to sleep. But it's just that thing every year, and it just keep your nerves in them butterflies till you get out that door."

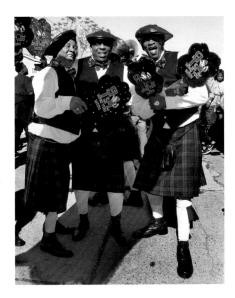

Lyle Johnson, Raphael Parker, and Raymond Williams sporting kilts, 2015, by Judy Cooper

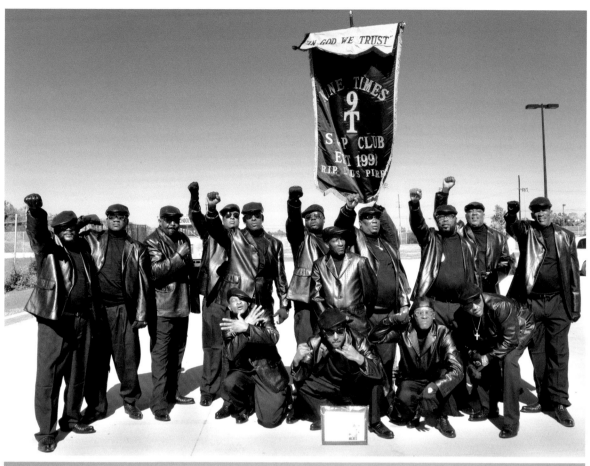

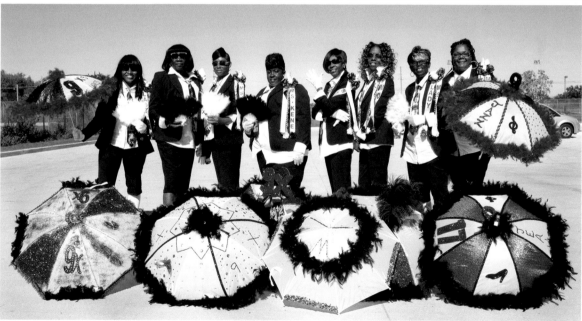

TOP Nine Times salutes the Black Panthers, 2016, by Judy Cooper
BOTTOM Original Lady Nine Times, 2016, by Judy Cooper

UNDEFEATED DIVAS, GENTS, AND KIDS

SOCIAL AID AND PLEASURE CLUB

1999

Neighborhood

Downtown (Sixth and Seventh Wards)

Parade Day

Third Sunday in January

Antoinette "Net" Devezin, president and founder of the Undefeated Divas, has been parading since the age of one, and she has the dance moves to show for it. "My whole family was into second lining," she said. "My father was in the YMO. I was in the kids division of Treme Sports in 1968." She remembers parading for six hours in those days. Net joined the Fun Lovers, a women's club formed by Misty Dee in 1973, and stayed with them until 1981, when she had her first child. She returned to parading in 1986, joining the Second Line Jammers, and later joined the Devastating Ladies.

In 1999, Net decided to form her own club, the Undefeated Divas. The Gents came on board in 2003, after Net married Kevin "Too Low" Devezin, who now leads the Gents. Like many clubs, it is a family organization. Net's father is always part of the parade, and the kids are mostly children and grandchildren of the members. The parade usually features a king and queen, who ride on floats with their entourages.

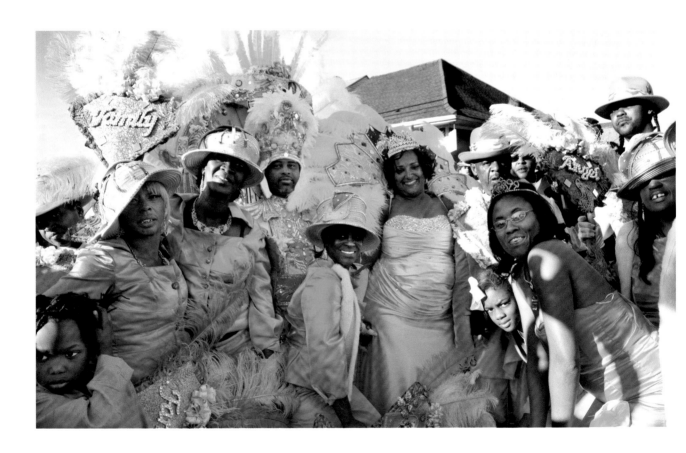

The family gathers round, 2014, by Judy Cooper

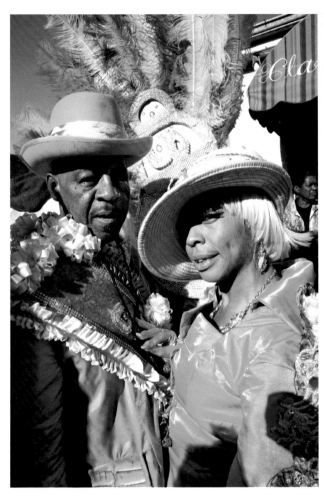
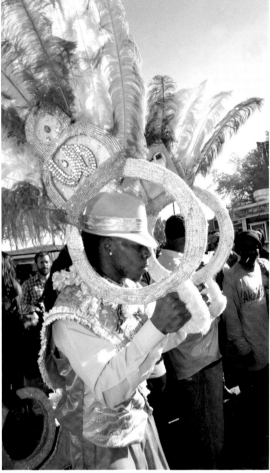

According to Net, a diva is "a goddess, a prima donna," and she designs the ladies' outfits and decorations accordingly. Bling is an important part of their adornment. According to Henri Devezin, Kevin's nephew, who designs for the Gents, "'Undefeated,' for us, is trying to top ourselves each and every year." The members always change outfits mid-parade, traditionally at "Granny's place," Kevin said, referring to Mercedes Bell, his grandmother, who passed away in August 2020.

LEFT Kevin "Too Low" and Antoinette "Net" Devezin outside Seal's Class Act, 2014, by Judy Cooper
RIGHT Henri Devezin, 2014, by Judy Cooper

DIVINE LADIES

SOCIAL AND PLEASURE CLUB

2000

Neighborhood

Uptown (Central City)

Parade Day

Third Sunday in May

Motto

This Is How We Do It

Angelina "Mrs. Divine" Sever, founder and president of the Divine Ladies, can be seen with her daughter, India, almost every Sunday at a second line. They know everybody, and everybody knows them. Angie paraded with a now-defunct group, the Lady Sequence, from 1997 to 1999, then decided to form her own club. India designs the ladies' outfits, and local dressmaker Gerry Bryan fabricates them in her Prytania Street studio.

For their parade, the Divine Ladies don't come out of a bar or residence but instead arrive at the corner of St. Charles and Jackson Avenues by different forms of transportation—limousines, buses, trolley-trailers, and more. One year they rode on a double-decker bus and danced on the top deck as they came up St. Charles. In 2016 they arrived in a fleet of pedicabs. Their king usually joins the parade at the first stop, Verret's Bar and Lounge, at the corner of Baronne Street and Washington Avenue.

One of their members, Sheketa Baptiste, died in March 2015, and, in addition to giving her a jazz funeral, the club dedicated its parade that year to her. "It is what she would have wanted," Angie said. A large photograph of Sheketa was carried at the front of the parade, and her likeness also adorned the members' fans.

Arriving by pedicab on St. Charles Avenue, 2016, by Judy Cooper

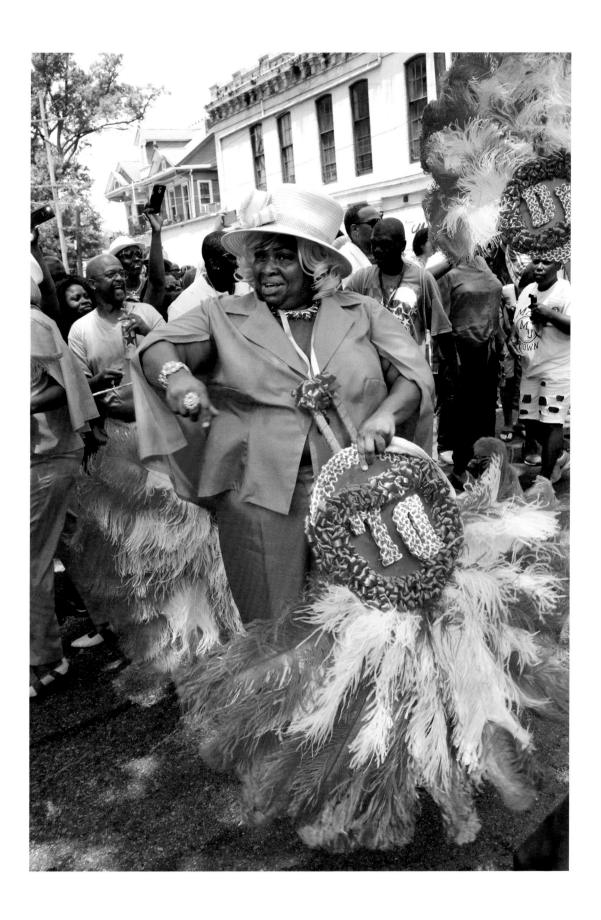

Angelina "Mrs. Divine" Sever dancing on St. Charles Avenue, 2016, by Judy Cooper

NEW GENERATION

SOCIAL AND PLEASURE CLUB

Neighborhood

Uptown (Central City)

Parade Day

Second Sunday in December

Motto

In God We Trust

Though the club was formed in 1999, its first parade took place in 2000, making the aptly named New Generation one of the first social aid and pleasure clubs of the twenty-first century. Terrence Williams was one of the founders and has been president from the beginning. The club began with seven members, but, little by little, the number dwindled. Currently, Terrence is the only member. To underscore this fact, he calls himself the "One Man Gang" and often emblazons the moniker on his streamer or yoke.

Sometimes one or two ladies, chiefly Nicole Lazard, parade with him. Terrence makes his own decorations and also makes them for other clubs, such as the Single Ladies and Valley of Silent Men.

Terrence began parading at the age of six with his father, who was then a member of the Scene Boosters. Terrence was in the Boosters' kids division, known as Kool and the Gang. Johnnie "Kool" Stevenson, leader of the division, would take the children to Shakespeare Park (now A. L. Davis Park) every Saturday to practice their dancing.

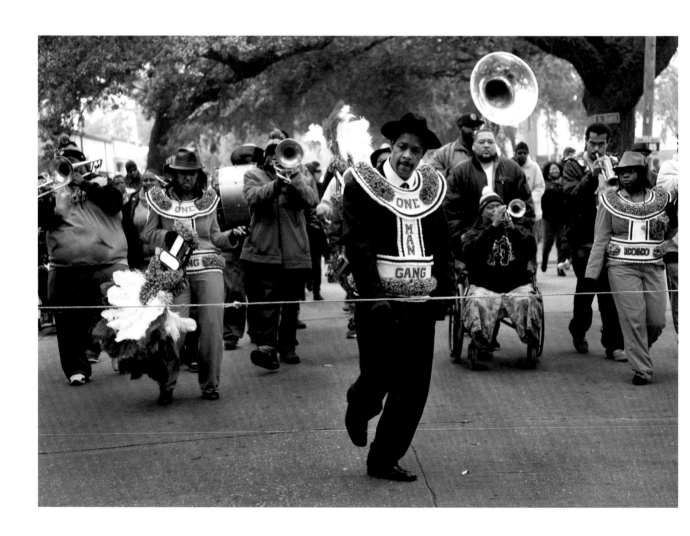

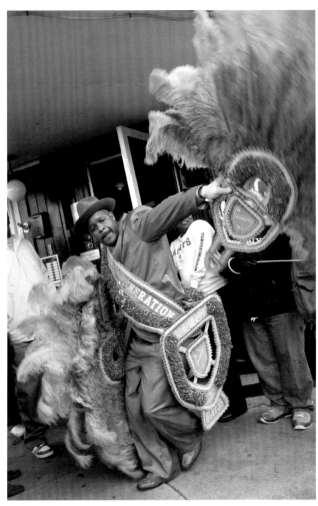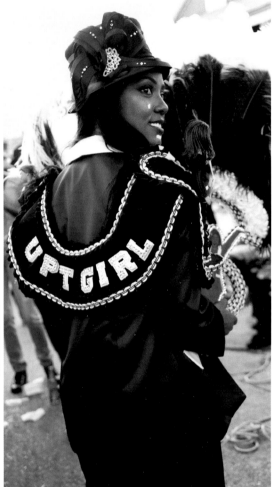

Terrence stopped parading later in adolescence, but, after the death of his father, in the early 1990s, he was invited by the Avenue Steppers to take his father's spot. He hasn't stopped parading since. In 1996, he and Anthony Holmes started the Men Rollers, which soon became the Lady and Men Rollers.

The New Generation parade always starts at A. L. Davis Park and follows a traditional route through Central City. Terrence likes to use the Hot 8 Brass Band, which he nicknames "None Other Than the Uptown Jukebox That Makes Your Body Rock."

OPPOSITE Terrence Williams leads the parade with the Hot 8 Brass Band behind him, 2013, by Judy Cooper

ABOVE New Generation, by Judy Cooper (left–right): Terrence Williams, 2011; Nicole Lazard, 2015

ORIGINAL C.T.C. STEPPERS

SOCIAL AID AND PLEASURE CLUB

2000

Neighborhood

Downtown (Ninth Ward)

Parade Day

Second Sunday in February

C.T.C. stands for "cross the canal"—a nod to the C.T.C. Steppers' status as the first club to parade across the Industrial Canal from the Lower to the Upper Ninth Ward. According to founder Jermaine Devezin, the club is indebted to the Big Nine, the oldest of the Ninth Ward clubs. In 1999, he and some friends got a group together, put on matching shirts, and danced on the sidewalk beside the Big Nine. "We danced so hard people said we needed our own club," he said. The next year, they made their debut, parading with the Big Nine, and in 2001 they got their own date.

Membership has always included men, women, and children. Some years they change outfits mid-parade. In 2016, they removed their jackets to show off decorative suspenders with shoulder patches topped by the traditional white dove. Their decorations—fans and baskets—are made by Adrian "Coach Teedy" Gaddies of Sudan. The baskets feature their logo, a bridge, which is also displayed on their banner with a second line couple dancing on top.

For a number of years, the C.T.C. Steppers crossed from the Lower to the Upper Ninth Ward, but in 2016, they reversed their route, ending in the Lower Ninth. On St. Claude Avenue, near the corner of Franklin Avenue, the parade passes a new mural that pays tribute to the clubs of the Ninth Ward, including the C.T.C. Steppers, the Big Nine, and Nine Times.

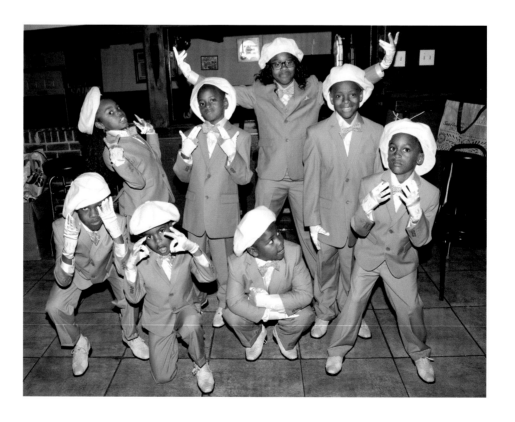

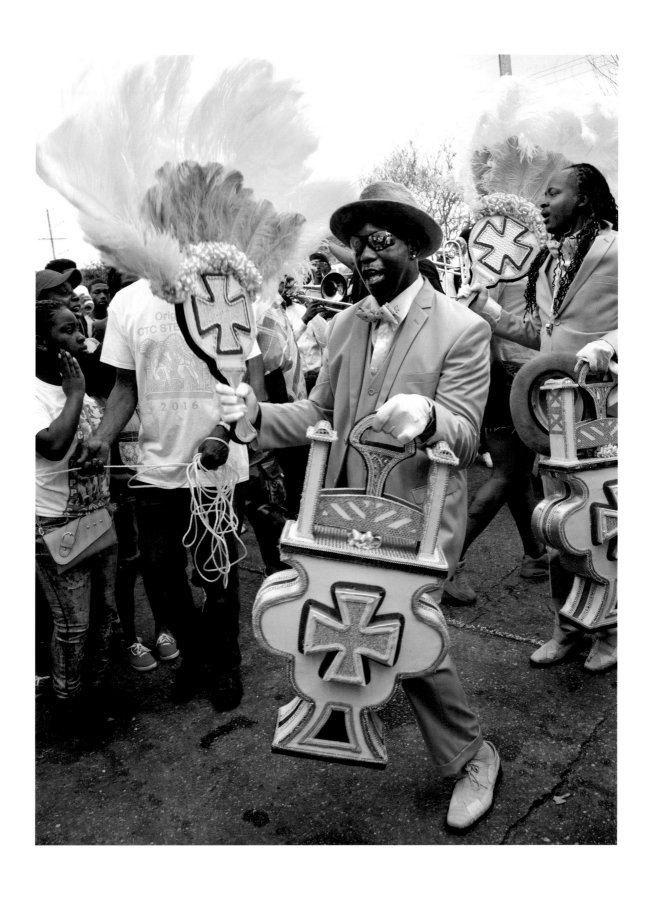

OPPOSITE C.T.C. Steppers, kids' division, 2016, by Judy Cooper
ABOVE Eugene Smith on St. Claude Avenue, 2016, by Judy Cooper

FAMILY TIES

SOCIAL AND PLEASURE CLUB

Neighborhood

Downtown (Sixth and Seventh Wards)

Parade Day

First Sunday in October

Motto

Blood Is Thicker than Water

As indicated by the name, almost all of the members of this club come from one large New Orleans family, the Fournettes of Ursulines Avenue in the Sixth Ward. "We are a very close-knit group," said Tyrone Brooks, president of the club. "We do things together all year long, not just for the parade."

The membership spans three generations, including children. A women's group, the Jazzy Ladies, began in 2008 and paraded with Family Ties for several years, but has not joined them since 2014.

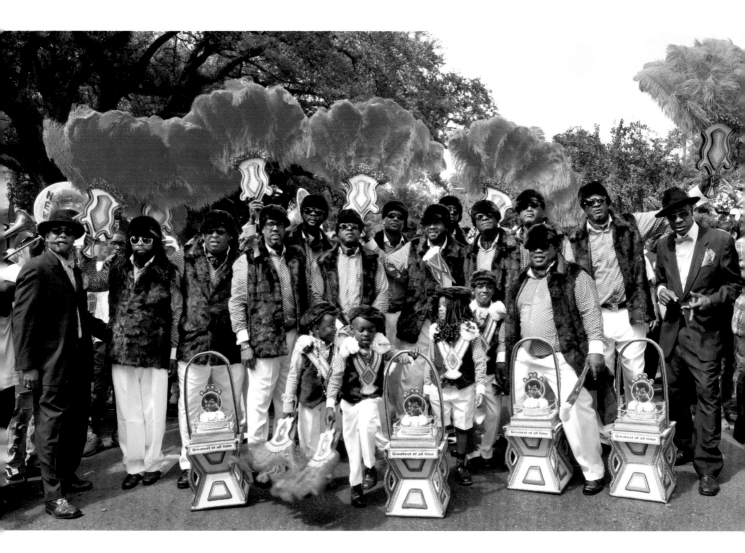

ABOVE Family Ties at its fifteenth anniversary, 2016, by Judy Cooper

OPPOSITE, LEFT Members of Family Ties (left–right): Kenneth DeGruy, Remy Evans, and Clarence Fleming, 2017, by Judy Cooper

OPPOSITE, RIGHT Albert Fournette on St. Bernard Avenue, 2016, by Judy Cooper

The parade has come out of John McDonogh (now closed) and Joseph S. Clark high schools, the alma maters of many of the members. Since 2016, the Prime Example Jazz Club has been the starting point. Their route circles the Sixth and Seventh Wards and usually includes a stop at A New Day Beauty Salon on St. Bernard Avenue.

The club's outfits, including shoes and hats, come from from Upscale Menswear out of Atlanta. Mink has been a favorite indulgence: members wore mink hats and vests in 2011, for the club's tenth anniversary, and again five years later for the fifteenth anniversary.

To salute the importance of alligator hide in second line regalia, Family Ties paraded with a live alligator in 2012 and 2013. In 2015, the club's decorations, made by Adrian "Coach Teedy" Gaddies, featured a bulldog, the mascot of Joseph S. Clark high school.

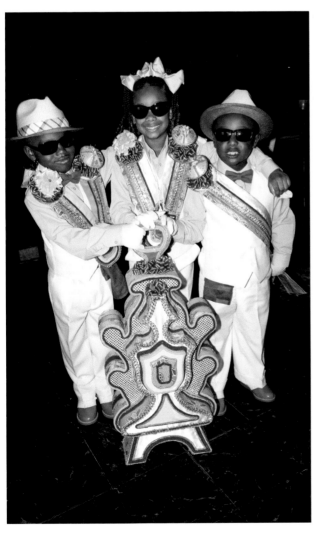
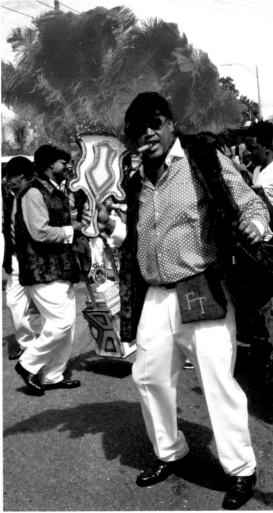

MEN OF CLASS

SOCIAL AID AND PLEASURE CLUB

2003

Neighborhood

Uptown

Parade Day

Third Sunday in October

Motto

We Saw, We Came, We Conquered;

Original Men Working Together

for a Purpose

Originally called the Undefeated Gentlemen, the Men of Class first paraded in 2006, three years after their founding. The club was formed by Anthony "Tony" Hookfin, who began parading in the late 1980s with the Men Jetsetters and, later, Devastation. As CEO of the Men of Class, he chose the colors for the outfits—"You can't be scared to wear color in a second line parade," he said—and ordered the suits from New York. Tony used to make the Men of Class's decorations himself but lost his ability to sew after suffering a stroke in the summer of 2014, which partially paralyzed his right side. His stroke, however, did not stop him from parading.

For its fifteenth anniversary, the club had planned to cross the Broad Street overpass twice, with an outfit change in between, but the parade was canceled because of the pandemic. In a November 2020 interview with DJ Action Jackson, Tony said the club would still celebrate the anniversary whenever parades were allowed to resume: "We stay prepared," he said. Less than one month later, Tony passed away, on December 3.

The Men of Class frequently host other clubs in their parades, including the Compassionate Ladies, the Queen Divas, and the King of Kings. In 2019, one division

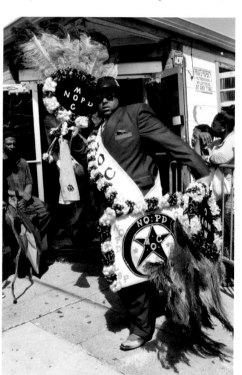

of the Ladies of Unity and Jack Williams of the Men of Unity joined the parade.

For the club's 2015 parade, members wore white and pink in honor of Breast Cancer Awareness Month. At a stop on the corner of Jackson Avenue and La Salle Street, a city official presented a proclamation recognizing the club's dedication to the cause. The next year, the Men of Class billed their parade as a "Dedication and Salute to Those Who Serve." The members' suits were dark blue and grey, and their decorations featured a replica of a police officer's shield. Regardless of the theme, audiences can always "expect class," said club president George Howard. "Can't expect nothing less."

ABOVE Jamal Caldwell salutes the NOPD, 2016, by Judy Cooper

OPPOSITE Anthony "Tony" Hookfin with Queen Sametta "Deedy J" Hawkins, 2014, by Judy Cooper

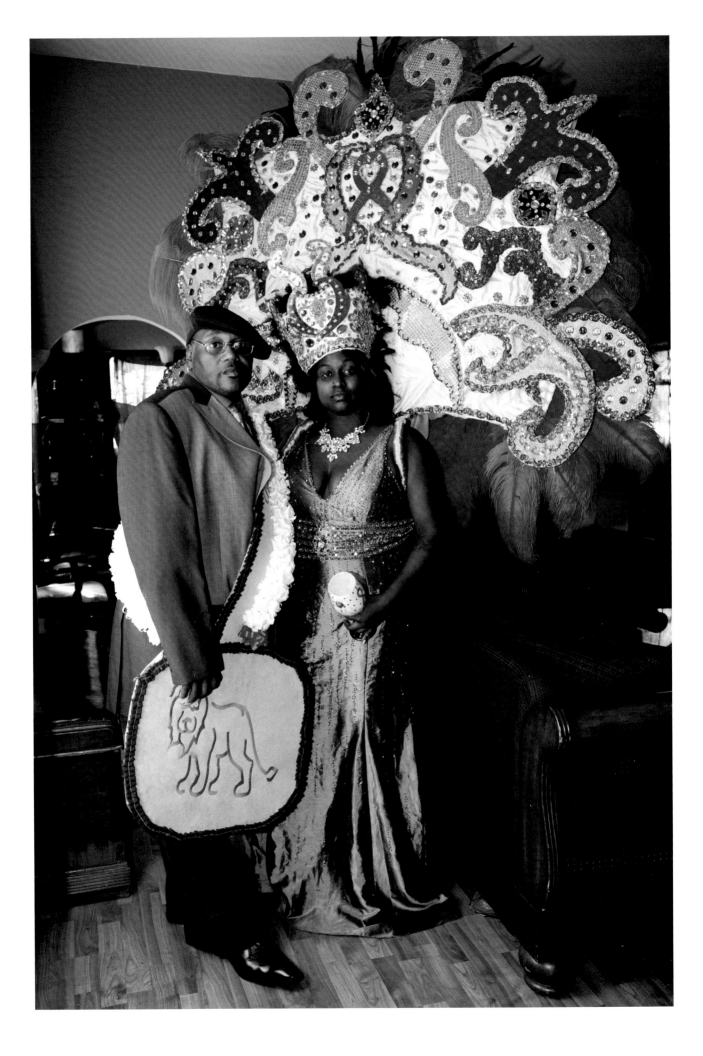

VIP LADIES AND KIDS

SOCIAL AID AND PLEASURE CLUB

Neighborhood

Uptown (Central City)

Parade Day

First Sunday in March

Founder and president Tamara Jackson Snowden grew up near Tammy's Lounge on Martin Luther King Jr. Boulevard, a frequent stop for second line parades, so, like many other second liners, she was introduced to the culture at an early age. The first club she joined was the Lady Sequence. When they disbanded in 2003, Tamara founded the VIP Ladies and Kids and took the Lady Sequence's parade slot. "VIP" stands for "Virtually Impressive Professionals," Tamara said. "Many of our ladies are career professionals—bankers, lawyers, military, nurses, law enforcement, and business professionals."

The club is active in community outreach. Members work with several churches and buy schoolbooks and uniforms to donate to students. Each summer, the Ladies and Kids take an educational trip to visit important historical sites, such as the Martin Luther King Jr. National Historical Park in Atlanta. Tamara also serves as president of the New Orleans Social Aid and Pleasure Club Task Force and as the director of Silence Is Violence, a nonprofit organization dedicated to ending violence in the African American community.

"'VIP' also stands for prestige and honor," she said, and the VIP Ladies like to dress the part. Their suits, hats, and shoes are usually ordered from New York. Wardell Lewis Sr. makes their decorations, which are usually fans. Their hats are particularly important to them, Tamara said: "Some clubs like shoes, but we are the *hat* club!"

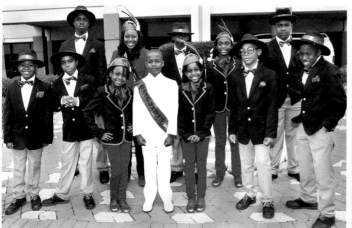 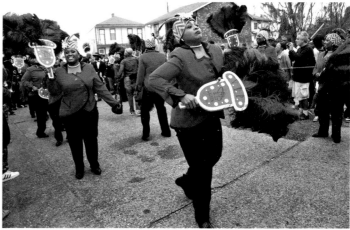

VIP Ladies and Kids, 2015, by Judy Cooper (left–right): VIP Kids; Farrah Petty and Karen Livers struttin' on South Liberty Street

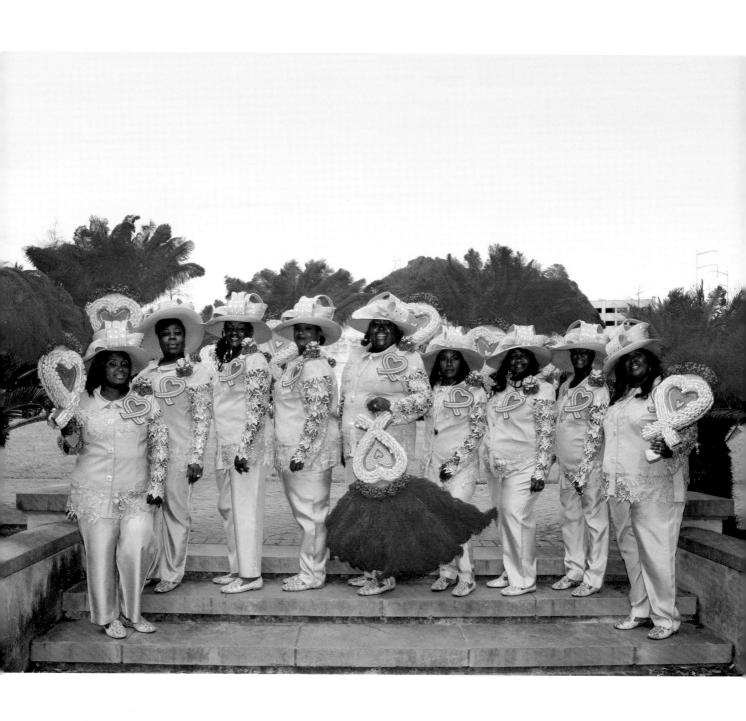

The hat club, 2016, by Judy Cooper

KEEP 'N IT REAL

SOCIAL AND PLEASURE CLUB

2004

Neighborhood
Downtown

Parade Day
Second Sunday in March

"I love second lining. I live for it," said Perry "Ice Bird" Franklin, president of Keep 'N It Real. He started out in the Mellow Fellows, a division of the YMO Jr. that had broken off to form its own club. He paraded with them for a few years, then joined the Revolution in 1996. Perry and some friends wanted to form a separate division of the Revolution, but, when their idea was rejected, they broke off to form Keep 'N It Real. "The name says it all," Perry said. "We want to be known as honest, up-front kind of guys." Several other clubs have paraded with them, including the Chosen Few and the Ice Divas.

The parade begins on Orleans Avenue at Bayou St. John. Because the members change outfits at the first stop—a barbershop on Broad Street, where they also pick up their queen—they don't come out at the start but instead gather in the street and take their cue to begin dancing from the band. The parade always ends at Club Good Times II on Conti Street, the club's home base.

Perry's wife, Rose Madison, helps with choosing the colors and ordering the suits. "We try to get suits that we can wear again," Perry said. "But we do buy alligator shoes. I still have the first pair that I wore with the Revolution. They never wear out."

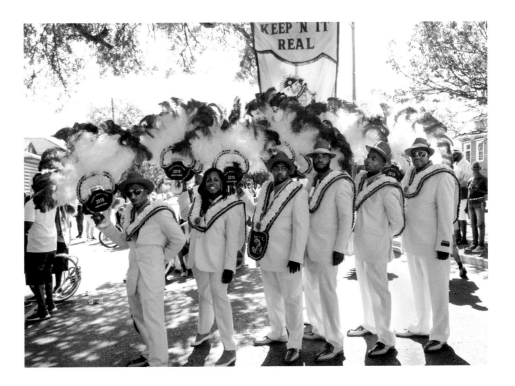

ABOVE Keep 'N It Real, 2018, by Judy Cooper
OPPOSITE Circle dance on St. Bernard Avenue, 2014, by Judy Cooper

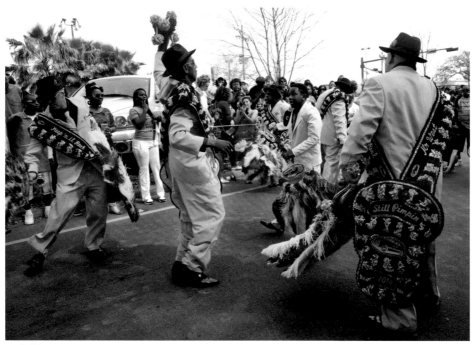

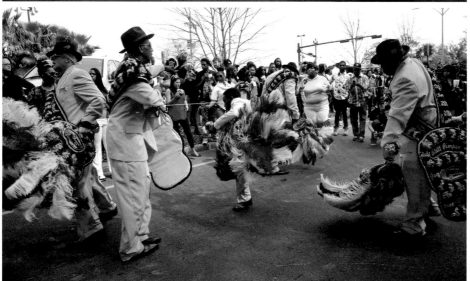

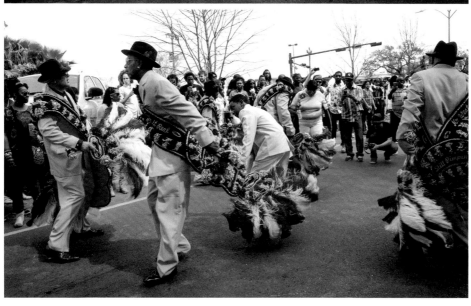

UPTOWN SWINGERS

SOCIAL AID AND PLEASURE CLUB

Neighborhood

Uptown

Parade Day

Last Sunday in June

(final parade of the season)

Motto

Come On Uptown

"I'm addicted to parading!" founder and president Ezell Hines liked to say. Like a number of other clubs, the Uptown Swingers grew out of the YMO Jr., with whom Ezell paraded from the age of five. In the 1980s, he was in the Swingers, a division of the YMO Jr. supposedly named for the 1973 Dodge Dart Swinger. The division broke off in 1986 to form a separate club and kept the Swingers name, then changed to the Uptown Swingers in 2004. The club has two different banners, reflecting both iterations of the group.

The Swingers parade in late June, closing out the season. According to Ezell, the club likes it this way, because they can "close it out right," he said. "Everybody'll be talking about us till next year." Like other clubs, this one is a family affair. The Swingers usually come out of Ezell's sister's house on Valence Street, and in 2015 the men picked up the club's women's division, the Lady Swingers, at the home of Ezell's sister-in-law.

"We like to use at least three colors," Ezell said of the club's outfits. The official colors are red, white, and blue, but they also like to change things up from year to year. Sometimes they wear suits with traditional streamers and fans; other years, they sport pants and shirts with decorated shoulder patches. For the 2015 parade, they wore eight-toned alligator shoes, with a multicolored belt to match. With Ezell's direction, members make their own decorations. As he frequently said, so much so that it was the theme of the 2016 parade, "You can't brag on something you don't make yourself."

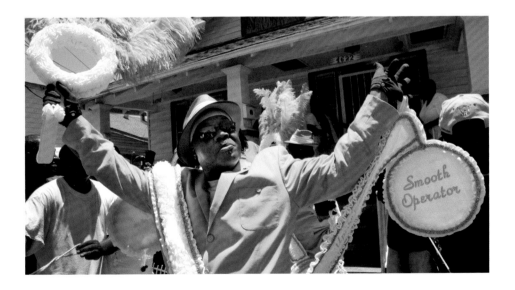

ABOVE Ezell Hines coming out of his sister's house, 2012, by Judy Cooper

OPPOSITE The Uptown Swingers' fifteenth anniversary, 2018, by Judy Cooper (top–bottom): Uptown Swingers; Lady Swingers

Ezell Hines passed away on November 1, 2020. Speaking to DJ Action Jackson about his death, club member Wellington "Scully Well" Ratcliff said, "He was a family man. He was totally dedicated to his club. . . . When we got ready to parade, he'd make sure our colors, our color scheme, our theme, whatever it was that year, he kept it hush-hush. He was one of the original cats that kept it old-school. . . . Zell had a vision."

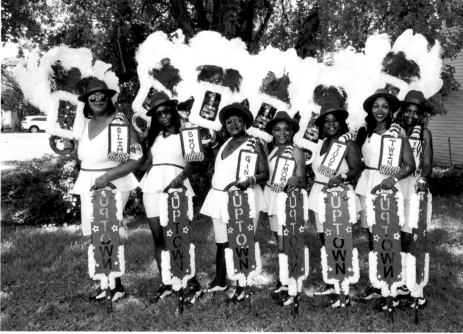

WE ARE ONE

SOCIAL AID AND PLEASURE CLUB

2006

Neighborhood
Uptown (Central City)

Parade Day
First Sunday in November

The name says it all: this club was started by a tight-knit group of family and friends as a way to unite and parade together. It has always included men, women, and children. "The foundation is in the kids—they are our future," said former president JeNean Sanders. "We all started going to parades with our parents or to see them parade." In 2014, their parade gave special focus to the kids with the theme "And the Children Shall Lead Them." The adult members walked alongside, but the children took center stage.

The club has a fondness for fur: in 2010 the women wore fur coats, and the following year they wore fur vests and hats. In 2014, the periwinkle of their palette honored stomach cancer awareness.

For a number of reasons, including health problems, the women of We Are One were not able to parade in 2016 and have not returned to the street since. A new men's division under the leadership of Edward Johnson, a relative who had previously participated as Mr. We Are One, took their place.

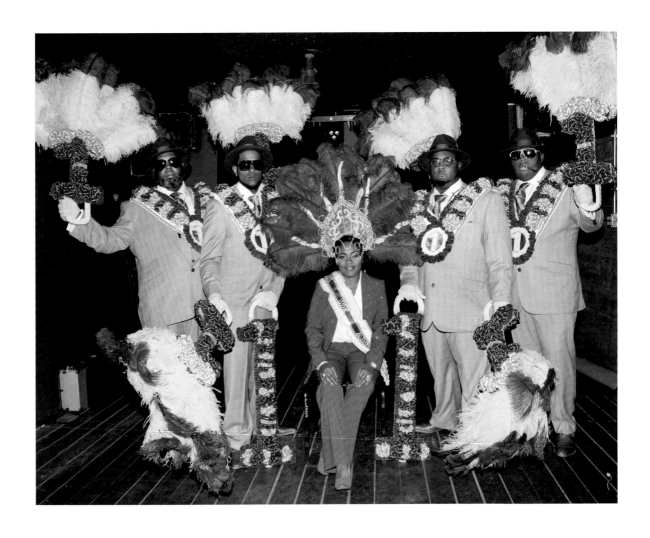

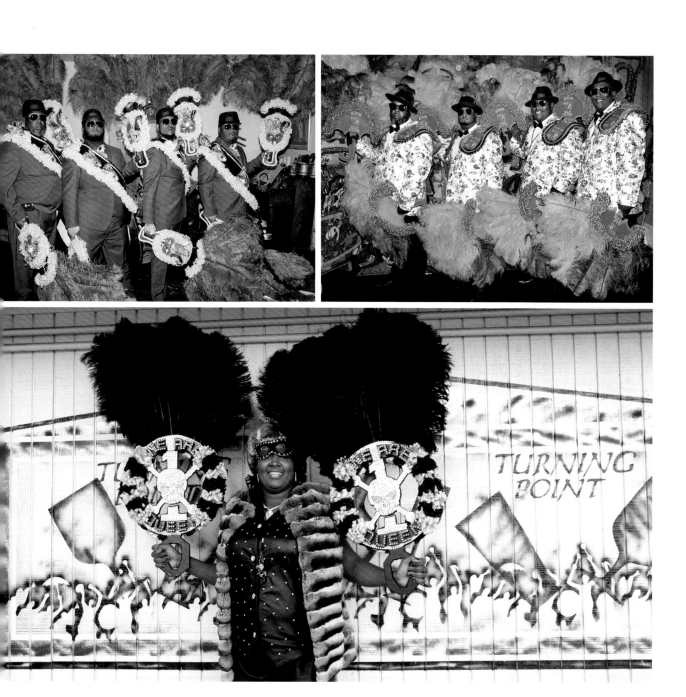

OPPOSITE Members of We Are One with Ms. We Are One, 2016, by Judy Cooper
ABOVE We Are One, by Judy Cooper (clockwise from top left): Mardi Gras colors, 2019; bold brocade, 2017; Queen Kim Johnson at the Turning Point, 2011

LADIES OF UNITY
MEN OF UNITY

LLC | SOCIAL AID AND PLEASURE CLUB

Neighborhood

Uptown

Parade Day

Fourth Sunday in January

The Ladies of Unity was founded by Wynoka "Nokie" Boudreaux Richardson, daughter of Monk Boudreaux, big chief of the Golden Eagles Mardi Gras Indians. Nokie also masks Indian with her father. She started the club in 2005, but Katrina prevented them from parading. After filing with the state in 2006, they first hit the streets in December 2007, after enough members had returned to the city. The following year, Monk and Jack Williams formed the Men of Unity as a brother club to the Ladies.

In 2010, during the Saints' championship season, the parade fell on the day of the playoff game against the Minnesota Vikings, and the entire city had Saints fever. Riding the excitement, the club members wore black and gold with mini footballs on their shoulders.

For many years, Nokie was the CEO of the Ladies while her sister Natcha Pleasant was the president. Following a financial disagreement in 2015 that resulted in an unpaid permit fee and near-cancellation of their parade, however, a rift formed between the club's two divisions. Nokie remains the leader of one, which she calls the Ladies of Unity LLC, while Carla Harris has taken up the reins of the other, which has retained the "SAPC" suffix.

Nokie usually makes the decorations for her division, as well as for other clubs. Her specialty is the "lady streamer" or yoke—smaller than the men's—and baskets with baby dolls. "It just comes to me," she said of her design work. "This is very spiritual, what we do."

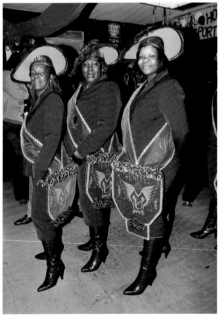 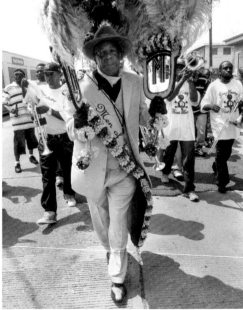

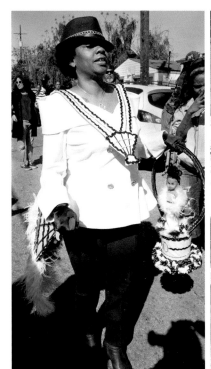
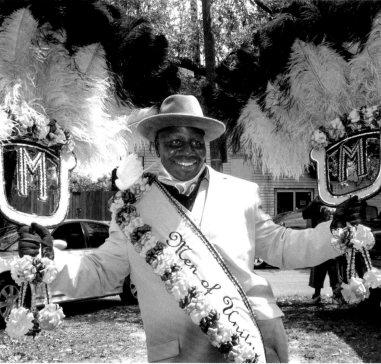
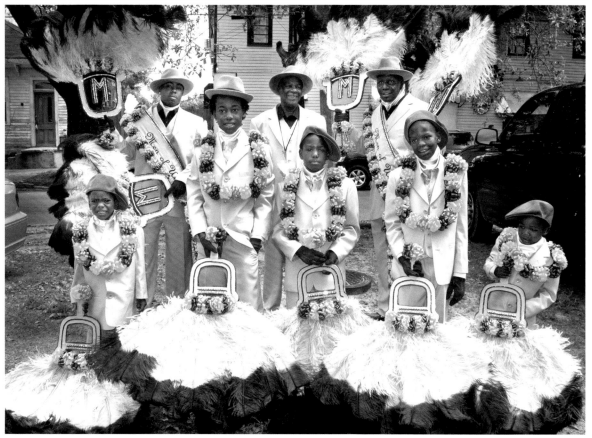

OPPOSITE, LEFT Elaine Morgan, Natcha Pleasant, and Kisha Williams, 2012, by Judy Cooper
OPPOSITE, RIGHT Monk Boudreaux, 2009, by Judy Cooper
ABOVE Ladies and Men of Unity, by Judy Cooper (clockwise from top left): Wynoka "Nokie" Boudreaux
Richardson, 2016; Jack Williams, 2009; Monk Boudreaux (center rear) and Jack Williams (right rear) with
young paraders, 2009

WOMEN OF CLASS

SOCIAL AID AND PLEASURE CLUB

2006

Neighborhood

Uptown

Parade Day

Not fixed; occurs in October, November, or December

Founder and CEO Lisa Williams, who had previously paraded with the Undefeated Divas, founded the Women of Class after returning to New Orleans after Katrina. Just before the storm, she had joined the newly formed Ladies of Unity, but they were unable to parade before the flood forced everyone out of town. When she returned, Lisa decided to form her own club. The Women of Class first came out with the Men of Class in October 2006, then were able to get their own date.

For their fifth-anniversary parade in 2011, they wore two different outfits and sported fans—created by Wynoka "Nokie" Boudreaux Richardson of the Ladies of Unity—decorated with translucent masks. The parade also featured a king (Anthony "Tony" Hookfin of the Men of Class), a queen, a Mr. WOC, a Ms. WOC, and a grand marshal.

The Women of Class parade uptown but do not always follow the same route. Though they have started at Fox III (formerly called Foxx II) several times, for their tenth anniversary, in 2016, they came out of the Eiffel Society nightclub. They like to change up their parade in other ways, such as arriving at the starting point one year on the backs of motorcycles driven by the members of the Smokin Aces Motorcycle Club.

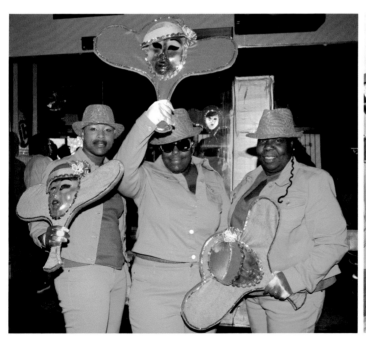 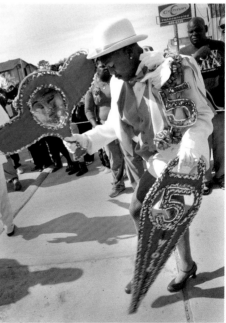

ABOVE Women of Class's fifth anniversary, 2011, by Judy Cooper (left–right): Shandrika Clark, Keisha Woodson, and Lisa Williams; Clark coming out the door
OPPOSITE Celebrating five years, 2011, by Judy Cooper (top–bottom): King Anthony "Tony" Hookfin and dukes; Queen Misty Jenkins and court

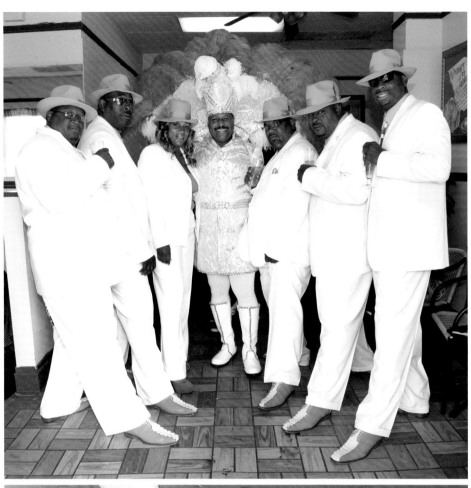

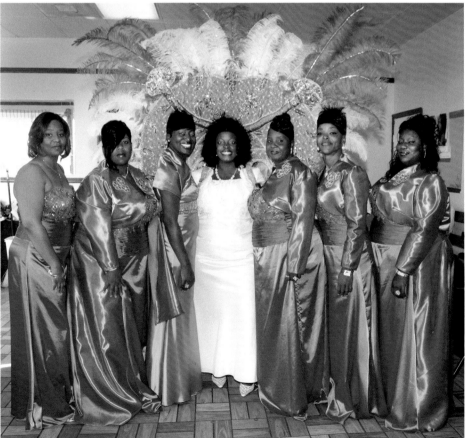

GOOD FELLAS

SOCIAL AND PLEASURE CLUB

Neighborhood
Uptown

Parade Day
Third Sunday in September

The name Good Fellas derives from founder Raynold Fenelon's childhood fascination with gangster movies and an appreciation for the Mafia's emphasis on loyalty. Mob mystique can be seen on the logo on their banner, which shows three men with hats and dark glasses sitting at a table with stacks of hundred-dollar bills.

Of the club's eight original members, only two remain: Raynold and Albert "Chui" Clark. Chui said that Good Fellas was his first club and will be his last: "Good Fellas Forever!" The club has two divisions, one for the men and the other for children—both boys and girls. Members wear the traditional uptown ensemble of suits, hats from Meyer the Hatter, and alligator shoes from Rubensteins. Kevin Dunn makes their sashes and fans, and, when they have a queen, her decorations are usually made by Nicholas "Norman" Nero.

For several years the Good Fellas' favorite place to come out was the Eiffel Society nightclub on St. Charles Avenue. The long ramp from the club to the street provided a perfect runway for the members to wave their fans and strut their stuff. A frequent stop is 2814 Washington Avenue, where Raynold grew up when it was still part of the Magnolia projects. The stop typically appears on the route sheet with the theme "Give Me My Project Back."

Raynold likes to play with themes and theatrics to fit them. For the 2008 parade's theme, "Big Dog Status," a large brown pit bull preceded the queen down the ramp. At the start of the 2010 parade, the club members appeared dressed like bums and carried "Will Work for Food or Money" signs, before changing into their real outfits later.

"It's a joyous occasion just to see my members happy," Raynold told Action Jackson. "If they enjoying themselves, then my job is done."

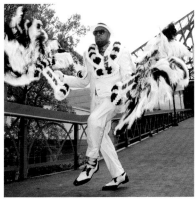 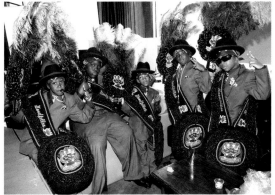

ABOVE Good Fellas, by Judy Cooper (left–right): Raynold Fenelon dancing down the ramp at the Eiffel Society, 2016; kids' division, 2011
OPPOSITE Albert "Chui" Clark coming down the ramp, 2008, by Judy Cooper

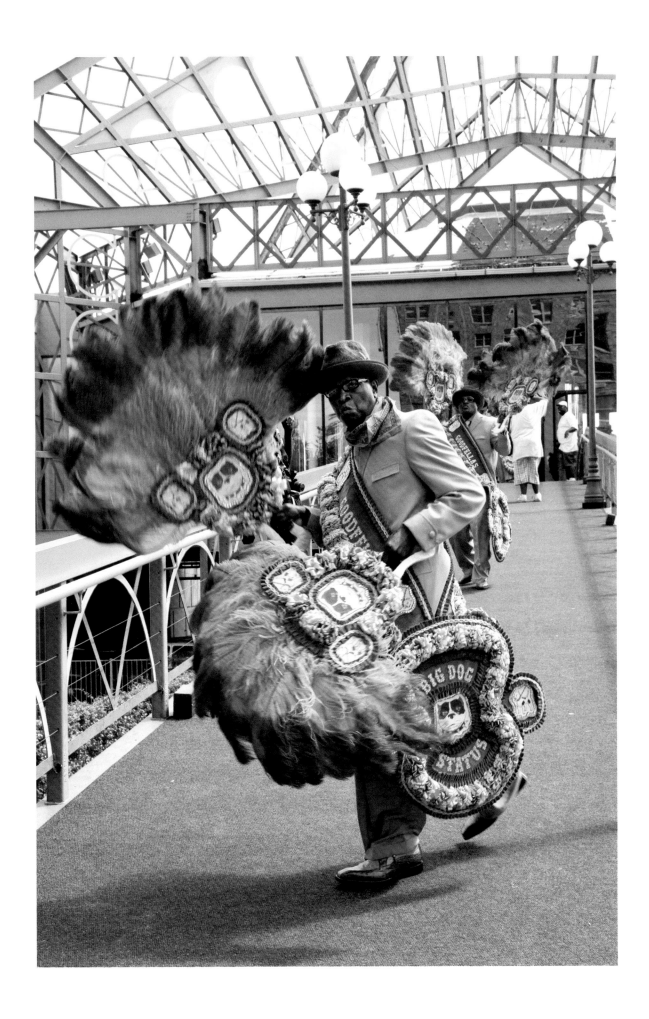

CHOSEN FEW

SOCIAL AND PLEASURE CLUB

Neighborhood

Downtown

Parade Day

Not fixed; usually a
Saturday in the spring

President Thomas Keelen had a vision for his club. He had paraded with the Jolly Bunch, starting at the age of six, and he wanted to return to that old second line tradition. After forming as a division of Sudan in 2007 and breaking off four years later, the club took its name from Anthony "Tuba Fats" Lacen's Chosen Few Brass Band, which played traditional jazz.

In keeping with the old days of second lining, the club has an all-male membership; they have no king, queen, or floats; and they make their own decorations. Their parade even has a name—the Traditional Jazz Cultural Parade Presented by Chosen Few Social and Pleasure Club Inc.—and the route sheet proclaims the club's philosophy: "[We] would like to make this event a Traditional Event so bring your umbrella and dancing shoes."

The Chosen Few paraded with other clubs—Family Ties, Keep 'N It Real, and Revolution—for six years, until they received their own slot in 2017. It remains a large group, boasting more than fifty members in two divisions, each with its own colors and band. A number of boys also parade with them. Like Sudan, the Chosen Few has a mission of mentoring boys in the second line culture. "I have kids at my house all the time helping make the decorations," Thomas said.

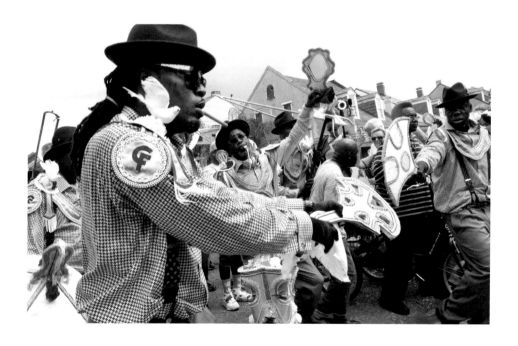

Dancing on Rampart Street, 2015, by Judy Cooper

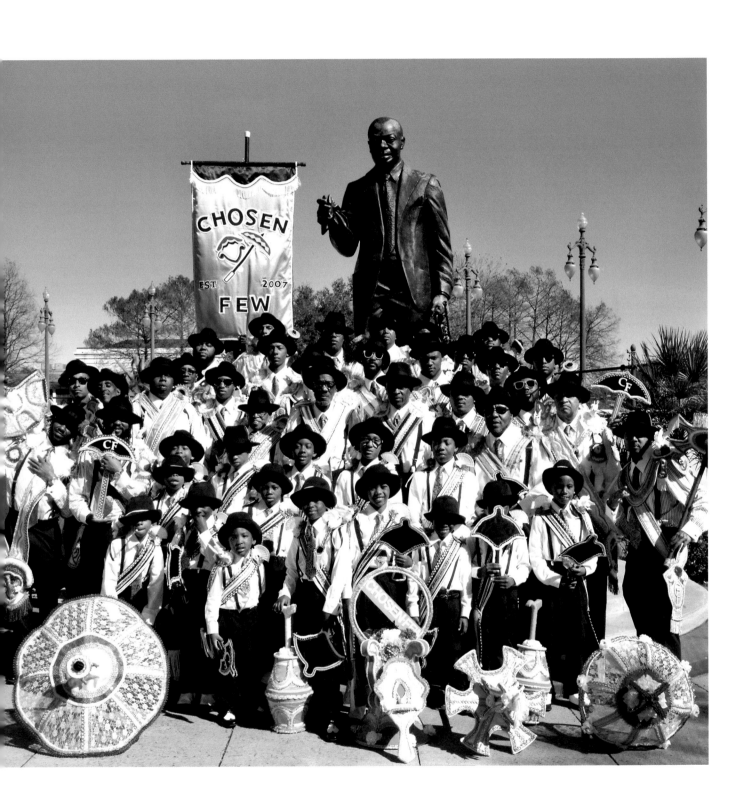

Chosen Few in Armstrong Park, 2017, by Judy Cooper

DEVASTATION
SOCIAL AID AND PLEASURE CLUB

1985

Neighborhood

Uptown (Central City)

Parades With

Perfect Gentlemen

Originally a division of the Young Men Olympian Jr., Devastation was founded by Charles "Poppee" Harris, his brother Wilmer, and Oliver Sparkman, who brought with them about twenty fellow YMO Jr. members. Poppee's son, Charles "PeeWee" Armstrong, who was three years old at the time, paraded with them from the beginning. Poppee retired in March 2005, just a few months before Katrina struck. The club continued for two more years, but with PeeWee and many other members still living out of town, it became inactive after 2007.

Even as years passed, PeeWee, the new CEO, was determined to revive the club. While still living in Dallas, he and club president Janero Hogan, based in Houston, spent over a year gathering twelve former members and recruiting new ones, including a women's division, the Devastation Divas. In 2016, the club made its comeback. Having lost their parade date during the hiatus, they came out with the Perfect Gentlemen, on June 19, Father's Day. "It is not easy coming back after nine years, but we are doing so as brothers and sisters," PeeWee said.

The symbolism of Father's Day that first year back was poignant—"I want to honor my father and my grandfather," said PeeWee, whose son and grandsons were in the parade. His mother was the queen, and his sister, Michelle Johnson, designed the decorations, which Poppee fabricated. "Parading is in our DNA," PeeWee said. "I want to keep our name alive and pass the tradition down to my sons and grandsons."

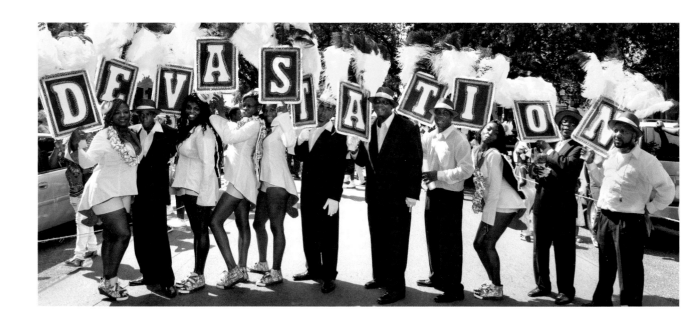

Charles "PeeWee" Armstrong (fourth from right) and Devastation in the club's first year back, 2016, by Judy Cooper

NKRUMAH BETTER BOYS
SOCIAL AND PLEASURE CLUB

Neighborhood

Uptown (Central City)

Parades With

New Generation (2013),

Divine Ladies (2017),

Original Four (2019)

Motto

African Americans Must Unite

This club was organized by Wardell Lewis Sr., who had previously started the Scene Highlighters and the Original New Orleans Buckjumpers. He named the new club for Kwame Nkrumah, the famous African leader who led Ghana to independence from Britain in 1957 and became its first prime minister and president. The club paraded for several years before becoming inactive in 2001. In 2013, Wardell Lewis Jr. organized a special reunion of the Better Boys to honor his father. Even though he was the honoree, Wardell Sr. made the decorations. Several years later, the club re-formed with a number of the original members. The Nkrumah Better Boys favor traditional uptown style—suits and hats with streamers and fans.

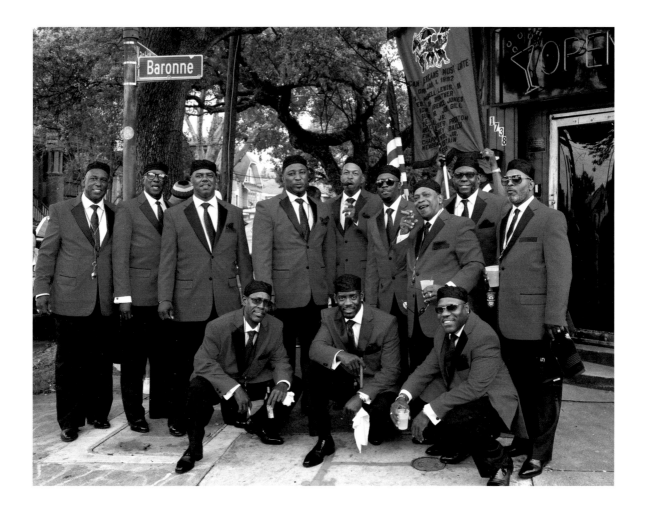

Nkrumah Better Boys, 2017, by Judy Cooper

VERSATILE LADIES OF STYLE

SOCIAL AID AND PLEASURE CLUB

2007

Neighborhood

Downtown (Treme)

Parades With

Sudan

Founder Cheryl Roberts's long history with second lining goes all the way back to Tambourine and Fan and the Bucket Men. After Katrina, she decided to form the Versatile Ladies of Style. The name was inspired by the members, a group of diverse professionals—teachers, social workers, health care workers, chefs, and more. Cheryl's uncle, Kenneth Dykes, then president of Sudan, invited the Versatile Ladies to parade with his club, and they became the first women's group to do so. Cheryl is intent on maintaining the dignity of her members. For example, she doesn't allow them to drink alcohol while parading. Like Sudan, the club prioritizes giving back to the community by volunteering at soup kitchens, organizing clothing and book drives, and working to mentor young women.

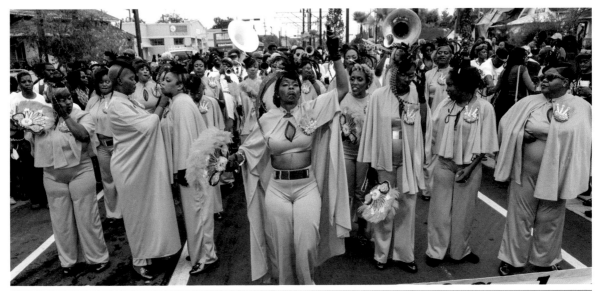

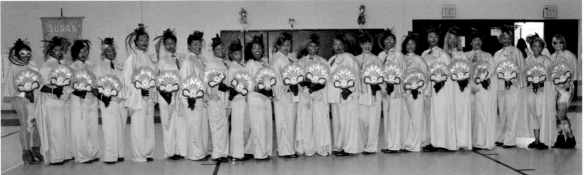

TOP Cheryl Roberts leads the parade, 2016, by Ryan Hodgson-Rigsbee
BOTTOM Versatile Ladies line up in the Treme Center, 2016, by Judy Cooper

LOWER NINTH WARD STEPPERS
SOCIAL AND PLEASURE CLUB

2008

Neighborhood
Downtown (Lower Ninth Ward)
Parades With
Big Nine

Walter "Lil Poppa" Carter was a member of the Big Nine, another Ninth Ward–based club, before founding his own group. The Lower Ninth Ward Steppers include men and women and have always paraded with the Big Nine, which acts as their parent club. As Ronald W. Lewis, the late president of the Big Nine, put it, "When a new club comes from your club, they are like your children. You welcome them." Walter, who masks Indian, makes the decorations himself. In 2017, the club adopted a Jamaican theme: the members dressed in green, red, yellow, and black, and their fans featured the face of Bob Marley, rendered in tiny stones. Their sashes bore the reggae singer's signature message, "One Love," as well as the Jamaican flag.

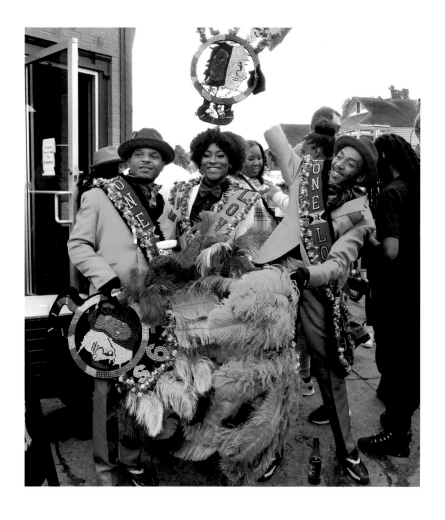

Walter "Lil Poppa" Carter (right) with the Lower Ninth Ward Steppers on St. Claude Avenue, 2017, by Judy Cooper

SPORTSMAN'S LADIES

SOCIAL AID AND PLEASURE CLUB

2009

Neighborhood
Uptown (Central City)

Parades With
Women of Class

Motto
I'm My Sister's Keeper

Founded by CEO Trinette Cockerham, the Sportsman's Ladies took their name from the Sportsman's Corner, a much-loved neighborhood bar, which also serves as their headquarters. The club first came out with the Men of Class but has paraded with that group's sister club, the Women of Class, since 2013. A men's group, the Sportsman's Hard Hitters, organized by William Cockerham, Trinette's father, paraded in place of the Sportsman's Ladies in 2015. Since then, the club has stayed off the street, as Trinette is determined to wait until they get their own parade day. The club organizes an annual toy giveaway for Christmas.

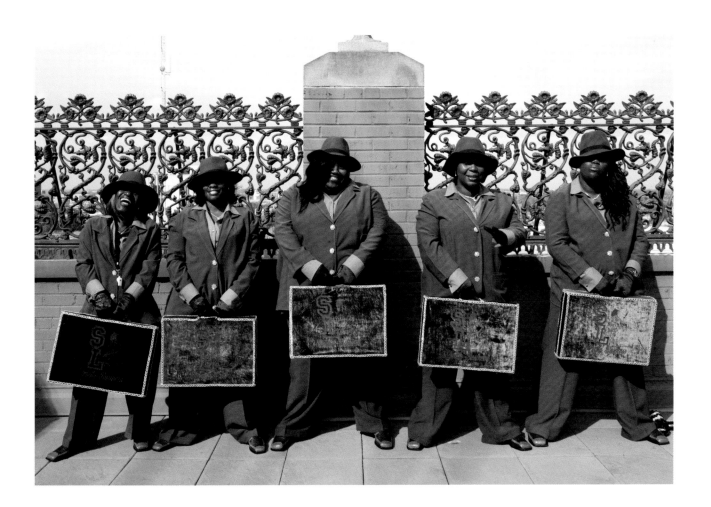

Trinette Cockerham (center) with the Sportsman's Ladies, 2014, by Judy Cooper

SOPHISTICATED LADIES WITH CLASS

SOCIAL AID AND PLEASURE CLUB

Neighborhood
Uptown
Parades With
Ladies of Unity

Founder and CEO Demetrice "Dede" Gaunichaux paraded with several clubs, including Devastating Ladies, Undefeated Divas, and Ladies of Unity, before starting the Sophisticated Ladies. From the beginning they have paraded with the Ladies of Unity and traditionally precede them out the door. "We are their standard bearer," Dede said. The club has a small membership, and Dede likes it that way. "I tell my members, 'Many are called, but few are chosen. We are the chosen ones.'" The club has spawned two others: in 2012 member Aisha Champagne broke off to form the Compassionate Ladies, and the next year Charlene Gray started Sisters of Change. For several years, the club has put on a Christmas program for patients at the Tulane Cancer Center, featuring brass bands, food and drink, and spa services.

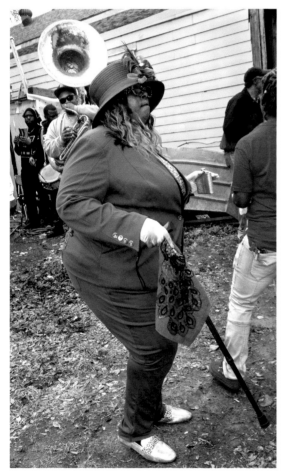 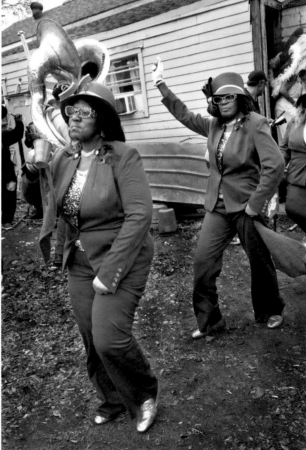

Sophisticated Ladies with Class, 2018, by Judy Cooper (left–right): Demetrice "Dede" Gaunichaux; coming out the door

BROTHERS OF CHANGE

SOCIAL AID AND PLEASURE CLUB

Neighborhood

Uptown (Central City)

Parades With

New Generation,

Ladies of Unity,

Perfect Gentlemen

Abraham "Bay Bay" Johnson founded the Brothers of Change with a long parading history behind him. He began as a kid with the YMO Jr. and went on to join the Original Four, the Uptown Swingers, and the Men of Unity. "I had it in mind to form a club of my own, even as a kid," he said. He was finally able to do so in 2011, and the Brothers of Change first paraded the following year, coming out with the New Generation. Following an ill-fated parade with the Ladies of Unity in 2015, in which an unpaid permit fee caused the NOPD to truncate their route, the Brothers of Change went on hiatus but were able to return to the streets in 2019 with the Perfect Gentlemen.

Bay Bay died suddenly in February 2020. He was known as someone who lived for second lining, someone who, when not in the first line, would pull an ice chest the whole route with drinks to sell to thirsty second liners. A night or two after his death, a group of friends put together a memorial second line in his honor, releasing balloons at the end of the route to the song "I'll Fly Away."

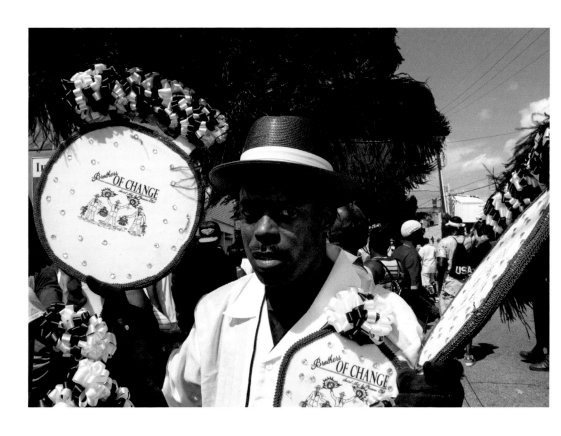

Abraham "Bay Bay" Johnson, Brothers of Change, 2019, by Judy Cooper

SISTERS OF CHANGE

SOCIAL AID AND PLEASURE CLUB

Neighborhood

Uptown (Central City)

Parades With

Perfect Gentlemen

After riding as queen in the first parade of the Brothers of Change, Charlene Gray, who had previously paraded with other clubs, decided to organize a sister club. Like the Brothers of Change, they were not able to get a date of their own, but have been able to parade with the Perfect Gentlemen from the beginning.

The Sisters order their clothes online, but their decorations are made locally and have included a number of standout items, such as intricately decorated butterflies on their fans in 2014. The following year the club unveiled a cobra motif, with three-dimensional serpents not only on the members' fans but also twisted around their bodies, the heads perched on members' shoulders where a dove would normally be. In 2019, the club was invited to parade at Jazz Fest, which Charlene took as a sign of her club's arrival as an established group. "We appreciated the opportunity to perform, to let more people know about us," she said.

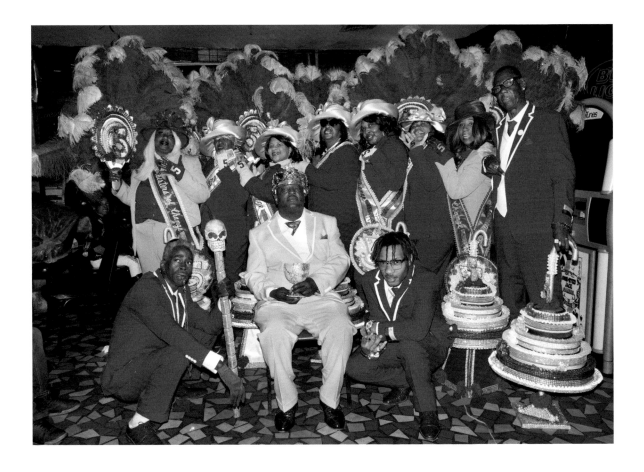

Charlene Gray (standing, second from right) and the Sisters of Change, celebrating the club's fifth anniversary, 2017, by Judy Cooper

ICE DIVAS
SOCIAL AND PLEASURE CLUB

Neighborhood
Downtown
Parades With
Keep 'N It Real

President and founder Catina "Black Ice" Braxton-Robertson grew up around the second line tradition in the Third Ward. She was a member of the Lady Rollers for fourteen years before she and five fellow members decided to break off. Racially integrated from the beginning, the Ice Divas first paraded with Keep 'N It Real in 2013. Because of the club's small size, Black Ice frequented other parades to recruit new members, paying particular attention to the dancers. (Rachel Carrico, a contributor to this book, joined the Ice Divas in this manner.) Wynoka "Nokie" Boudreaux Richardson of the Ladies of Unity has paraded with the Divas in the past and makes their decorations. Black Ice said her club is founded on loyalty, honesty, and inclusion: "We have an open-door policy. We welcome everyone."

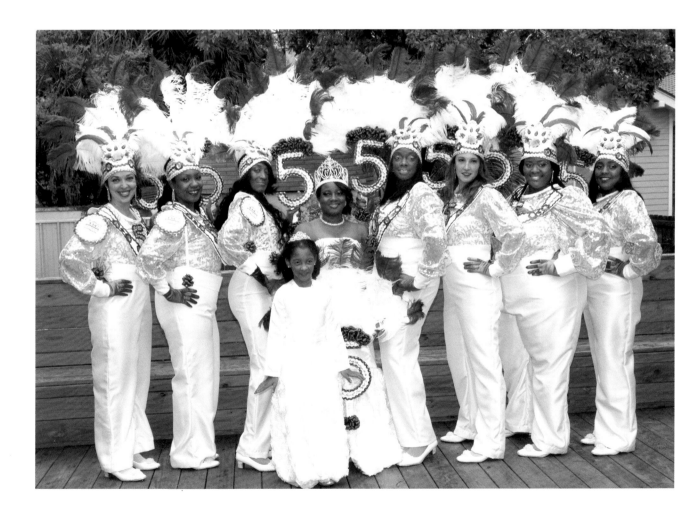

Ice Divas on the club's fifth anniversary, 2017, by Judy Cooper (left–right): Rachel Carrico, Wynoka "Nokie" Boudreaux Richardson, Tari Ballard, Princess Noelle Sanders, Queen Jerrelda Sanders, Catina "Black Ice" Braxton-Robertson, Kristy Magner, Enjoli Pannell, and Arrielle Guice

KING OF KINGS

YOUTH FOUNDATION

Neighborhood

Uptown

Parades With

Men of Class,

Single Ladies,

Perfect Gentlemen

King of Kings, now made up primarily of young people, was formed by Dwayne Smith after he rode as king with the Lady Buckjumpers. He contacted some other former kings to start a new club, hence the name. As the men began to drop out, Dwayne decided to focus the club on the kids, following in the SAPC tradition of mentoring set forth by the Tambourine and Fan and the Bucket Men. The children traditionally wear jackets and pants with streamers and fans, and the boys and girls help to make their own decorations.

Dwayne organizes events with the kids, such as visits to the aquarium and church outings. Some Sundays, they also attend a second line parade. Dwayne conducts regular meetings with the parents, who often tell him that their child's academic performance improves after becoming a member of the club.

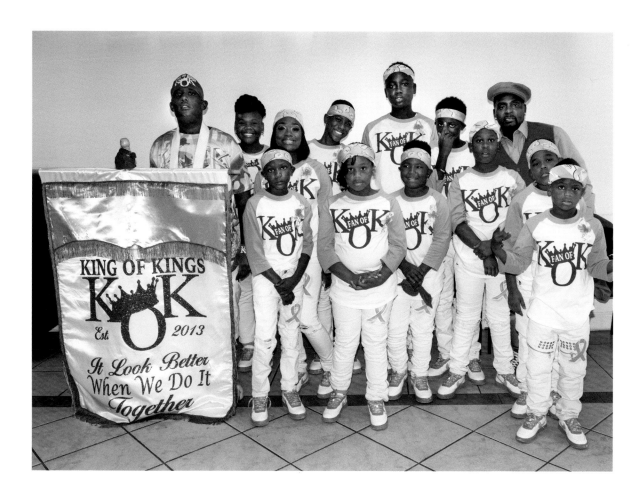

Dwayne Smith (back right) with King of Kings before the Men of Class parade, 2018, by Judy Cooper

265

ONE MORE TIME

SOCIAL AND PLEASURE CLUB

Neighborhood

Downtown (Treme and Seventh Ward)

Parades With

Dumaine Street Gang

This all-male club was organized by Larry Rainey, Ernest Johnson, and Bilal Nadir, who were all members of the Money Wasters in the late '90s and wanted to parade "one more time." "Between all of us, we have two hundred or three hundred years of parading experience," said Bilal, whose father, Robert Williams, paraded with the Jolly Bunch back in the day. One More Time's outfits are decidedly old-school: pants and shirts, shoes from Rubensteins, and hats from Meyer the Hatter. They also wear yokes with a patch on each shoulder, the traditional dove sitting atop one side and, sometimes, a cocktail glass on the other.

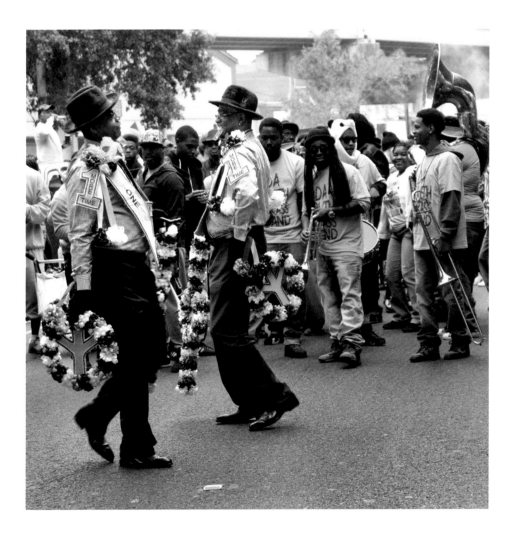

One More Time, 2014, by Judy Cooper

DIGNIFIED ACHIEVABLE MEN (DAM)

SOCIAL AND PLEASURE CLUB

2014

Neighborhood
Varied
Parades With
Perfect Gentlemen,
Money Wasters

Founder and CEO Dismas Johnson used to parade with the Original Big 7 and wanted to form his own club as a way to bring new voices to the SAPC community. "It is up to the younger generation to keep the tradition going," he said. The club started with only men but has grown to include ladies and kids. For the first three years the club joined the Perfect Gentlemen for their annual Father's Day parade— one year, in 2017, arriving mid-parade by dancing off of a St. Charles Avenue streetcar. Since then, DAM has paraded downtown. Sometimes the members wear suits; other years they favor shirts and pants with suspenders and bow ties. They make their own decorations, which are usually streamers and fans.

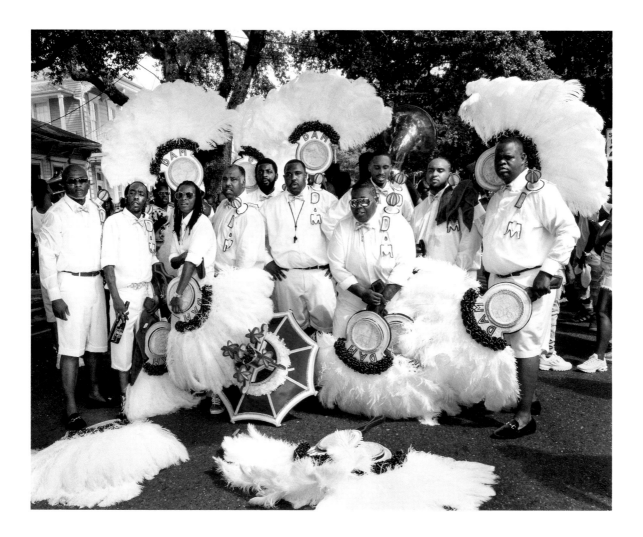

Dismas Johnson (center front, with fan) with DAM on Washington Avenue, 2018, by Judy Cooper

Neighborhood
Downtown (Ninth Ward)
Parades With
Dumaine Street Gang

The club with the unpronounceable name was started by Troy Materre, Corey Woods, and a few other members of Nine Times. Often asked about the origin of the name, Troy said they couldn't think of anything else, and so they went with three question marks. Though ??? parades with the Dumaine Street Gang in the Sixth and Seventh Wards, the founders represent the Ninth Ward and would like to parade there when the club gets its own date. The group favors traditional outfits with stately colors—navy and pewter their first year out, chocolate brown and sienna the next—and fans bearing their logo. One year each member wore a patch on his shoulder bearing his initials. The members make their decorations themselves; the first year, pressed for time, they produced their fans in just two days.

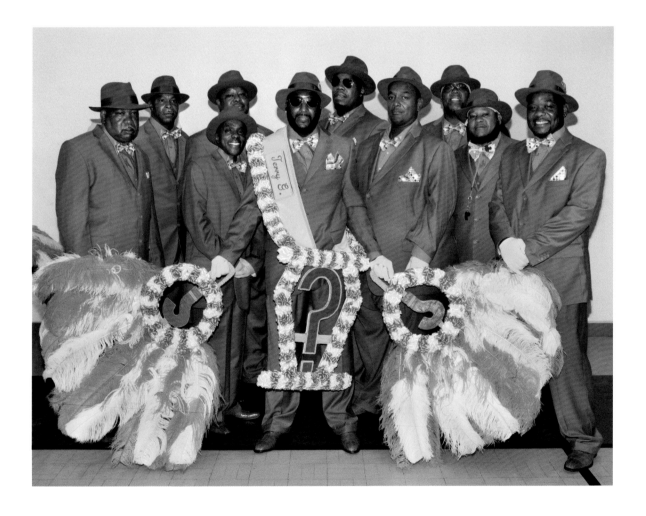

Troy Materre (back row, far left) and Corey Woods (front row, left), ???, 2016, by Judy Cooper

SPIRIT 2 DA STREET
SOCIAL AND PLEASURE CLUB

Neighborhood
Downtown (Treme)
Parades With
Sudan

"Second lining is my first earthly passion," said Larry Terrence, president and founder of Spirit 2 Da Street. Larry started parading in the early '70s with the Scene Boosters before moving to Atlanta, where he lived for twenty years. "But the spirit of New Orleans never left me," he said. When Larry returned, it was with two goals in mind: to join a church and to join a second line club. After five years parading with the Ole & Nu Style Fellas, he broke off to form Spirit 2 Da Street. "I learned a lot from [Ole & Nu Style cofounder] Sue Press about how to organize a club," he said. The mission of the new club, as expressed in the name, is to "bring the spirit of the Lord to the streets and to have fun." Larry, who has a family background in sewing and Mardi Gras Indian beadwork, makes decorations for the club along with other members.

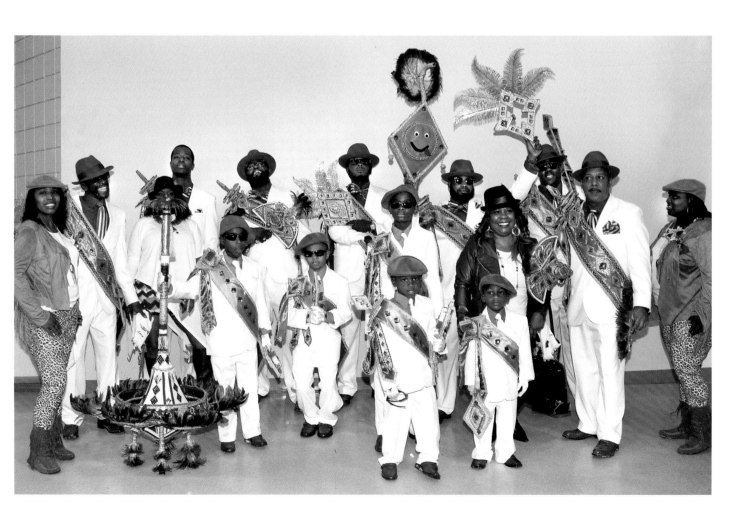

Larry Terrence (second from left), Spirit 2 Da Street, 2015, by Judy Cooper

YOUNG ROLLERS
SOCIAL AND PLEASURE CLUB

Neighborhood

Downtown (Treme and Seventh Ward)

Parades With

Dumaine Street Gang

Jahmad Randolph founded this club of young people when he was fifteen years old. He and other members had previously paraded with the Revolution, and starting his own group had been a dream since the age of eight. Composed of boys and girls, the club has now grown from eight original members to more than ten.

The Young Rollers' 2019 parade was dedicated to the memory of "Uncle" Lionel Batiste, the beloved drummer for the Treme Brass Band who passed away in 2012. The kids dressed in black tuxedos and wore white band caps, carrying fans with a likeness of Uncle Lionel. The younger boys carried toy drums that they beat as they paraded down the street.

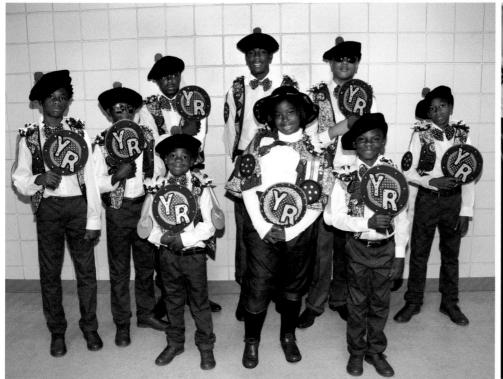

LEFT Sporting tam-o'-shanters for the club's inaugural outing, 2016, by Judy Cooper
RIGHT Tribute to Uncle Lionel, 2019, by Judy Cooper

FOOTWERK FAMILY
SOCIAL AND PLEASURE CLUB

Neighborhood
Varied

Parades With
Family Ties

Founder Derrick Santa Cruz started parading with Sudan when he was a kid, following in the footsteps of his stepfather, who paraded with the club for twenty-five years. Years later, after he had children himself, Derrick's interest in parading returned. Inspired by his years of dancing on the sidewalk with friends, he formed Footwerk Family. "I wanted to go back to the old days when people really danced," he said. The club's membership includes men, women, and children.

For their outfits, Footwerk Family combines old second line style—shirts, matching pants and hats, and suspenders—with even older touches, such as the knickerbocker style of the pants, cropped just below the knee, as well as custom-made saddle shoes. In another nod to tradition, Derrick gives the brass band, Da Truth, a playlist before the parade, asking them to play traditional songs for the first hour and a half. After that the band can play what they want. Derrick chooses the colors, usually three, orders the clothes and shoes, and makes the decorations. "I want to make the cost of parading affordable," he said. "You don't have to spend a fortune to look good."

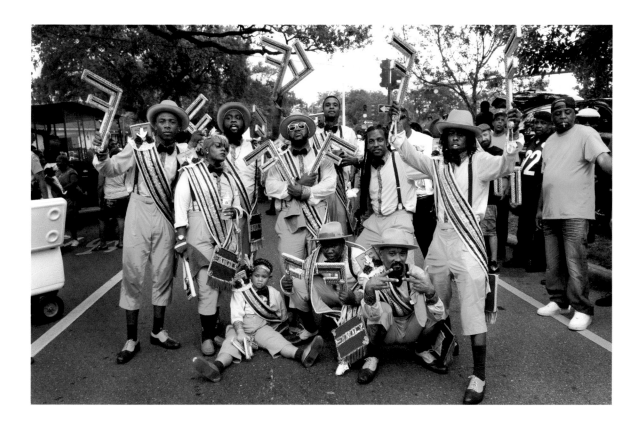

Derrick Santa Cruz (center, arms crossed) with Footwerk Family on St. Bernard Avenue, 2017, by Judy Cooper

MY BROTHER'S KEEPER (MBK)

SOCIAL AND PLEASURE CLUB

Neighborhood
Uptown (Central City)

Parades With
Single Men

Motto
United We Stand

Like many other SAPCs, My Brother's Keeper (MBK) grew out of an older club. The founding members belonged to Nine Times and wanted to form a division of it, but the older club refused. "We wanted to do our own thing," said CEO and cofounder Larry Morgan. The members—men and women—frequently make a big showing at other second lines, wearing their MBK shirts. They first came out with the Single Men in the spring of 2018. Edward "Lil" Randolph, MBK president, knew Richard Anderson of the Single Men from the Melpomene housing project, where they both grew up.

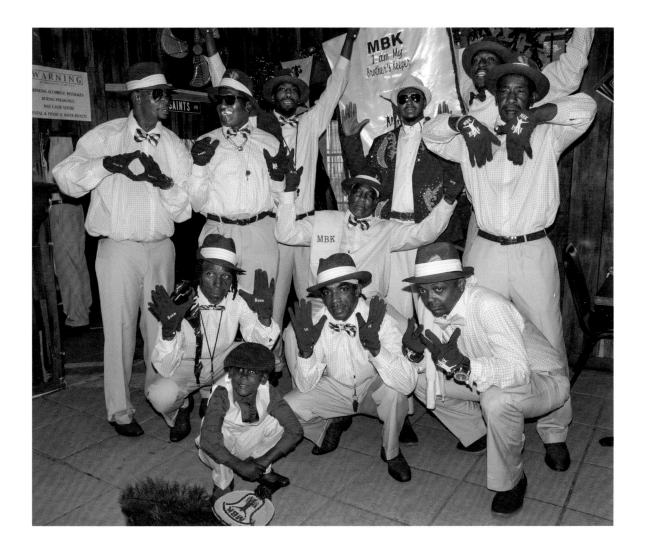

MBK before its first parade, 2018, by Judy Cooper

TEAM WOODY
SOCIAL AND PLEASURE CLUB

Neighborhood

Downtown (Ninth Ward)

Parades With

Single Men

Founder Woodrow "Woody" Randall decided to start Team Woody when he was king of the Nine Times parade in 2015. "I knew then and there that I wanted my own club," he said. Some of the dukes who rode with him that year joined him as founding members. Though the club parades uptown with the Single Men, Woody and his team come mostly from the Ninth Ward—"out da jungle!" as one member put it. The club made its debut in traditional style, with suits, matching hats and shoes, and fans. For 2019, they came out as railroad men, wearing dark blue overalls and conductor's hats.

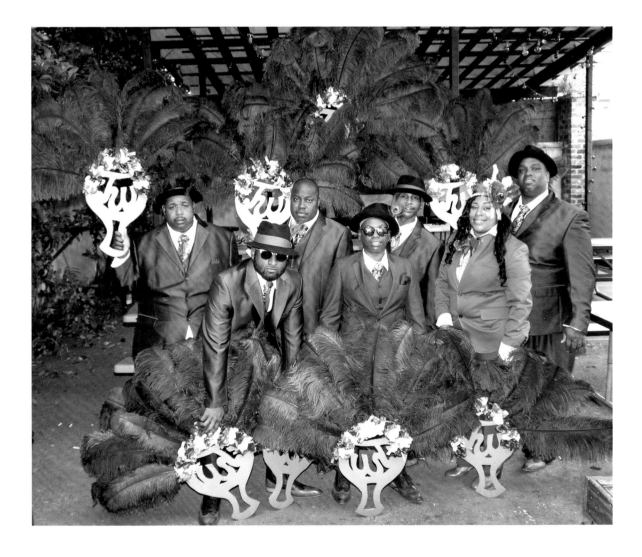

Woodrow "Woody" Randall (front left) with Team Woody, 2018, by Judy Cooper

UNEXPECTED REBELS

SOCIAL AND PLEASURE CLUB

2017

Neighborhood
Uptown
Parades With
Perfect Gentleman

Founder Prystal "Problem Child" Wilson previously paraded with the Compassionate Ladies. In 2017, she decided to form her own club, the Unexpected Rebels. Their first parade was with the Perfect Gentlemen, on Father's Day. With the theme of "Beauty and the Beast," they wore royal blue, red, and yellow. There are nine members—women, men, and kids—including Problem Child's mother and stepfather, making this club another family affair.

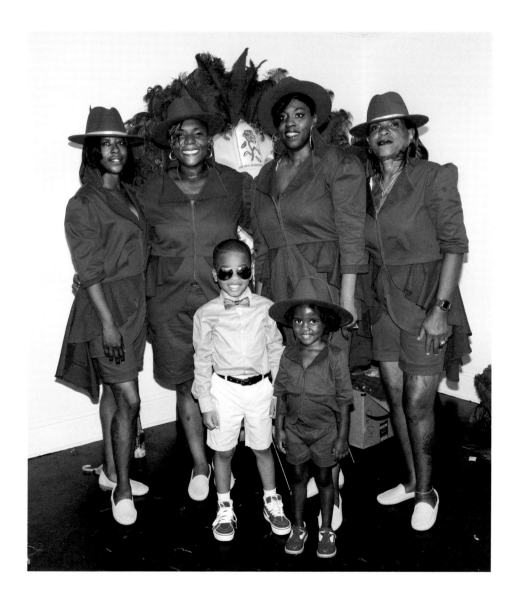

ABOVE Prystal "Problem Child" Wilson (second from left), Unexpected Rebels, 2019, by Judy Cooper
OPPOSITE Banners at the parade honoring Alfred "Bucket" Carter, 2012, by Judy Cooper
FOLLOWING SPREAD Popular Ladies at Jazz Fest, ca. 1999, by Judy Cooper

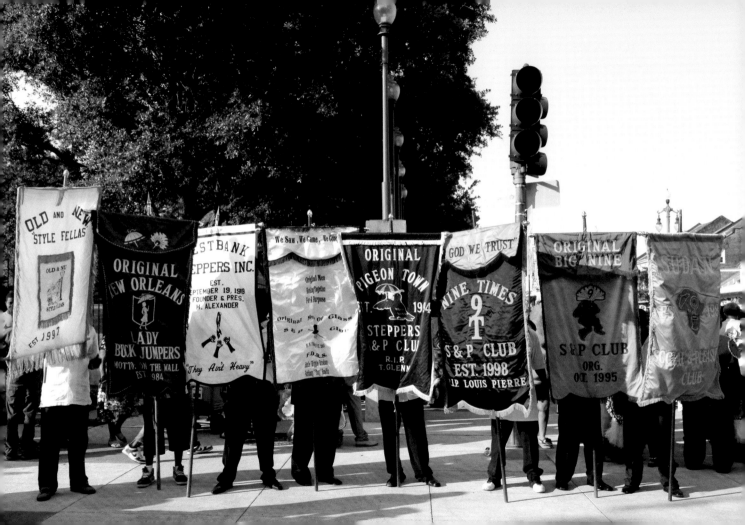

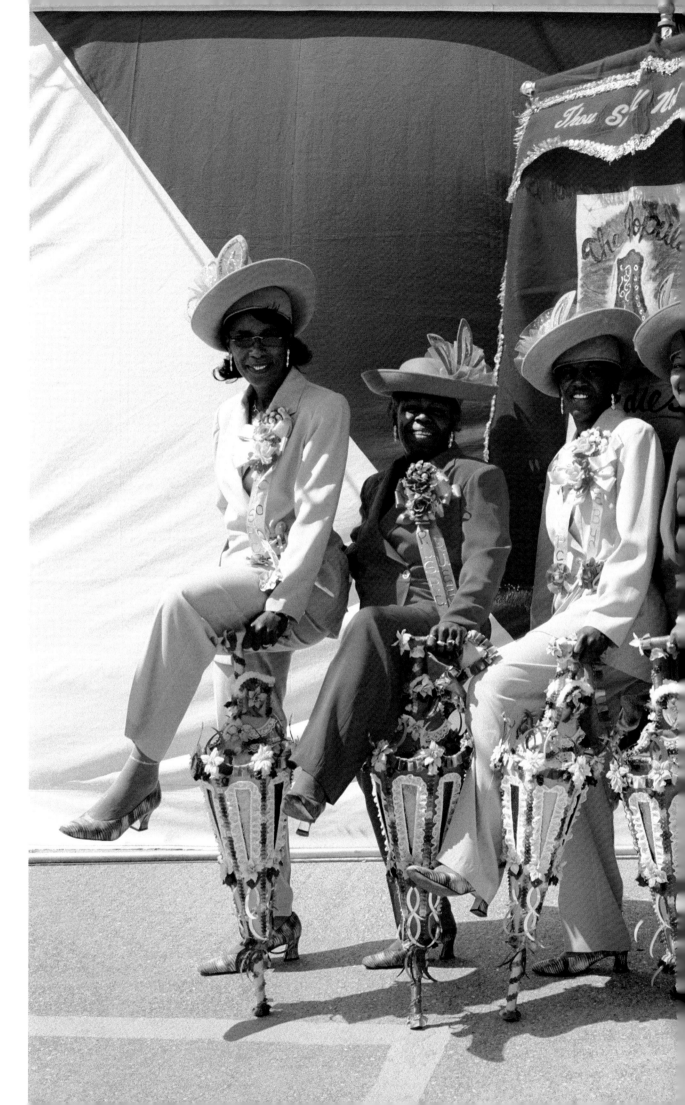

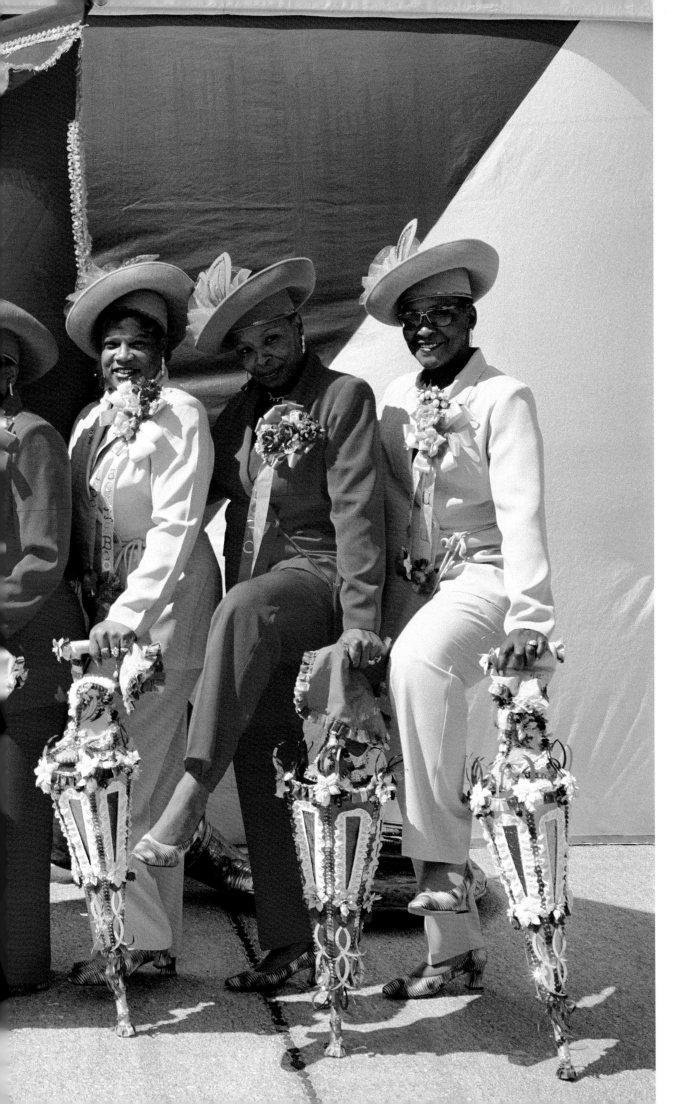

PART IV

EPILOGUE

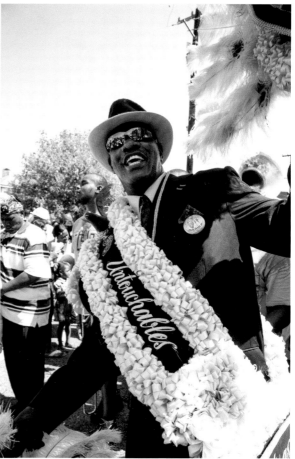
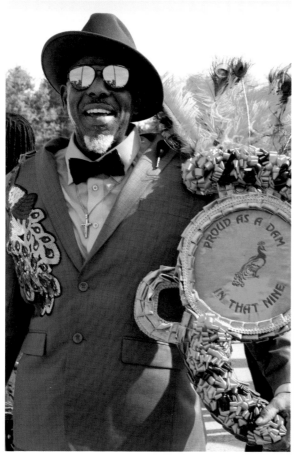
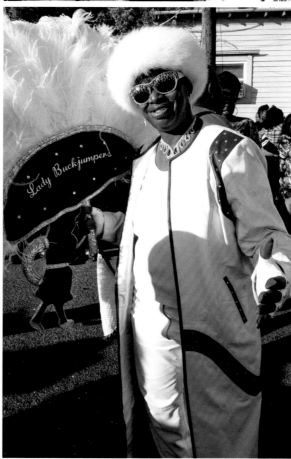

THE YEAR WITHOUT SECOND LINES

CHARLES "ACTION" JACKSON

Better known by his radio name, DJ Action Jackson is a community leader and broadcast journalist whose podcast, Takin' It to the Streets, *is posted weekly to WWOZ.org. He also deejays on-air every Thursday afternoon, often doing in-studio interviews with club members during the second line season. In conversation with **Norman Dixon Jr.** of the Young Men Olympian Jr.,* **Raphael Parker** *of Nine Times, and* **Linda Tapp Porter** *of the Lady Buckjumpers, he reflects on the effects of the COVID-19 pandemic on the second line community. Jackson's one-on-one interviews, conducted in November 2020, have been edited together and condensed for publication.*

It happened so abruptly, because we were just getting back off a break for Mardi Gras. The second line takes a two-week break during Mardi Gras. They had one, no more than two more parades after that when the city totally shut down. Of course, nobody knew that it would take this type effect. And no, we did not know what to do. I had scheduled podcasts, because every week I interview the president of the social aid and pleasure club—whoever's coming up that Sunday. So, I already had interviews lined up, and every week it was, "Well, I'm not sure we're parading, but if we do, we are ready, we on the wall," meaning, our clothes is ready. But the mayor and the governor, who I call mommy and papa, they say we can't go take it to the streets.

Ms. Tamara Jackson Snowden, president of the VIP Ladies, who's also the president of the New Orleans Social Aid and Pleasure Club Task Force, she sat down with the city and the mayor when this first broke out. Norman Dixon was at that particular meeting, too, and the initial response was—you can't walk around in a bubble at a second line, you know? You can't carry plexiglass at the second line; it's a moving entity. So the only normal solution was to wait until everybody's safe and not at risk, which will be the

vaccination. So when the NOPD said that, it was like, "Okay, y'all got the answer—don't come back." We're talking about every second line Sunday? And the answer's, "No, I'm telling y'all, until we get this under control, there absolutely won't be no second line." The Valley of Silent Men, they were going to celebrate turning thirty-five. They said they're just going to do it next year instead. Tony Hookfin from the Men of Class, he was going to do fifteen years. He said whenever they come back, they still doing the anniversary. They take those anniversary parades very, very seriously. That's a milestone, you know, especially those older clubs—thirty-five years, out in the street, one hundred thirty-five years for YMO—so yeah, they keep accountability of that.

This little mind that I have, it just—I couldn't sit down. I mean, I call myself something like Paul Revere, like, "The second line is coming! The second line is coming!" So when I thought about it, and by them saying there wasn't going to be no more second lines till the vaccine, I'm like, oh man! So I said, let's try to find a way to go on Facebook and show some of the video footage that we have from previous parades.

Before Katrina, me and a couple different camera people would go out to the second line and record the second line. And from about 2010, I got together with Mr. C from Mr. C's TV, and we created a thing where I'd go out there with him to meet at the beginning and then do some interviews; we'd go to one or two or three of the stops and catch 'em live doing the second line. Once the clubs got familiar with us to go in between the rows of paraders, we'd get these exclusive shots. So we have all this footage that we've been sitting on.

So every Sunday from one to three, we stream live on Facebook from the Treme Hideaway, owned by Derrick Tabb of Rebirth Brass Band and the Roots of Music, showing the footage of each club on the date they were supposed to come out. And that may help ease some of the stress that people are going through by not being able to go to second line. Because it's four hours of therapy, we call it. That's really what it is.

Now my question for the clubs is, well what are y'all doing during the pandemic? Are y'all planning on returning? How are y'all doing? Did y'all lose any members? I'm more concerned now with the health of people.

———————————————

Jackson: So let's start with the beginning: how are you and your members doing during this pandemic?

Dixon: Like everybody in the country, we are in a point in our lives where we're struggling. But I tell you what, I'm glad we're an organization who believes in God and counts on Him in times of trouble. Basically, that's what we've been doing. We had a couple of members, five or six, that really were on their deathbeds during this pandemic. I tell everybody, every once in a while in your lifetime, you get to measure something that you participate in or that's a part of your life. And in the forty-six years I've been a part of the Young Men, this pandemic has really made me measure and look

at how fortunate I am to be a part of this group and how proud I am to be a part of it. During this pandemic, you had 125 men come together and pray, support each other, and just be there for each other. We had some who, five, six months—and I mean every day—we never missed a day of supporting them and calling them and praying with them, looking in on their families, the wives. We had a Facebook Live where, more than once I had to tell members, you know, "You can't give up, you can't quit." And after it was all said and done, they came through it, and they just said how the membership and prayer, first of all, got them through it. Right now, all of our members have actually survived, unlike Zulu, who lost a number of members.

Jackson: They just lost one of their past kings, George Rainey. Zulu took a big hit.

Dixon: They're a brother club of ours, and we have a close relationship. We have several members who are in both organizations.

Jackson: How are you all feeling, because I want to say minus Katrina, this was the only time y'all never be able to hit the streets—because you all hit the streets rain, snow, or shine.

Porter: True. That's true. At first, Action, it was a bad feeling, but when I got together—because you know me, I'm going to put something together—when I got with my girls, we realized there was other things that we can do to celebrate the Lady Buckjumpers among ourselves without pulling a crowd together.

Jackson: So what are some things have you all been doing to stay connected?

Porter: The other night we did, like, we just rolled around—popped in some places that wasn't closed. With our usual thing, we would have got on one of them little party buses and ride to different spots where we going stop at for the parade, but this time we did it in our cars. Some of them wasn't open, but we just did it to make ourself feel like we would have been feeling around this time of the year. It was a nice thing to do; we just know we can't do like we used to do.

Jackson: I don't think nobody could. It's getting worse.

Porter: And we love our people, so we not trying to put nobody in harm, you know.

Parker: We just recently done a bike ride Sunday for our parade day. All four divisions was there—well, not the kids, there's five divisions with the kids. The route we was riding with the bikes, I don't think they would have made it. Lady Nine Times, that's our original first women's division, so most of them are like up in age, so some of them came and some didn't because of underlying stuff with the pandemic. But we had a nice little cookout and all of that, kept our social distance, DJ, regular New Orleans stuff. Me and my members and the people that come and enjoy our parade, the multitude of people that come out with us for our community, a lot of them not doing too good anyway. That's what they was relaying that Sunday at this bike ride we did.

The theme was COVID Nine Times, because, like COVID-19 is a sickness, COVID Nine Times is a sickness too, because they're sick the parade is not going to be able to

go. You got that COVID Nine Times? Come bike it or hike it and cure your mind in the Nine. So the ones that completed the route, they considered theirself cured because at least they went the whole route.

Jackson: Are any of the members feeling depressed or some kind of way behind not parading?

Porter: Probably me. I've been doing it for thirty-six years. Probably me. And you know something, Action, around this time, you know what time it is for me.

Jackson: We're talking about your son, who was a world-renowned rap force, Soulja Slim. He was gunned down, unfortunately, [in 2003,] during the week of your parade, right around Thanksgiving.

Porter: I really try not to think about it, especially around this parade time. But now we don't have it with this pandemic, and you ain't got nothing to do, and your mind is idle, and you just think all kind of—but I just give it to God and just pray and try to make the best of every day. Because yeah, this year it [the anniversary], this year it fell on the day he got killed—Thanksgiving fell on the day he got killed. The parade was one of those times that I didn't have to think about it, because I was always busy. But now I ain't got that to do, so yeah, I'm one of the depressed people.

Jackson: Oh, wow. Well, and I know you're going to miss getting up there [to Slim's former residence] during your parade, going on that doorstep by the Magnolia project, doing that tribute of going to that porch over there.

Porter: Yeah. He wasn't into the second lining—that's me. But he never would let his mama pass that area where she couldn't see him. Even if he just stand up for a few minutes to wait till I pass. So that's the area I always do a tribute to him. And I ain't telling many people, but I'm still going to do that tribute to him. I ain't told people, because I don't want—I respect the mayor, I respect the mayor—but I have to do that tribute to him on that day.

Jackson: Have folks been able to do any kind of under-the-radar parades of any sort?

Parker: No one really has done any parade. Now, some people, they have tried to have a band, mainly for a funeral or something, like around the block. But a real actual parade? No. No one hasn't been doing no parades undercover or anything like that. Because parades don't go undercover. That word of mouth is so strong, a real parade ain't going to happen undercover.

Jackson: When you hear that tuba from a second line band, I don't know where the people come from, but they just show up. Once you hear that boom-boom-boom-boom, suddenly it's, wait, where'd these people come from? Fortunate for the second line band, that's what they do. But unfortunate for the second line band, that's what they do. I'm one of the first links to the parade, and I absolutely won't post no type of gathering on *Takin' It to the Streets* because, you know—and I wouldn't encourage nobody to do it.

Jackson: When the pandemic started and Jazz Fest was canceled, that was absolutely one of the worst things for the second lines, because that's how they really get funding for police escorts. All the second line groups come to the Jazz Fest and the festival pays them. It takes the pressure off of paying for the police and the permit, gives 'em a chance to focus more on their clothes and their bands and the floats. So Ms. Linda, how did Jazz Fest—not getting paid from Jazz Fest—affect the club?

Porter: Yeah, Jazz Fest is one of the biggest contributions to our club. And not only that: when you parade at Jazz Fest you get to meet a lot of people, you understand? And those people get us to come out of town to do a festival for them or whatever. But yeah, Jazz Fest is one of the things that, when we get that money, we put it to start the club off for the new year besides the funds we raise during the year.

Jackson: Could the clubs survive or come up with their own money if they don't have Jazz Fest again?

Parker: Oh, of course. If you know there's no Jazz Fest, then you make your plans from there. Maybe you have an extra function or two, an extra event or two, to be able to fund that. That's the way to solve that.

Jackson: Well, what's concerning for me: we've been locked down before, and if we keep spiking up again, the clubs won't have a chance to do any type of events—the dances and balls where they sell tickets to help pay for their stuff. A lot of the vendors at the second line, who sell food or barbecue or whatever, to raise money for your club, for whatever missing funds it is—and then a lot of people is not even working, trouble paying rent and all that stuff. So even if a group had some type of savings, it's putting a big dent.

Porter: Yeah, we can't—it is. We can't do none of that right now. Half of the club working and half not working, and then some of them have to take two or three jobs to make it. So even if we did, was able to put some of those things on, all the members wouldn't be able to participate.

Jackson: Do you think the NOPD might lower the permit fee because of the pandemic and how hard it's been on everybody?

Parker: They may, but I wouldn't bet on it. I wouldn't bet.

Jackson: Already, people will spend light bill money, automobile money, condo money, to get ready for these parades. It breaks up households, you know? I had a lot of flack at my own house when I was trying to do this, cause every extra dime you come up with, it goes toward this. There's a lot of money involved with going out there. But the sacrifices for that event, it's a cultural thing that, if you're not deeply involved in it, you wouldn't understand, you know?

Dixon: People's been affected by the pandemic. If you can pay your dues, you pay 'em.

If you can't, you don't. But nobody's being dropped because they're not financially up-to-date. That's just what we do. What we going to do is, you tell us if you're struggling, and we're going to help you. All of our members are paying their dues, but we were able to give each of these families that was struggling—and we weren't trying to raise money, not going on the TV, not going to the public, just sacrifices that members did to help these wives whose husbands weren't able to work—I'll tell you, as a grown man, it made me cry because of the giving attitude. I didn't have to ask but once. I sent out one text; I was getting numbers.

Jackson: Well that's what makes a resilient second line organization: not only do they parade on that given Sunday—that's their *last* event of the year. All during the year, they take care of their own self and their own neighborhoods. Pretty much twenty to twenty-nine groups, I know, feed the homeless or feed the elderly or something—same with back-to-school supply.

Thank goodness for one of the entities out there, Mr. Devin [De Wulf] over there at the Krewe of Red Beans. They're doing a great job. He came to me, met with me to get names of the club presidents, and tracked them down, because they wanted to "feed the second line." They want to make groceries for people, especially the elders who—well at the time it started, it was phase two [of the city's reopening from the shutdown]—they weren't even leaving their house. So, they will come to your house, give you a list to choose from, go make the groceries, and bring it back to your doorstep. And that was—like, the seniors was calling me, thanking me so much for getting 'em connected with the Krewe of Red Beans, because they was making three, four hundred dollars' worth of groceries.

Dixon: The Krewe of Red Beans, that's one of the nicest bunch of guys I've had the pleasure of meeting. Sitting down and talking to them after you introduced us, it was a blessing. Our missions are the same. And they were able to help ten of our members who were all over the age of seventy-five, giving them groceries and hot meals.

Jackson: It's such a great help. Not only that, it helps the Mardi Gras Indians and the bands. The bands pretty much lucked out the most, because not only was the Krewe of Red Beans feeding—they were hiring people, giving them a chance to make some money. So if the band member had a car and was available on Friday, you know, whatever, then he would get hired. And that was another big help, because the bands—they're the ones taking the lick the hardest. Most of those cats, that was their *job*, you know? Before, every time somebody passed away, you'd hire a band. Everybody getting married, or digging ground for a new building, a dignitary coming in from the airport—they will hire a band. So with a lot of that gone, the bands are picking up only a little money now. Even a band like Rebirth—they won a Grammy—or the Stooges, who was on a world tour, all that abruptly stopped, like, overnight.

Jackson: From what I'm understanding out of a lot of these conversations, the pandemic has created not just a big financial burden for the clubs but also, in some cases, major depression.

Dixon: It's been a trying time for social and pleasure clubs, benevolent clubs that are out there, because this is what we do. What makes this time so trying is that it comes with so much stress and frustration, and how do we deal with the stress and frustration usually? We participate in social events, from football to second lines every Sunday, from walking in the French Quarter to looking forward to festivals. That's our reliever. But this has taken all of that away.

Jackson: It has taken a toll.

Dixon: People don't realize, I guess, how when you have something right in front of you and you enjoy it, you don't know how much you should be appreciating it. I tell you, I talk to people, every time they see me: "Man, when is the second line coming back? When we going to be able to be back in them streets? When we going to be able to enjoy what we love doing?" And to top it off, you have no answer. Right now, we don't have a clue. So, what the Young Men have been doing is this has been a time where we have been closer than ever. When I was coming up as a young boy in the '70s, at seven years old in this organization, being around my father and his friends, those old, legendary men of the Young Men and just watching them, I'd say how in the world could anybody, members of this organization, ever be closer than those guys were? And here comes this pandemic. And it's been epic. What brings you closer than they were? A pandemic.

Jackson: So what do you miss the most about hitting the streets?

Porter: The people. Man, I'm like my son. My son loved New Orleans. I love New Orleans. I can't even think of nowhere else I would want to live. Second line Sunday, fun day, man, we live for that. Me and my sister were talking about it the other day: it's just not the same, because we don't have nothing to do. All we could do is just come on back home, look at TV, cook, whatever. But Sunday was the fun day, man. That was the day. We miss that.

Jackson: Because from, you know, when the slavery time was going on, you can only go to Congo Square, you know, on a Sunday. So that kind of, like, flowed over to the streets a little bit. So Sunday is very precious; it's a stress release. And you know, it's the best medicine in the world. Out of all the medicines in the world, that will give you two forms of medication you have to take, that make you feel good, and that's dance and laughter.

Jackson: I guess the hardest question that no one—I never even asked this question before, but I thought of it today: what mindset—I guess you can only speak for yourself—would you have if we would never be able to second line again?

Parker: Oh, [*exhales sharply*].

Jackson: I know.

Parker: Damn. Excuse me.

Jackson: I just thought of that.

Parker: Wow. I tell you, I'm going to move. I think I'm going to leave New Orleans after that. I ain't going to be there on a Sunday after Sunday after Sunday—and they're going to be trying to do something, you know what I'm saying? At that point I'd probably be trying to do something, and if we still couldn't? Wow.

Jackson: I think I had that feeling when I created Secondine Sunday from the Hideaway, with showing some of that footage of that stuff. Every week you're saying, "This is what this really was. We're missing that so bad."

Jackson: After Katrina, we put on this mass second line [see p. 53 for more]. Every club was in this one second line, and that got almost the majority of the people finally to come back to New Orleans, 'cause at the time nobody was coming back. Every club just wore whatever they had to represent their club, and we all marched under one banner. So that is definitely an idea that's spinning and wheeling—just to have something, and I'm talking about as soon as possible, just to give everybody something.

Dixon: I'm glad you brought that up, because there's a couple things that we have lined up. One is the Young Men Olympics clubhouse is going to be named the Norman Dixon Sr. Clubhouse. On that day, we are going to actually have a second line. We're going to remember those members who might have died during this time. Now, we've been blessed to have just one out of a hundred-and-something—and we don't know if COVID was the cause of death or not—but we're going to remember him more on that day.

Jackson: You haven't been able to have a traditional jazz funeral, right?

Dixon: Well, for that funeral for Rene Weaver, our procession inside the church, the tribute that we do to our members, all of that inside the church, that still happened, so we are grateful for that. But as far as the activities that we normally do, we did our dirge with the body and the coffin to the hearse, where we deposit the body in the hearse, and after that, there was no second line. We might have played maybe two songs and then we just went off to the gravesite and did the rest of our ceremony there. But the only thing that's come out was the actual second line.

Jackson: This is New Orleans culture, to have a jazz funeral. There have been icons who passed—like Ezell Hines, president of the Uptown Swingers. Ronald Lewis. Mr. Sylvester Francis, who captivated the culture, keeping it preserved over there [at Backstreet Cultural Museum]. And Kim Boutte. Kim was with the Mardi Gras Indians, you know, Fi Yi Yi, but she was also involved with the second line, every week. Such a sweet little thing. She was a supporter—you know, it takes more than that person that's in the group to help 'em out. Most people in the social club world going to get a sendoff like that, and it's so difficult to have that service without something. Some of them might go around the block or something like that, but for the most part anybody being buried, there's no second line, and I know it's killing everybody. Because it's just, we never knew we would miss it like this.

Dixon: We just going to keep praying and keep drawing on God and drawing together and supporting each other through this pandemic, not only us but the community. We are going to be passing out food to those who are working with their kids at home. It's so scary sometimes trying to reach our elderly, because they're so fragile. And you don't want to be the one that open that door, you know—if they're staying home, protected, you don't want to be the one that's bringing something in there that might not be safe for 'em. But as far as the Young Men Olympics, we're going to keep doing what we do: show our benevolence to each other and to the community until this passes.

Jackson: Any final shout-outs?

Parker: First of all, I want to shout-out to the almighty, the one up top looking over all of us. I want to shout-out to Action Jackson, for intervening in this interview right here. And to be part of this book, appreciate that. Want to send a shout-out to everyone who came on the bike ride we did with the Nine Times. And I want to send a shout-out to all the social aid and pleasure clubs that got to be patient and humble at this time, because patience is a virtue around this time on our journey for our lives.

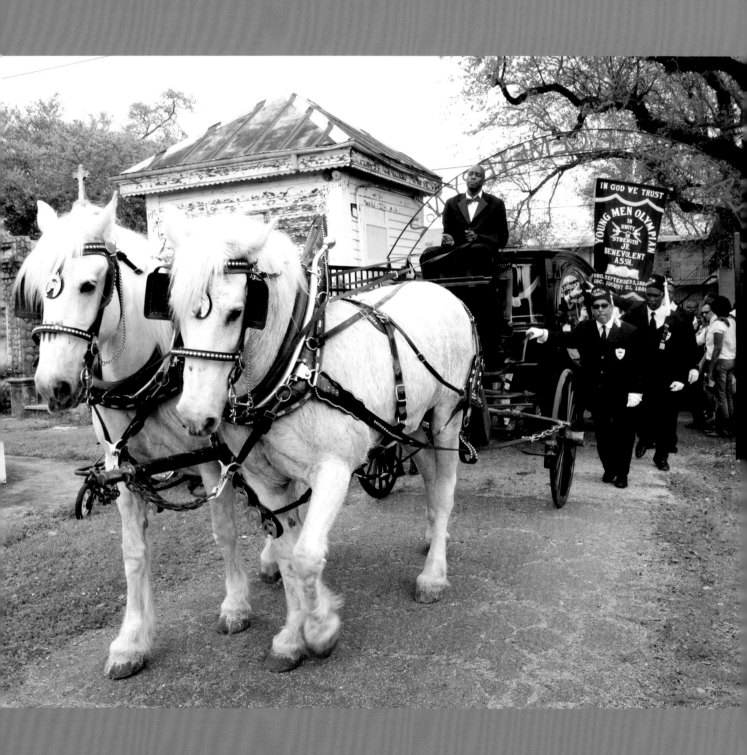

A TRADITIONAL JAZZ FUNERAL FOR ALFRED "BUCKET" CARTER

MATT SAKAKEENY

All Young Men Olympian Junior Benevolent Association members are entitled to a Funeral Procession. . . . We try to keep funerals as similar as possible, however the desires of the family are our main concern. The package includes the following: (1) Draping of the door of the deceased brother's residence; (2) Acquisition of a band of music; (3) Pall Bearers; (4) the Opening and Closing of the Crypt (ie., If interment of the body will be in one of the YMO Crypts located in Lafayette Cemetery #2 on Washington Avenue); and (5) the Funeral Procession.

—Young Men Olympian Junior Benevolent Association charter

On March 21, 2015, Alfred Carter was laid to rest according to the guidelines of the Young Men Olympian Junior Benevolent Association. A raconteur known to all as "Bucket," he loved to tell jokes and dole out advice while rolling a toothpick or cigar in the corner of his mouth, and he explained to anyone who asked that the nickname came from the shape of his head. "He was loved by everybody, uptown, downtown, it does not matter," remembered Norman Dixon Jr., whose father, Norman Dixon Sr., grew up with Bucket. "I think that's one of the reasons why he lived so long, because he wasn't a person who would get stressed out over little things as people do these days." He worked over forty years at the same job, as a warehouse manager for the K&B drugstore chain, in part because his priorities lay mostly elsewhere—in the institutions of family, church, and the YMO Jr.

Born in 1936, Bucket was a fixture in Central City, where his parents ran a beauty parlor and barbershop across the street from Greater St. Stephen Full Gospel Baptist Church. "He was raised in that church," said Belva Carter, Bucket's daughter, "and he

went every Sunday." Bucket was also a regular down the block at the Sportsman's Corner bar, at Second and Dryades Streets, where he's been missed since he passed away. "I'll be going by the bar and they say, 'Girl, we really miss your daddy,'" Belva said. Bucket was a member of the YMO Jr.'s First Division, which held regular meetings at the Sportsman's, just a few blocks from the organization's headquarters at the corner of South Liberty and Josephine Streets. For decades before the clubhouse opened in 2004, they held their meetings at the Gertrude Geddes Willis Funeral Home, one block down South Liberty. Bucket joined the YMO Jr. at the age of five; as a member for seventy-five years, he witnessed changes in the organization and saw many of his brothers come and go, but the brotherhood endured. For a man who did not seek wealth or power, he amassed instead an abundance of community, and within it he earned status and respect. When he suffered a massive heart attack and fell to his death at the age of eighty, his community rallied around the family to offer support and ensure that he was laid to rest in a funeral befitting his stature.

"Our motto is, 'We take care of the sick and we bury the dead,'" said Dixon, who arranged for the organization's "Sick Committee" to meet with Belva and her siblings. They were visited the day after Bucket's passing. Among the elected officials within the YMO Jr., the members of the Sick Committee "are the ones who go out and visit the sick, and when a member dies they meet with the family, and find out what the family wants done and what they want us to do," Dixon said. Bucket had left specific instructions about where and how he wanted to be buried, what music should be played during and after the service, and which clothes he would be dressed in for the viewing. "A week

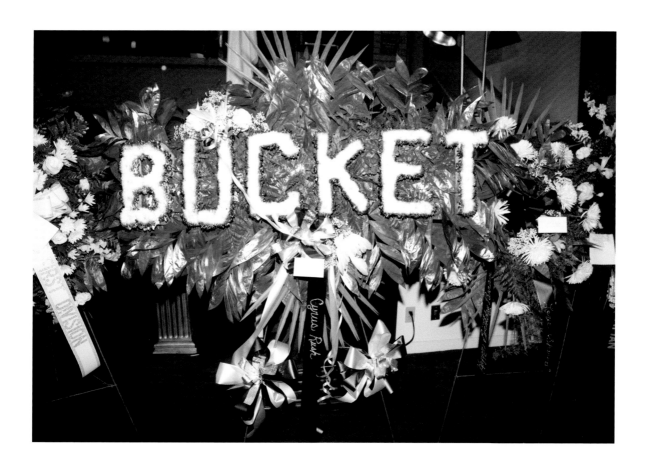

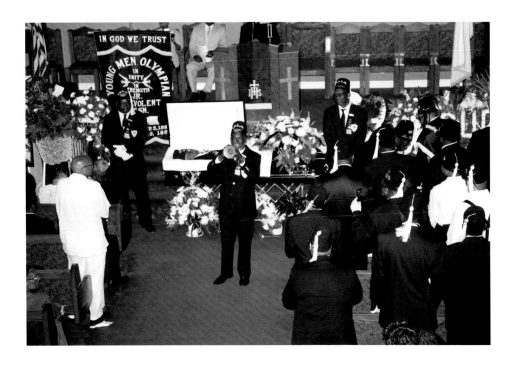

before he died he called my brother back here," Belva said, gesturing to Bucket's room in the house she inherited from him. "Got his suit out, everything he wanted to be laid out in." Bucket had always been a sharp dresser, heading downtown to Canal Street back when department stores like D. H. Holmes, Godchaux's, and Maison Blanche were still open. "They knew his name when he walked in the door," said Belva, recounting how the owner of Meyer the Hatter came to her father's funeral to pay his respects.

———————————————

The morning of the service arrives on Saturday, March 21, and Alfred "Bucket" Carter is laid out in his black suit and tie, white shirt and corsage, black-and-white handkerchief, and fez cap with "Y.M.O. Jr." printed in white above the symbol of a handshake, matching the patch on his pocket and medallion around his neck. Arranged in a half-couch display at the front of the Israelite Baptist Church on Martin Luther King Jr. Boulevard, he is surrounded by framed portraits, the YMO Jr. banner, and flower arrangements, including a massive display of daisies spelling out "B-U-C-K-E-T." The clothes, the open casket, the displays all testify to the prestige of the deceased, as do the large crowds filling the pews. Meanwhile, the Young Men Olympian have marched from their clubhouse with the horse-drawn carriage and brass band that will lead the procession. Bucket's brothers march in to the church in precise order, dressed exactly like him, with two positioning themselves astride the casket and the rest seated in the front rows, across the aisle from the family.

OPPOSITE Funeral flower arrangement, 2015, by Judy Cooper
ABOVE Trumpeter Gregg Stafford plays during the service, 2015, by Judy Cooper

Greater St. Stephen relocated out of Central City after a fire in 2008, but Pastor Brandon M. Boutin visits from the church to shepherd the service. Between the readings of scripture that start the ceremony and the rousing sermon that ends it, there are testimonials—by Norman Dixon Jr. and Quint Davis, among others—and musical selections that draw appreciative responses from the "amen corner." Emotions reach their peak when trumpeter Gregg Stafford steps to the lectern and plays the traditional hymn "Just a Closer Walk with Thee," swinging the rhythm to get the congregation clapping along, with shouts of "Yeah!" and "Alright!" filling the space between his breaths. In the 1970s Bucket encouraged Stafford to join YMO Jr., and he left instructions with his children to have the trumpeter play in the service and lead the jazz funeral procession. "So delivering the solo on his behalf had to be strong," Stafford later explained. "The community was there. All my heart, my feelings, my emotions was there."

After Pastor Boutin's eulogy, the congregants line up for the final viewing, and then Bucket's casket is carried out and down the front steps, where those in the church join a crowd of spectators who have been awaiting this public stage of the burial. Young Men Olympians yell, "Open up," clearing a pathway for the pallbearers to lead Bucket to a horse-drawn carriage at the curb, swaying the casket to the achingly slow dirge "What a Friend We Have in Jesus." Holding his trumpet to his mouth with one hand, Stafford marches up the column to place his other hand on the casket.

Stafford chose to join the First Division of the YMO Jr. precisely because of its commitment to tradition, and he is here to ensure that the music adheres to traditional

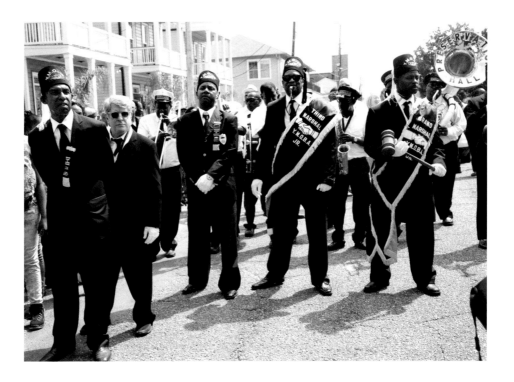

The funeral procession begins, 2015, by Judy Cooper (left–right): Leonard Harris, Quint Davis, Carl McCloud, Joseph Spots, and Jerome "DJ Jubilee" Temple

repertoire, tempos, and dynamics. Police have blocked off traffic, and crowds line the sidewalks of Martin Luther King Jr. Boulevard, facing the street where a dozen musicians are "turned out" in traditional uniform of white shirt, black pants and shoes, and white visored cap. After the body is loaded into the carriage, the grand marshal shouts, "Two-by-two, everybody line up," and the cortege proceeds down the street in precise order of the members, the band, the carriage, and the banner reading "In God We Trust—Young Men Olympian Jr. Benevolent Association—In Unity, In Strength—Org. September 3, 1884—Inc. August 23, 1885." Along with the family and the mortuary staff, they make up the first line, while the crowd falling in step alongside and behind them forms the second line.

Leading the procession to the gravesite, the band makes the transition to upbeat spirituals and popular songs that is the defining characteristic of the jazz funeral. The snare drummer taps out a rolling cadence to set the faster tempo, the grand marshal blows his whistle in time, and by the time the horns enter with the opening phrase of "Oh, Didn't He Ramble" some in the second line have already begun their spins, drops, and jumps. The musicians stop playing to sing a verse, and others join in. *Didn't he ramble? He rambled* . . . Everyone is now moving with a syncopated lilt in their step, many stoic expressions give way to smiles, and a few second liners wave handkerchiefs or decorated umbrellas. *Rambled all around. In and out of town* . . . The carriage moves along the dotted centerline of the street, preceded by the band, with the YMO Jr. out front, the tassels on their fezzes swinging in unison to the rhythm. *Didn't he ramble? Didn't*

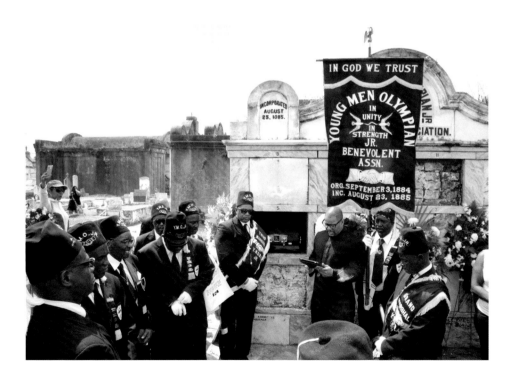

Pastor Brandon M. Boutin reads the order of burial before interment in the YMO Jr. crypt in Lafayette Cemetery No. 2, 2015, by Judy Cooper

he ramble . . . We turn off Martin Luther King Jr. Boulevard and head back through the Central City neighborhood where Bucket lived his whole life surrounded by friends and family. *He rambled 'til the butcher cut him down . . .* The verse ends, the horns go back up, and someone in the second line starts a call-and-response chant over the instrumental arrangement: "Y-M-O!" ("Bucket!").

When Bucket's procession approaches Lafayette Cemetery No. 2, the historically black graveyard seven blocks up Washington Avenue from the white Lafayette No. 1, the up-tempo music abruptly stops, and a slow, sparse drumroll returns. The Young Men Olympian reassemble into precise order, and as they march two-by-two under the massive cast-iron gates of the entryway, someone reassures a somber elderly member, "It's alright unc', get him in there." "Just a Closer Walk with Thee" is sounded again, respectfully soft, Stafford holding a long legato note over the supple melody, prompting a reaction of "Blow that horn!" At the gravesite, Pastor Boutin reads the order for burial:

> We brought nothing into this world, and it is certain we can carry nothing out. The Lord gave, and the Lord hath taken away; blessed be the name of the Lord.
>
> Man, that is born of a woman, hath but a short time to live, and is full of misery. He cometh up, and is cut down, like a flower; he fleeth as it were a shadow, and never continueth in one stay.
>
> In the midst of life we are in death: of whom may we seek for succour, but of thee, O Lord, who for our sins art justly displeased?
>
> Yet, O Lord God most holy, O Lord most mighty, O holy and most merciful Savior, deliver us not into the bitter pains of eternal death.

The moment of quiet reflection concludes with the interment of the body in the Young Men Olympian vaults, and each member places a hand on the casket as they exit. Out on Washington Avenue, the crowd gathers one last time, and the band launches the final leg of the procession to the YMO Jr. clubhouse for the repast. This is a song with no name, known colloquially as "Tuba Fats" after the man who wrote it (Anthony "Tuba Fats" Lacen). There are no words to the song, just a string of melodic riffs that follow one another like lines of free verse, but the song's familiarity and renown among this community cannot be overstated. Shirts untuck, collars unbutton, beer bottles pop open, and those in the YMO Jr. and the second line here to celebrate Bucket's life are overabundant with joy. When the Young Men Olympian finally file into their clubhouse, they pass a man with a T-shirt emblazoned with Bucket's picture and the caption "Let My Work Speak For Me—Mr. Bucket—2015—Though I'm Gone My Memory Shall Live On."

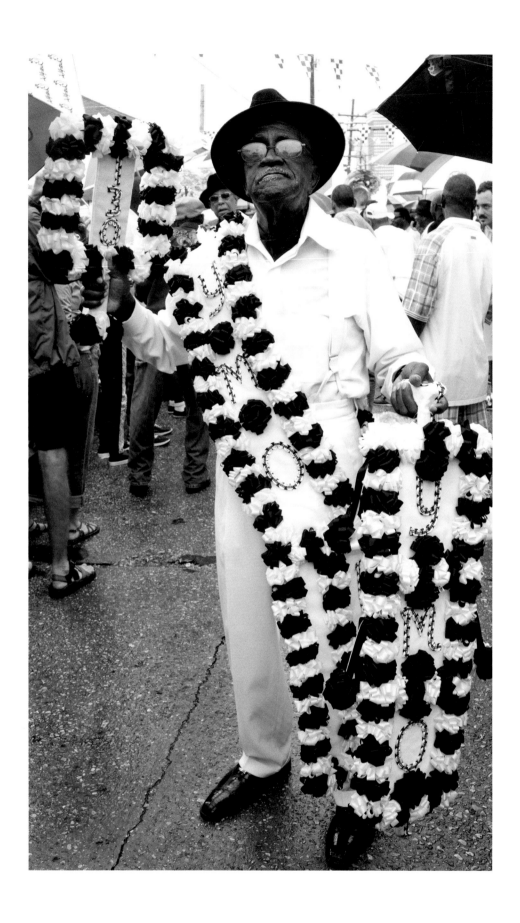

Bucket Carter's final parade with the YMO Jr., 2014, by Judy Cooper

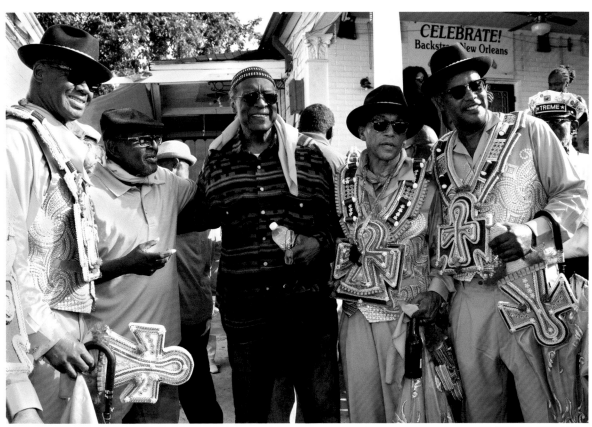

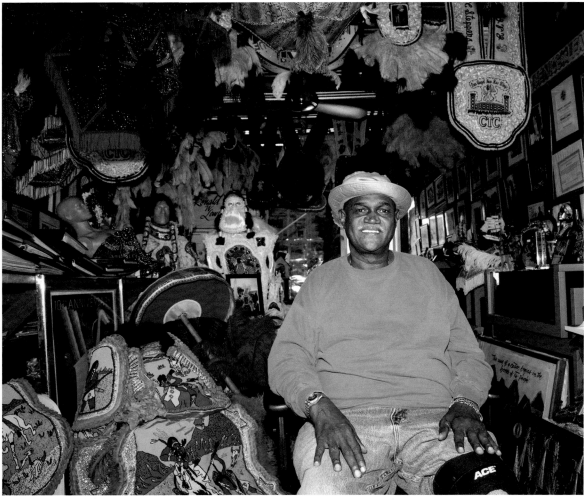

HERITAGE ON DISPLAY

The Historic New Orleans Collection dedicated the exhibition Dancing in the Streets *to two men, Sylvester Francis and Ronald W. Lewis, whose museums have done more to preserve and showcase the history and culture of social aid and pleasure clubs than any other individuals or institutions in the city. Both men died in 2020, in a double blow to New Orleans's cultural community.*

BACKSTREET CULTURAL MUSEUM

Founded in 1999 by photographer, videographer, author, and historian Sylvester "Hawk" Francis (1946–2020), the Backstreet Cultural Museum has presented the history and culture of social aid and pleasure clubs and Black masking traditions for over two decades. A member of the Gentlemen of Leisure Social Aid and Pleasure Club, Francis's interest in documenting the tradition reportedly began when a photographer offered to sell him a photo of himself in his parade outfit. He determined to photograph as many parades as he could, giving one copy of the photos to the subjects and keeping one for himself. His first camera was a Brownie Hawkeye, hence the nickname "Hawk." He subsequently purchased a Super 8 video camera with which to document jazz funerals, second lines, and Black Carnival traditions.

In 1990 he began collecting physical items, starting with a mask worn that year by Big Chief Victor Harris for his Spirit of Fi Yi Yi suit. It became the first acquisition for a museum housed in a two-car garage behind his Seventh Ward home. In 1999 Francis moved his collection into the former Blandin Funeral Home in Treme, which had been the starting point of many jazz funerals. The museum has become a treasured community center and cultural landmark. Francis would often give personal tours to visitors, and he distributed route sheets for upcoming second lines to anyone interested. Working

OPPOSITE, TOP Bruce Sunpie Barnes, Fred Johnson, and Townsley Hamilton of the Black Men of Labor stand outside the Backstreet with Sylvester Francis (second from left) and Jerome Smith (center), 2016, by Judy Cooper
OPPOSITE, BOTTOM Ronald W. Lewis surrounded by his collection of Mardi Gras Indian and second line materials at the House of Dance and Feathers, 2010, by Judy Cooper

with the Neighborhood Story Project (NSP), Francis coproduced *Fire in the Hole: The Spirit Work of Fi Yi Yi and the Mandingo Warriors*, a collaborative ethnography by the Committee Members of Fi Yi Yi. It was published in 2018 by NSP and the University of New Orleans Press.

After a half century spent working to preserve Black history and culture in New Orleans, Francis passed away on September 1, 2020. His legacy survives in the deep, lasting contributions he made to the city's cultural fabric and in the museum, which continues under the stewardship of his daughter Dominique Dilling Francis.

www.backstreetmuseum.org

HOUSE OF DANCE AND FEATHERS

Ronald W. Lewis (1951–2020) of New Orleans's Ninth Ward was a founder of the Original Big Nine Social and Pleasure Club, a Mardi Gras Indian with the Choctaw Hunters, a visual artist who made suits for both groups, a member of the North Side Skull and Bone Gang, and an author, historian, collector, and curator. In 2003 he founded the House of Dance and Feathers, a museum dedicated to Black parading culture and history located behind his Ninth Ward home on Tupelo Street. The museum was located in a shed behind his house—a product of his wife telling him he could no longer continue to store all his Mardi Gras Indian and second line memorabilia in the house. A close friend of Sylvester Francis, Lewis credited Francis and the Backstreet Cultural Museum with inspiring him to exhibit his own collection in his own neighborhood. Lewis continued to collect and filed for articles of incorporation in early 2005.

In August, Katrina came along and washed it all away. Lewis evacuated to Thibodaux, but over the ensuing months he met New Orleans architect Dan Etheridge and Patrick Rhodes from the Kansas State University School of Architecture. Rhodes and his students offered to rebuild the museum. They began work in the spring of 2006 and were finished in August of that same year.

Working with Rachel Breunlin of the Neighborhood Story Project, Lewis created a book telling the story of the museum as well as the history and culture of New Orleans's Black parading traditions. *The House of Dance and Feathers: A Museum by Ronald W. Lewis* was published in 2009, and it remains one of the best books in publication on Mardi Gras Indians and social aid and pleasure clubs.

Lewis died of COVID-19 on March 20, 2020, but his passion for his work and community will live on, inspiring those who knew and admired him.

www.houseofdanceandfeathers.org

SAMPLE PARADE SCHEDULES

1988 SEASON

August 16	**Valley of Silent Men**	*Red Lantern Bar, Dryades Street*
September 3	**Ladies Zulu**	*Jackson Avenue*
September 18	**Jolly Bunch**	*Pete and Alice Bar, Simon Bolivar Avenue*
September 25	**Young Men Olympian Jr.**	*Elks Hall, Harmony Street*
October 16	**Golden Trumpets**	*Seafood Shack, Orleans Avenue*
October 23	**Original Four**	*Armstrong Park*
November 6	**Money Wasters**	*North Claiborne and Ursulines Avenues*
November 13	**Sudan**	*St. Claude and St. Bernard Avenues*
November 20	**Scene Boosters**	*Rose Tavern, North Dorgenois and Thalia Streets*
December 11	**Buckjumpers**	*Glass House, South Saratoga Street*
December 18	**Ladies and Gentlemen of Leisure**	*Boss Place, Pauger and North Derbigny Streets*

Note: This season did not span the winter and spring, owing to the relatively small number of clubs at the time. This roster also includes the starting point of each parade. Source: William Jankowiak, Helen Regis, and Christina Turner, Black Social Aid and Pleasure Clubs: Marching Associations of New Orleans *(New Orleans: Jean Lafitte National Historical Park and the National Park Service, 1989).*

1997-98 SEASON

August 17	**Valley of Silent Men**	December 21	**Perfect Gentlemen**
August 25	**Fazio Steppers**		**Double Nine**
August 31	**Black Men of Labor**	December 25	**Togetherness**
September 7	**Ladies Zulu**	December 28	**Rollers**
September 14	**Prince of Wales**		**Big Nine**
September 21	**Jolly Bunch**		**Just Stepping**
September 28	**Young Men Olympian Jr.**	January 4	**Second Line Jammers**
October 11	**Golden Trumpets**		**Treme Sidewalk Steppers**
	Chosen Few	January 11	**Original Black Magic**
October 19	**Popular Ladies**		**Untouchables**
October 26	**Avenue Steppers**	January 18	**Ladies of Essence**
	Original Four	March 1	**Devastating Ladies**
November 2	**Money Wasters**	March 8	**Step N Style**
	Jolly Bunch Sisters	March 15	**Single Men**
November 9	**Original Gentlemen**	March 22	**Westbank Steppers**
	Sudan	March 29	**Big Nine**
November 16	**Scene Boosters**		**Lady Sequence**
November 23	**Westbank Steppers**	April 5	**Positive Ladies**
November 30	**Lady Buckjumpers**	April 12	**Pigeon Town Steppers**
December 7	**Young Steppers**	April 20	**Revolution**
	Devastation	May 10	**Nkrumah Better Boys**
December 14	**Lady Jetsetters**	May 17	**Ladies Over 30**
	Calliope High Steppers		
	Dumaine Street Gang		

Note: Because of Mardi Gras, there were no scheduled second line parades in February. Similarly, the last weekend in April and the first weekend in May saw no parades because of Jazz Fest. Source: Times Picayune, August 24, 1997.

2019-20 SEASON

August 25	**Valley of Silent Men**
September 1	**No parade scheduled;**
	possible makeup
September 8	**Young Men Olympian Jr.**
	(mini)
September 15	**Good Fellas**
September 22	**Young Men Olympian Jr.**
	(regular)
October 6	**Family Ties**
October 13	**Prince of Wales**
October 20	**Men of Class**
October 27	**Black Men of Labor**
	Original Four
November 3	**We Are One**
November 10	**Sudan**
November 17	**Nine Times**
November 24	**Lady and Men Buckjumpers**
December 1	**Dumaine Street Gang**
	Westbank Steppers
December 8	**New Generation**
December 15	**Big Nine**
December 22	**Women of Class**
December 29	**Lady Rollers**

January 5	**Perfect Gentlemen**
January 12	**Lady Jetsetters—CANCELED**
January 19	**Undefeated Divas**
January 26	**Ladies and Men of Unity**
February 2	**Treme Sidewalk Steppers**
February 9	**C.T.C. Steppers**
March 1	**VIP Ladies and Kids**
March 8	**Keep 'N It Real**

CANCELED BECAUSE OF COVID-19:

March 15	**Single Men**
March 22	**Revolution**
April 5	**Single Ladies**
April 12	**Pigeon Town Steppers**
April 19	**Ole & Nu Style Fellas**
May 10	**Original Big 7**
May 17	**Divine Ladies**
	Zulu
May 24	**Money Wasters**
May 31	**Scene Boosters**
June 21	**Perfect Gentlemen**
June 28	**Uptown Swingers**

Source: New Orleans Police Department

ABOUT THE AUTHOR

Judy Cooper is a photographer living and working in New Orleans. She earned a PhD in French language and literature from Tulane University and taught at the college level before becoming a photographer. Cooper worked for a number of years as a freelance photographer specializing in fine art photography. For fifteen years, starting in 1998, she served as staff photographer for the New Orleans Museum of Art.

Known for her whimsical portraits of colorful New Orleanians, Cooper has shown her work in numerous local, regional, and national exhibitions. She has presented solo shows in New Orleans, Baton Rouge, Chicago, Houston, New York, and Kaunas, Lithuania. A major exhibition of her work, entitled *Living Color: Photographs by Judy Cooper*, was shown at the New Orleans Museum of Art in 2008.

Cooper first became interested in photographing the social aid and pleasure clubs of New Orleans in the late 1990s. At first, her interest was purely visual, but as she got to know more of the participants and learned about the tradition, she began to conceive of a book that would celebrate its history, pageantry, and community. Hurricane Katrina strengthened her resolve to write such a book. Continuing to photograph the parades every week, she reached out to a number of writers and photographers to contribute to the project. Many years later, she is deeply gratified to be finally seeing this dream become a reality.

As a gift to the social aid and pleasure club community, in gratitude for their time and cultural work, Cooper has donated a portion of her author's fee to the New Orleans Jazz and Heritage Foundation's Norman Dixon Sr. Annual Second Line Parade Fund. She has also made sure that The Historic New Orleans Collection will be able to donate copies of the book to every social aid and pleasure club.

Judy Cooper with Paul "Stumbling Man" Landry of the Prince of Wales, 2019, by MJ Mastrogiovanni

CONTRIBUTORS

CONTRIBUTING WRITERS

RACHEL CARRICO

Rachel Carrico is an assistant professor of dance studies in the School of Theatre and Dance at the University of Florida and a proud member of the Ice Divas Social and Pleasure Club. Her research explores the aesthetic, political, and social histories of second lining. Her scholarship has been published in *TDR: The Drama Review*, *The Black Scholar*, and several edited volumes, including *Freedom's Dance: Social, Aid and Pleasure Clubs in New Orleans* (2018), *The Oxford Handbook of Dance and Competition* (2018), and *Walking Raddy: The Baby Dolls of New Orleans* (2018). In 2008 Carrico cofounded the performance ensemble Goat in the Road Productions in New Orleans, with whom she launched Play/Write, a youth playwriting festival in New Orleans schools. She has also been a contributor to *New Orleans Data News Weekly* and a consultant for *Buckumping* (2018), a documentary film on New Orleans vernacular dance directed by Lily Keber. She holds a PhD in critical dance studies from the University of California, Riverside, and an MA in performance studies from New York University.

FREDDI WILLIAMS EVANS

Freddi Williams Evans is an independent scholar who is internationally recognized for her scholarship on historic Congo Square. She is the author of numerous essays and *Come Sunday: A Young Reader's History of Congo Square* (2017), which received a bronze medal from the 2018 Independent Publisher Book Awards and was a finalist for the 2018 Next Generation Indie Book Award. Her book *Congo Square: African Roots in New Orleans* (2011), the first comprehensive study of the historic site, was named the 2012 Humanities Book of the Year by the Louisiana Endowment for the Humanities. Her research and advocacy influenced the 2011 New Orleans City Council's decision to

change the name of the location from Beauregard Square to Congo Square. Evans has served on multiple committees to erect historical markers that commemorate African American history in New Orleans, including the marker at Congo Square, and she co-chaired the New Orleans Committee to Erect Historic Markers on the Slave Trade.

CHARLES "ACTION" JACKSON

Charles "Action" Jackson is a radio DJ, podcaster, and longtime "ambassador to the second line." Born and raised in the Ninth Ward of New Orleans, Jackson has worked the club scene for more than forty years. After spending ten years in the Louisiana Army National Guard and holding a thirty-year career in law enforcement, he began his work in broadcasting as a guest host on Q93 with DJ Slab 1. In 2012 he moved over to community radio station WWOZ, where his podcast and webpage, *Takin' It to the Streets*, has become the premier source of information about upcoming second lines. The show has won awards from the Press Club of New Orleans and the Louisiana Association of Broadcasters. Jackson has also served as a host for video coverage of second lines, starting in 2004 with photographer and documentarian Randolph "Mookie" Square and, beginning in 2009, with Mr. C's TV.

MATT SAKAKEENY

Matt Sakakeeny is associate professor of music at Tulane University. He is the author of *Roll With It: Brass Bands in the Streets of New Orleans* (2013) and coauthor of *Keywords in Sound* (2015) and *Remaking New Orleans: Beyond Exceptionalism and Authenticity* (2019). He is a board member of two nonprofit organizations, the Roots of Music after-school program and the Dinerral Shavers Educational Fund. Sakakeeny has received a grant from the Spencer Foundation for his next book, on marching band education in the New Orleans school system. He is also the guitarist and bandleader of Los Po-Boy-Citos, and he released a solo album in 2018 as the Lonely Birds.

MICHAEL G. WHITE

Michael G. White is an internationally renowned clarinetist, educator, composer, writer, producer, and jazz historian. After receiving his PhD in Spanish at Tulane University, he returned to his alma mater, Xavier University of Louisiana, where he currently teaches African American music. White learned jazz over many years by performing in hundreds of social club parades, church processions, and jazz funerals. He has made over eighty recordings, fifteen under his own name and others with artists such as Wynton Marsalis, Paul Simon, and Taj Mahal. He has also published numerous essays, book chapters, encyclopedia entries, and liner notes. White's awards include the National Endowment for the Arts's National Heritage Fellowship and the Louisiana Endowment for the Humanities's Humanist of the Year award. He regularly performs with his Original Liberty Jazz Band and Michael White Quartet.

CONTRIBUTING PHOTOGRAPHERS

BRAD EDELMAN

Brad Edelman developed a passion for photography and the arts early in life. He continued to cultivate these interests throughout his college football years and career as an NFL Pro Bowl guard for the New Orleans Saints. For his second act, Edelman embarked on a personal and professional artistic journey that featured broadcasting, music, acting, and, ultimately, a return to photography, where he focused his eye on the soulful music, culture, and texture of the visual landscape of New Orleans.

RYAN HODGSON-RIGSBEE

Ryan Hodgson-Rigsbee is a native of Chicago now based in New Orleans. After studying photojournalism at Ohio University, he worked as a staff photographer at the *Orange County Register* and has freelanced for the *New York Times*, *Condé Nast Traveler*, *OffBeat* magazine, and many others. Hodgson-Rigsbee also collaborates with numerous New Orleans nonprofits, businesses, and artists such as WWOZ, Birdfoot Festival, Make Music NOLA, the Mardi Gras Indian Hall of Fame, and others to reach the public with photography that is both compelling and culturally responsible.

PABLEAUX JOHNSON

Pableaux Johnson is a photographer, journalist, and author of three books on Louisiana food culture. His writing and photographic work appear regularly in the *New York Times* and *Garden and Gun*. He has displayed his New Orleans "action portrait" work in solo shows at the University of Mississippi, UCLA, and the University of North Carolina at Chapel Hill. Raised in New Iberia, Louisiana, Johnson has lived in New Orleans and photographed its diverse street culture since 2001. He tours the US with his food/travel project the Red Beans Road Show, which carefully avoids second line Sundays.

CHARLES MUIR LOVELL

Charles Muir Lovell has spent more than ten years documenting the city's second line parades, social aid and pleasure clubs, and jazz funerals, capturing and preserving these vibrant elements of New Orleans culture. His photographs have been exhibited nationally and internationally and are held in several permanent collections, including The Historic New Orleans Collection. He is the recipient of the 2020 Michael P. Smith Award for Documentary Photography from the Louisiana Endowment for the Humanities.

MICHAEL "MJ" MASTROGIOVANNI

MJ Mastrogiovanni is a self-taught photographer born and raised on the East Coast and now living in New Orleans. Since moving to the city, Mastrogiovanni has immersed

himself in the unique culture of the city, making pictures at Sunday second lines, Mardi Gras Indian events, jazz funerals, and wherever a brass band might strike up in the streets—be it uptown, downtown, or back-of-town.

LESLIE PARR

Leslie Parr is the A. Louis Read Distinguished Professor of Mass Communication Emerita at Loyola University New Orleans, where she taught photography and history courses for thirty-five years. She is the author of *A Will of Her Own: Sarah Towles Reed and the Pursuit of Democracy in Southern Public Education* (2010), *Ozark Elders: A Photo-Documentary* (1981), and *Visits with Ozark Country Women* (1979).

LINDA A. RENO

L. A. Reno is a photographer and educator who spent her formative years outside of Chicago. Early adulthood brought her down below the Mason-Dixon line, where she earned an MA in journalism from the University of Texas at Austin, and she has never looked back. Reno currently divides her time between Jacmel, Haiti, and New Orleans—the best, most beautiful places on earth. The sights, sounds, smells, tastes, textures, and culture of the Global South inspire all her work. Throughout her endeavors, it is this visceral sense of culture that she seeks to both reveal and revel in.

J. R. THOMASON

J. R. Thomason feels that a good photo should move, motivate, and inspire for all eternity. That has been his goal for over thirty years, ever since his passion for photography evolved into his profession. Self-taught, he is committed to excellence in the creative and technical worlds of video, photography, and post-production. As a fine art photographer, Thomason has served a wide range of clients in the United States and abroad, leading him to amass a body of work captured on five continents. Thomason sees his profession as a magic carpet ride that takes him around the world, allowing him to share experiences with many great people.

ERIC WATERS

Eric Waters has been a professional photographer for more than thirty-five years. A student of the late Marion J. Porter of Porter's Photo News, Waters is known best for capturing the energetic scenes of New Orleans second lines and Mardi Gras Indians. He is the official photographer of the Black Men of Labor, and his work has appeared in local and national magazines, newspapers, and brochures, as well as in gallery shows and exhibitions. His photography illustrates the book *Freedom's Dance: Social, Aid and Pleasure Clubs in New Orleans* (2018). In 1985 he founded the nonprofit Ebonimages, which works to document African American culture in New Orleans.

ACKNOWLEDGMENTS

"Words don't fail me now" as I try to express my deep and undying gratitude to all the many people whose support, encouragement, assistance, and collaboration have made this book possible. It was a veritable community. Family and friends were patient and steadfast in their support during a long, often circuitous journey on a sometimes-bumpy road. Sonja Dupois of St. Martinville offered a quiet, lovely retreat where I did a significant amount of the writing. Some of my friends assisted with the writing, including Leslie Parr, Lisa Rotondo-McCord, and Johanna Rotondo-McCord. Deepest thanks to all the book's contributors; your essays and images have enriched this publication beyond my wildest dreams.

Working with The Historic New Orleans Collection (THNOC) has been a pleasure from beginning to end. John H. Lawrence, emeritus director of museum programs, and Jude Solomon, former curator of photographs, guided me in exploring the rich historical materials and photographs in The Collection's holdings. Bruce Boyd Raeburn and Lynn Abbott, both formerly of the Hogan Jazz Archive at Tulane University, provided assistance in gathering images from the Hogan's Ralston Crawford Collection of Jazz Photography. Thanks also to Rachel Lyons at the New Orleans Jazz and Heritage Foundation Archive and Yvonne Loisel in the Louisiana Division of the New Orleans Public Library.

THNOC's acceptance of my book for publication was the ultimate validation of my project. I felt totally secure knowing that my book was in the capable hands of Jessica Dorman, director of publications. Molly Reid Cleaver, my editor, took on the monumental job of whipping the text into shape, a job that she executed with great aplomb. I was constantly impressed with her writing skills as well as her attention to detail. Book designer Georgia Scott has assembled the text and photographs with the utmost care and creativity. She, like the others, has been an absolute joy to work with. Thanks as well to the curators of the *Dancing in the Streets* exhibition—John H. Lawrence, Eric

Seiferth, Jude Solomon, and Jason Wiese—for putting together an array of photographs and artifacts that truly pays homage to New Orleans's parading tradition.

I saved my biggest thanks for last, and that is to the many men and women who comprise New Orleans's community of social aid and pleasure clubs and who put on such delightful parades year after year. Their love for the tradition and dedication to the culture has been my deepest inspiration. I hope this book is a worthy song of praise for their endeavors.

—*Judy Cooper*

Johnnie "Kool" Stevenson at Jazz Fest, 1999, by Judy Cooper

BIBLIOGRAPHY

BOOKS AND ARTICLES

Ake, David. *Jazz Cultures*. Berkeley: University of California Press, 2002.

Armstrong, Louis. *Satchmo: My Life in New Orleans*. New York: Prentice Hall, 1954. Reprint, New York: Da Capo, 1986.

Barker, Danny. *A Life in Jazz*, illustrated ed. New Orleans: The Historic New Orleans Collection, 2016.

Barnes, Bruce Sunpie, and Rachel Breunlin, eds. *Talk That Music Talk: Passing On Brass Band Music in New Orleans the Traditional Way*. New Orleans: University of New Orleans Center for the Book, 2014.

Bechet, Sidney. *Treat It Gentle*. 1960. Reprint, New York: Da Capo, 2002.

Bell, Caryn Cossé. *Revolution, Romanticism, and the Afro-Creole Protest Tradition in Louisiana, 1718–1868*. Baton Rouge: Louisiana State University Press, 1997.

Blassingame, John W. *Black New Orleans, 1860–1880*. Chicago: University of Chicago Press, 1973.

Blesh, Rudi. *Shining Trumpets: A History of Jazz*. New York: Knopf, 1946.

Brothers, Thomas. *Louis Armstrong's New Orleans*. New York: W. W. Norton, 2006.

Breunlin, Rachel, and Ronald W. Lewis. *The House of Dance and Feathers: A Museum by Ronald W. Lewis*. New Orleans: Neighborhood Story Project and University of New Orleans Press, 2009.

Burns, Mick. *Keeping the Beat on the Street: The New Orleans Brass Band Renaissance*. Baton Rouge: Louisiana State University Press, 2008.

Campanella, Richard. *Bienville's Dilemma: A Historical Geography of New Orleans*. Lafayette: Center for Louisiana Studies, University of Louisiana at Lafayette, 2008.

Carrico, Rachel. "Dancing Like a Man: Competition and Gender in the New Orleans Second Line." In *The Oxford Handbook of Dance and Competition*, edited by Sherril Dodds, 573–95. New York: Oxford University Press, 2019.

———. "Un/Natural Performances: Second Lining and Hurricane Katrina." *The Black Scholar* 46.1 (2016): 27–36.

Clifford, Jan, and Leslie Blackshear Smith. *The New Orleans Jazz and Heritage Festival*. New Orleans: e/Prime Publications, 2005.

Cotton, Deborah. *Notes from New Orleans: Spicy, Colorful Tales of Politics, People, Food, Drink, Men, Music, and Life in Post-Breaches New Orleans*. Self-published, Cafe Press, 2007.

Dunbar-Nelson, Alice. "People of Color in Louisiana: Part I." *The Journal of Negro History* 1, no. 4 (Oct. 1916): 361–76.

Eagleson, Dorothy Rose. "Some Aspects of the Social Life of the New Orleans Negro in the 1880s." Master's thesis, Tulane University, 1961.

Evans, Freddi Williams. *Congo Square: African Roots in New Orleans*. Lafayette: University of Louisiana at Lafayette Press, 2011.

Fischlin, Daniel, Ajay Heble, and George Lipsitz. *The Fierce Urgency of Now: Improvisation, Rights, and the Ethics of Cocreation*. Durham: Duke University Press, 2013.

Flint, Timothy. *Recollections of the Last Ten Years in the Valley of the Mississippi*. 1826. Edited by George R. Brooks. Carbondale: Southern Illinois University Press, 1968.

Floyd, Samuel A., Jr. "Ring Shout! Literary Studies, Historical Studies, and Black Music Inquiry." *Black Music Research Journal* 11, no. 2 (1991): 265–87.

Gottschild, Brenda Dixon. *The Black Dancing Body: A Geography from Coon to Cool*. New York: Palgrave Macmillan, 2003.

Green, Elna C., ed. *Before the New Deal: Social Welfare in the South, 1830–1930*. Athens: University of Georgia Press, 1999.

Hall, Gwendolyn Midlo. *Slavery and African Ethnicities in the Americas: Restoring the Links*. Chapel Hill: University of North Carolina Press, 2005.

Hazzard-Donald, Katrina. "Hoodoo Religion and American Dance Traditions: Rethinking the Ring Shout." *Journal of Pan African Studies* 4, no. 6 (2011): 194–212.

Jacobs, Claude. "Benevolent Societies of New Orleans Blacks during the Late Nineteenth and Early Twentieth Centuries." *Louisiana History* 29, no. 1 (Winter 1988): 21–33.

Jankowiak, William, Helen Regis, and Christina Turner. *Black Social Aid and Pleasure Clubs: Marching Associations of New Orleans*. New Orleans: Jean Lafitte National Historical Park and the National Park Service, 1989.

Jones, Ferdinand. *The Triumph of the Soul: Cultural and Psychological Aspects of African American Music*. New York: Praeger, 2000.

Knowles, Richard H. *Fallen Heroes: A History of New Orleans Brass Bands*. New Orleans: Jazzology, 1996.

Latrobe, Benjamin Henry. *The Journals of Benjamin Henry Latrobe, 1799–1820: From Philadelphia to New Orleans*, edited by Edward C. Carter and Lee W. Formwalt. New Haven: Yale University Press, 1980.

Lomax, Alan. *Mister Jelly Roll: The Fortunes of Jelly Roll Morton, New Orleans Creole and "Inventor of Jazz."* Berkeley: University of California Press, 1952.

Marable, Manning, and Kristen Clarke, eds. *Seeking Higher Ground: The Hurricane Katrina Crisis, Race and Public Policy Reader*. New York: Palgrave MacMillan, 2008.

McCarthy, Kevin, D. J. Peterson, Narayan Sastry, and Michael Pollard. *The Repopulation of New Orleans after Katrina*. Santa Monica, CA: RAND Gulf States Policy Institute, 2006.

Nine Times Social and Pleasure Club. *Coming Out the Door for the Ninth Ward*, 2nd ed. New Orleans: Neighborhood Story Project, 2007.

Parr, Leslie Gale. "Sundays in the Streets: The Long History of Benevolence, Self-Help, and Parades in New Orleans." *Southern Cultures* 22.4 (2016): 8–30.

Regis, Helen. "Second Lines, Minstrelsy, and the Contested Landscapes of New Orleans Afro-Creole Festivals." *Cultural Anthropology* 14, no. 4 (November 1999): 472–504.

Regis, Helen A., and Shana Walton. "Producing the Folk at the New Orleans Jazz and Heritage Festival." *Journal of American Folklore* 121, no. 482 (Fall 2008): 400–440.

Rublowsky, John. *Black Music in America*. New York: Basic, 1971.

Sakakeeny, Matt. *Roll With It: Brass Bands in the Streets of New Orleans*. Durham and London: Duke University Press, 2013.

———. "'Under the Bridge': An Orientation to Soundscapes in New Orleans." *Ethnomusicology* 54, no. 1 (Winter 2010): 1–27.

Schafer, William J., with Richard B. Allen. *Brass Bands and New Orleans Jazz*. Baton Rouge and London: Louisiana University Press, 1977.

Smith, Michael P. *Mardi Gras Indians*. Gretna, LA: Pelican, 1994.

Sublette, Ned. *The World That Made New Orleans: From Spanish Silver to Congo Square*. Chicago: Lawrence Hill, 2008.

Thompson, Robert Farris. "When the Saints Go Marching In: Kongo Louisiana, Kongo New Orleans." In *Resonance from the Past: African Sculpture from the New Orleans Museum of Art*, edited by Frank Herreman. New York: Museum of African Art, 2005.

Walker, Harry Joseph. "Negro Benevolent Societies in New Orleans: A Study of Their Structure, Function, and Membership." Master's thesis, Fisk University, 1937.

Waters, Eric, and Karen Celestan. *Freedom's Dance: Social, Aid and Pleasure Clubs in New Orleans*. Baton Rouge: Louisiana State University Press, 2018.

White, Michael G. "Dr. Michael White: The Doc Paulin Years (1975–79)." *Jazz Archivist* 23 (2010): 2–20.

———. "New Orleans's African American Musical Traditions: The Spirit and Soul of a City." In *Seeking Higher Ground: The Hurricane Katrina Crisis, Race, and Public Policy Reader*, edited by Manning Marable and Kristen Clarke, 87–106. New York: Palgrave Macmillan, 2008.

———. "The New Orleans Brass Band: A Cultural Tradition." In *The Triumph of the Soul: Cultural and Psychological Aspects of African American Music*, edited by Ferdinand Jones and Arthur C. Jones, 69–96. Westport, CT: Praeger, 2000.

Woodruff, Ann. "Society Halls in New Orleans: A Survey of Jazz Landmarks, Part I." *Jazz Archivist* 20 (2007): 11–28.

Zander, Marjorie Thomas. "The Brass-Band Funeral and Related Negro Burial Customs." Master's thesis, University of North Carolina at Chapel Hill, 1962.

AUDIO AND VIDEO RECORDINGS

Barker, Danny. Interview with Michael G. White. July 21–23, 1992. Smithsonian Jazz Oral History Program.

Bunk's Brass Band and Bunk's Dance Band. *Bunk's Brass Band and 1945 Sessions*. American Music AMCD-6, 1992.

Dirty Dozen Brass Band. *My Feet Can't Fail Me Now*. Floating World / Retroworld FLOATM 6046, 2011.

Eureka Brass Band. *New Orleans Funeral and Parade: The Original 1951 Session*. American Music AMCD-70, 1992.

———. *The Music of New Orleans, Vol. 2: Music of the Eureka Brass Band*. Smithsonian Folkways FW02462 / FA 2462, 1958.

[Dejan's] Olympia Brass Band. *The Olympia Brass Band of New Orleans*. GHB BCD-108, 2005.

Jackson, Charles "Action." *Takin' It to the Streets* (podcast). WWOZ.org.

Logsdon, Dawn, dir., and Lolis Eric Elie, writer. *Faubourg Tremé: The Untold Story of Black New Orleans*. DVD. San Francisco: California Newsreel, 2007.

Lomax, Alan. *Jazz Parades: Feet Don't Fail Me Now*. Videotape. New York: Association for Cultural Equity, 1990. Available on Folkstreams, http://www.folkstreams.net/film,126.

Rebirth Brass Band. *Feel Like Funkin' It Up*. Rounder CD 2093, 1989.

———. *Rebirth of New Orleans*. Basin Street BSR 1202-2, 2011.

Various artists [Hot 8, Liberty, and Treme Brass Bands]. *New Orleans Brass Bands: Through the Streets of the City*. Smithsonian Folkways SFW40212, 2014.

Young Tuxedo Brass Band. *Jazz Begins: Sounds of New Orleans Streets—Funeral and Parade Music.* Collectables, 2007.

UNPUBLISHED INTERVIEWS

Batiste, William. Interview with Judy Cooper. September 2015.

Brown, Leander "Shack." Interview with Rachel Carrico. December 16, 2015.

Buckner, Edward. In conversation with Judy Cooper. 2010 and June 2011.

Davis, Rodrick "Scubble." Interview with Rachel Carrico. January 16, 2014.

Gable, Terry. Interview with Rachel Carrico. January 24, 2014.

Carter, Alfred "Bucket." Interview with Judy Cooper. June 2012.

Davis, Quint. Interview with Judy Cooper. January 31, 2012.

Dixon, Norman, Jr. Interview with Charles "Action" Jackson. November 24, 2020.

———. Interview with Judy Cooper. October 14, 2015.

Dunn, Kevin. Interview with Judy Cooper. July 31, 2011.

Goldstein, L. J. Interview with Judy Cooper. January 2014.

Green, Linda. Interview with Judy Cooper. September 2014.

Hines, Ezell. Interview with Judy Cooper. June 6, 2015.

Hookfin, Anthony "Tony." Interview with Judy Cooper. November 2013.

Jackson, Charles "Action." Interview with Molly Reid Cleaver. November 18, 2020.

Johnson, Fred. Interviews with Judy Cooper. January 16, 2014, and June 2020.

Lewis, Wardell, Sr. Interview with Judy Cooper. July 4, 2013.

Matranga, Jack. Interview with Judy Cooper. June 18, 2014.

Meyer, Sam. Interview with Judy Cooper. July 12, 2014.

Parker, Raphael. Interview with Charles "Action" Jackson. November 30, 2020.

Patterson, Wallace. Interview with Judy Cooper. September 2015.

Porter, Linda Tapp. Interview with Charles "Action" Jackson. November 25, 2020.

Press, Sue. Interview with Judy Cooper. July 31, 2014.

Robertson, Bernard. Interviews with Judy Cooper. May 2014 and December 27, 2020.

Rubenstein, Andre. Interview with Judy Cooper. July 12, 2014.

Smith, Jerome. Interview with Judy Cooper. February 2, 2015.

Smith, Terrinika. Interview with Rachel Carrico. August 8, 2014.

Snowden, Tamara Jackson. Interview with Rachel Carrico. April 21, 2014.

Stern, Joe. Interviews with Judy Cooper. February 2006 and September 2014.

Williams, Robert. Interview with Judy Cooper. 2011.

ARCHIVAL IMAGE CREDITS

PAGE	CAPTION
10	Ladies Zulu, ca. 1970, by Jules Cahn. *Jules Cahn Collection at The Historic New Orleans Collection, 2000.78.1.1951*
11	Young Men's Protective Association of Algiers parade, 1956, by Ralston Crawford. *Courtesy Hogan Archive of New Orleans Music and New Orleans Jazz, Tulane University Special Collections, Tulane University, New Orleans, LA*
20	Treme Sports, ca. 1970, by Jules Cahn. *Jules Cahn Collection at The Historic New Orleans Collection, 2000.78.1.1854*
22	*The Bamboula*, 1886, by E. W. Kemble. *The Historic New Orleans Collection, 1974.25.23.53.* It is important to note that Kemble did not make this sketch from direct observation; rather, Kemble drew from George Washington Cable's descriptions of the dances at Congo Square, written decades after the gatherings ended.
25	*Bamboula: danse des nègres*, op. 2, composed 1848, by Louis Moreau Gottschalk. *The Historic New Orleans Collection, 86-913-RL*
27	Praline seller, ca. 1940, by Joseph Woodson Whitesell. *The Historic New Orleans Collection, 1978.122.2*
33	Second line, Caldonia Club funeral, 1958, by Ralston Crawford. *Courtesy Hogan Archive of New Orleans Music and New Orleans Jazz, Tulane University Special Collections, Tulane University, New Orleans, LA*
34	Top: Young Men Olympian Jr. Benevolent Association, 1967, by Jules Cahn. *Jules Cahn Collection at The Historic New Orleans Collection, 2000.78.7.61*
34	Bottom: Gilbert Heedly funeral, 1993, by Michael P. Smith. *Photograph by Michael P. Smith © The Historic New Orleans Collection, 2007.0103.2.198*
39	Louis Armstrong as king of Zulu, 1949, by Bob Ostrum and Bob Stearns. *William Russell Jazz Collection, MSS 520, acquisition made possible by the Clarisse Claiborne Grima Fund, The Historic New Orleans Collection, 92-48-L.76*
41	Robert Williams, Jolly Bunch, 1987, by Michael P. Smith. *Photograph by Michael P. Smith © The Historic New Orleans Collection, 2007.0103.8.1732*
42–43	Avenue Steppers, 1982, by Michael P. Smith. *Photograph by Michael P. Smith © The Historic New Orleans Collection, 2007.0103.2.132*
44	Top: Jolly Bunch parade, 1958, by Ralston Crawford. *Courtesy Hogan Archive of New Orleans Music and New Orleans Jazz, Tulane University Special Collections, Tulane University, New Orleans, LA*

144 Eureka Brass Band at an Algiers funeral, 1956, by Ralston Crawford. *Courtesy Hogan Archive of New Orleans Music and New Orleans Jazz, Tulane University Special Collections, Tulane University, New Orleans, LA*

145 Young Tuxedo Brass Band at a parade of the Merry-Go-Round Social and Aid Club, 1961, by Ralston Crawford. *Courtesy Hogan Archive of New Orleans Music and New Orleans Jazz, Tulane University Special Collections, Tulane University, New Orleans, LA*

146 Members of the Excelsior Brass Band, ca. 1960, by Jules Cahn. *Jules Cahn Collection at The Historic New Orleans Collection, 2000.78.1.73*

147 Olympia Brass Band at the funeral of jazz clarinetist George Lewis, 1969, by Michael P. Smith. *Photograph by Michael P. Smith © The Historic New Orleans Collection, 2007.0103.2.156*

149 Onward Brass Band, ca. 1970, by Jules Cahn. *Jules Cahn Collection at The Historic New Orleans Collection, 2000.78.1.102*

150 Doc Paulin Dixieland Jazz Band, ca. 1975, by Jules Cahn. *Jules Cahn Collection at The Historic New Orleans Collection, 2000.78.1.16*

151 Hurricane Brass Band, with Leroy Jones on trumpet and Anthony "Tuba Fats" Lacen on tuba, ca. 1975, by Jules Cahn. *Jules Cahn Collection at The Historic New Orleans Collection, 2000.78.1.94*

152 Dirty Dozen Brass Band, ca. 1990, by Michael P. Smith. *Photograph by Michael P. Smith © The Historic New Orleans Collection, 2007.0103.8.67*

153 Rebirth Brass Band, 1984, by Michael P. Smith. *Photograph by Michael P. Smith © The Historic New Orleans Collection, 2007.0103.4.354*

INDEX

Note: Photographs are indicated by page numbers in *italics*.